LEARNING RESOURCES CTR/NEW ENGLAND TECH.
GEN PR5263.R6 1986
Rosenberg, J The darkening glass :

3 0147 0001 1911 8

PR5263 .R6 1986

Rosent

The Da W9-DAM-487

THE DARKENING GLASS

A PORTRAIT OF RUSKIN'S GENIUS

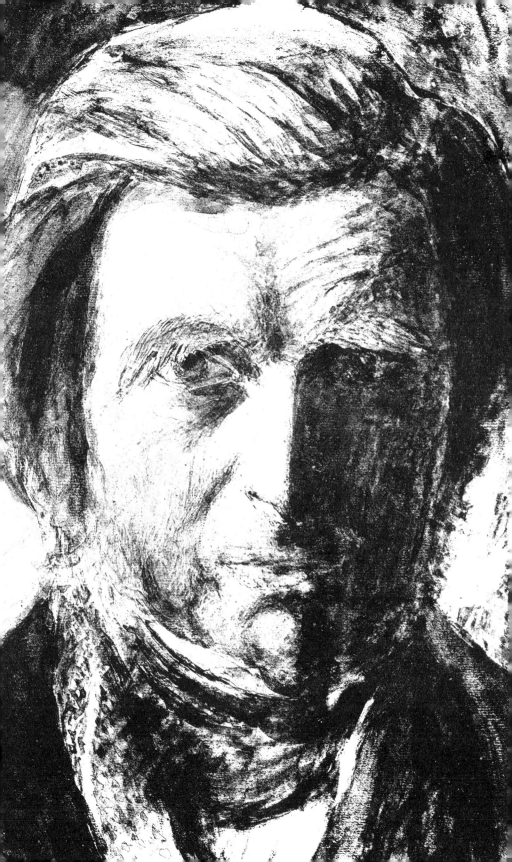

THE DARKENING GLASS

A PORTRAIT OF RUSKIN'S GENIUS

BY JOHN D. ROSENBERG

 COLUMBIA UNIVERSITY PRESS

NEW YORK 1986

Frontispiece: SELF-PORTRAIT WITH BLUE NECKCLOTH, *c.* 1873

Library of Congress Cataloging-in-Publication Data

Rosenberg, John D.
 The darkening glass.

 Bibliography: p.
 Includes index.
 1. Ruskin, John, 1819–1900. 2. Authors, English—
19th century—Biography. 3. Critics—Great Britain—
Biography. 4. Artists—Great Britain—Biography.
I. Title.
PR5263.R6 1986 828'.809 [B] 86-17148
 ISBN 0-231-06387-3

COPYRIGHT © 1980 JOHN D. ROSENBERG
LIBRARY OF CONGRESS CATALOG CARD NUMBER: 61-16678
MANUFACTURED IN THE UNITED STATES OF AMERICA

To D. S. R.

in boundless gratitude

This study, prepared under the Graduate Faculties of Columbia University, was selected by a committee of those Faculties to receive one of the Clarke F. Ansley awards given annually by Columbia University Press.

CONTENTS

ILLUSTRATIONS

TAKEN FROM DRAWINGS BY JOHN RUSKIN

PREFACE

This book is about Ruskin's mind, its wayward genius, its sickness, its essential sanity. Because Ruskin was the most personal of writers, the book is also about his life, but only in so far as it shaped—or warped—what he wrote. Like his life, his works are a compound of chaos and order, blindness and perception; the contours of his thought were at all points contiguous with the perplexities and epiphanies of his daily experience.

Ruskin began writing in earnest at the age of seven. He ceased sixty years later, after a final attack of madness forced him to lay down his pen. In the interim he published more than forty books, several hundred lectures and articles, and with the accuracy of a solitary fanatic recorded in his diaries every thought, image, and emotion which crossed his consciousness. Many of his works are ill-organized and incomplete, fragments of a larger, never-realized design which constantly shifted with the growth of his thought. Some are trivial; yet none is lifeless, for he brought to his most trifling digression the energy and undisciplined abundance of his genius. The variety of subjects he wrote about is astonishing, but no less so than the individuality of his point of view. To isolate that point of view without crushing its vitality or denying its contradictions, to trace its development through his criticism of art and of society, to perceive it in his analysis of the forms of clouds, the composition of a painting, or the structure of an ideal commonwealth is the aim of this book. For the wonder of Ruskin is both his disorder and oneness—the triumph of a unified vision over an often divided and ravaged mind.

The division of Ruskin's thought into chapters and books has

little meaning. In *The Stones of Venice* he wrote of the barbarity of nineteenth-century capitalism; in *Modern Painters*, of the stratification of the Alps. His thought has a way of spilling over from book to book, advancing and recoiling, but always emanating from a central core of perception that has a life and form of its own. One seems to have wandered without a guide into a vast gallery where finished masterpieces hang alongside hasty sketches, titles of objects are misleading, the rooms arranged at random and the partitions dividing them arbitrarily placed. No single work can be understood apart from the others, and the whole is as remarkable as it is at first glance unintelligible.

Amidst the confusion five books stand out as foci of consolidation and achievement. The first, *Modern Painters*, was begun when Ruskin was in his early twenties. The others—*The Stones of Venice*, *Unto This Last*, *Fors Clavigera*, and *Praeterita*—were written in each of the successive decades of his career, *Praeterita* marking his end as a writer. These are the works which most richly display the temper of Ruskin's mind; they record the dominant epochs of his intellectual life and form the major divisions of this study.

In the course of my research I have incurred several obligations which I am very pleased to acknowledge. My thanks are due to Dr. Joan Evans, who, in making Ruskin's diaries available to me in advance of their publication, placed at my disposal the most important new material bearing on his life and thought. I am also indebted to the Bodleian and Pierpont Morgan Libraries and the Ashmolean Museum for permission to consult unpublished Ruskin letters, manuscripts, and drawings; to The City College and Columbia University for research grants; and to the Samuel S. Fels Fund, whose generosity enabled me to devote my undivided energies to completing this book.

Of those who have read the manuscript, I am especially grateful to Professor Jerome H. Buckley for his encouragement and astute criticism; to Professor Marjorie H. Nicolson, who wisely persuaded me that this book should be written; to Henry Wiggins of the Columbia University Press; to my friends Thomas Fulton, Babette

Fulton, and Elliott Zuckerman; and to my wife, Barbara, for bearing with my obsession and for being my severest critic. Scarcely a page of the manuscript has passed her scrutiny without gaining in clarity or grace.

I would also like to thank for their helpful suggestions Professors Albert Hofstadter, Susanne H. Nobbe, David A. Robertson, Jr., Meyer Schapiro, and Marshall E. Suther, Jr. For R. H. Wilenski, who has written the only comprehensive study of Ruskin's mind worthy of its subject, I feel an admiration unimpaired by my occasional quarrels with his conclusions. Lastly, I owe an incalculable debt to E. T. Cook and Alexander Wedderburn, disciples of Ruskin, who early in the century edited the magnificent thirty-nine volume Library Edition of his works.

J. D. R.

New York, 1961

(ART)

I. NATURE, TRUTH, AND TURNER

Ruskin's study of art began with the patterned carpet on his nursery floor. His mother, a stern, puritanical Scot, allowed him neither playmates nor playthings. He passed his childhood in serene but unrelenting solitude, lightened only by the ingenuities of his own observation. He examined the patches of color on the floor, counted the bricks in the walls of the neighboring houses, and, with rapturous and riveted attention, watched from the nursery window as the watercarts were filled from a dripping iron post at the pavement edge. Almost from infancy Ruskin was forced to find in his powers of eye and mind the chief pleasures of his being. Alone in the nursery or enclosed by the walled garden of his home at Herne Hill, he focused his attention on the forms and patterns which later delighted him in the landscapes of Turner and the jeweled surfaces of Fra Angelico.

When Ruskin and his parents toured the Continent with their post chaise and courier, the countryside seemed to possess a grandeur all the greater for the confinement he had known at home; the cathedrals a splendor magnified in contrast to the Evangelical chapel— an ugly, "oblong, flat-ceiled barn"—where the Ruskins worshiped; the palaces a brilliance heightened by the remembered drabness of Herne Hill. His diaries of these tours are a prolonged, ecstatic hymn to sights which moved him more deeply than anything else he was ever to experience. He had already taught himself to see with extraordinary intensity; now he was learning to shape a prose as precise and potent as his own powers of observation.

Prior to Ruskin's matriculation at Oxford, all that was essential to his education had transpired in the self-engrossed quiet of Herne

Hill, in the neighboring galleries of London, and among the moun-
tains and valleys of the Alps. His mother, the first and most impor-
tant of his tutors, had imbued him with a sense of mission, a sacred
destiny in the service of God. On his thirteenth birthday he was
given a copy of Rogers's *Italy* illustrated by Turner; the gift initiated
him into his life's work. In Turner's vignettes he discovered the di-
vinity of nature which he was later to celebrate in *Modern Painters*.

Modern Painters began as a pert reply to an attack on Turner
published in *Blackwood's Magazine* in 1836, the year Ruskin entered
Oxford. Turner had just exhibited *Juliet and Her Nurse, Rome
from Mount Aventine,* and *Mercury and Argus* at the Academy;
his reputation had long been established—he had become a Royal
Academician in 1802—but critical opinion turned against him as he
moved toward the bold and luminous compositions of his great final
period. On Turner's advice, the young Ruskin did not publish the
article. But in defending Turner against *Blackwood's* charge of infi-
delity to nature, Ruskin laid the groundwork for *Modern Painters*.

The book would be less perplexing if Ruskin had known more
about art when he began it, or learned less in the course of its com-
position. The first volume appeared in 1843, when he was twenty-
four and still quite ignorant of art; the fifth and final volume was
published in 1860, when his interest had shifted from art and nature
to society and man. The point of view remains constant; the range
of vision widens enormously.

Although Ruskin had observed nature closely since his child-
hood—he carried on his tours a device of his own making which
measured the intensity of the blue of the sky—he was ill equipped to
document his assertion that Turner was the greatest master of land-
scape art. For his study of landscape painting before he wrote *Mod-
ern Painters* had been confined largely to a few Turners and to the
Dulwich and National Galleries, the latter then possessing fewer
than two hundred paintings.

Two years after publishing the first volume he set out on one of
the most memorable journeys of his life. Traveling without his
parents for the first time, he was overwhelmed in Italy by a wealth
of beauty of which he had known almost nothing. In Florence he

sketched and wrote as if he had been given new eyes. "I went yesterday to Santa Maria Novella," he wrote to his father:

There is the Madonna of Cimabue, which all Florence followed with trumpets to the church; . . . *there* is the great crucifixion of Giotto; there, finally, are three *perfectly* preserved works of Fra Angelico, the center one of which is as near heaven as human hand or mind will ever or can ever go.

The tour culminated in Venice, at the Scuola di San Rocco, where the power of Tintoretto struck him with the force of a revelation:

I have had a draught of pictures . . . enough to drown me. I never was so utterly crushed to the earth before any human intellect as I was to-day—before Tintoret. . . . He took it so entirely out of me to-day that I could do nothing at last but lie on a bench and laugh.

Ruskin returned to England in the autumn of 1845. The second volume of *Modern Painters*, published six months later, is a testament to his newborn love of Italian art; Tintoretto and Fra Angelico nearly usurp the place of Turner and nature.

The third and fourth volumes did not appear until 1856, long after Ruskin's first visit to the Scuola di San Rocco and the ensuing digression which produced *The Stones of Venice*. In the interim, his study of architecture convinced him that all the arts of the nineteenth century would remain barren until its artisans had been freed from the monotony of the machine. The temper of his mind was also changing. His belief in the divinity of art and nature began to yield to his knowledge of the waste and tragedy of life.

In 1858, two years before completing *Modern Painters*, Ruskin experienced a religious "unconversion" at Turin as crucial to the final form of the book as was his unpublished article on Turner, his discovery of Tintoretto, or his architectural studies in Venice. One day in Turin he walked out of a dim Waldensian chapel in disgust with a sermon on the wickedness and dullness of the wide world. He wandered through the festive streets of the "condemned city" to the Royal Gallery, where, looking at Veronese's *Solomon and the Queen of Sheba* glowing in the brilliant sunlight, he calmly shed the Evangelicalism which had obtruded into the first two volumes of *Modern Painters*. It was characteristic of Ruskin that his religious

and esthetic responses were complementary aspects of a single emotion; his shutting of the door of the sectarian chapel coincided with his espousal of humanism in the later volumes, with their praise of Veronese, of "The Naturalist Ideal," and of the powers and glories of man.

The pert article on Turner had grown into five volumes, and even then was never completed. As Ruskin wrote in the closing chapter, he had the power only to end the work, not to conclude it, for it had led him into fields of infinite inquiry. If he had not constantly related all that he had ever discovered to all that he was in the process of discovering, forever modifying, acquiring, growing but never discarding, he might have written a much briefer and tidier book. Yet *Modern Painters* records with absolute fidelity the progress of an absolutely articulate mind.

ii

If one reads the book in the anthologized excerpts which Ruskin despised, one confronts massive, sonorous paragraphs in praise of seas and skies, trees and mountains, rocks, light, and even weeds. Out of context, these passages degenerate into exhibitions of Ruskin's delight in his own virtuosities of observation and of prose. Yet they are necessary to the grand design of *Modern Painters:* Ruskin anatomizes nature in order to show that of all her imitators Turner most faithfully portrayed her infinite variety.

Look, observe, and *see* recur with obsessive frequency throughout the book. For Ruskin was eye-driven, even photoerotic, and confessed to "a sensual faculty of pleasure in sight" to which he knew no parallel. All the forms of the visible world leaped into animate life before his eyes; nor could he resist recording the play of light upon the life of things. His medium was a prose charged with the sudden clarity of first sight. Not diffuseness, but an almost licentious amassing of detail characterizes the purple patches of *Modern Painters.* They are hymns of adoration to the intricate, potent, holy, and inexhaustible nature that danced in Ruskin's mind. The understanding of *Modern Painters* begins with the recognition that Ruskin looked at the material universe with preternatural vivacity

and clarity, and believed that what he saw was divine. *Modern Painters* affirms Turner's conviction, voiced on his deathbed: "The Sun is God."

The prose hymns to nature throughout *Modern Painters* suggest that the book belongs more to the history of Romanticism than to the history of art. They are the counterparts of Wordsworth's invocations in *The Prelude:*

> To presences of God's mysterious power
> Made manifest in Nature's sovereignty,
>
> . . .
>
> Ye Presences of Nature in the sky
> And on the earth! Ye Visions of the hills!

Through a kind of supernatural naturalism both Wordsworth and Ruskin ignored the Christian dichotomy separating the perfection of the Creator from the sin-blighted creation and brought a pagan adoration of nature to their worship of God.

Ruskin's first ecstatic sight of the Alps was a religious revelation. The distant ranges, lovelier than "the seen walls of lost Eden," decided his destiny "in all that was to be sacred and useful." Shortly before he began *Modern Painters*, at a time when he was anxious and ill, he returned to the Alps. There he found his life again: "What good of religion, love, admiration or hope, had ever been taught me, or felt by my best nature, rekindled at once; and my line of work . . . [was] determined for me." Wordsworth also dedicated himself to his life's work before the altar of nature. Returning home alone across the fields, he saw the sun rise and the mountains glow in reflected light:

> My heart was full; I made no vows, but vows
> Were then made for me; bond unknown to me
> Was given, that I should be, else sinning greatly,
> A dedicated Spirit. On I walked
> In thankful blessedness. . . .

Both men felt that their intense response to nature was the sign of a special grace which conferred a priestly responsibility. The love and knowledge of art which Ruskin sought to communicate were not of technicalities but of "the universal system of nature—as

interpreted and rendered stable by art." The real aim of landscape painting had been degraded and mistaken; he was convinced that, if rightly interpreted, it might become "an instrument of gigantic moral power." The study of art was the study of nature, God's second book. This was Ruskin's justification for the years spent sketching mountains, climbing scaffolds to copy faded frescoes, studying skies and trees and pictures of skies and trees.

Wordsworth's moralization and deification of nature became, in Ruskin's hands, an ambitious program for the moralization and deification of art. Like the priest, the artist should assume the exalted role of "commentator on infinity." In communion with nature, he is also a communicant of the Deity, and it is his priest-like task to interpret his vision of the visible world through his art. This concept brings together the three dominant motifs of *Modern Painters:* adoration of God, of nature, and of art—especially the art of Turner, in whose landscapes and seascapes Ruskin saw an image of sacred, inexhaustible Nature.

Thus he could praise Turner as an artist-priest who "looks back over the universe of God and forward over the generations of men. . . . Let each exertion of his mighty mind be both hymn and prophecy; adoration to the Deity, revelation to mankind." The passage is not merely rhapsodic. It is part of Ruskin's ambitious and largely successful attempt to show the Victorian public, habituated alike to the elevated idiom of the sermon and to gross insensitivity toward art, the seriousness, indeed the "morality"—and hence the *beauty*— of art. Although it is just to accuse Ruskin of preaching, it is also naïve. By writing sermons he got the Victorians to lend him their ears that he might open their eyes.

By opening their eyes—Charlotte Brontë wrote that *Modern Painters* gave her a "new sense," sight—he hoped to enlarge their sensibilities and revolutionize the appreciation of art, as Wordsworth and Coleridge had revolutionized the appreciation of poetry. His task was not simply to judge painters but "to summon the moral energies of the nation to a forgotten duty, to display the use, force, and function of a great body of neglected sympathies and desires" which neo-classical art could no longer arouse. Eighteenth-century

canons of propriety in poetry and of composition in art had lost their authority and vitality. *Modern Painters* is the last great statement of the English Romantic renovation of sensibility as the *Lyrical Ballads* is the first. Nature is the central term in both, Wordsworth equating it with "simplicity" in his attack on Augustan poetry, Ruskin with "truth" in his attack on the Grand Style in art.

Nature, however, is a term of infinite latitude. To the Augustans it signified a mechanism rather than an organism, a naked, open, and mathematical daylight. When they said that art must imitate nature, they did not mean that it must be "natural" in the Romantics' sense of the word, but that it must be well proportioned and decorous. If nature failed in *their* sense to be natural, they mended her, dressing her to advantage in formal gardens, finding that they could thus garland her with a grace she alone could "ne'er so well express."

Ruskin meant something radically different by art and nature. He was Browneian, Burtonian, and medieval when he believed nature to be alive with symbols and spirits. He saw incredible lessons of Christian "humility and cheerfulness" in the qualities of grass, just as Browne, in *The Garden of Cyrus*, had discerned hieroglyphs of divinity in the quincuncial forms of trees, leaves, and even the belly of the water beetle. He was pre-Christian when he worshiped the animistic presences he beheld throughout "the living inhabitation of the world—the grazing and nesting in it,—the spiritual power of the air, the rocks, the waters." And he was a nineteenth-century Romantic when he perceived nature not as order and mechanism but as energy and life, as "unwearied unconquerable power," as "wild, various, fantastic, tameless unity."

One element of Ruskin's attitude toward nature remains constant: God is felt not only as the author of creation but as an actual power within it. The eighteenth century's praise of nature was merely a polite nod in the direction of the first chapter of Genesis. But *Modern Painters*, in its passionate study of trees and skies, mountains, seas, and living things, is a reconstruction of Genesis itself. The stamp of the Maker is still seen fresh on His works; Ruskin still hears the pronouncement, "And it was good."

That pronouncement echoed throughout his life. In the 1883

preface to *Modern Painters* II, written forty years after the publication of *Modern Painters* I, he quotes the sonorous words of Linnaeus' *Systema Naturae:* " 'Deum sempiternum, immensum, omniscium, omnipotentem, expergefactus transeuntem vidi, et obstupui.' 'As one awaked out of sleep, I saw the Lord passing by—eternal, infinite, omniscient, omnipotent, and I stood as in a trance.' " When, after completing *Modern Painters,* he protested against the Industrial Revolution's laying waste of nature and of men, the force of his invective was that of a sacred rage against a blasphemy, against the ravaging of God's garden and the mutilation of His gardeners.

Ugliness in nature or art is a kind of death, a negation of the "felicitous fulfilment of function" in living things which Ruskin called "Vital Beauty" and which he attributed to the energies of the Deity. In Ruskin's sense, art is thus necessarily religious. The chief aim of *Modern Painters,* he wrote, is to declare "the perfectness and eternal beauty of the work of God." Great art is the simultaneous and inseparable praise of God, of man, and of nature. This is the meaning of the aphorism which Ruskin placed at the head of *The Laws of Fésole:* "All great art is praise." It celebrates the divinity of life.

If art is conceived as an image of the holiness of nature, then one kind of art—Ruskin called it geometric—must be excluded from greatness: "The law which it has been my effort chiefly to illustrate is the dependence of all noble design, in any kind, on the sculpture or painting of Organic Form." This sentence has led some of Ruskin's critics to accuse him of preferring photographic realism to any form of abstraction, even though he continually berated mere imitation as the most contemptible of esthetic pleasures. He despised Canaletto's "servile and mindless imitation"; and Turner was scarcely a literal imitator of nature. Yet truth to nature was the most constant demand he made of the artist.

The problem would be much simpler if Ruskin had had the semantic decency not to use the same word for contradictory things. At times he makes truth synonymous with the "bare, clean, downright statement of facts." In this spirit he commits his literalist excesses, asserting that "every alteration of the features of nature

has its origin either in powerless indolence or blind audacity." If this were all that Ruskin meant by truth, *Modern Painters* would necessarily be a violent—and absurd—attack on Turner. We might then expect Ruskin to have written the following criticism of Turner which Graham Hough cites as typical of the age. It was published in 1839, a few years before *Modern Painters* I appeared and the very year in which Turner, at the peak of his powers, exhibited *The Fighting Téméraire* at the Academy. The piece appeared in *Fraser's Magazine* and was by William Thackeray:

On n'embellit pas la nature, my dear Bricabrac; one may make pert caricatures of it, or mad exaggerations, like Mr. Turner in his fancy pieces. O ye gods! why will he not stick to copying her majestical countenance, instead of daubing it with some absurd antics and fard of his own? Fancy pea-green skies, crimson-lake trees, and orange and purple grass . . . shake them well up . . . and you will have an idea of a fancy picture by Turner.

One remembers poor Sissy Jupe in *Hard Times*, who was bullied in Mr. M'Choakumchild's schoolroom because she liked carpets with floral patterns (people must not trample on flowers) and wallpaper with prints of horses (quadrupeds do not walk up and down walls). One thinks of the centerpiece which Prince Albert designed with life models of Victoria's favorite dogs, a dead hare, and the remnants of a dead rat, all the "actual tokens of happy hunting." One recalls John Everett Millais's wife, the former Mrs. John Ruskin, shivering in the January winds to pose for an illustration of Tennyson's *Saint Agnes' Eve* or Elizabeth Siddal lying long and submissively in a tub of cold water as she modeled for Millais's *Ophelia*. The same desire for fidelity to nature drove Holman-Hunt to the Holy Land, that he might observe, *in situ*, the flora and fauna for his weary *Scapegoat*.

Yet this pursuit of literal fact which goaded the Pre-Raphaelites and provoked Thackeray's denunciation of Turner also produced the finest painting shown in a recent exhibition of One Hundred and Fifty Years of British Art. So that he might better see what he later painted in the *Steamer in a Snowstorm*, Turner had himself lashed to the masts of the *Ariel* and for four hours rode out a gale.

The whole theory of truth in *Modern Painters* is an attempt to explain why only an artist who had studied nature with photographic fidelity and precision could have rendered so magnificently a scene no camera could catch.

Ruskin's own drawings from nature and his minute analysis of thousands of Turner's on-the-spot studies for later paintings had convinced him that no one could paint well who had not first observed closely. But he sometimes confused close observation with great art, as he did in overrating the Pre-Raphaelites.[1] He studied botany, geology, and meteorology, amassed a large collection of minerals, measured the flow of glaciers, and described in his diaries every sunrise he ever saw. The discussion of truth in *Modern Painters* often serves as an excuse for tacking these irrelevant technical studies onto an esthetic theory. In this way Ruskin justified the years spent gratifying perfectly legitimate curiosities which in his eyes required a higher sanction than that of amateur play. Inevitably the impulse to connect all that he was learning with all that he had already learned resulted in sporadic incoherence.

The esthetics of *Modern Painters* becomes less of a jumble once we recall that Ruskin set out to demonstrate Turner's superiority over two very different kinds of artists—Claude, Gaspar Poussin, and Salvator Rosa on the one hand, Canaletto and the Dutch realists on the other, "the various Van somethings and Back somethings, more especially and malignantly those who have libelled the sea." Turner is Ruskin's ideal between the two extremes of

[1] Ruskin also overestimated the Pre-Raphaelites because they gratified his taste for the subject-picture, a kind of illustrated anecdote in which the communication of an "idea" took precedence over composition or technique. The same excessive emphasis on the content rather than the syntax of painting led him to assert: "The picture which has the nobler and more numerous ideas, however awkwardly expressed, is a greater and a better picture than that which has the less noble and less numerous ideas, however beautifully expressed" (*The Works of John Ruskin*, ed. E. T. Cook and Alexander Wedderburn [London, George Allen, 1903–1912], III, 91). This is at best a half-truth, less insidious but scarcely more adequate than Fernand Léger's articulation of the opposite view: "I deny absolutely the subject. . . . Technique must become more and more exact. . . . I prefer a mediocre picture perfectly executed to a picture beautiful in intention but not executed" (*New York Times*, obituary article, August 18, 1955).

Subsequent references to Ruskin's *Works* will be indicated only by volume and page numbers.

mindless imitation and false idealization. He could praise Turner's fidelity to nature and at the same time damn the Dutch because Turner conveyed "higher and more occult kinds of truth" which could be rendered only by some sacrifice of imitative accuracy. He could praise Turner's apparent freedom of interpretation and at the same time condemn Claude because Turner's departure from fact was not based on "ignorance of nature" or poverty of imagination. In answer to Thackeray's charge—"*On n'embellit pas la nature, my dear Bricabrac*"—he sought to show that Turner expressed a more complex truth than any other landscapist. In answer to Reynolds and the practitioners of the Grand Style—art must not imitate but embellish nature—he sought to prove that she was already quite finely and variously dressed.

The subtle dialectic of truth in *Modern Painters* is often reduced to the injunction which Ruskin intended for the beginning artist alone: go to nature "rejecting nothing, selecting nothing, and scorning nothing." To this must be opposed the countless passages in which Ruskin insists upon the unique inventiveness of all great art:

Each great artist conveys to you, not so much the scene, as the impression of the scene on his own originality of mind. . . . All that is highest in art, all that is creative and imaginative, is formed and created by every great master for himself, and cannot be repeated or imitated by others. . . . The painter who really loves nature . . . will make you understand and feel that art *cannot* imitate nature; that where it appears to do so, it must malign her and mock her.

Ruskin, an admirer of Blake, almost paraphrases Blake's assertion that "Men think they can Copy Nature. . . . This they will find Impossible, & all the Copies or Pretended Copiers of Nature, from Rembrandt to Reynolds, Prove that Nature becomes to its Victim nothing but Blots & Blurs."

How, then, does Turner gratify both Ruskin's great reverence for fact and his even greater reverence for inventive genius? The contradiction exists only if we confuse nature with a photograph of nature, a fixed and imitable fact. For Ruskin nature was infinitely various, infinitely potent, but visible only to eyes which, in Wordsworth's phrase, half-create what they perceive. Imitation was im-

possible; the re-creation of part of nature's infinity was all the artist could hope for. Turner re-created the largest segment, and was thus at once the most truthful and creative of landscapists. The Dutch realists maligned through tedious overspecificity; the old masters mocked by turning away.

When Ruskin looked at nature he beheld Turner, or rather he saw in nature what Turner saw. The chapter on "The Truth of Space" suggests this identity. Ruskin observes that, no matter how close an object is, there is always something which you cannot see distinctly; conversely, a distant object retains some mark of texture to distinguish it from vacant space. The blades of grass in a meadow a mile away can be distinguished from a piece of wood painted green. "And thus nature is never distinct and never vacant, she is always mysterious, but always abundant; you always see something, but you never see all." She possesses a finish which "no distance can render invisible, and no nearness comprehensible. . . . And hence in art, every space or touch in which we can see everything, or in which we can see nothing, is false." The Dutch masters supply everything, counting each brick; the Italians and French see only "a dead flat."

Ruskin illustrates the point with the foreground houses in *A Roman Road,* a landscape in the style of Nicolas Poussin. Each house is a lifeless square mass with a light and dark side, and black touches for windows. The walls are a dead gray, the windows a dead black. Nature would have let us see

the Indian corn hanging on the walls, and the image of the Virgin at the angles, and the sharp, broken, broad shadows of the tiled eaves . . . the carved Roman capital built into the wall, and the white and blue stripes of the mattresses stuffed out of the windows, and the flapping corners of the mat blinds. All would have been there; not as such, not like the corn, or blinds or tiles, not to be comprehended or understood, but a confusion of yellow and black spots and strokes, carried far too fine for the eye to follow, microscopic in its minuteness, and filling every atom and part of space with mystery, out of which would have arranged itself the general impression of truth and life.

Nature "never distinct and never vacant," the confusion of yellow, the spots and the strokes—all suggest the visual world of

Turner and the Impressionists. The suggestion becomes stronger as Ruskin criticizes the monotonous regularity of the battlements in Claude's *Marriage of Isaac and Rebecca*. Nature would have hinted at innumerable, scarcely defined forms, vague shadows and lights and hollows making of "that whole space of colour a transparent, palpitating, various infinity." In effect, this is what *Turner* would have painted.

Transparency, energy, variety, and infinity: the four words epitomize Ruskin's vision of nature and of Turner. "It is in this power of saying everything," he wrote, "and yet saying nothing too plainly, that the perfection of art . . . consists." His whole quarrel with the Dutch realists and Canaletto stems from their intolerance of ambiguity, their incapacity to render spaciousness without vacuity, multiplicity without overdistinctness. His criticism of Flemish painting stresses a studious and mechanical lack of vitality:

The people looked out of their windows evidently to be drawn, or came into the street only to stand there for ever. . . . Bricks fell out methodically, windows opened and shut by rule; stones were chipped at regular intervals; . . . the street had been washed and the houses dusted expressly to be painted in their best.

So too with Canaletto. Despite the precision and crowding, his Venice is empty and utterly still. The canals have ceased to flow and the streets to echo. Yet with all its quiet spaces, its skies merging with the waters and the sun irradiating both, Turner's Venice is littered with active life, light, and energy. It is infinite both in magnitude and detail, "never distinct, never vacant." The reasoned, luminous, expansive confusion of Turner was, for Ruskin, the fullest possible mirroring of life. Thus he could argue that Turner, who supposedly distorted and embellished nature, was most true to her in the great, daring period of *The Slave Ship* and *Steamer in a Snowstorm*.

iii

The first volume of *Modern Painters* is about nature and truth; the second is about beauty and imagination. An experience Ruskin had in the summer of 1842 accounts for the change. The incident—

really a revelation—occurred near Fontainebleau. Ruskin had wandered along a path and found himself resting on the bank of a cart road. The only prospect was a small aspen set against the sky:

Languidly, but not idly, I began to draw it; and as I drew, the languor passed away: the beautiful lines insisted on being traced. . . . More and more beautiful they became, as each rose out of the rest, and took its place in the air. With wonder increasing every instant, I saw that they "composed" themselves, by finer laws than any known of men. At last, the tree was there, and everything that I had thought before about trees, nowhere.[2]

To perceive the animate artistry of nature the artist must lose his awareness of self and become a mere "mirror of truth, . . . passive in sight, passive in utterance." Here Ruskin is faithful both to his personal experience and to his Romantic heritage, to Wordsworth's "wise passiveness" or Keats's "negative capability," the capacity to submit to experience in order to record it more accurately and richly. Yet if passivity led to truth, and truth to the avoidance of convention, it could not of itself create art. The necessary corollary to wise passiveness was, in Wordsworth's phrase, the ability to cast "a certain colouring of imagination" over one's subject, a "light that never was on sea or land." This was the light Ruskin saw in Turner—the subtle light which *was* on land and sea but which had never before been caught on canvas.

The theory of imagination in *Modern Painters* II is Ruskin's attempt to resolve the paradox which Wordsworth quite innocently posed in the Preface to the *Lyrical Ballads* and Coleridge sophisticatedly belabored in the *Biographia Literaria:* how does one get from fact to art? How does one faithfully color truth with imagination? All the great Romantics grappled with the problem. No group of poets and artists was ever more obsessed with accuracy: Tennyson observing the precise color of ash buds in March is a

[2] Ruskin expresses this sense of nature's artistry in the best of his drawings and water colors. Prior to 1842 his drawings are often derivative—after the manner of Prout, Roberts, or Turner (see XXXVIII, 218–19). After 1842, in addition to graceful precision of line and delicacy of texture, his work is distinguished by a feeling for the disciplined motion and life of nature itself, an organic surge of forces animated by the vital intelligence he had perceived at Fontainebleau.

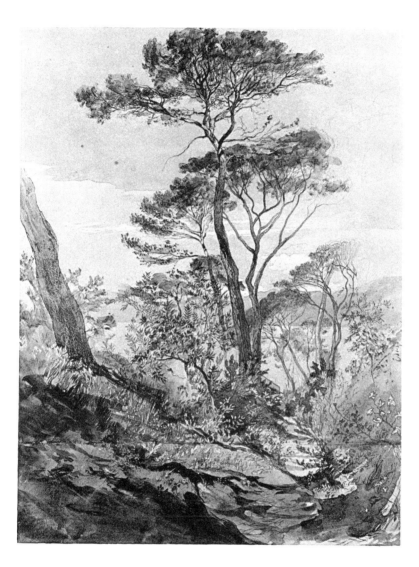

STUDY OF STONE PINE AT SESTRI, 1845

Romantic; Millais using a magnifying glass to paint his foreground foliage is, like all the Pre-Raphaelites, a Romantic; so too Turner minutely noting the shifts in color as the sun rises from the sea. It is above all as accurate observers that Ruskin praises Wordsworth, Turner, Byron, and Scott. Jacques Barzun is wholly right in maintaining that *realism* was the basic intention of Romantic art. Passionately reverent of fact and equally scornful of neo-classic conventions, the Romantics needed a middle term to bridge the gap between observing and creating, between the colors and tonalities and idioms they brought to art and the new forms which they shaped to express them. Their worship of imagination began in their cult of fact.

If they described imagination in almost religious terms, they did so because they equated it with revelation. Looking at nature as if it were new-created, they constructed theories of perception and imagination to account for the newness of their world and the staleness of the world of neo-classic art. The artists forsaking the studio for nature, the poets studying her at first hand, felt that for the first time since the Greeks they were seeing things and stating things as they truly are. Their very intensity of observation was itself an imaginative act, perception and creation simultaneously. This was Ruskin's own experience at Fontainebleau, and it colored his sense of nature and of Turner throughout *Modern Painters*.

As truth in *Modern Painters* I seems tailored to Turner's advantage, so imagination in *Modern Painters* II works to the advantage of Romantic painting and poetry. Ruskin distinguishes, as Wordsworth and Coleridge had done before him, between fancy and imagination—the first a mechanical linking of the parts of a work of art, the second an organic fusing of all its elements. The terms provided a sophisticated way of saying that Romantic art was great (i.e., imaginative) and that neo-classic art was not (i.e., merely fanciful). The distinction seemed not to record a personal preference but objectively to describe how the literature and painting of their predecessors had failed and how their own had opened up wide, untouched areas of reality.

Ruskin's chapter on "The Grand Style" is a defense of the

Romantics' unfastidious submission to experience. It celebrates the uniqueness of the commonplace, the democratizing of sensibility which made Constable's cowherds more credible than Reynolds's aristocrats, Wordsworth's Lucy more attractive than Pope's Belinda. Ruskin begins by quoting Reynolds's assertion that the Grand Style required the avoidance of the particular. Dutch or "low" art, Reynolds wrote, resembles history in its inclusion of detail; Italian or "high" art resembles poetry in stressing only the invariable, "the great and general ideas which are fixed and inherent in universal Nature." Ruskin applies this generalization to a quatrain from Byron's "The Prisoner of Chillon"; its essence as poetry, he finds, resides not in a decorous regard for the invariable, but in an imaginative apprehension of the singular and particular.

Experience revealed to the Romantics, as it did to Ruskin, a multiverse rather than a universe. Hence their stress on the concrete over the general, the "real" over the ideal. Hence, too, their faith in feeling and distrust of the tidiness of reason. It was the Romantic in Ruskin who mistook Augustan grace for coldness, wit for insincerity. He accuses Pope of hypocrisy for having written of a shepherdess,

> Wher'er you walk, cool gales shall fan the glade;
> Trees, where you sit, shall crowd into a shade.

But elsewhere he praises a similar couplet of Wordsworth's—

> The floating clouds their state shall lend
> To her; for her the willow bend—

for its "exquisite *rightness*." The bending of Wordsworth's willows is poetry, the crowding together of Pope's trees is affectation "asserted in the teeth of nature and fact."

The same bias against classicism blinded him to the extent to which Turner had built upon the work of predecessors whom Ruskin despised. He attributes Turner's greatness to his "strength of English instinct" gradually breaking through "fetter and formalism." English instinct is another term for English Romanticism, and by formalism Ruskin means the classical traditions of the Academy.

Yet Turner himself remarked that he learned more from Watteau than from anyone else, and the *Liber Studiorum* was done in emulation of Claude's *Liber Veritatis*.

Ruskin again stresses the realism of imaginative art in the chapter on "The Naturalist Ideal." He points out that the Madonna in Tintoretto's *Adoration of the Magi* is not an enthroned queen but an unaltered portrait of a Venetian girl; the Magi are Venetian senators, and the figure with a basket in the left foreground is a market-woman of Mestre. All great painting preserves this individuality; only the meaner idealist disdains it. The phrase *naturalist ideal* contains the full force of both words: "naturalist, because studied from nature" and ideal because arranged into coherent wholeness by the artist, who does not invent what he depicts but sees it as an unalterable fact.

In this sense Iago is as ideal as Desdemona. The entire power of the artist "to describe rightly what we call an ideal thing, depends on its being thus, to him, not an ideal, but a *real* thing." A pseudo-idealist would have fashioned Dante's centaur Chiron—who parts his beard with a bloody arrow before he speaks—from handsome bodies of men and horses. "But the real living centaur actually trotted across Dante's brain, and he saw him do it." There are, then, no vulgarities possible to the true idealist; he conveys "a *whole* truth, however commonplace. . . . Vulgarity is only in concealment of truth, or in affectation."

Ruskin comes closest to resolving the paradox of fact and imagination in a chapter on "Turnerian Topography," in which he compares his own painstaking drawing of an Alpine gorge with Turner's freer rendering of the same rock-strewn scene. By raising the scale of the rocks and recomposing the foreground to emphasize the violence of the stream and the avalanches, Turner has expressed the "far higher and deeper truth of mental vision—rather than that of the physical facts." The alterations, however, are not arbitrary but part of "an entirely imperative dream, crying, 'Thus it must be.'"

Noting how often Turner introduces remembered details, how-

ever insignificant, from earlier studies, Ruskin contends that Turner's composition was an arrangement of remembrances, "an act of dream-vision" in which diverse recollections were linked by new and strange laws. Turner's imagination, like Dante's, seems to have consisted not in the voluntary production of new images, but in an involuntary summoning, at precisely the right moment, of things actually seen:

Imagine all that . . . these men had seen or heard in the whole course of their lives, laid up accurately in their memories as in vast storehouses, extending, with the poets, even to the slightest intonations of syllables heard in the beginning of their lives, and with the painters, down to minute folds of drapery, and shapes of leaves or stones; and all over this unindexed and immeasurable mass of treasure, the imagination brooding and wandering, but dream-gifted, so as to summon at any moment exactly such groups of ideas as shall justly fit each other: this I conceive to be the real nature of the imaginative mind.

The artist so gifted possesses "the most accurate and truth-telling faculty" of the human mind, imagination. No matter how frequently he portrays the same scene, each new version retains, like a recurrent dream, the full undistorted force of the original image.

The Romantic muse demanded two complementary fidelities of the "dream-gifted" artist: truth to fact and truth to imagination. She appeared as Kubla Khan or as the Leech Gatherer; she was painted exotically by Turner and mundanely by Constable. That *Modern Painters* is at times confusing in its adherence to opposite ideals is no more surprising than that Romanticism itself veered in so many directions in pursuit of its multiverse. The dream or vision recurred in Romantic art not because it represented an escape from the real, but because it symbolized, in the vigor, multiplicity, and freedom of its associations, Romantic reality itself.

iv

Ruskin's "Ideas of Beauty," like his "Ideas of Truth," originated in his personal experience. A manuscript not published until after his death recounts an incident on which he based his theory of Typical Beauty, the quality we perceive in a stone, a flower, a beast

or a man as "typical of the Divine attributes." He had been lying, one overcast summer evening, on a mossy rock in the valley of Chamonix:

Suddenly, there came in the direction of Dome du Goûter a crash—of prolonged thunder; and when I looked up, I saw the cloud cloven, as it were by the avalanche itself, whose white stream came bounding down the eastern slope of the mountain, like slow lightning. . . . Like a risen spirit . . . the Aiguilles of the south broke through the black foam of the storm clouds. One by one, pyramid above pyramid, the mighty range of its companions shot off their shrouds. . . . Spire of ice—dome of snow—wedge of rock . . . a celestial city with walls of amethyst and gates of gold—filled with the light and clothed with the peace of God. And then I learned . . . the real meaning of the word Beautiful. With all that I had ever seen before . . . the image of self had not been effaced in that of God. . . . Without sense even of existence . . . the immortal soul might be held forever . . . wrapt in the one contemplation of the Infinite God. It was then that I understood that all which is the type of God's attributes—which in any way or in any degree—can turn the human soul from gazing upon itself . . . and fix the spirit—in all humility—on the types of that which is to be its food for eternity;—this and this only is in the pure and right sense of the word BEAUTIFUL.

The passage is a Christian rendering of the Romantics' vision of nature. It was also in an Alpine valley that Wordsworth had an almost identical experience. Woods, rock, winds, and torrent filled the narrow chasm:

> Black drizzling crags that spake by the way-side
> As if a voice were in them, the sick sight
> And giddy prospect of the raving stream,
> The unfettered clouds and region of the Heavens,
> Tumult and peace, the darkness and the light—
> Were all like workings of one mind, the features
> Of the same face, blossoms upon one tree;
> Characters of the great Apocalypse,
> The types and symbols of Eternity,
> Of first, and last, and midst, and without end.

Ruskin's idiom is more overtly religious than Wordsworth's, but Wordsworth's is no less an adaptation of the language of faith to the experience of nature. *Modern Painters* II is Ruskin's adaptation of

that language to the experience of art. Indeed, one begins to suspect that the Romantic esthetic, with its demand for submissiveness and loss of self, its ennobling of the peasant rather than the aristocrat, the cottage rather than the castle, its mystical ecstasy before the beauty of the God-in-Nature, is an unconscious pilfering from modes of Christian experience.

Theoria, Ruskin's term for the faculty which apprehends beauty, not only delights in the sensuousness of forms but perceives "the immediate operation of the Intelligence" which created them. Theoria's discerning in things a reflection of the Absolute suggests a Platonic source for the "Ideas of Beauty." In Ruskin's eyes, however, matter was not a mere shadowing forth of spirit, but an incarnation of spirit itself. No one in the nineteenth century had a greater reverence for the physical world; he worshiped equally the materiality of God and the spirituality of matter.

There is a still better reason for rejecting Plato as the source of Ruskin's Ideas of Beauty. If matter is only a blot on the lucid surface of reality, sense experience must be, as it was for Plato, merely illusory. Yet Ruskin wrote that "the greatest thing a human soul ever does in this world is to *see* something, and tell what it *saw* in a plain way. Hundreds of people can talk for one who can think, but thousands can think for one who can see. To see clearly is poetry, prophecy, and religion,—all in one." The eye, with its "intellectual lens and moral retina," is here a metaphor for the whole range of sensory, moral, and mental faculties which not only register, but order, interpret, and learn to love what they rightly perceive.

"The Theoretic Faculty" represents Ruskin's attempt to bring all of these activities to bear on what we usually isolate as "esthetic experience." He refused to use the latter term because he felt it reduced the appreciation of beauty "to a mere operation of sense, or perhaps worse, of custom; so that the arts which appeal to it sink into a mere amusement, ministers to morbid sensibilities, ticklers and fanners of the soul's sleep." Impressions of beauty are neither restrictedly sensuous nor intellectual. Mere animal consciousness of the sensuous pleasure of art he calls "Aesthesis." But "the exulting,

reverent, and grateful perception of it I call Theoria." Ideas of beauty are necessarily *moral* ideas.

Such ideas enabled Ruskin to build the broadest possible bridge between the perception of art and the activities of life. The same impulse which led him to attack the deleterious fiction of Esthetic Man in art led him to attack the fiction of Economic Man in society—a device for exploiting man the mechanism without worrying about the debasement of man the organism. He fought estheticism not because he feared what was lovely, but because he thought it too important to divorce from what was good and true. In the same way he condemned the philistines for caring only about what was materially good and being oblivious of beauty. The esthete and the philistine were both half men in pursuit of the broken ends of a single ideal—the life, literally, of *integrity*, in which the related goodnesses of matter and sense, spirit and art, were felt in their oneness.

The history of the second half of the nineteenth century bears Ruskin out. What began as a desire among the Philosophic Radicals for social reform, a spreading of the goods of life, degenerated into a pursuit of matter for matter's sake. Estheticism countered Victorian materialism with the pursuit of art for art's sake. The esthete was really the philistine up-ended. *Modern Painters* attempted to gather between ten covers ideals which, even as Ruskin wrote, were falling apart. How much they have disintegrated is apparent from a twentieth-century critic's charge that he "is always seeking to graft moral or religious issues upon aesthetic." Ruskin could not understand—did not want to understand—Whistler's assertion that art is selfishly preoccupied with her own perfection. When Whistler criticized him for being an artist among political economists and a political economist among artists, he was not, really, invalidating Ruskin's efforts as either but responding with irritation and wit to that breadth of vision Ruskin compressed into the aphorism, "So far from Art's being immoral, in the ultimate power of it, nothing but Art is moral; Life without Industry is sin, and Industry without Art, brutality."

II. MOUNTAIN GLOOM AND MOUNTAIN GLORY

In order to concentrate on Ruskin's esthetics I have, until now, ignored a radical shift in the tone of *Modern Painters*, a change which was the prelude to Ruskin's career as a social critic. During the decade separating the second volume (1846) from the third (1856), Ruskin became less moved by the beauty of art and nature than by the waste, mystery, and terror of life. The tone of the first two volumes is pious and lyrical; that of the later volumes is humanistic and tragic. In *Modern Painters* I and II Ruskin looked at the peaks of mountains and saw God; in *Modern Painters* III, IV, and V he looks at their bases and sees shattered rocks and impoverished villages. The face of the Creator withdraws from the creation and in its place man emerges as a tragic figure in the foreground of a still potent, but flawed, nature. With that withdrawal, Ruskin's interest moves from mountains to men, from art to society.

Ruskin most clearly expressed his attitude toward nature in *Modern Painters* I when, in a footnote, he quoted the lines from "Tintern Abbey,"

> Nature never did betray
> The heart that loved her . . .

Nature was beautiful even in decay and revealed scarcely anything like "positive deformity, but only degrees of beauty." Merely to exist was to partake of divinity, and hence of beauty, as for St. Augustine simply to exist was to partake of God, and hence of goodness. Ruskin appropriated this loveliest of sophistries and made ugliness an absence of beauty, not a positive part of creation, as St. Augustine had made evil the absence of good, not a positive product of God.

Ruskin's instinctive reverence for matter would not at this time allow him to believe that nature had fallen from perfection with the fall of man.

But the Evangelicalism he had acquired from his mother and had not yet rejected dwelt almost pathologically upon the corruption and depravity of *human* nature. These disparate points of view led him to the curious dualism of *Modern Painters* II. Although he attributes perfection to all the orders of the natural world, when he turns to humanity he breaks into an unconscious parody of an Evangelical sermon: man bears the terrible stamp of degradation, his features are lined by sickness, darkened by sensuality, convulsed by passion. The heavens reveal our iniquity and the earth rises up against us. Lapsed, fallen, wrecked, we are in imminent peril of damnation.

This sermon, which Ruskin wrote in 1846, is, I suspect, quite like the one that disgusted him at Turin in 1858, when he walked out of the Waldensian chapel to look at Veronese's voluptuous *Solomon and the Queen of Sheba*. During the decade under discussion the Evangelical in Ruskin developed into the humanist. Human nature seemed redeemed and, by a kind of parallel reversal, nature lapsed from her perfection.

While courting Effie Gray in 1847, Ruskin wrote to her that the Biblical promise of golden streets did not appeal to him. He preferred an immortality "among the snowy mountains and sweet vallies [*sic*] of this world." Let us look at one of these valleys as it appeared to him in 1860, when he was completing the last volume of *Modern Painters*. He had been reading a rhapsodic sermon which cited the beauties of the Highlands—sunshine, fresh breezes, bleating lambs, and clean tartans—as evidence of God's goodness. He then recalled seeing such a little valley of soft turf, enclosed by rocks and fern, quite like the one described in the sermon. The clergyman's pleasant prospect of lamb and tartan suddenly changed, in Ruskin's Highland valley, into symbols of the insufficiency of the Wordsworthian view of nature:

The autumn sun, low but clear, shines on the scarlet ash-berries and on the golden birch-leaves, which, fallen here and there, when the breeze has not caught them, rest quiet in the crannies of the purple rock. Beside

the rock, in the hollow under the thicket, the carcase of a ewe, drowned
in the last flood, lies nearly bare to the bone, its white ribs protruding
through the skin, raven-torn; and the rags of its wool still flickering from
the branches that first stayed it as the stream swept it down. A little
lower, the current plunges, roaring, into a circular chasm like a well . . .
down which the foam slips in detached snow-flakes. Round the edges of
the pool beneath, the water circles slowly, like black oil; a little butterfly
lies on its back, its wings glued to one of the eddies, its limbs feebly
quivering; a fish rises, and it is gone.

The passage is bitterly and mockingly ironic. For here in a setting
of absolute peace we suddenly stumble on Darwin's Nature, not sim-
ply and openly struggling to survive but with stealth and gratuitous
malignance extinguishing life; the raven feeds on the symbol of
innocence, the lamb.

At the turn of the brook Ruskin sees a picturesque group—a man
fishing, a boy, and a dog—"picturesque and pretty group enough
certainly, if they had not been there all day starving." The dog's
ribs are nearly as bare as the dead ewe's; the boy's wasted shoulders
cut into his ragged tartan jacket. Ruskin had recorded a similar
scene in his diary for April 1851. He had met by the side of a pool
a man who for ten years since his wife's death had made his living
by picking up rags and bones. I doubt that Ruskin intended any
parallelism, but in Wordsworth's "Resolution and Independence"
there is another impoverished old man, also met by a poolside.
Wordsworth's leech-gatherer, however, is a figure of perdurable
dignity and saintly endurance. Ruskin's ragpicker is simply a half-
starved, hard-featured old man. The sweet valleys of this world have
become, to adapt Keats's phrase, not vales of soul-making but of
soul-breaking; the Highlands have their shadows and ugliness as well
as their sun and heather.

The excerpt from Ruskin's diary appears in the same chapter in
which he argues, modifying his evaluation of Fra Angelico in *Mod-
ern Painters* II, that the "purist religious schools" fell short of the
highest rank. Death, pain, and decay were for them only momen-
tary accidents in the course of immortality. However admirable,
their state of mind implies a degree of intellectual weakness. The
great artist must not evade the fact of evil, but gaze without fear

into the darkness. He must not "pass on the other side, looking pleasantly up to the sky, but . . . stoop to the horror, and let the sky, for the present, take care of its own clouds."

The passage is self-admonitory. For it was Ruskin who had used hundreds of pages in *Modern Painters* I and countless hours of close observation to describe the intricate forms and beauties of clouds. He is, as it were, putting his cyanometer aside; he will no longer measure the blue of the sky but stoop to the social horrors of the earth. But he could not permanently keep his eyes from the clouds and when, very late in his career, he looked again, they had become storm clouds driven by a plague wind, a malevolent, diabolic fury in which, Lear-like, he saw the symbol of his own insanity.

The later volumes of *Modern Painters* provide the first clear indications of the shift from the God-in-Nature of *Modern Painters* I and II to the Satanic nature of *The Storm-Cloud of the Nineteenth Century*. Ruskin startlingly juxtaposes the two natures in the final chapters of *Modern Painters* IV—"The Mountain Gloom" and "The Mountain Glory." The latter is a hymn of praise, in the manner of *Modern Painters* I, to the "great cathedrals of the earth" with their gates of rock and vaults of purple. But the chapter on mountain gloom introduces us to Ruskin's Wasteland, in which his doubt and deepened sense of the terror of life darken both his own prose and the radiant nature of the earlier volumes.

Ruskin takes the reader to an Alpine village beautifully set among ravines and streams. But in place of the joys of a pastoral idyl, he finds only

torpor—not absolute suffering—not starvation or disease, but darkness of calm enduring; the spring known only as the time of the scythe, and the autumn as the time of the sickle. . . . Black bread, rude roof, dark night, laborious day, weary arm at sunset; and life ebbs away. No books, no thoughts, no attainments, no rest; except only sometimes a little sitting in the sun under the church wall, as the bell tolls thin and far in the mountain air; a pattering of a few prayers, not understood, by the altar rails of the dimly gilded chapel, and so back to the sombre home, with the cloud upon them still unbroken—that cloud of rocky gloom, born out of the wild torrents and ruinous stones, and unlightened, even in their religion, except by the vague promise of some better thing un-

known, mingled with threatening, and obscured by an unspeakable horror,—a smoke, as it were, of martyrdom, coiling up with the incense, and, amidst the images of tortured bodies and lamenting spirits in hurtling flames, the very cross, for them, dashed more deeply than for others, with gouts of blood.

The prose, with its cloud of gloom and unspeakable horror, is prophetic of the violent imagery of *The Storm-Cloud*. We read the passage rightly if we understand it as Ruskin's discovery that he, as well as the Alpine peasants, could not live by mountains alone. This impression is strengthened a few pages further into the chapter, where Ruskin describes Sion, the capital of the canton of Valais. The town, situated in the Rhone valley and flanked by Alps, is one of the most picturesque in Switzerland. But Ruskin sees it as a disintegrating wreck, an image of wasted, fallen nature. The passage is a closely ordered confusion of diseased life passing into decay and of decay clinging to a disordered life. The main street winds among spaces of barren ground fringed by ditches half filled up and walls half broken down. Unfinished houses arise amidst the weeds:

It is difficult to say, in any part of the town, what is garden ground and what is waste; still more, what is new building and what old. . . . The plaster, with its fresco, has in most instances dropped away, leaving the houses peeled and scarred; daubed into uncertain restoration with new mortar, and in the best cases thus left; but commonly fallen also, more or less, into ruin. . . . The lanes wind among these ruins; the blue sky and mountain grass are seen through the windows of their rooms and over their partitions, on which old gaudy papers flaunt in rags: the weeds gather, and the dogs scratch about their foundations; yet there are no luxuriant weeds, for their ragged leaves are blanched with lime, crushed under perpetually falling fragments, and worn away by listless standing of idle feet. There is always mason's work doing, always some fresh patching and whitening; a dull smell of mortar, mixed with that of stale foulness of every kind, rises with the dust, and defiles every current of air; the corners are filled with accumulations of stones, partly broken, with crusts of cement sticking to them, and blotches of nitre oozing out of their pores. The lichenous rocks and sunburnt slopes of grass stretch themselves hither and thither among the wreck; . . . the grass, in strange sympathy with the inhabitants, will not grow *as* grass, but chokes itself with a network of grey weeds. . . . The rest of the herbage is chiefly composed of the dwarf mallow, the wild succory, the wall-rocket, goose-

THE MOUNTAIN GLOOM, 1846

foot, and milfoil; plants, nearly all of them, jagged in the leaf, broken and dimly clustered in flower, haunters of waste ground and places of outcast refuse.

The raven-torn lamb and the flower in a wasteland of refuse mark Ruskin's deepened awareness of evil. The description of Sion closes with the warning that it is cunning self-deception to see only beneficence in the creation and to ignore nature's warning of man's mortality and doom. Rather than looking on nature, in Wordsworth's phrase, "as in the hour of thoughtless youth," Ruskin has begun instead to hear the oppressive "still, sad music of humanity." His prose, extremely sensitive in registering his shifts of feeling, takes on the darkened tones of that music in *Modern Painters* IV and V. The mountain gloom overshadows the mountain glory.

Turner, priest of the sacredness and sublimity of nature in *Modern Painters* I, now exemplifies the unredeemed pathos Ruskin had begun to see in the life of the ninetenth century. He remains the painter of "the loveliness of nature," but a nature now "with the worm at its root: Rose and cankerworm—both with his utmost strength; the one *never* separate from the other." Ruskin still looked at nature and beheld Turner, but the Turners he now saw resembled the blighted Alpine village, with its half-starved peasantry, more than the sunlit peaks on which Ruskin had knelt to pray. In *Modern Painters* V he examines several plates from the *Liber Studiorum* and finds impoverished farmyards, stagnant streams, rotting trees, and fever-struck children. Turner has become the painter of a fallen nature which echoes the sad music of humanity. He is distinguished from all other landscape artists not, as he was in *Modern Painters* I, by his faithful portraiture of a divine creation, but by the strength of "his sympathy with sorrow, deepened by continual sense of the power of death."

Ruskin traces the development of that sympathy and sense of death in an extraordinary chapter contrasting the boyhoods of Giorgione and Turner. It begins with a highly mannered description of the Venice which Giorgione's eyes first opened upon:

What a world of mighty life, from those mountain roots to the shore;— of loveliest life, when he went down, yet so young, to the marble city

. . . nay, rather a golden city, paved with emerald. For truly, every pin-
nacle and turret glanced or glowed, overlaid with gold, or bossed with
jasper. . . . No foulness, nor tumult, in those tremulous streets, that filled,
or fell, beneath the moon; but rippled music of majestic change. . . .
Above, free winds and fiery clouds ranging at their will;—brightness out
of the north, and balm from the south, and the stars of the evening and
morning clear in the limitless light of the arched heaven and circling sea.
 Such was Giorgione's school.

 And such the ornate prose which, at the point of excess, abruptly
modulates to the squalid actuality of a brick-enclosed pit, formed
by a block of close-set houses near Covent Garden, where Turner
was born. Turner grows up in a neighborhood of "dusty sunbeams
. . . deep furrowed cabbage-leaves at the greengrocer's; magnificence
of oranges in wheel-barrows round the corner; and Thames' shore
within three minutes' race." He attaches himself with faithful child-
love to all that bears an image of his place of birth; hence his fore-
grounds have "a succulent cluster or two of greengrocery at the
corners" and he paints great ships breaking up so that he can display
chests of oranges scattered on the waves. Hence, too, his love of
litter and toleration of ugliness:

Dead brick walls, blank square windows, old clothes, market-womanly
types of humanity—anything fishy and muddy, like Billingsgate or Hun-
gerford market, had great attraction for him. . . . No Venetian ever
draws anything foul; but Turner devoted picture after picture to the
illustration of effects of dinginess, smoke, soot, dust, and dusty texture;
old sides of boats, weedy roadside vegetation, dung-hills, straw-yards,
and all the soilings and stains of every common labour.

 Of course, this is not *all* that Turner painted, any more than the
bright hills and luminous skies described in *Modern Painters* I ex-
haust the range of his subjects. But in the final volume Ruskin
delights in Turner's gross actuality, which the youthful author of
Modern Painters I ignored both in Turner and in nature. Indeed,
the boyhood of Turner contrasts not only with that of Giorgione
but with Ruskin's own—with the sheltered child of *Praeterita*, cut
off from companions and playing in the orderly enclosed garden of
Herne Hill. Ruskin takes vicarious pleasure in Turner's experience
of the odors, sympathies, and moral terrors which were beyond the
walls of his own childhood garden.

As Turner's youth among low-class London life developed his endurance of ugliness, so it educated him to poverty and to evil. Reynolds and Gainsborough, brought up on the country boy's reverence for the squire, painted "the squire and the squire's lady as centres of the movements of the universe, to the end of their lives." But Turner saw the rich dealing with the poor in dark lanes by night; he wandered around wharves and was the friend of sailors and fishmongers. He picked up his first bits of vigorous English in the markets, "his first ideas of female tenderness and beauty among nymphs of the barge and the barrow." In *Modern Painters* I Ruskin had contrasted the conventionalities of the Grand Style with truth to nature. But here the contrast is between Reynolds's respectable innocence and Turner's tragic vision of a "multitudinous, marred humanity." Turner paints nature because he finds "no beauty elsewhere than in that." Of the life of men, he paints only their labor, their sorrow, and their death.

The chapter concludes with a description of the marred humanity which, during Turner's youth, had died on the battlefields of Europe and in the streets and factories of England. The passage reflects more sharply than any other in *Modern Painters* the change that had overtaken Ruskin since that summer evening at Chamonix when he had seen in a sudden clearing of the clouds a revelation of God. His prose is rich in those allusive resonances and muted sonorities which rise to violence in his writing of the 1860s and '70s and do not abate until, in *Praeterita,* he achieves a style of uncanny ease and directness:

And their Death. That old Greek question again;—yet unanswered. The unconquerable spectre still flitting among the forest trees at twilight; rising ribbed out of the sea-sand;—white, a strange Aphrodite,—out of the sea-foam; stretching its gray, cloven wings among the clouds; turning the light of their sunsets into blood. This has to be looked upon, and in a more terrible shape than ever Salvator or Dürer saw it. . . . The English death—the European death of the nineteenth century—was of another range and power; more terrible a thousand-fold in its merely physical grasp and grief; more terrible, incalculably, in its mystery and shame. What were the robber's casual pang, or the range of the flying skirmish, compared to the work of the axe, and the sword, and the famine, which was done during this man's youth on all the hills and

plains of the Christian earth, from Moscow to Gibraltar? He was eighteen years old when Napoleon came down on Arcola. Look on the map of Europe and count the blood-stains on it, between Arcola and Waterloo.

Not alone those blood-stains on the Alpine snow, and the blue of the Lombard plain. The English death was before his eyes also. No decent, calculable, consoled dying; no passing to rest like that of the aged burghers of Nuremberg town. . . . But the life trampled out in the slime of the street, crushed to dust amidst the roaring of the wheel, tossed countlessly away into howling winter wind along five hundred leagues of rock-fanged shore. Or, worst of all, rotted down to forgotten graves through years of ignorant patience, and vain seeking for help from man, for hope in God—infirm, imperfect yearning, as of motherless infants starving at the dawn; oppressed royalties of captive thought, vague ague-fits of bleak, amazed despair.

ii

The fits of amazed despair, the vain seeking for God, describe not only the England Turner presumably observed in the early nineteenth century but also the confusion of purpose and uncertainty of faith Ruskin himself felt in 1860 when concluding *Modern Painters*. The roots of this despair reach back to the 1840s, when he began to doubt his inherited religious beliefs. By 1851 his faith was "being beaten into mere gold leaf, and flutters in weak rags from the letter of its old forms. . . . If only the Geologists would let me alone, I could do very well, but those dreadful Hammers! I hear the clink of them at the end of every cadence of the Bible verses." When he was with his wife in Venice he wrote anxious, almost daily letters to his father complaining of his loss of faith. He found the prophecies contradicting themselves and the prophets "savouring of tripods and hot air from below." At one point he felt himself to be "on the very edge of total infidelity" and experienced "a terrible sense of the shortness and darkness of life—and dread of death."

It is impossible to appreciate the magnitude of Ruskin's conflict in these letters without first appreciating the peculiar closeness of the ties which bound him to his parents. He was confessing to a crime. He wrote a letter at once ironic, petulant, and apologetic, excusing himself to his mother for having missed a Protestant service

in Venice, although the only service was in German, which he would not have understood. He regrets that his mother has been crying over his "depravity," but he is no worse than he has ever been; he has written a ninety-page commentary on the Book of Job since his arrival and holds prayers every day, reading the entire English service on Sundays to the household servants. But Ruskin was more deeply disturbed than the superficial ironies of this letter indicate, for it was immediately followed by another, in which he cautiously repeated his explanation for fear that the first letter might have gone astray.

In view of Ruskin's confessions of doubt, it seems inconceivable that he continued to hold services at all. But apart from achieving the comforting continuity of transferring the pious tone of the elder Ruskins' home to Venice, Ruskin was also remaining faithful to his deepest convictions. For although his mother's particular variety of Protestantism was losing its hold upon him, and that loss caused him and his parents much pain, he never lost his fundamental faith in Christianity. Thus in the last important letter from Venice concerning his religious crisis, he explains to his father that, although he has come to the place where "the two ways meet," he does not mean "the division between religion and no religion: but between Christianity and philosophy. . . . The higher class of thinkers" have for the most part forsaken the peculiarly Christian doctrines and devoted themselves instead to improving this world. He would have become such a person, had God not appointed him "to take the *other* turning."

Ruskin came far closer to that turning than this letter suggests. Yet I think that some of his biographers have erred in uncritically equating his beliefs of the 1860s and '70s with those of the Religion of Humanity, which substituted the divinity of Man for the divinity of God, was militantly secular, and, while preaching the ethics of Christianity, denied its dogmas. For the most classic and moving expression of the Religion of Humanity, we must look to John Stuart Mill, one of the "higher class of thinkers" in Ruskin's letter. Mill's belief in the perfectibility of man and his social radicalism originated in the rationalism and optimism of the eighteenth cen-

tury. But Ruskin's social criticism was colored by his Augustinian sense of the mystery and tragedy of terrestrial life, and his "socialism" is rooted not in the age of reason but in the radical ethics of the Gospels.

Both men were passionate believers in the nobility and brotherhood of man. But for Ruskin, unlike Mill, there could be neither nobility nor brotherhood without the fatherhood of God. It came to him as a fearful discovery that "God has allowed all who have variously sought Him in the most earnest way, to be blinded" and that "Puritan—monk—Brahmin—churchman—Turk—are all merely names for different madnesses and ignorances. . . . What message I have given is all wrong: has to be all re-said another way, and is, so said, almost too terrible to be serviceable." But it never seriously occurred to him that part of his revised message might be that God does not exist.

In one of the letters from Venice just quoted, Ruskin drew a parallel between his enfeebled religious conviction and his loss of delight in nature. Neither happened suddenly or categorically. In *Praeterita* he wrote that in 1837, when he was eighteen, he felt for the last time "the pure childish love of nature." But his diary for 1841 shows him standing at sunrise before an opened window, from which he "looked out and caught the blaze of the pyramid of snow which closes the vally [*sic*], full fronting the east sun, and staggered back into the room: I could not have conceived I should have felt it so much. Thank God! I have lost none of my old joy in the Alps." Still, Ruskin's feeling for nature perceptibly declined. The almost daily, semi-mystical occurrences of his youth became in the 1850s and '60s prized, isolated moments passionately seized upon as the return of an *old* emotion.[1]

With this loss of sensibility, Ruskin had seriously to reconsider

[1] Francis G. Townsend contends that by 1849 "Ruskin's landscape feeling was dead." The date is too arbitrary and dead too strong a word. But Townsend argues perceptively and persuasively that Ruskin's loss of this feeling led to the growth of his interest in society. See *Ruskin and the Landscape Feeling: A Critical Analysis of His Thought During the Crucial Years of His Life, 1843–56* (Illinois Studies in Language and Literature, Vol. XXXV, No. 3, Urbana, Ill., University of Illinois Press, 1951), p. 49.

the role of landscape set forth in *Modern Painters* I and II. The worship of nature in the third volume is synonymous not with the worship of God but with an escape from the drab tensions of nineteenth-century life and an evasion of commitment to the needs of men. The Dark Ages, Ruskin writes in the chapter on "Modern Landscape," is a misnomer. They were the bright ages, ours the dark, with brown brick walls, colorless clothes, "jaded intellect, and uncomfortableness of soul and body." With the onset of ugliness and want of faith, "men steal out, half-ashamed of themselves for doing so, to the fields and mountains," where, finding color, variety, and power, they delight in them to an extent never before known. They see in sunsets and sunrises "the blue, and gold, and purple, which glow for them no longer on knight's armour or temple porch." Contemporary literature and art are forced to seek in an idealized past and in external nature the satisfactions no longer attainable in ordinary life.

The moral of the chapter on "The Moral of Landscape" is that among the great benefactors of the human race the "dreaming love of natural beauty—or at least its expression—has been more or less checked by them all, and subordinated either to hard work or watching of *human* nature."

The passage, indeed the whole chapter, is highly autobiographical. For it was Ruskin who had turned from mountains to the hard study of political economy and to the close watching of human nature. With that shift, he ceased to champion the realism of Romantic art and literature. What began as a sort of supplementary Preface to the *Lyrical Ballads* becomes, in the later volumes of *Modern Painters*, a social criticism whose insights are essentially those of Dickens's *Hard Times*. Wordsworth's love of nature, Ruskin writes, would have been quite worthless were it not for his war on pomp, his exaltation of simple feelings, and his understanding of the ways of men. The intense love of nature in the nineteenth century is characteristic not "of the first order of intellect, but of brilliant imagination, quick sympathy, and undefined religious principle . . . being, for the most part, strongest in youth." When he wrote these lines, Ruskin had already experienced a weakening of religious faith

associated with a waning love of nature and a waxing social con-science. Each experience interacted with the other and produced that complex realignment of values accompanying his transition from the criticism of art to the criticism of society. The confusion of will and the despair which burden his letters of the 1850s are products of this readjustment.

Ruskin's mind lacked tidy compartments. Any one of its wide areas of thought shaded off into all the others. His contradictions are the local shifting and discords of a larger consonance, quite like that of a Chartres window, in which a shadow cast on one panel causes all others to oscillate in altered tones. Possibly the earliest cause of the changed tone of *Modern Painters* was that Ruskin him-self felt the loss Wordsworth describes in the Immortality Ode:

> There was a time when meadow, grove, and stream,
> The earth, and every common sight,
> To me did seem
> Apparelled in celestial light,
> The glory and the freshness of a dream.
> It is not now as it hath been of yore;—
> Turn wheresoe'er I may,
> By night or day,
> The things which I have seen I now can see no more.

This sense of the passing away of a glory from the earth, to-gether with a growing distaste for the puritanical rigors of his weak-ening Evangelicalism, prepared Ruskin for the revelation which came to him at Turin late in the summer of 1858. In the spring of that year he had completed the exhausting labor of unscrambling, cataloguing, and mounting some 19,000 sketches which Turner had bequeathed to the National Gallery. Depressed and confused of pur-pose, he set out for Switzerland, where for the first time in his life he found the top of the St. Gothard dull. At Bellinzona he soon tired of the hills and took the train to Turin, where six weeks of brilliant, penetrating impressions crystallized changes in his views of life and art which had been forming for over a decade.

There was, first, Ruskin's unconversion from Evangelicalism.

The darkness of the Waldensian chapel, the cracked voice of the stunted preacher, the pall and doom of his message to the languid congregation all contrasted with the images of life, light, harmony, and joy which greeted Ruskin as he quit the chapel and entered the Turin Royal Gallery, through whose opened windows, glowing in the warm afternoon sun, "there came in with the warm air, floating swells and falls of military music . . . which seemed to me more devotional, in their perfect art, tune, and discipline, than anything I remembered of evangelical hymns." The elder Mrs. Ruskin, after her son had spent lavishly on grapes, partridges, and the opera, sent him five pounds that he might make his "peace with Heaven" through a gift to the churches of Vaud. This he did after some pious talk with a local clergyman. But he derived far greater pleasure from an exactly matching gift of his own, made to a ballerina at Turin. "She was not the least pretty . . . but did that work well always; and looked nice,—near the footlights." [2]

The gift to the ballerina was one of Ruskin's periodic gestures of defiance toward his parents which relaxed the strain of a dependence and submissiveness far more persistent than his occasional rebellions. She was part of the symbolism of Ruskin's Turin experience, unlike the reality of the young girl Ruskin saw—and never forgot—lying half naked on a heap of sand. The girl appears in a letter Ruskin wrote to his father shortly after leaving Turin. I quote it at some length, for it belongs, in a roundabout way, with the series of discoveries Ruskin made when he left the chapel and found himself in front of Veronese's *Solomon and the Queen of Sheba:*

Sunday Evening, Paris, 12*th September,* 1858
I am amazed to find that the Parisians will not for a moment bear comparison with the Turinoises. . . . There is a terrible and strange hardness into which the unamiable ones settle as they grow old. An Italian woman, at the worst, degrades herself into an animal; but the French woman degrades herself into a Doll;—the gardens looked to me as if they were full of automata or waxworks. . . . An Italian, however ferocious or sensual, always looks like a man, or like a beast; but these

[2] It is a revealing commentary on Ruskin's unconversion that his mother, on Puritan principle, could not be persuaded to enter a theater.

French look like nutmeg-graters—they don't make tigers, or snakes, or sloths of themselves, but thumbscrews. . . . In Italy one constantly sees a wild, graceful, confessed poverty, without abject misery; but here, there is no interval between starvation and toilette. One of the finest things I saw at Turin was a group of neglected children at play on a heap of sand—one girl of about ten, with her black hair over her eyes and half-naked, bare-limbed to above the knees, and beautifully limbed, lying on the sand like a snake; an older one did something to offend her, and she rose with a spring and a shriek like a young eaglet's—as loud as an eaglet's at least, but a good deal sweeter, for eagles have not pleasant voices. The same girl, here, in the same station of life, would have had her hair combed and plaited into two little horns on each side of her head—would have had a parasol and pink boots, and would have merely pouted at her companion instead of shrieking at her. . . . Something better than a picture might have been made of the little Italian eaglet, if anybody had taken her in hand: but nothing whatever of the parasoled and pink-booted children.

In part, Ruskin is voicing an old preference in new terms, here applied to humanity rather than to art. He is praising a kind of Italian "Vital Beauty" as opposed to the false proprieties of the French "Grand Style" in *dames, messieurs,* and *enfants.* But the passage, which surely perplexed Ruskin's parents, is also sharply anti-Puritan. Ruskin allows himself to delight in the energetic animality— however ferocious or sensual, bare-limbed or snake-like—of the human form. He feels rapture over a potency which, prior to Turin, he had permitted himself freely to feel only in the presence of mountains and seas.

The opulent and crowded painting Ruskin saw on entering the Royal Gallery at Turin hung over a doorway at an inaccessible height. He had a scaffolding erected on which he spent weeks making detailed studies of King Solomon and the sumptuous Queen of Sheba. He also wrote a series of "Notes on the Turin Gallery," one of which is of particular interest. It is a synthesis of the experiences which led to his unconversion, his intense response to the young girl on the sand, and his preference in the later volumes of *Modern Painters* for Veronese, a "naturalist idealist," over the "purist" Fra Angelico. The note begins with Ruskin's perplexity over the fact that Veronese and Titian, although frankly sensuous, were invari-

ably noble, while an Annunciation by the pious Gentileschi was essentially base:

Certainly it seems intended that strong and frank animality, rejecting all tendency to asceticism, monachism, pietism, and so on, should be connected with the strongest intellects. . . . Homer, Shakespeare, Tintoret, Veronese, Titian, Michael Angelo . . . Turner, are all of them boldly Animal. Francia and Angelico, and all the purists, however beautiful, are poor weak creatures in comparison. I don't understand it; one would have thought purity gave strength, but it doesn't. A good, stout, self-commanding, magnificent Animality is the make for poets and artists, it seems to me.

One day when I was working from the beautiful maid of honour in Veronese's picture, I was struck by the Gorgeousness of life which the world seems to be constituted to develop. . . . Can it be possible that all this power and beauty is adverse to the honour of the Maker of it? Has God made faces beautiful and limbs strong, and created these strange, fiery, fantastic energies, and created the splendour of substance and the love of it . . . only that all these things may lead His creatures away from Him? And is this mighty Paul Veronese, in whose soul there is a strength as of the snowy mountains, and within whose brain all the pomp and majesty of humanity floats in a marshalled glory . . . this man whose finger is as fire, and whose eye is like the morning—is he a servant of the devil; and is the poor little wretch in a tidy black tie, to whom I have been listening this Sunday morning expounding Nothing with a twang—is he a servant of God?

Although it is often treacherous to interpret Ruskin's writing by the light of his psychic life, which was itself so enigmatic, it is difficult not to see in this note Ruskin sent to his father a defiant rejection of the whole Puritan discipline which had emptied his childhood of toys and made it immoral for him on the Sabbath to gaze at the Turners which lined the walls of his home. Of course one can admire Veronese without first experiencing a religious crisis. But the vigor of Ruskin's contempt for the black-tied wretch seems to reinforce the energy of his admiration for a painter whose overripe Venus presses a spurt of milk from her breast, and whose Cupid is a decadent satyr. From one point of view Ruskin's sense of the goodness of the material creation had broadened to include man. From another point of view he was deliberately shocking his parents with his discoveries at Turin. Previously he had argued that great

art, the sacred record of God's second book, expresses man's delight in God's work, not his own. Now he argues that great art is "*the expression of a mind of a God-made great man.*"

Although Ruskin's worship of the Deity remained constant, the seat of holiness has shifted from external nature to the human soul. As a consequence of this shift, Ruskin largely denies the Fall and more than half raises man from the lapsed depravity of *Modern Painters* II. The most direct "manifestation of Deity to man is in His own image, that is, in man." He is the "sun of the world; more than the real sun. . . . Where he is, are the tropics; where he is not, the ice-world." The love of nature, which first led Ruskin to the study of art, here leads him to the study of man; the study of man leads him in the closing chapters of *Modern Painters* to the criticism of society. Early in the work he praises art which represents the divinity and energy of nature. Toward its conclusion he praises art which represents, and he seeks a society which humanely orders, the divine energies of man.

Another set of notes written within a year or so of Ruskin's unconversion shows how intimately connected were his esthetic and religious experiences. The painter, Ruskin writes, is gifted with a redundance of nervous, physical, and sensory energies which "sustain his hand and eye in unbroken continuousness of perception and effort." If exhausted or depressed, he does not impute his depression to a flaw in the universe or look for consolation in supernatural help. His pleasures are the shapes and colors of this world, which are as abundant as were the fruits in Paradise. Nothing presents itself to him which is "not either lovely, or tractable, and shapable into loveliness; there is no Evil in his Eyes;—only Good, and that which displays good. Light is lovely to him; but not a whit more precious than shadow."

Such a man cannot feel the discontent with the world from which arise the common forms of religious life. If people lose their beauty in grief, age, or wickedness, their faces then express the variety and character which make painting them all the more pleasurable. The painter has no desire to mend the world, "unless, perhaps,

it might be better with fewer fogs in it." At all events, the best we can do for him is get out of his way and let him go on painting. There may be "religious shepherds, labourers, farmers, merchants, shopmen, manufacturers—and Religious painters, so far as they make themselves manufacturers—so far as they remain painters—no."

These "Notes on a Painter's Profession as Ending Irreligiously" seem to contradict Ruskin's claim in *Modern Painters* that greatness in art cannot be achieved by impious men. But by piety he meant not religious zeal but a joyous reverence of life, and by morality the disciplined harmony of its powers. He had always asserted that the first morality of a painter, or of anybody else, is to know his business. That Ruskin sometimes used words in their narrowest, sometimes in their broadest sense, was part of the same impulse to paradox which caused his wife to remark that he was a conservative in France because there everyone was radical, and a radical in Austria, where everyone was conservative. It was part, too, of his lifelong struggle to wrest a harmony from those conflicting impulses and ideas which make him so strongly and strangely representative of our composite nature. The painter is here irreligious in exactly the degree that, as prophet of God sent to comment on His creation, he was excessively religious in *Modern Painters* I and II. The Note represents one of those radical shifts in the dialectic of Ruskin's thought. That dialectic is confusing not so much because it is contradictory as because it responds so fully and sensitively to the antinomies of experience itself. Ruskin's life and books, however disorderly in themselves, reveal the order inherent in the struggle to achieve order.

Through a kind of Christian humanism he exalts in *Modern Painters* V both the animal and spiritual nature of man, as previously through a kind of Christian naturalism he had exalted both the holiness of matter and the beauty of spirit. Asceticism or sensuality isolates either the body or the soul, neither of which can profitably despise or expel the other. For man's nature is "nobly animal, nobly spiritual. . . . All great art confesses and worships both." It is as if Ruskin, an admiring reader of Browning, had resumed the argument

of "Fra Lippo Lippi." Fra Lippo's prior insists that he "paint the
soul" and despise the body. Fra Lippo protests that he must be faith-
ful to both, for he has learned

> The value and significance of flesh
> . . .
> —The beauty and the wonder and the power,
> The shapes of things, their colours, lights and shades,

all of which are parts of God's creation. Browning's portrait of Fra
Filippo Lippi, who himself portrayed delightfully earthy angels
(one of them in the Uffizi *Madonna and Child* looks like a Floren-
tine urchin), expresses the same inseparable love for the nobly ani-
mal and nobly spiritual which Ruskin had come to prize as he was
completing *Modern Painters*.

Because he believed that the two natures of man were most
perfectly balanced by the Venetian painters of the Renaissance, he
preferred them to the Florentine and Umbrian schools. In the rest
of Italy, he argues, piety had become "abstract"; the latter schools
generally separated their saints from their citizens, their sacred busi-
ness from their secular. But the Venetian "madonnas are no more
seated apart on their thrones, the saints no more breathe celestial air.
They are on our own plain ground—nay, here in our houses with
us." Worldly affairs are transacted fearlessly in their presence; chil-
dren play with pet dogs at Christ's feet. Ruskin confesses that he
had once found this irreverent and, indeed, a decade previously,
before his anti-Catholicism had disappeared along with his militant
Protestantism, he would have seen only "Romanist vulgarity" in the
naturalism of Venetian art. But now he praises the interpenetration
of sacred and secular. A variant form of the same insight led him
several years later to criticize an audience of bankers for building
their churches in one style and all else in another; they had sepa-
rated their religion from their life.

After analyzing several paintings of Veronese and Titian in
which religious subjects are placed in naturalistic settings, Ruskin
concludes that the Venetian mind was "wholly realist, universal, and
manly." In the breadth of his realism the painter "saw that sensual
passion in man was, not only a fact, but a Divine fact." Though the

highest of animals, man yet remains a perfect animal whose happiness, health, and nobility "depended on the due power of every animal passion, as well as the cultivation of every spiritual tendency." But Ruskin knew such passion only as a divine, not as a physical fact; after six strained years his wife annulled their marriage on the grounds of non-consummation. The gloomy course of Ruskin's mental and emotional history suggests that he was quite prophetically, quite tragically, right about the dependence he here describes. The revelation on the sands and in the gallery at Turin had come too late; or perhaps it had come with such poignant force precisely because Ruskin could not translate it into fact.

<p style="text-align:center">iii</p>

It is tempting to take 1860—the year *Modern Painters* was completed and the precise mid-point of Ruskin's life—as the dividing line on one side of which falls his career as art critic and on the other, with the publication of *Unto This Last* also in 1860, his career as a critic of society. But the change is of emphasis only, not of direction. The closing chapters of *Modern Painters* are a preface to *Unto This Last*. The welfare state Ruskin advocates in *Unto This Last* evolved from the study of Gothic architecture which he began in 1846. In turn, several leading principles of that study appear in *The Poetry of Architecture*, which he published when he was only eighteen. A decade before that, under his mother's tutelage, he had already embarked on those annual marathon readings of the Bible, from Genesis to Apocalypse, which colored alike his understanding of art and society.

Possibly the clearest sign of the unity of Ruskin's thought is that it is impossible to pick it up in isolated fragments; to seize on any single idea is to grasp, at one end or another, the whole interlocking complex. Ruskin once apologized during a lecture for having announced his subject as Crystallography and then talking about Cistercian Architecture. But the lecture on Crystallography, he explained, would have included something on Cistercian Architecture, and it was only through great self-denial that he could keep the talk on architecture away from the subject of Crystallography. This in-

ability to keep his subjects apart is at once the vice and virtue of Ruskin's mind. It makes chaos of single chapters, confusion even of entire books; but the whole of Ruskin's opus is an uninterrupted dedication to the Oneness of the many. For so prolific a writer, he had a surprising fondness for aphorisms, by which he managed forcefully to yoke together art and morality, wealth and life, stock exchanges and souls. One of these brief, dogmatic assertions occurs in the chapter entitled "The Law of Help" in *Modern Painters* V; it concludes part of a discussion on composition in painting and begins Ruskin's protracted attempt to define the just "composition" of society.

He defines composition as "the help of everything in the picture by everything else." The more perfect the harmony of the elements of a painting, the greater will be its vitality. A perfectly pure, and hence perfectly vital, state of anything is that in which all the parts are entirely consistent. The destruction of such organization is a form of death, a separation or, literally, a "decomposition" of parts. The principle is equally applicable to esthetics or economics: "Government and co-operation are in all things and eternally the laws of life. Anarchy and competition, eternally, and in all things, the laws of Death." This sentence heralds Ruskin's attack upon free enterprise and his advocacy of the Welfare State in *Unto This Last*. But the grounds for that attack were first laid years before in his analysis of "Ideas of Beauty" in *Modern Painters* II.

One of these ideas, typical of the Deity, Ruskin termed "Purity, or the Type of Divine Energy." Matter is pure when it is in a state of maximum vitality and energy. This condition is attractive to us because it expresses the "constant presence and energizing of the Deity by which all things live and move, and have their being." Ruskin's discussion of purity relates very closely to his sentence on cooperation as the law of life, competition the law of death: the competitive society is an *impure* society, one in which men are placed in an unhealthy and devitalized relationship to one another. Instead of forming a cooperative and energetic whole, their Hobbesian war of all against all yields anarchy or death.

The well-composed society, like the well-composed painting,

thus possesses a quality which is essentially but never narrowly moral. It is as impossible to abstract the moral tone from Ruskin's esthetic criticism as it is to isolate the esthetic overtone from his social criticism. There may be irreligious painters but not, in his sense of the word, immoral painters, for their "magnificent animality" is a sign of vital and controlled organization of powers in themselves moral. The artist, himself a product of society, produces an art whose style is an accurate index to the moral qualities of that society. A decadent society produces a decadent art; a joyless or smog-ridden society produces dismal art, or none at all. A thing of beauty may be a joy forever, but only for those who have the leisure to look at it with unwearied and educated eyes. The England of Manchester or Birmingham could not, Ruskin believed, produce artists or a public capable of appreciating art. His impulse to social reform thus stemmed from his belief that beauty was a sacrament in which all were entitled to partake but from which most were in fact excluded: industry without art is brutality, art without industry is guilt.

Although we have found a path in *Modern Painters* clearly connecting Ruskin's two careers, it would be misleading to quit our study of that sprawling work with the impression that the path is particularly straight or well marked. *Modern Painters* is a work of abundant genius, but its genius is not without digressions, contradictions, and, in the later volumes, symptoms of the instability of interest and temperament which culminated in Ruskin's insanity. On the other hand, it is equally misleading to argue, as a brilliant critic of Ruskin has done, that his change of interest was due to a failure to capture the "art dictatorship" of England and to a sudden loss of esthetic receptivity. True, Ruskin did lose some of his passion for pictures, but the loss was part of that larger collapse of nature whose perfection he could no longer find mirrored in art. Nonetheless, in the 1870s he enthusiastically discovered painters and paintings he had never before appreciated. And his concern with economics and politics arose long before he completed *Modern Painters*.

We will be more faithful to the facts of Ruskin's career if we

interpret more generously the motive underlying his shift of interests. There was, as we have seen, the crucial change in his attitude toward nature. Once nature had come to include the carcass of the ewe as well as the peak of Mont Blanc, landscape art had lost its hold upon him as "an instrument of gigantic moral power." His sense of the divinity of nature in *Modern Painters* I was inseparable from his sense of the divinity of art, especially Turner's art. But what nature and art lost in divinity, man appears to have gained; society's stifling and perversion of that divinity aroused Ruskin's sensibilities in the closing volumes of *Modern Painters* and thereafter.

In the eighteen-year course of writing the book, Ruskin had acquired a social conscience. As a child he had traveled the breadth of England during a period of appalling exploitation and poverty. But he saw only a green and pleasant land and the stately homes of his father's wealthy sherry patrons. As a young man touring Italy he noted in his diary: "La Spezia. . . . Beggars all day intolerable–howling, dark eyed brats of children, to be got rid of by a centime." The stakes rose, for by middle age he had given away to various persons and causes a fortune of nearly half a million dollars.[3] In 1840, however, the beggars of Lucca were "persevering and pestiferous in the last degree"; and at Pisa the noble effect of the tower was spoiled by the beggars who, like the children of La Spezia, kept up a perpetual howl. By 1859 the cry of the beggars had become more than an obstacle in the foreground of Ruskin's esthetic pleasure. "As I grow older," he wrote to Charles Eliot Norton, "the evil about us takes more definite and overwhelming form in my eyes. . . . To fill starved people's bellies is the only thing a man can do in this generation, I begin to perceive." Four years later that cry had risen to a shrieking crescendo:

I am . . . tormented between the longing for rest . . . and the sense of the terrific call of human crime for resistance and of human misery for help—though it seems to me as the voice of a river of blood which can but sweep me down in the midst of its black clots, helpless.

[3] £31,000 calculated on the basis of the relative purchasing power of the dollar in 1877 and 1960. £31,000 is a minimal figure and excludes a large number of miscellaneous benefactions. For Ruskin's use of his inheritance from his father, see XVIII, xxix, and XXIX, 99–104.

There is nothing here of wounded pride, but much to suggest a badly injured psyche. If we must delve into a motive for the changed direction of Ruskin's career, we may better find it in the rising cry of the beggars, symbols, possibly, of the burden of guilt Ruskin bore for his wealth, his leisure, his extravagant purchases of art; possibly even symbols of the voices he dreaded to hear accuse him of madness or impotence; but the sign also of that *caritas* for which we need seek no motive, and which led him to spend the rest of his life and sanity trying to grace the world with art and society with love.

III. A GOTHIC EDEN

In no field more than architecture does Ruskin appear to the modern mind at once so prescient and so perverse. He clearly foresaw the architectural revolution of this century, but denounced what he prophesied as mechanistic and inhuman. He wanted an architecture which would be, in Frank Lloyd Wright's phrase, truly "organic" and responsive to modern needs; yet he sought it in the weathered marbles and salt-sprayed capitals of Venice.

The source of much that is perplexing in Ruskin's attitude toward architecture was a movement which arose well before his birth and is inseparable from Romanticism—the Gothic Revival. Curiously, the Revival in England began as a kind of self-conscious jest. It was as if grown men, half ashamed of departing from neo-classical modes of feeling and expression, and only half aware of dissatisfaction with them, sought amusement by turning to the past and fashioning archaic toys in stone or prose. Horace Walpole used a medieval setting to play upon emotions of terror in *The Castle of Otranto* precisely as he toyed with the sentimental and picturesque at Strawberry Hill, his Gothic villa. Only after the maturity of Romanticism itself did the Revival become a cause which, in the writings of Pugin and Ruskin, yielded whole philosophies.

Walpole typifies the movement in its "literary" and amateur phase. On purchasing Strawberry Hill he wrote, "It is a little plaything house that I got out of Mrs. Chenevix's [toy] shop, and is the prettiest bauble you ever saw." For more than twenty years he added bits of Gothic here and there, regardless of their origin or function; the chimney piece in his bedchamber was adapted from one of the sepulchers at Westminster Abbey. Walpole enjoyed a

kind of medieval charade, much as Marie Antoinette delighted in
retiring from the court to play the pastoral game of *petite bergère*.
He fabricated a highly self-conscious, highly sophisticated deceit,
as did his readers—fellow residents in the twilight of the Age of
Reason—who shuddered delightedly at the contrived terrors of *The
Castle of Otranto*.

Another literary amateur, William Beckford, built the most re-
markable structure of the Revival in its dilettante period. On an
estate not quite wholly enclosed by a wall seven miles long, this
eccentric millionaire erected Fonthill Abbey, a gigantic mock-up of
an illustration from a Gothic novel. The Abbey was over three
hundred feet long and was surmounted by an immense octagonal
tower twice the height of the twin towers of Durham Cathedral.
Obviously not "a little plaything house," it was nonetheless built
with the same ignorance of the nature of Gothic as was Strawberry
Hill.

Yet for the first time in almost two centuries men like Walpole
and Beckford could cultivate Gothic, however bastardized, and be
thought merely odd, not out of their wits. The French converted
some of their cathedrals into barracks for Revolutionary troops and
sold other remnants of the "Dark Ages" as rubble, but the tide of
awakened sympathy for a somehow more heroic, holier, and simpler
age was clearly ascendant. It swept into the main stream of Ro-
manticism and seemed, suddenly, to wash over the face of nature
and of the past. Gothic cathedrals were no longer grouped with
mountains as the barbaric blunders of nature or of superstitious men.
Wordsworth's response to nature in the Gothic setting of "Tintern
Abbey" would have been inconceivable forty years before he wrote
the poem. When Winckelmann, the great historian of Greek art,
journeyed over Ruskin's beloved St. Gotthard Pass in 1760, he was
so appalled by the mass of rock and ice that he drew down the car-
riage blinds and awaited the more civilized contours of the Italian
countryside. Five years later Gibbon visited the Piazza San Marco—
the very center of Ruskin's Gothic pilgrimage—and complained of
"a large square decorated with the worst architecture I ever saw."

But in the same year that Gibbon judged Venice as the rationalist

must ever judge her, Thomas Percy published his *Reliques of Ancient English Poetry*, an anthology in which the old and the new, the authentic and the contrived, jostle each other in the manner of Strawberry Hill. English poetry, like English architecture, was establishing contact with the past. Percy's *Reliques*, Macpherson's *Fragments of Ancient Poetry*, and the Elizabethan imitations of the young Chatterton presaged the great ballad recreations of Wordsworth, Coleridge, and Keats, and the lesser ones of Scott, whose novels awakened wide sympathy for the monuments and mores of the Middle Ages.

What began in verse as pastiche and deception eventually produced first-rate poetry; medievalism in painting and architecture was far less successful. The Pre-Raphaelites' attempt to recapture the directness, brilliant color, and religious conviction of medieval art resulted in a strained and, to us, ludicrous naïveté.[1] In architecture the principles of medieval building were not taken seriously or seriously understood until Pugin's *Contrasts* was published in 1836.[2] By then the future of architecture lay with the use of new materials which deprived Gothic of all structural *raison d'être*. Had plate glass, cast iron, and structural steel been developed a century later, or had the Revival begun earlier, the movement might have borne the same creative relationship to the great cathedrals of the twelfth and thirteenth centuries that the best architecture of the Renaissance bears to ancient Greece and Rome. Instead, the Gothic Revival was caught in an historical pincers, and in this light we should assess Ruskin's contribution to it.

During the decade that preceded the publication of *The Seven Lamps of Architecture* (1849), the movement stimulated a national debate—the Battle of the Styles—which colored all of Ruskin's writ-

[1] Perhaps because their inspiration was so excessively literary and derivative rather than visual: Rossetti painted *Dante's Dream*, *The Lady of Shalott*, and *La Belle Dame sans Merci*; Millais painted *Ophelia* and *Mariana;* Holman-Hunt painted *The Eve of St. Agnes.* The Romantic muse too often feeds upon itself in their works.

[2] The single notable exception was Dr. John Milner (1752–1826), medievalist, author, and priest, who designed the Gothic New Chapel at Winchester. That both Milner and his successor Pugin were Catholics gave the early Revival a distinctly Catholic orientation.

ing on architecture. Imitation Gothic momentarily triumphed over imitation Renaissance as early as 1834 when, after the burning of the Houses of Parliament, the committee which drew up terms for the competing architects required that the new designs be either Gothic or Elizabethan. Societies were formed in Oxford and Cambridge for the preservation and promotion of Gothic architecture. Scholars, antiquarians, and architects published works on the monuments of the Middle Ages, and the firms which fabricated Gothic designs prospered.

Ruskin, arriving late on the scene, objected to much that had been built and written. His chief target was the Renaissance; but within the Revival itself he had to combat the ignorant enthusiasts who, by wantonly "restoring" rather than preserving Gothic, were everywhere threatening to destroy it. He had also to convince the movement that Gothic could not simply be transcribed from archeologically accurate plans into contemporary buildings. Above all, coming after Pugin, an articulate convert to Catholicism, he had to persuade the public that the revival of Gothic could be a national rather than a sectarian enterprise. He had much to learn and perhaps something to fear from Pugin's brilliant advocacy of Gothic.[3]

In the year of his conversion, Pugin published *Contrasts; or, a Parallel between the Noble Edifices of the Fourteenth and Fifteenth Centuries, and Similar Buildings of the Present Day; Shewing the Present Decay of Taste.* The book is far more compact and pungent than its title. It consists of a brief introductory essay and a series of matched engravings, two to a page, each contrasting an example of the architecture of the Middle Ages with its modern counterpart. Three potent elements of Romanticism meet and reinforce one another in Pugin's pages: a longing glance at an idealized past, a quickened religious consciousness, and a summary rejection of neo-classicism as devoid of humanity or sincerity.

[3] The debt cannot be proved, and Ruskin flatly denies it in an appendix to *Modern Painters* III (V, 428–29). Yet Graham Hough's discussion of Ruskin's probable indebtedness to Pugin is convincing, however unflattering to Ruskin (*The Last Romantics* [London, Gerald Duckworth & Co., 1949], p. 90). For an illuminating account of the influence of Pugin, Ruskin, and William Morris on the Gothic Revival, see Hough, pp. 83–102.

The more Pugin studied medieval architecture, the more convinced he became that Gothic was not a style but a way of life. So conceived, and so desired, Gothic might become a means of reforming England socially and religiously. With the image of countless begrimed and stunted London churches of the Revival before us, it is almost impossible to conceive of the holy enthusiasm which once filled its supporters. But the Revival appears less of a mystery if we see it as part of a larger European movement which transformed all the arts and made architecture a subject of vital concern.

Pugin's thesis is quite simple and in many respects resembles Ruskin's. Their understanding of medieval architecture is remarkably similar, but they differ violently on the consequences of its revival in the nineteenth century. Pugin argued that the structural elements of Gothic were fairly well understood, but that the principles which once animated it were lamentably lacking in English life. Only "a restoration of the ancient feelings and sentiments" could restore Gothic to its former magnificence. Once Pugin had removed Gothic from the architect's studio and presented it as the product of a whole culture and a unified faith, he could contend that the revival of Gothic required the restoration of the beliefs from which it had arisen. The plea for Gothic became a plea for England to rejoin the Church of Rome, for it was

the faith, the zeal, and, above all, the unity, of our ancestors, that enabled them to conceive and raise those wonderful fabrics . . . ere heresy had destroyed faith, [and] schism had put an end to unity. . . . When these feelings entered in, the spell was broken, the Architecture itself fell with the religion to which it owed its birth, and was succeeded by a mixed and base style devoid of science or elegance.

The argument in pictures was even more effective than the argument in words. One of the plates (they were all engraved by Pugin, who, like Ruskin, illustrated his own books) depicts a Catholic town in 1440 and is paired with a satire of the same town in 1840. The first shows a walled town dominated by a magnificent Late Gothic abbey on its outskirts. It is a kind of medieval idyl, with innumerable delicate spires, high-gabled houses, and, in the foreground, a broad stream crossed by a stone bridge on which stands a little

chapel. In the modern town the abbey is in ruins and the foreground is overpowered by a hideous, windowless jail. Factory chimneys and the smokestack of a huge gas works replace the spires. The churches have either been destroyed, chopped down to a kind of truncated Gothic, or stunted into a boxy Renaissance.

Pugin used the Gothic city not for esthetic purposes but as an instrument of radical propaganda. Like Ruskin, he made architecture important because he conceived it as a means of reshaping the national life. The revival of the Middle Ages was only in part an escape from the tensions and ugliness of industrial civilization. At bottom it was an attempt, however fated to failure, to revolutionize that civilization. Pugin's two cities were a recurrent metaphor which became increasingly common as England was defaced by industrialism and her laborers were enslaved by the machine.

The medieval town is a kind of Heavenly City, ideally beautiful, humane, and at peace; the modern town is an inferno filled with sulphurous smoke and the restlessness of unsatisfied needs. The two cities appear in Carlyle's *Past and Present,* with its splendid evocation of medieval St. Edmundsbury played off against Manchester's brutal suppression of the cotton operatives. The cities reappear in Dickens's *Hard Times,* in which Coketown's serpentine coils of factory smoke, blackened bricks, and foul-smelling river contrast with the single remnant of Merrie England, Sleary's circus. Tennyson's Camelot, before Arthur's realm "reels back into the beast," is the classic nineteenth-century image of the heavenly Gothic city.

William Morris, Ruskin's disciple, juxtaposes the surviving Gothic cathedral which rises above a modern factory town and the

monotonous hideousness of dwelling-houses for the artisans; here the gang of field-labourers; twelve shillings a week for ever and ever, and the workhouse for all day of judgment, of rewards and punishments; on each side and all around the nineteenth century, and rising solemnly in the midst of it, that token of the "dark ages," their hope in the past, grown now a warning for our future.

Morris followed Ruskin's path from the arts to social reform, with Gothic playing the same central role in his career. As an undergraduate he helped Rossetti decorate the Oxford Union with quaint

designs from Arthurian legend. His verse—he himself described it as "the idle singing of an empty day"—recaptures the ambience of medieval romance. But after reading Ruskin's chapter "On the Nature of Gothic," he sought to create a society in which "an art made by the people for the people" might flourish and the wage slavery of industrialism be replaced by a return to an agrarian, communal life. The author of *The Defense of Guenevere* and *The Earthly Paradise* eventually joined the Social Democratic Federation and founded the radical Socialist League. Morris is the most extreme instance, as Ruskin is the most influential, of the bond linking Romanticism to the Gothic Revival, and both to social reform.

Ruskin himself employs the motif of the two cities in a lecture on "Modern Manufacture and Design" which he gave in 1859. His point is that "beautiful art can only be produced by people who have beautiful things about them, and leisure to look at them." But northern England, where he lectured, was rapidly turning itself into a gigantic coalpit:

Just outside the town I came upon an old English cottage . . . left in unregarded havoc of ruin; the garden gate still swung loose in its latch; the garden, blighted utterly into a field of ashes, not even a weed taking root there; the roof torn into shapeless rents; the shutters hanging about the windows in rags of rotten wood; before its gate, the stream which had gladdened it now soaking slowly by, black as ebony and thick with curdling scum; the bank above it trodden into unctuous, sooty slime: far in front of it, between it and the old hills, the furnaces of the city foaming forth perpetual plague of sulphurous darkness; the volumes of their storm clouds coiling low over a waste of grassless fields, fenced from each other, not by hedges, but by slabs of square stone, like gravestones, riveted together with iron.

Pugin's modern town was merely hideous; Ruskin's symbolizes a satanic triumph over life itself. To this barren, blighted landscape Ruskin opposes the distant prospect of Pisa as it appeared to a medieval artist. A glittering river, brilliant sky, vine-clad hills, and troops of knights contrast with the depopulated darkness of that other, infernal city. In place of the furnaces, a dome and bell tower and, beyond them, the peaks of the Apennines gleam in an

untroubled and sacred sky . . . which opened straight through its gates of cloud and veils of dew into the awfulness of the eternal world;—a

heaven in which every cloud that passed was literally the chariot of an angel, and every ray of its Evening and Morning streamed from the throne of God.

The sacred sky over Pisa, with its rays streaming from the throne of God, veils a city more of myth than of fact. It recalls another city of flashing spires which the young knight Gareth sees rising from the morning mist as he approaches Camelot. One of Gareth's retinue remarks,

> Lord, there is no such city anywhere,
> But all a vision.

The Gothic Revival recreated a Middle Ages even more splendid than the historic fact, and contrasted it with an image of industrial England more hideous, if possible, than that which had actually arisen in the nineteenth century. Medieval Europe became a kind of second Eden, a Christianized Golden Age, a pastoral and holy paradise "where flies no sharp and sided hail / And a few lilies blow." One might suppose that man had not fallen from grace until the Renaissance, and that nature had remained uncorrupted until the Industrial Revolution. Flowers then seemed somehow brighter, skies clearer, men more loving, and buildings more beautiful than they had ever been before or since.

Ruskin's image of the medieval town has the jeweled quality of a Fra Angelico. His Venice is a city of shimmering color and sacred festivals in which artists work effortlessly in freedom and create under the stimulus of an unquestioned faith. One hears no chanting of the *Dies Irae* in his medieval churches. There is no filth, no plague, no famine. The skies are perpetually cloudless and no one anxiously crosses himself to ward off unseen spirits or the torments of hell. Ruskin failed to realize that the great cathedrals expressed not only the relative freedom of the Gothic artist and the fervor of his worship of God, but also the patronage of a Church which dominated her artisans as firmly as the great princes of Italy were to direct the arts of the Renaissance. In playing the "humility" of the Middle Ages against the competitive pride of the Renaissance he failed to acknowledge the worldly rivalries which raised the nave of

Amiens higher than that of Rheims, and Beauvais higher than both. Nor did he properly appreciate the curious mixture of naïveté and self-interest, faith and fear, which convinced the medieval builders that by erecting their glorious temples to the Virgin, they were also purchasing real estate in the City of God.

If Ruskin and other apologists of the Gothic Revival idealized the past, they were perpetuating an ideal whose origins reached back to the Middle Ages itself: the dream of a united Europe realizing under Christianity the harmonious flowering of all the sciences and arts. This is what Proust meant when he wrote of Ruskin,

L'unité de l'art chrétien au moyen âge, des bords de la Somme au rives de l'Arno, nul ne l'a sentie comme lui, et il a réalisé dans nos cœurs le rêve des grands papes du moyen âge: l' "Europe chrétienne."

ii

At once fascinated and repelled by the "papal dream," Ruskin sought to Protestantize the Middle Ages and thus refute Pugin's contention that the revival of Gothic required the restoration of England to the Catholic Church. I do not believe, as R. H. Wilenski has suggested, that Ruskin was in imminent danger of being "seduced" into the Church when he was writing *The Seven Lamps* and *The Stones of Venice*. Rather he was deeply disturbed to find himself so moved by the art and architecture of the Catholic Middle Ages, and the disturbance acted as an irritant inflaming his anti-Catholic prejudices. Possibly, too, the weakening of his Evangelical convictions called for the reassuring tonic of bigotry. Even after he shed his prejudices, and still later at Assisi when he worked in a Franciscan cell and dreamed that he had been made a tertiary of the Order of St. Francis, he remained too radically an individualist, too Protestantly insistent upon his own interpretation of God's word, ever to have become a Catholic.

St. Augustine wrote of those members of the Church of the Earthly City who are excluded from the City of God, and those outside the Earthly Communion who are members of the Heavenly one. Perhaps in time Ruskin became one of the latter, but he could never have been blessed in both congregations. Responding to an

inquiry whether he had become a communicant, he replied in one of his last letters:

I gladly take the bread, water, wine, or meat of the Lord's Supper with members of my own family or nation who obey Him, and should be equally sure it was His giving, if I were myself worthy to receive it, whether the intermediate mortal hand were the Pope's, the Queen's, or a hedge-side gipsy's.

This is not the stuff converts are made of; nor, possibly, even saints.

To appreciate the disturbing power High Mass at the great Continental cathedrals exercised over Ruskin's mind, we should recall the Evangelical chapel to which his parents took him as a child. Rigorously disciplined, deprived of the sources of pleasure and play which might have gratified his instinct for rich color and intricate texture, he regularly sat through the service at Beresford Chapel, Walworth Road. It was a

Londonian chapel in its perfect type . . . an oblong, flat-ceiled barn, lighted by windows with semi-circular heads, brick-arched, filled by small-paned glass held by iron bars, like fine threaded halves of cobwebs; galleries propped on iron pipes, up both sides; pews, well shut in, each of them, by partitions of plain deal, and neatly brass-latched deal doors, filling the barn floor, all but its two lateral straw-matted passages; pulpit . . . a stout, four-legged box of well-grained wainscot . . . decorated with a cushion of crimson velvet, padded six inches thick, with gold tassels at the corners; which was a great resource to me when I was tired of the sermon, because I liked watching the rich colour of the folds and creases which came in it when the clergyman thumped it.

Such chapels were dour not by accident but on principle. Any resemblance to the plan and fabric of a Catholic church smacked of the intervention of detested authority between the individual worshiper and his salvation. The attempt to revive Gothic was tantamount to reviving the foul superstitions of the Dark Ages. Popery appeared to lurk behind every pinnacle and to peep out from every niche. In rejecting the services of the Catholic Church, Protestantism had also to reject its structure, and the flat-ceilinged barns of London and the manufacturing towns represented the rational, functional solution to a form of worship which abolished the hierarchical raised choir, the exalted pulpit, and banished the whole iconogra-

phy which it equated with Romanism. Paradoxically, the quickening
of religious consciousness which accompanied the Romantic revival
contributed both to the High Church's readopting elements of Cath-
olic ritual and to the Dissenters' eradicating all traces of Catholic
worship. It would distort the truth, but not violently, to assert that
Ruskin wrote *The Seven Lamps* in order to justify to his Protestant
conscience his growing appreciation of Catholic architecture and
forms of worship.

One of the seven lamps or "spirits" of architecture—"The Lamp
of Sacrifice"—displays the dialogue of a mind ill at ease with itself.
On the one hand, by praising the "offering of precious things,
merely because they are precious, not because they are useful or
necessary," Ruskin expressed that love of rich color and highly
wrought decoration which first attracted him to Gothic. On the
other hand, he had to convince himself and his public that the advo-
cacy of such architecture was not a betrayal of Protestantism. The
very title of the chapter effectively begs the question: to object to
the spirit of sacrifice was to be chary of giving, and hence unchris-
tian. Ruskin is arguing, in effect, that if Beresford Chapel looked
less like a barn, it would be more Christian, not less Protestant. Yet
the argument was so novel to the Evangelical mind that he had to
support it with a battery of footnotes condemning the vulgarity and
exhibitionism of ornament in "the Papist's temple."

The point is not that Ruskin was in danger of forsaking his par-
ticular persuasion, but that he reacted to Catholicism with extreme
ambivalence, expressing intense admiration for Catholic art and
architecture, and intense scorn for Catholicism itself. He had felt no
conflict in 1845 when he was overwhelmed by the work of Fra
Angelico. For it was one thing to admire in a gallery a Catholic
artist who had been dead for four centuries; but it was another
matter altogether to be an awed and alien witness at a church serv-
ice he had been educated to despise.

Ruskin's dilemma becomes painfully apparent if we compare the
anti-Catholic notes in *The Seven Lamps* [4] with his diary of the same

[4] In the 1880 edition he deleted the notes as "pieces of rabid and utterly
false Protestantism" (VIII, 15).

period. He wrote after attending Mass at Rouen in 1848, "I felt convinced that freed from abuses, this *mode* of service was the right one, and that . . . all these burning lamps and smoking censers, all these united voices and solemn organ peals had their right and holy use in this their service." [5] A few months later Ruskin asserted in a note in *The Seven Lamps:*

The entire doctrine and system of that Church is in the fullest sense anti-Christian . . . its lying and idolatrous Power is the darkest plague that ever held commission to hurt the earth. . . . Exactly in proportion to the sternness of our separation from them, will be not only the spiritual but the temporal blessings granted by God to this country.

The Stones of Venice (1851–53) continues Ruskin's anxious conflict of attitudes between Catholic art and Catholic worship. In the Cathedral of Murano he was deeply moved by the Byzantine mosaic of the weeping Madonna, set in a field of gold, who extends her hands to the spectator in a gesture of blessing. Only a decade earlier he had described the Vierge Noire of Chartres as "a black doll."

But now in San Donato—"The whole edifice is . . . a temple to the Virgin: to her is ascribed the fact of Redemption, and to her its praise"—he must justify his admiration without implicating himself or the architecture he loves in Mariolatry. Thus he asks his reader not to reverence the worship of the Virgin as a redeemer, but to appreciate the desire for redemption and the sincerity of the worship itself.

The same ambivalence informs a famous passage in which Ruskin takes his reader to the Piazza San Marco, into the Duomo, down the nave, and through the dimly lit chapels. He responds intensely to the maze of intersecting lines and lights which lead deviously but inevitably to "the Cross that is first seen, and always, burning in the centre of the temple." Then, as if in self-admonition, and at the cost of destroying the massed splendor of the image he has created, he explains away San Marco's power of inspiring devotion. It is not the architecture or the mosaics which cast a spell of comfort on those

[5] Cf. an entry he made eight years earlier at Rome: "A great fuss about Pope officiating in the Sistine chapel: Advent Sunday. . . . No music worth hearing; a little mummery with Pope—an ugly brute—and dirty Cardinals" (*The Diaries of John Ruskin*, ed. Joan Evans and John Howard Whitehouse [Oxford, Clarendon Press, 1956–1959], I, 116. Hereafter cited as *Diaries*).

who enter, but a rich assemblage of influences which, "in all ages and countries, have been more or less employed in the support of superstition." Darkness and the mystery of confined recesses, the judicious use of artificial light which seems to yield a kind of sanctity, precious materials and incense—all these "stage properties of superstition" abound in San Marco more than in any other church in Europe. Thirty years later Ruskin reread this passage and wrote, "I am struck, almost into silence, by wonder at my own pert little Protestant mind."

His mind was nowhere more pertly Protestant than in an appendix to *The Stones of Venice* entitled "Romanist Modern Art," a bitter, brilliant, and contemptible attack on Pugin as "one of the smallest possible or conceivable architects." Its very violence betrays not only jealousy of Pugin but also fear that Ruskin himself might be swayed toward Catholicism by "painted glass and coloured tiles." No fatuity, he writes, is baser than

being lured into the Romanist Church by the glitter of it, like larks into a trap by broken glass; to be blown into a change of religion by the whine of an organ-pipe; stitched into a new creed by gold threads on priests' petticoats; jangled into a change of conscience by the chimes of a belfry. I know nothing in the shape of error so dark as this, no imbecility so absolute, no treachery so contemptible.

Apart from Ruskin's private motives for attacking Pugin in his notes and ignoring him in his text, he had also to remove from Gothic the sectarian taint it bore in the public mind. The best ecclesiastical architecture in England was the property of either the Anglo-Catholic or the Roman Catholic Church. Indeed, the identification of Gothic with Catholicism was so strong that when Palmerston succeeded in having a Renaissance design replace Gothic for India House, the *Daily Telegraph* congratulated the nation for appreciating "the difference between a Foreign Office and a Roman shrine." [6]

To combat this equation of a style with a particular church,

[6] The *Telegraph* might have been more chary of its praise if it had known that with a few strokes of his pen Sir Gilbert Scott, architect of the rejected design, transformed the projected Gothic Foreign Office into St. Pancras Railway Station. See Osbert Lancaster, *Pillar to Post* (London, John Murray, 1938), p. 40.

Ruskin argued that neither in its origin nor in its revival should Gothic be thought peculiarly ecclesiastical. When the great cathedrals were built, the pointed arch appeared in the shop door as well as the cloister; the buttress expressed no special sacredness, the pinnacle no special sect. If Gothic were revived for churches alone because it was believed uniquely holy, then the Revival would succeed only in separating the national life from the national religion. "You can't have bits of it here, bits there—you must have it everywhere or nowhere. It is not the monopoly of a clerical company—it is not the exponent of a theological dogma." However strange it seems to us, Ruskin believed that the cardinal virtue of Gothic was its adaptability to all purposes. A Renaissance cottage would be an absurdity. Gothic was "the *only rational* architecture," for with its undefined "slope of roof, height of shaft, breadth of arch, or disposition of ground plan," it could "shrink into a turret, expand into a hall, coil into a staircase, or spring into a spire, with undegraded grace and unexhausted energy." An advocate of the Revival, Ruskin was paradoxically one of the earliest, and remains one of the most articulate, advocates of functionalism. By the *only rational* architecture he meant the only functional architecture, the one that most easily and honestly expresses the widest variety of forms.

Even if Gothic had once adorned the shop front as well as the cloister, there remained the awkward fact that the medieval Church and medieval architecture had followed a parallel development and decline. Ruskin overcame this embarrassment by contending that Gothic expressed permanent, universal impulses of mankind independent of the historic Church. The six characteristics which he analyzed in "The Nature of Gothic" correspond, in a Ruskinian way, to *human* nature. Indeed, most of them—love of nature, love of change, disturbed imagination, generosity—were as characteristic of Ruskin as of the architecture he described. His own love of nature led him to exaggerate the naturalism of Gothic. Thus he praised the "energy and naturalism," by which he meant the incipient Protestantism, of certain medieval leaf designs. Yet the designs retain a certain pontifical rigidity, for the leaves are "accurately numbered, and sternly set in their places; they are leaves in office, and dare not

stir nor wave." Into this half-realized naturalism Ruskin read an allegory of "the Christian element struggling with the Formalism of the Papacy. . . . The good in it, the life of it, the veracity and liberty of it, such as it has, are Protestantism in its heart; the rigidity and saplessness are the Romanism of it."

Although Ruskin succeeded in Protestantizing and nationalizing the principles of the Revival, he was too clear-sighted not to perceive its ultimate failure, and too honest not to recognize his own. In "The Mystery of Life and Its Arts," a lecture delivered in 1868, he spoke of Gothic as incompatible with the deforming mechanism and misery of the modern city:

Sometimes behind an engine furnace, or a railroad bank, you may detect the pathetic discord of its momentary grace, and, with toil, decipher its floral carvings choked with soot. I felt answerable to the schools I loved, only for their injury. I perceived that this new portion of my strength had also been spent in vain.

Four years later he acknowledged his indirect influence on "nearly every cheap villa-builder" in London, and deplored the fact that the public houses sold their gin and bitters under pseudo-Venetian capitals. Finally, in the 1874 edition of *The Stones of Venice* he wrote that he would have preferred

that no architects had ever condescended to adopt one of the views suggested in this book, than that any should have made the partial use of it which has mottled our manufactory chimneys with black and red brick [then known as the Streaky Bacon Style], dignified our banks and drapers' shops with Venetian tracery, and pinched our parish churches into dark and slippery arrangements for the advertisement of cheap coloured glass and pantiles.

The result was inevitable. The wonder is not that it occurred, but that Pugin and Ruskin so long believed it could be avoided. Even if Pugin had succeeded in uniting Anglicanism with Roman Catholicism, he would have found it impossible to restore the "ancient feelings and sentiments" which had decayed alongside the plundered abbeys he loved. The England of Cardinals Wiseman and Manning was irretrievably remote from that of Thomas à Becket and Carlyle's hero, Abbot Samson. Ruskin's hope that the London

of the nineteenth century "may yet become as Venice without her despotism, and as Florence without her dispeace" was equally chimerical. Both men failed to see, because they despised it so intensely, that industrialism was evolving forms and techniques of building which made Revival Gothic an anachronism even before the movement was well under way. Ruskin tried to resurrect and universalize a style which, more than any other, had expressed the values and solved the structural problems of a particular age. When he saw the mockery of his efforts materializing about him, he abandoned the attempt to revive Gothic architecture and founded, at a great expense of energy and capital, a Gothic society in miniature. The St. George's Guild was an agrarian community of believers pledged to love nature and each other as intensely as they despised coal, steam, and commercialism.

The enduring part of Ruskin's work with the Gothic Revival is not some unsuccessful buildings scattered here and there in England and America. Rather it is the humane social and economic philosophy which "The Nature of Gothic" inspired toward the close of the century. Yet Ruskin's influence on architecture is still strongly, if indirectly, felt. More than anyone else in the nineteenth century, he convinced the profession and the public alike that architecture was not an isolated science of compass and rule, but a vital index of esthetic and moral values. His insistence that a building must be "honest" if it is to be beautiful, functional and expressive of its materials and locale if it is to merit admiration, is echoed less eloquently today. Those who associate his name with wedding-cake Gothic have never read his work. Indeed, he is to be condemned not for admiring monstrosities but for desiring impossibilities: a revolution in social and economic values which would have made it possible to build permanently, feelingly, and beautifully, instead of throwing up pre-built slums for quick profit and resale. More than a century ago he had this to say of suburbia:

I look upon those pitiful concretions of lime and clay which spring up, in mildewed forwardness, out of the kneaded fields about our capital— upon those thin, tottering, foundationless shells of splintered wood and imitated stone—upon those gloomy rows of formalized minuteness, alike

without difference and without fellowship, as solitary as similar—not merely with the careless disgust of an offended eye, not merely with sorrow for a desecrated landscape, but with a painful foreboding that the roots of our national greatness must be deeply cankered when they are thus loosely struck in their native ground.

The indictment is potent because it refuses to rest on esthetic grounds alone. Precisely as Ruskin had hoped to make the study of art "an instrument of gigantic moral power," so he tried to make architecture a means of humanizing the nation's values. Frank Lloyd Wright's projected Broadacre City is no less ambitious in intention or sublimely impracticable.

When Ruskin was eighteen he asserted in *The Poetry of Architecture* that no one can be an architect who is not a metaphysician. He meant that no architect can be without a hierarchy of values, and I suppose no good one ever has been, regardless of other gifts. Yet even if architects need not be metaphysicians, the great ones, like Wright, are moralists, and it is as a superbly articulate moralist who could not divorce the science of building from the art of living that Ruskin compels attention.

IV. WINDOWS OF AGATE

"There is no law, no principle, based on past practice," Ruskin wrote in *The Seven Lamps*, "which may not be overthrown in a moment, by the arising of a new condition, or the invention of a new material. . . .The time is probably near when a new system of architectural laws will be developed, adapted entirely to metallic construction." That time was at hand only two years after the publication of *The Seven Lamps* in 1849, when Queen Victoria and Prince Albert received the ovations of the crowd which had gathered for the opening of the Crystal Palace, Joseph Paxton's gigantic greenhouse of cast-iron ribs and plate glass. The huge, triple-tiered structure enclosed a ground area four times greater than that of St. Peter's. Yet Paxton, for the first time employing the techniques of prefabrication on a grand scale, erected the palace in less than six months.

Ruskin despised it. He was as much at odds with his contemporaries as he is with modern architectural opinion, which shares the Victorians' awed admiration for the boldness and ingenuity of Paxton's achievement. The authoritative study of the architecture of the period devotes a forty-page chapter to the Crystal Palace entitled "Ferrovitreous Triumph." Ruskin deplored the triumph because he foresaw in the techniques and materials of the Palace the dehumanized monotony of much of contemporary urban architecture: "You shall draw out your plates of glass," he predicted, "and beat out your bars of iron till you have encompassed us all . . . with endless perspective of black skeleton and blinding square." The blank glitter of the lifeless slab flashed on Ruskin's mind almost a century before it was to rise in reduplicated regularity.

What Ruskin refused to see was as remarkable as what he had prophesied. Despite the merits of the Crystal Palace, he could not respond to it *as architecture*. He regarded it as an enormous gadget, as admirable for its mechanical ingenuity as a screw frigate or a tubular bridge; but mechanical ingenuity, he insisted, has nothing to do with art. An early advocate of the doctrine that materials should determine form, Ruskin nevertheless denied the use of the very materials which functionally shaped the Crystal Palace [1] and later determined the characteristic forms of the finest contemporary buildings—not the black skeletons or, worse, the embossed aluminum boxes, but the truly original structures which have made of architecture the most vital of modern arts.

Ruskin's hostility to the new building techniques and materials was in part hostility to industrialism itself. Railroads, steamships, or exhibition halls displaying boilers and lathes not only appeared ugly in themselves, but symbolized the mechanization which threatened to substitute in the daily life of the worker the pulsing of the machine for the rhythm of nature. The very irregularities of the Gothic façade, with its materials quarried from the earth rather than forged in the furnace, its ornament carved by hand rather than stamped by machine, represented for Ruskin the only natural and humane form of building. By failing to recognize that the black skeletons might become free-floating forms, he cut himself off from the fertile movement which evolved an esthetic based upon structural steel, plate glass, and reinforced concrete. Yet much of what he had to say of the architecture of stone is true of the architecture of steel; and we merely surpass Ruskin's own perversity if we refuse to see that the virtues he praised in certain buildings are, by and large, those to be desired in all.

His acute discomfort over Victorian architectural innovations was also the product of overfamiliarity with the building of the past. He had studied the architecture of stone and wood too closely, had gauged its capacities too accurately, not to feel a kind of ma-

[1] See VIII, 68, where Ruskin asserts that "metals may be used as a *cement*, but not as a *support*," and IX, 455–56, where he disallows the extensive use of glass or iron in "noble architecture."

laise before structures which could rise several stories on slender cast-iron columns and freely vault distances unspannable by pure masonry. One of the pleasures of architecture arises from its defiance of gravity with the maximum of daring and ingenuity commensurate with stability. A building which to the eye appears over-supported is ponderous, however impressive its monumentality. (Imagine the columns of the Parthenon without their fluting, which seems to lighten supports capable of bearing many times their required load.) An apparently undersupported building is unrelievedly painful. Had Gothic sprung up overnight, the medieval burgher might have reacted to the first pointed arch with the same unease that Ruskin felt when standing in front of a new building in Oxford Street. The huge stone pillars of the second story were apparently carried by the edges of plate glass in the first:

I hardly know anything to match the painfulness of this and some other of our shop structures, in which the iron-work is concealed; nor even when it is apparent, can the eye ever feel satisfied of their security, when built, as at present, with fifty or sixty feet of wall above a rod of iron not the width of this page.

If the Victorians were hesitant to use the new materials in any but the most utilitarian structures, they were, after all, on the threshold of the most radical architectural innovation in the seven hundred years since the Gothic builders pointed the Romanesque arch and opened their walls to large expanses of glass. The early architects in iron were uncertain rather than consciously deceitful when they hung false façades on the concealed supports of their buildings. Like the public, they had to readjust their traditional assumptions concerning the strength of wood, stone, and mortar in order to gauge the actual capacities of the new materials.

The very freedoms afforded by these materials convinced Ruskin that they would yield unnatural or ugly forms. He believed that a building should harmonize with the contours of its environment. But the strength and malleability of metals would enable the architect to deny his dependence upon nature by concealing the relationship between the structural problems he encountered and the forms he created to solve them. Thus Ruskin preferred the grace of a stone bridge, which rises to its highest point where it spans the

depths of a river and then slopes in diminishing arches across the shallows, to the unvaried symmetry of an iron bridge. The older form sympathizes with "the spirit of the river" and marks "the nature of the thing it has to deal with and conquer." But the tubular bridge, with its level roadway and monotonous arches, reflects the "pontifical rigidities of the engineering mind." The one expresses the vulgar unity of inflexible law; the other, the greater unity of cloud, wave, and tree.

Ultimately Ruskin rejected the new architecture because he saw, in R. H. Wilenski's words, that it "would have no organic need of sculpture, and in his view this meant that such architecture could never be an art." Prefabrication of the new materials eliminated the creative labor of the mason and sculptor, and hence, for Ruskin, deprived a structure of all intelligence or interest. When he looked at a building, his eye was not caught by proportion, line, or mass, for these were too abstract to gratify his visual demand for color and richly ornamented detail. It was surface, not structure, to which he instinctively turned. An edifice whose excellence consisted solely in its proportioning of masses was nothing more than "architectural doggerel"; the architect had achieved no more than the poet who had mastered only his grammar. Ruskin's admiration "attached itself *wholly* to the meaning of the sculpture and colour on the building. . . . The sculpture and painting were, in fact, the all in all." An architect who was not also a sculptor and painter was only "a framemaker on a large scale."

This arbitrary dichotomy between construction and ornament, architect-sculptor and mere builder, runs throughout Ruskin's writings on architecture. The first volume of *The Stones of Venice* is devoted to the structural principles of Gothic; yet Ruskin scarcely mentions vaulting and concentrates on those features which lend themselves to sculptural detail, such as capitals. When he helped design the Oxford Museum of Natural History, one of the chief buildings of the Gothic Revival, he was more concerned with the color of the stone and with the statuary in the niches than with the function or form of the building itself. For ornamentation was, in Ruskin's eyes, "the divine part of the work," which was called into play only after the structure had been designed and "the forms

of its dead walls and dead roofs" determined. To animate those walls was the true function of the architect. "Only Deity, that is to say, those who are taught by Deity, can do that."

The architect-deity was to recreate on his façades, as the artist-deity of *Modern Painters* had recreated on his canvases, the infinite variety and shadings of natural forms. His ornament should express "man's delight in God's work" and its success depended on "the sculpture or painting of Organic Form." Since modern buildings inevitably lacked these forms, Ruskin found them leaden and joyless. So too he believed that their builders had labored in a kind of sullen slavery, in contrast to the Gothic artisan who carved his own faith, creativity, and love of nature throughout his bible in stone.

The restless, wayward energies of Ruskin's mind found points of interest and repose on the thickly encrusted surfaces of Gothic, but were repelled by the relative chastity of a Renaissance facade or the monotony of a Crystal Palace. He endlessly speculated on the "ideas" of medieval sculpture precisely as he had speculated on the "ideas" contained in paintings. And as he overstressed representation at the expense of form in art—"the greatest picture is that which conveys to the mind of the spectator the greatest number of the greatest ideas"—so he overvalued the sculptural at the expense of the structural in architecture.[2]

It is impossible to exaggerate the extent to which brilliant areas

[2] The point needs qualification. Although Ruskin often writes of painting as if it were merely a vehicle for the communication of ideas, he also insists that the first business of a painter is to know how to paint, and that he must not copy the literal fact before him but faithfully render his imaginative vision of the fact. Similarly, no matter how often he insists upon the fidelity of sculpture to natural forms, he is aware that the representation in stone ought not, and cannot, be a literal duplication of the object in nature. The point is best made by Ruskin himself. The true artist "does not carve the form of a thing, but cuts the effect of its form (XIX, 251). . . . The first office of . . . sculpture is not to represent the things it imitates, but to gather out of them those arrangements of form which shall be pleasing to the eye in their intended places (VIII, 171). . . . [Noble abstraction consists in] using any expedient to impress what we want upon the mind, without caring about the mere literal accuracy of such expedient (IX, 288). . . . Sculpture is essentially the production of a pleasant bossiness or roundness of surface. . . . The pleasantness of that bossy condition to the eye is irrespective of imitation on one side, and of structure on the other (XX, 214)."

of light and color attracted Ruskin to an architecture of deeply incised stone, stained glass, lustrous marble, and mosaic.[3] He believed that the Gothic architect-sculptor thought in terms of light and shade, shadow itself serving him as a dark color through whose means he achieved rest, force, and solidity. The modern architect must not conceive his design "in its miserable liny skeleton," but as it will be "when the dawn lights it, and the dusk leaves it; when its stones will be hot, and its crannies cool; when the lizard will bask on the one, and the birds build in the other." His paper lines and proportions are valueless, for he must work "by spaces of light and darkness; and his business is to see that the one is broad and bold enough not to be swallowed up by twilight, and the other deep enough not to be dried up like a shallow pool by a noon-day sun." Ruskin's drawings render this architectural chiaroscuro exquisitely. They show an almost obsessive fascination with the highlightings of dark clusters of ornament against luminous backgrounds, with the spilling of light on inlaid disks of marble or its penetration into the recesses of porch and niche.

Ruskin's hostility to Renaissance and nineteenth-century architecture stemmed in part from their lack of this extravagant play of light, color, and shadow. The only church of the Gothic Revival that he unequivocally praised—All Saints, in London—made lurid use of alternating bands of colored brick, and the interior was crowded with patterned marbles, frescoes, and glazed tiles. It was, above all, the "perfect and unchangeable colouring" that Ruskin admired in San Marco. But the Renaissance was a winter which "was colourless as it was cold; and although the Venetian painters struggled long against its influence, the numbness of the architec-

[3] Cf. this passage from a deleted portion of *Praeterita*, in which Ruskin describes his excitement on reaching Abbeville in time to see the sunlight still striking the towers of St. Wulfran: "One part of the pleasure, however, depended on an idiosyncrasy which extremely wise people do not share,—my love of all sorts of filigree and embroidery, from hoarfrost to the high clouds. The intricacies of virgin silver, of arborescent gold, the weaving of birds'-nests, the netting of lace, the basket capitals of Byzantium, and most of all the tabernacle work of the French flamboyant school, possessed from the first, and possess still, a charm for me of which the force was entirely unbroken for ten years" (XXXV, 157 n. 3).

ture prevailed over them at last." Tintoretto and the pre-Renaissance architecture of Italy gratified Ruskin's instinct for color, just as the starker, ruggedly angular Gothic of the North satisfied his desire for the massing of brilliant lights against darkened backgrounds. In the middle of the nineteenth century, he wanted improbable cities to arise, like the one Isaiah promised as a comfort to afflicted Jerusalem: "Behold, I will lay thy stones with fair colours, and lay thy foundations with sapphires. And I will make thy windows of agates, and thy gates of carbuncles, and all thy borders of pleasant stones."

The distinction Ruskin drew between the mere builder of dead walls and the architect who animates them with color and ornament was of course a fallacy. But it was shared by his contemporaries and explains why most of the important architectural innovations of the nineteenth century were not the work of architects at all. It accounts, too, for the confusion of esthetic aims which led the Victorians to erect a structure of revolutionary simplicity and then clutter the interior of their hall of glass with hideous bric-a-brac and boilers decorated in Gothic motifs. The incongruity between the building and its contents is the most revealing symbol of the age.

The Crystal Palace was designed by a gardener who had built ingenious greenhouses, had worked with cast iron and glass, but had received no formal architectural training. Indeed, had Paxton been trained academically, had he been anything but a "mere builder" possessing genius, he might have had an utterly unmemorable career fabricating designs in Revival Gothic or pseudo-Renaissance. As it was, he and other gifted engineers who were also experimenting with the new techniques and materials designed the exhibition halls, railway terminals, bridges, factories, and warehouses which, because they were wholly utilitarian and thus devoid of traditional associations, were accepted by the public. As Sigfried Giedion has put it, "construction played the part of architecture's subconsciousness, [and] contained things which it prophesied and half revealed long before they could become realities."

Where homes, churches, or civic buildings were concerned, the

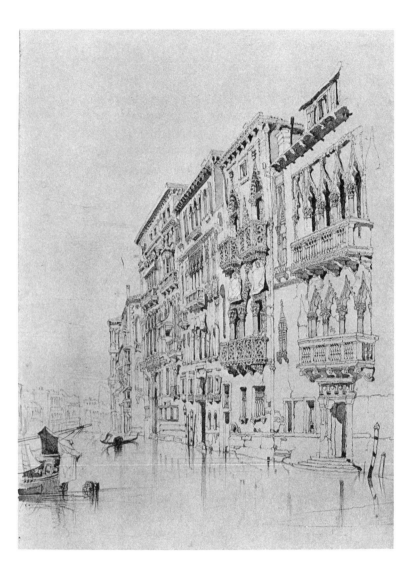

VENICE: CASA CONTARINI-FASAN, 1841

Victorians demanded architects, men of traditional education and feeling, rather than engineers. The schism between the two was typical of the increasing specialization of talent in the nineteenth century. The medieval architect not only had been the technical master of the materials he handled, but had expressed the values and aspirations of his culture. So too, Christopher Wren not only had been trained in the Five Orders of the Academy, but also was a master builder who prided himself on his genius as an engineer. But in the nineteenth century, when thought and feeling, technical skill and esthetic merit, were so often at cross purposes, the engineers erected graceless but innovative structures, while the architects proliferated designs which, despite Pugin's and Ruskin's misguided hopes, had lost contact with the age and were hence devoid of vitality.

ii

If Ruskin had merely deepened the appreciation of Gothic and prolonged the mistaken attempt to revive it, our discussion might end here. But he influenced a disciple who has shaped contemporary architecture according to the cardinal principle on which Ruskin based his esthetics: the dependence of all vital and beautiful design on Organic Form. Ruskin is Frank Lloyd Wright's link [4] to the Romantic tradition; Wright has made Ruskin important to an understanding of the architecture of today.

Defining precisely what Ruskin meant by "Organic Form" is as difficult as defining what Wright means by "Organic Architecture." They are not so much terms as whole philosophies, attitudes toward existence itself, symbols of an inner sense that the life and forms of nature ought to suggest the life and forms of art, indeed shape the structure of society itself. For both men, nature—the nature wor-

[4] When still a boy, Wright was given a copy of *The Seven Lamps of Architecture*, apparently the only book on architecture which he read before his formal training began (see Grant C. Manson, *Frank Lloyd Wright to 1910: The First Golden Age* [New York, Reinhold Publishing Corp., 1958], p. 11). In addition to *The Seven Lamps*, Wright mentions among the books he read during his formative years *The Stones of Venice, Modern Painters,* and *Fors Clavigera* (*An Autobiography* [New York, Duell, Sloan & Pearce, 1943], pp. 33, 53).

shiped by the Romantic poets—is the great tutor and the source of all vital inspiration. Ruskin advises the young architect to concentrate upon the study of "natural form," to learn to abstract the essential lines of structure from "organic actions and masses." The student will learn more valuable lessons "in the school of nature than in that of Vitruvius." For Wright, the basis of "an architectural education [is] a knowledge derived from nature," which for centuries has been the source-book of architectural motifs. "Her wealth of suggestion is inexhaustible. . . . She has beneath her more obvious forms a practical school in which a sense of proportion may be cultivated, when Vignola and Vitruvius fail as they must always fail." Ruskin's conviction that "all beautiful lines are adaptations of those which are commonest in the external creation" finds its echo in Wright's assertion that "true FORM is always organic in character. It is really nature-pattern."

Much of Wright's actual work in architecture, as well as his architectural theory, is an attempt to realize this peculiarly Ruskinian sense of nature. The practical result is an architecture which delights in revealing its materials, expressing the contours and character of its environment, and capturing in its shapes and rhythms the essential lines of natural growth, the "secrets of form related to purpose that would make of the tree a building and of the building a tree." The theoretical result is an esthetic which, like Ruskin's, profoundly abhors the geometric regularities of the Renaissance and feels a sympathy for the naturalism of Gothic surpassed only by an antipathy to the machine. Wright's invective against the soullessness of the slab stems from the same impulse which led Ruskin to condemn the Crystal Palace and to foresee in its unrelieved symmetries an endless perspective of black skeletons and blinding squares. But although Ruskin could conceive of no alternative to Organic Form other than Gothic, Wright, by exploiting rather than rejecting the techniques of industrialism, has shaped the new materials to express the very lines Ruskin had believed to exist only in nature and in the architecture of the Middle Ages.

Wright, like Ruskin, defines architecture not as mere building but as "life itself taking form" in harmony with man and his en-

vironment. The vital sinuosities of a tree, a flower, or a shell suggest the ways in which "form follows function." Ruskin had responded to the same principle in nature when, in *Modern Painters*, he defined Vital Beauty as the perfect adaptation of a creature to its life and purpose, its "felicitous fulfilment of function." In tracing the history of medieval architecture, he applauded the moment when the Romanesque arch rose to a point and then curved to accommodate the cusp, for the new shape not only sustained the load of the arch more efficiently but also suggested the curve of a leaf. Both Ruskin and Wright condemn Renaissance architecture on moral grounds—"a form of grando-mania," Wright calls it, "singularly bastardised . . . be-corniced and be-pilastered." But their fundamental grievance is that the Renaissance cut itself off from nature, and hence in Ruskin's words raised "an ambitious barrenness of architecture, as inanimate as it was gigantic."

Such architecture, Ruskin believed, had lost all contact with the vitality and naturalism of Organic Form. Its flaccid capitals lack the spring and elasticity of natural curves:

It is as if the soul of man, itself severed from the root of its health . . . lost the perception of life in the things around it; and could no more distinguish the wave of the strong branches, full of muscular strength and sanguine circulation, from the lax bending of a broken chord, nor the sinuousness of the edge of the leaf, crushed into deep folds by the expansion of its living growth, from the wrinkled contraction of its decay.

Even the grotesque sculpture of the Renaissance portrays only a factitious terror, for it is not a terror taken from life. The dragons on the tomb of the Doge Andrea Vendramin are covered with marvelous scales, yet they lack horror or sting. So too the birds are perfectly plumed, "but have no song in them; its children lovely of limb, but have no childishness in them."

Ruskin's and Wright's belief that the Renaissance divorced itself from nature, and thus produced sterile or monstrous forms, involves us in an awkward issue—the nature of nature. To the Renaissance architect, nature appeared to be less a process of growth than a fixed condition of being, a great cosmological chain precisely

proportioned in all its parts. Through an analogous system of pro-
portions, the architect strove to create a microcosm in marble which
mirrored the mathematical structure of the cosmos. Exact sym-
metry of design was thought to be as necessary to the beauty of a
building as consonant intervals were to the harmony of music. A
contemporary of Alberti or Palladio felt the same exalted contact
with nature and supernature before a Renaissance façade that Rus-
kin felt before a Gothic one, or that an admirer of Organic Archi-
tecture feels before a house of Wright's. The lasting innovations in
architecture are products not of variations in style but of revolu-
tions in cosmology.

Palladio carried these first principles of Renaissance architecture
to their logical extreme. His ground plans resemble exercises in
plane geometry; indeed, the page schematically illustrating his villas
in Rudolf Wittkower's study of the period is scarcely distinguish-
able from a monochrome reproduction of a painting by Mondrian.
His villas, like his palaces, are laid out along a central axis, with
exactly symmetrical rooms branching out from both sides. A single
mathematical ratio governs every proportion, exterior and interior,
of the typical Palladian building. The exactitude of such ratios bore
witness, as it were, to the objective correspondence between the
structure of the building and the mathematical nature of reality.
But when in the eighteenth century skepticism questioned the exist-
ence of objective reality and in the nineteenth century Romanticism
recreated nature as an organism rather than as a mathematical for-
mula, the cosmic rationale for Renaissance proportions was de-
stroyed. Hume denied that beauty depends upon "geometrical truth
and exactness," because beauty was a wholly subjective experience,
just as Ruskin later condemned the Five Orders of Renaissance ar-
chitecture as inane "recipes for sublimity," because the sublimity of
nature lay not in her symmetry but in the infinite variety of her
freedom. Wright, who is more cryptic than Ruskin, says the same
thing: "the pattern of reality is supergeometric." Both counsel the
young architect to study nature, not Vitruvius and Palladio. Neither
quite realized that she presents a different face to each of her stu-
dents, or that the crystal is no less natural than the leaf.

Graham Hough has suggested that Ruskin's prejudice against geometric form was so strong that, if God were a mathematician, Ruskin could accept Him only if He erred a little in all His calculations.[5] But the Deity appeared to Ruskin not as an erring mathematician but as an artist of impenetrable subtlety whose variations on a given theme could not be reduced to formulas or "orders." Thus he argues that proportions are as infinite "as possible airs in music," and that one might as reasonably master them by imitating the works of the past as learn to compose melodiously by calculating the mathematical relationship of the notes in Mozart's *Requiem*. Architecture no more consists in the art of proportion than does any other art. For "*all* art, and all nature, depend on the 'disposition of masses' . . . whether of colours, stones, notes, or words. Proportion is a principle, not of architecture, but of existence." So too Wright believes that the sense of proportion is a "gift from nature," the one subject that the young architect cannot be taught.

Organic Form or Nature-Pattern—Ruskin's and Wright's terms are often interchangeable—is thus a kind of occult symmetry, an irregular regularity whose rhythm is not that of fixed ratios but of arching branches. It is a sympathy with observed life; a half esthetic, half mystical joy in the vitality, abundance, and variety of natural forms; an emotion and an idea which seems to have passed, in part at least, from the pages of Ruskin to those of Wright:

Man cannot be taken, still less can he take himself, away from his birthright, the ground and remain sane. . . . His spirit is conditioned com-

[5] Cf. Ruskin's assertion that "in modern imitations of Gothic work the artists think it religious to be wrong, and that Heaven will be propitious only to saints whose stoles or petticoats stand or fall into incredible angles" (XXII, 219). Of course, Ruskin can always be quoted on two sides of any question, and Hough persuasively accuses him of failing to see that "geometrical form can also express the forms of nature, perhaps in a more fundamental way than 'naturalism'" (*The Last Romantics* [London, Gerald Duckworth & Co., 1949], p. 37). One thinks of the Romanesque leaf capitals which Ruskin admired for their naturalness, and Buckminster Fuller's "geodesic domes," which are based upon the interlocking lattice patterns found in the structure of atoms and molecules. The Romanesque leaf design was the more natural form in an age which perceived nature macroscopically; Fuller's tetrahedral surfaces are forms more natural to an age which apprehends reality mathematically on a sub-molecular scale.

pletely upon normal relationship of his life to what we call the life of nature. . . . We may deduce laws of procedure inherent in all natural growths, to use as basic principle for good building. We are ourselves a product of such natural law. . . . True architecture . . . is poetry. A good building is the greatest of poems when it is organic architecture. . . . Every great architect is—necessarily—a great poet. He must be a great original interpreter of his Time, his Day, his Age.

By imperceptible degrees the creed of nature ceases, in the hands of Ruskin and Wright, to be the doctrine of an esthetician and becomes the weapon of a moralist. The presumed departure of the Renaissance from nature produced, in Wright's words, not simply ugly but morally debased buildings, "mere mask[s] upon a meretricious life . . . lack[ing] integrity in every sense." The concealed chains required to gird Michelangelo's dome of St. Peter's are for them the symbol of the deceits upon which an architecture of unnatural artifice and ostentation must depend. As Ruskin put it, a clearly false assertion concerning a mode of support or the nature of a material is a "moral delinquency." Both men are offended by the quality of mind which detached columns from the load they apparently bore and which erected ornate façades towering over the churches they masked.

Yet in the radical sense used by Ruskin and Wright, no architecture is wholly "natural." The iron bands which brace the great tower of Salisbury Cathedral are suspiciously like Michelangelo's chains; the Parthenon deceives us in innumerable ways; the marble facing of San Marco, despite its apparent transparency and fragility, conceals a filling of the coarsest materials. However much the bridge ought to express "the spirit of the river," the tree a building, and the building a tree, in a sense all architecture deceives us, and we welcome the deception. The repose of the Parthenon, the vaulting aspiration of Gothic, the magnificence of Renaissance, even the "naturalness" of a Wright house depend upon an ingenious contrivance of line, mass, and material which, by emphasizing one element at the expense of another, creates an effect as much contingent upon concealment as upon revelation. The only architecture which is wholly natural is the cave.

The doctrine of fidelity to nature led Ruskin to his finest per-

ceptions, but at times it blinded him, particularly in his analysis of Gothic. When he defined one element of Gothic as "the love of natural objects for their own sake, and the effort to represent them frankly, unconstrained by artistical laws," he was at best on dubious ground. He never recognized the degree of *intended* stylization in early Gothic sculpture, the rigid yet exquisitely graceful chastity of line which, for example, elongates every curve and disciplines every movement of the kings and queens on the west front of Chartres. He wanted them to unbend a bit, to "advance" to a freer naturalism, not realizing that they had already achieved a poised and perfect sophistication.

Yet to the same principle—truth to nature and its corollary, the frank expression of materials—we owe Ruskin's brilliant analysis of the degeneration of Gothic into flamboyance. He singles out the evolution of tracery as the sign of the fatal extinction of the "Lamp of Truth." In the early Gothic windows, the architect stressed the forms of the penetrations, "the lights as seen from the interior," rather than the intermediate stone. All the grace of the window lay in the outline of its light, treated at first "in far off and separate stars, and then gradually enlarging, approaching," until they filled the whole space with their effulgence. In this "pause of the star," when both space and dividing stone were equally stressed, we see

the great, pure, and perfect form of French Gothic; . . . the rudeness of the intermediate space had been finally conquered . . . the light had expanded to its fullest, and yet had not lost its radiant unity, principality, and visible first causing of the whole.

The pause of the star lasted scarcely fifty years. The fatal imbalance was marked by "the substitution of the *line* for the *mass*, as the element of decoration." Once the intervening stone had been reduced to the minimum possible thinness, the arrangement of the lines themselves, "like some form in a picture, unseen and accidentally developed, struck suddenly, inevitably," on the architect's sight. Until that moment, the stonework was treated as a stiff, unyielding substance. But then, at the end of the period of pause,

the first sign of serious change was like a low breeze, passing through the emaciated tracery, and making it tremble. It began to undulate like the threads of a cobweb lifted by the wind. It lost its essence as a struc-

ture of stone. Reduced to the slenderness of threads, it began to be considered as possessing also their flexibility. The architect was pleased with this his new fancy, and set himself to carry it out; and in a little time, the bars of tracery were caused to appear to the eye as if they had been woven together like a net. This was a change which sacrificed a great principle of truth; it sacrificed the expression of the qualities of the material; and, however delightful its results in their first developments, it was ultimately ruinous.

The architect, by denying the fragility and weight of the stone, disproved "the first conditions of his working, and the first attributes of his materials." Tracery then became not only ductile but penetrable, so that when two moldings met, one appeared to pass independently through the other. This final stage of falsity annihilated the structural integrity and beauty of Gothic. From the habits engendered by these abuses stemmed shrunken pillars, flattened arches, lifeless ornament, and distorted, extravagant foliation, "until the time came when, over these wrecks and remnants, deprived of all unity and principle, rose the foul torrent of the Renaissance."

To an age allergic to value judgments, Ruskin appears in all such passages inordinately prone to confuse esthetics and morality. Yet the very catholicity of this point of view is its strength. It enriches the thought of both Ruskin and Wright with the resonance of life and, in comparison, reduces the writings of the specialist to the boredom of a monotone. We cannot achieve an organic architecture, Wright told an audience on the eve of the Second World War, unless we achieve an organic society. Three quarters of a century earlier Ruskin prophetically observed that no architecture would be possible in cities whose streets are "but the drains for the discharge of a tormented mob" and whose inhabitants are merely atoms "in a drift of human dust . . . [circulating] by tunnels underground."

V. VENICE: STONES AND TOUCHSTONES

The perceptive visitor is either repelled by Venice or willingly submits to her, and luxuriates in his submission. Indifference is impossible in a city which assaults the senses so violently and which concentrates, within its few square miles of salt flat and stone, sizable fragments of the religious and esthetic history of Europe. Offended or seduced, one is nonetheless tantalized by the energies of avarice and art, rapacity and faith, which filled Venice's churches with loot from the Crusades and which enabled a race of hard bargainers to create a city of exquisite fantasy and grace.

Mary McCarthy, the most brilliant modern chronicler of Venice, is impatient with Ruskin's tirades against the impious luxuries of the city in its decline and characterizes him as an "overdue Jeremiah." Yet if Ruskin occasionally writes in *The Stones of Venice* like an angry prophet, rebuking Venice's infidelity and loss of loveliness, he has also composed her Song of Songs. Jeremiah speaks in the final volume—an irate, erratic, and brilliant sermon on stones which chastises the Venice of the Renaissance. But for the Byzantine and Gothic city, Ruskin feels and communicates the passion of a lover anatomizing, feature by feature, the virtues of his beloved. "There is the strong instinct in me," he wrote to his father in 1852, "which I cannot analyse—to draw and describe the things I love . . . a sort of instinct like that for eating or drinking. I should like to draw all St Mark's . . . stone by stone—to eat it all up into my mind—touch by touch."

When Ruskin was writing the book in Venice, he was in fact more wedded to the city than to his wife. He was oddly oblivious of her, hardly touched by the flattering attention paid her by the English and Austrian aristocracy, at whose masked balls and opera parties she shone, but which Ruskin attended reluctantly, more than once departing early and alone so that he might enjoy in solitude the sound of the sea lapping against the city or the effects of moonlight striking the lagoon. His letters and diaries show him in turn totally absorbed by the city and totally self-absorbed by the great effort of mind and imagination through which he deciphered and splendidly recreated her past. The one marriage was never consummated; the other produced the most elaborate and eloquent monument to a city in our literature.

Despite its magnitude, *The Stones of Venice* is one of Ruskin's most orderly books. The facts he amassed fit into an over-all historical pattern, through which he traces the founding of the city, its Byzantine and Gothic periods, and its transition to Renaissance. In addition to chronological unity, *The Stones of Venice* possesses unity of theme: "The relation of the art of Venice to her moral temper," he wrote, "is the chief subject of the book, and that of the life of the workman to his work . . . is the most important practical principle developed in it." Both ideas originated in *The Seven Lamps*, in which Ruskin had asserted that a nation's architecture accurately mirrors its moral life, and that "the right question to ask, respecting all ornament, is simply this: Was it done with enjoyment—was the carver happy while he was about it?" This last point, almost an irrelevant aside in the earlier book, was the source of the great central chapter of *The Stones of Venice*, "The Nature of Gothic," and in turn led Ruskin in the 1860s to his radical assault upon the social and economic structure of England.

The actual stones of Venice served Ruskin as touchstones which confirmed the principles of *The Seven Lamps*. His digressiveness was curbed by the orderly flow of Venetian history and by the requirements of a consistently maintained thesis. But in place of the tedious unity of a chronicle, he succeeded in evoking the drama of a morality play, in which the sequence of doges and styles marks

not only moments in Venice's history but also forces contending for the esthetic integrity, indeed the survival, of the city itself.

An almost neurotic sense of urgency and mission drove Ruskin to his labors of research at Venice. From early youth he had been haunted by the passage in the Gospel of St. John which enjoins us to do the work of Him that sent us, for "the night cometh, when no man can work." In his mid-twenties he had written in his diary of the "long steps" he had already taken to the grave and of the shadow which death cast toward him "across the mirage of years." Prematurely conscious of the wreck of time within himself, he responded with intensified alarm to the ruins of time and the blunders of the restorers which he encountered everywhere on the Continent.[1] We owe to Ruskin more than to anyone else the substitution of historic conscience for capricious alteration and the desire to preserve rather than to "restore" the monuments of the past. But we are as much indebted to his horror of decay as to his love of art for the peculiar intensity which made his plea for preservation so compelling.

The very works of art he most wanted to take in, "touch by touch," appeared most in danger of being lost. Buckets caught the rain water which seeped through Tintoretto's ceilings in the Scuola di San Rocco; large fissures had appeared in the walls of the Doge's Palace. The sheer sensuous fervor which the marbles and canvases of Venice aroused in Ruskin thus became associated with an imperative duty, a sacred salvaging of the city and of his own talents from the wastes of time.

This sense of urgency enabled him to complete the enormous scholarly labor of the book and still communicate a feeling of vital contact with his subject. He wrote to his father in 1852 that he had examined piece by piece buildings covering five square miles, read

[1] Cf. this letter, mailed from Rouen, which the newly wedded Effie Ruskin wrote to Ruskin's parents: "John is perfectly frantic with the spirit of restoration here and at other places, the men actually before our eyes knocking down the time worn black with age pinnacles and sticking up in their place new stone ones to be carved at some future time. . . . John is going to have some Daguerreotypes taken of the Churches as long as they are standing . . . they are destroying them so fast" (Sir William James, *The Order of Release* [London, John Murray, 1947], p. 123).

some forty volumes of the city's archives, and made elaborate ar-
chitectural drawings—all while deciphering the conflicting chro-
nology of the Venetian antiquaries and composing his book. The
index to the final volume alone contains eighty pages of detailed
information on nearly every important building in Venice. And
Ruskin amassed some six hundred quarto pages of notes, and as
many drawings, in addition to those he incorporated in the text.
Yet if *The Stones of Venice* is a work of scholarship, it is far more
notably a work of art. At the time the book appeared, professional
architects were struck by Ruskin's perversity in praising the un-
couth St. Mark's "in direct opposition to every other critic and
architectural writer who has spoken of that edifice." His image of
Venice was as radically fresh and brilliant as Turner's vision of her
sea and sky.

By some unanalyzable process Ruskin transformed the hundreds
of quarto pages, the tracings of moldings, and the counting of
columns, into an exciting book. Consider, for example, the careful
measurements of the tides in and around Venice which he compiled
in his notebooks. No material could be less promising. Yet in the
chapter which recounts the founding of Venice, the flow of these
waters—"the salt breeze, the white moaning sea-birds, the masses of
black weed separating and disappearing gradually, in knots of heav-
ing shoal, under the advance of the steady tide"—convinces us of
the historic presence of the city, of our being witness to an actual
birth. In a sentence or two Ruskin dissipates the picture-postcard
image of Venice and then depicts a barren, hostile topography of
salt flats and inlets through which the tidal range was just sufficient
to allow water transport and clearance of waste, yet limited enough
to immunize the newly founded settlement against attack from the
sea. The ultimate character of the city is thus shown to depend
upon a precariously regulated accident of nature.

More than the quantity of fact, the intensity and precision of
Ruskin's perceptions give the book its actuality. He had the nov-
elist's sense of detail, the poet's involvement in the nexus of sounds,
sights, and smells which fix an experience in our consciousness.
In Volume II he describes a gondola journey along the canals of

Murano before the reader is taken to the mother church of San Donato. He passes women sitting in doorways, workmen from the glassworks sifting glass dust on the pavement, barges laden with large tubs of fresh water, a bridge with a small red lion on the parapet, rows of cottages with sun glowing on their whitewashed walls and sparkling on the green water; he hears cries "ringing far along the crowded water, from vendors of figs and grapes, and gourds, and shell-fish," cries mingling with others still more violent and strange which negate the unregarded sentence stenciled in black on the walls of the houses: *"Bestemme non più: Lodate Gesù"*—Swear no more: Praise Jesus.

But the reader would tire of these fragmented images of Venice, however vibrant with actuality, if they did not fall into a larger pattern of meaning. He would feel the same fatigue if Ruskin had insisted on the abstract pattern alone—the relation of Venetian art to her moral temper—without constantly startling him with the color and brilliance and sounds of the city itself. The lecture on Venice's splendor and decay is delivered *in situ*.

The magnificent cadences of the opening chapter initiate us into the rhythms of that larger pattern:

Since the first dominion of men was asserted over the ocean, three thrones, of mark beyond all others, have been set upon its sands: the thrones of Tyre, Venice, and England.

The fall of the first has been recorded in perhaps the most touching words ever spoken by the Prophets of Israel against the cities of the stranger. Venice, her successor,

is still left for our beholding in the final period of her decline: a ghost upon the sands of the sea, so weak—so quiet,—so bereft of all but her loveliness, that we might well doubt, as we watched her faint reflection in the mirage of the lagoon, which was the City, and which the Shadow.

The lines of this fading image seem to trace a warning uttered by "every one of the fast-gaining waves, that beat like passing bells, against the STONES OF VENICE."

The first chapter sketches in briefest outline the major epochs of Venetian history, from the founding of the city in the fifth century to the Napoleonic decree at the end of the eighteenth which

dissolved the Republic. More than conveying a body of facts, the chapter enforces a sense of their momentousness to the fate, the arts, and the moral life of Europe. The Doge's Palace assumes the central role in this drama. After the power and religion of the Roman Empire were "laid asleep in a glittering sepulchre," the swords of the Lombard and Arab rose "over its golden paralysis." Opposite in character and mission, but alike in their magnificence of energy,

they came from the North and from the South, the glacier torrent and the lava stream: they met and contended over the wreck of the Roman empire; and the very centre of the struggle, the point of pause of both, the dead water of the opposite eddies, charged with embayed fragments of the Roman wreck, is VENICE.

The Ducal palace of Venice contains the three elements in exactly equal proportions—the Roman, Lombard, and Arab. It is the central building of the world.

Ruskin reads in the successive modifications of the Palace the flourishing and fall of the city. The Byzantine character of the building remained essentially unchanged until 1301, when the first Gothic addition was begun. In 1423, when the Grand Council convened in its newly completed Sala, the Gothic portion had assumed its final form. This period marks, for Ruskin, the height of Venice's splendor as a center of the arts, of her power as a nation, and of her faith. The theme of the book is the necessary dependence of the first two upon the last. In the year following the completion of the Gothic Sala, the Council's decree to rebuild the old Palace was acted upon. The first blow struck against the Palace sounded "the knell of the architecture of Venice,—and of Venice herself."

The date of that blow runs like a motif through *The Stones of Venice*. In 1423 the great Doge Tomaso Mocenigo died, his death marking the "visible commencement" of Venice's fall. Ruskin contrasts his tomb with that of the Doge Andrea Vendramin, who died in 1478 and, after a brief, disastrous reign, was also interred in the church of SS. Giovanni e Paolo. Mounting a ladder, Ruskin examined the hand of the Vendramin effigy turned toward the spectator. Climbing higher and searching for its fellow, he found that it had none; the effigy is a mere block on its inner side. The face,

heavy and disagreeable in feature, "is made monstrous by its semi-sculpture."

Ruskin saw in this half-carved monument a symbol of the deception and insensibility of Renaissance Venice, just as he interpreted Titian's portrait of the Doge Antonio Grimani, kneeling before an unconvincing image of Faith, as a symbol of its infidelity. Outward religious observances remained strict; senators and doges were still painted praying to the Virgin or St. Mark. But between Giovanni Bellini's birth in 1423 and Titian's in 1480 faith had died and formalism had taken its place. Thus in Titian's painting the figure before whom the Doge kneels is a coarse portrait of one of the artist's least graceful models: "Faith had become carnal."

The parallel decline of faith and art in Venice, Ruskin writes, was mirrored throughout Europe. Gothic architecture, even before it was superseded by the "rigidities" of the Renaissance, had dissipated itself in extravagant, enervated coils and foliations. In art, mythologies at first ill-understood were then perverted into feeble sensualities which took the place of religious subjects:

Gods without power, satyrs without rusticity, nymphs without innocence, men without humanity, gather into idiot groups upon the polluted canvas, and scenic affections encumber the streets with preposterous marble.

Christianity and morality, intellect and art, all crumbled in one wreck.

One can easily quarrel with Ruskin's evaluation of the Renaissance or question the sincerity of the faith which led medieval Venice to exact the highest possible price from her prostrate Christian neighbors before furnishing arms for the Fourth Crusade. One can argue that the discovery of the trade route around the Cape of Good Hope in 1488 rather than the Renaissance hammer stroke of 1424 heralded the fall of Venice. Ultimately Ruskin's thesis is vulnerable on broader ground than that of fact. The reader of *The Stones of Venice* must eventually ask himself just what sort of history he is reading, indeed must ask whether he is reading history at all.

The answer is unequivocally no, if one accepts the "objective"

historian's position that the very best we can do is present the facts and resolutely refuse to judge them. Carried to its logical limits, this view destroys the historian's own domain, for the mere selection of an event, the choosing of one value-purged specimen rather than another, is itself an impermissible act of judgment. Certainly *The Stones of Venice* is not an economic or political history. Ruskin dates the decline of Venice's internal strength well in advance of her loss of prosperity. And changes of government, he wrote in a manuscript draft of the opening chapter, "are the expression rather than the cause of changes in character. . . . The history of every people ought to be written with less regard to the events of which their government was the agent, than to the disposition of which it was the sign."

When Ruskin writes of the great Doges Enrico Dandolo and Tomaso Mocenigo, we can detect the influence of Carlyle's view of history as the biography of great men. But Venice owed her victories, Ruskin writes, less to her individual heroes than to the particular discipline and values of the culture which molded them. Finally, *The Stones of Venice* is not even art history, for it is too arbitrary in what it illustrates and is concerned with far more than the arts.

In so far as *The Stones of Venice* presents a total view of Venetian civilization, a view compounded of its people, its arts, its acts, its thought, the book is a kind of archetypal cultural history. But in its moral orientation it is as anti-modern as Shakespeare's histories or the chronicle of Israel's fate recorded by her prophets. None gives us history as such. Each subordinates events to the overriding pattern which orders them, the pattern which shapes our ends, rough hew them as we will. Neither wealth nor power but Israel's false dealings with the Lord of Righteousness inexorably determine her passage from glory to the chastisement of captivity. The chronicle of tribal growth, nationhood, and dispersal has become a fateful moral drama which reveals, under divine scrutiny, the character of its protagonists. This is essentially the kind of history Ruskin was writing, or that Shakespeare wrote when he

shaped the chaos of English medieval history into a drama of punishment and expiation for the guilt of Richard's blood. At the close of *King John*, the Bastard makes the choric comment that England will never lie at the foot of a conqueror if to herself she "do rest but true." Venice did not, and fell: that is the burden of Ruskin's book.[2] It is a Christian epic, magnificent in scope, which in its final volume—*The Fall*—completes the chronicle of a Gothic paradise lost. Titian's coarsened image of Faith rather than Venice's surrender to the Turks is the sign and instrument of her destruction.

Ruskin's interpretation of Venetian history rests on two assumptions: the art of a nation is an accurate index of its moral temper, and this temper, more than anything else, determines its fate. But is the evidence of the arts that clear? And however gratifying to one's sense of justice, however much one responds to the dramatic and esthetic integrity of the patterning, is there in fact a moral force in history which governs the rise and fall of nations? At the risk of subverting Ruskin's achievement in *The Stones of Venice*, let me offer a seductive half-truth.

Suppose that, still wrestling with his Evangelical conscience, Ruskin found in Venice the same overpowering stimulus to sensation, the same assault upon a rigid code that, say, Thomas Mann's hero experienced in *Death in Venice*. Of course it was a fatally diseased Aschenbach who found disease in Venice, whereas Ruskin created a masterpiece from its decay. But unquestionably Venice hastened for Ruskin the death of an untenable code which, although dying, still exacted its stern tribute. Might not his violent hostility to Renaissance Venice have been a kind of atonement for the spell which this most arrogantly voluptuous of cities cast upon him? Could the pattern of Gothic glory and Renaissance decline reflect not objective fact but Ruskin's half-guilty submission to

[2] After completing *The Stones of Venice*, Ruskin ceased to believe in the divine patterning of history and was far less certain of his own religious faith. He wrote to J. A. Froude in 1864 that "there is no law of history any more than of a kaleidoscope. With certain bits of glass—shaken so, and so—you will get pretty figures, but what figures, heaven only knows. . . . The history of the world will be for ever new" (XXXVI, 465).

Venice in her youth and his hatred of her old age, an ambivalence which gratified both his intense esthetic delight and his compulsion to preach out against the iniquities of an Italianate Babylon?

Perhaps Mary McCarthy is right, and Ruskin's indictment of Renaissance architecture is merely the potent rhetoric of an "overdue Jeremiah":

Pagan in its origin, proud and unholy in its revival, paralyzed in its old age, yet making prey in its dotage of all the good and living things that were springing around it . . . an architecture invented, as it seems, to make plagiarists of its architects, slaves of its workmen, and sybarites of its inhabitants; an architecture in which intellect is idle, invention impossible, but in which all luxury is gratified, and all insolence fortified;— the first thing we have to do is to cast it out, and shake the dust of it from our feet for ever.

Yet the pattern of *The Stones of Venice* does not conform merely to a psychological necessity. The thesis of the book—the close connection between a nation's art and its moral life—is valid, once we understand its terms. Our own limitations, not Ruskin's, cause us to confuse the "moral" in art with the "respectable" in behavior and to suppose that an artist's style is a kind of after-polish rather than the unique modality of his vision. Style, for Ruskin, was inseparable from the man, from the complex integration of faculties which impel him to express one truth rather than another. The aggregate of individual styles which characterize a period is, in turn, inseparable from the culture which it reflects. We shy away from Ruskin's idiom and prefer to deal with art in less morally weighted terms: what we study as Mannerism he dismissed as vapidity and affectation. But his insight into the dependence of all creativity upon its moral environment is, I believe, vital to any meaningful discussion of art.

The interdependence of esthetic and moral values was, of course, a central principle of Ruskin's thought. It was not so much a doctrine he held as his innate mode of perceiving things, an instinctive habit of organizing his experience into identities rather than dichotomies. We can trace the idea back to *The Poetry of Architecture*, which Ruskin published when he was not yet twenty and which,

in its insistence that the character of a nation is written on the façades of its buildings, foreshadows *The Seven Lamps* and *The Stones of Venice*. He is writing about the futility of imitative architecture, but see how quickly the esthetic issue becomes a moral one:

It is utter absurdity to talk of building Greek edifices now; no man ever will, or ever can, who does not believe in the Greek mythology. . . . The mistake of our architects in general is, that they fancy they are speaking good English by speaking bad Greek. . . . The endeavour to be Gothic, or Tyrolese, or Venetian, without the slightest grain of Gothic or Venetian feeling; the futile effort to splash a building into age, or daub it into dignity, to zigzag it into sanctity, or slit it into ferocity, when its shell is neither ancient nor dignified, and its spirit neither priestly nor baronial,–this is the degrading vice of the age. . . . Our national architecture never will improve until our population are generally convinced that in this art, as in all others, they cannot seem what they cannot be. . . . The architectural appurtenances of Norman embrasure or Veronaic balcony must be equally ineffective, until they can turn shopkeepers into barons, and schoolgirls into Juliets.

In the final volume of *The Stones of Venice* Ruskin concludes, largely from the evidence of tombs, that the Venice of the Renaissance was trying to "seem" what in spirit she had ceased to be.[3] Death approached the Gothic tombs as a comforter; the adornment was simple and religious, the perfect type of monument consisting of a raised sarcophagus of stone which bears a recumbent figure, the whole being covered with a canopy. In the early Renaissance tombs, curtains and columns became more important than the Virgin and saints, who were eventually superseded by a clutter of allegorical representations of Fame, Victory, and the Muses. In the later monuments, as "the pride of life" increased, so too did the fear of death. At length the definite character of the sarcophagus was lost and it began to function as a mere stage for the statue. The monument to the Doge Andrea Vendramin (*c.* 1480) is one of the last to display

[3] The evidence is weighted, for Ruskin scarcely mentions the great Venetian painters–Titian, Tintoretto, and Veronese–who flourished in the sixteenth century. True, he had paid them a splendid tribute in *Modern Painters*, and the book under discussion is about the *stones* of Venice; but he never quite reconciled his love for a school of art with his hatred of an exactly contemporary architecture.

the recumbent figure in death. A few years later this posture be-
came disagreeable to polite minds. Figures which before had been
laid at rest upon the tomb "raised themselves on their elbows, and
began to look round them. The soul of the sixteenth century dared
not contemplate its body in death." The book, so carefully plotted
around a series of contrasting symbols, ends with the juxtaposed im-
ages of simple Gothic tombs and ever more inane Renaissance monu-
ments celebrating the virtues of virtueless men. Ruskin houses the
body of Renaissance Venice in an overblown, tasteless sarcophagus.

The image is all the more potent because of its contrast with
"that first and fairest Venice which rose out of the barrenness of
the lagoon," a city of "graceful arcades and gleaming walls, veined
with azure and warm with gold, and fretted with white sculpture
like frost upon forest branches turned to marble." This was a city
of solemn, splendid festivals which in their brilliance, elaborate
pageantry, and depth of fervor were to the national life a kind of
outdoor equivalent to High Mass at San Marco. Ruskin, in por-
traying medieval Venice, seems to extend the walls of the cathedral
to include the entire city in a single magnificent rite.

The Church of Santa Maria Formosa was the center of the most
famous of these festivals. Annually from the tenth through the
fourteenth centuries a procession of twelve maidens, elaborately
costumed in jewels by each of the *contrade* or districts of the
city, made a pilgrimage to the church and offered prayers of grati-
tude to the Virgin for her saving the brides of Venice from an at-
tack by pirates in 943. The ancient church stood until the eight-
eenth century, when it was destroyed by an earthquake and entirely
rebuilt. With the image of the festival and its twelve "Maries" fresh
in the reader's mind, Ruskin leads him to the site of the modern
church, still dedicated to St. Mary the Beautiful. At the base of
the tower he sees "a head,—huge, inhuman, and monstrous,—leering
in bestial degradation, too foul to be either pictured or described."
Its fellows, scattered on the bridges and many of the buildings
erected at the fall of the Republic, alike express the "spirit of idiotic
mockery . . . characteristic of the last period of the Renaissance."

One final image of the city—the Venice Ruskin saw in the mid-

dle of the nineteenth century—will lead us from the chief subject of
the book, the relation of Venetian art to her moral temper, to its
"most important practical principle," the relation of the artisan to
the society in which he works. Ruskin guides the reader through
the narrow rows of shops which crowd together almost to the very
edge of the piazza opening upon San Marco. There, through the
troops of ordered arches, rises

a multitude of pillars and white domes, clustered into a long low pyra-
mid of coloured light; a treasure-heap, it seems, partly of gold, and
partly of opal and mother-of-pearl, hollowed beneath into five great
vaulted porches, ceiled with fair mosaic, and beset with sculpture of
alabaster, clear as amber and delicate as ivory.

Above them rises the second tier of vaults, amidst which

the breasts of the Greek horses are seen blazing in their breadth of
golden strength, and the St. Mark's lion, lifted on a blue field covered
with stars, until at last, as if in ecstasy, the crests of the arches break into
a marble foam, and toss themselves far into the blue sky in flashes and
wreaths of sculptured spray, as if the breakers on the Lido shore had
been frost-bound before they fell, and the sea-nymphs had inlaid them
with coral and amethyst.

The image is splendid, but utterly static and lifeless, like the
waves frozen into marble. It is Venice seen through the eyes of an
esthete with a great gift for word-painting. Ruskin allows only one
sign of vitality, the doves which fill the porches, "nestle among the
marble foliage, and mingle the soft iridescence of their living
plumes, changing at every motion, with the tints, hardly less lovely,
that have stood unchanged for seven hundred years."

Then, in the paragraph which immediately follows (and is al-
ways omitted from collections of Ruskin "gems"), the dove, with
its weight of Christian association, reappears as a symbol of the de-
basement of the square and all that it consecrates. The vision of
San Marco is no longer a fantasy isolated from time and humanity.
What, Ruskin asks, is the effect of all this splendor on those who
pass beneath it?

Priest and layman, soldier and civilian, rich and poor, pass by it alike
regardlessly. Up to the very recesses of the porches, the meanest trades-

men of the city push their counters; nay, the foundations of its pillars
are themselves the seats—not "of them that sell doves" [4] for sacrifice, but
of the vendors of toys and caricatures. Round the whole square in front
of the church there is almost a continuous line of cafés, where the idle
Venetians of the middle classes lounge, and read empty journals; in its
centre the Austrian bands play during the time of vespers, their martial
music jarring with the organ notes,—the march drowning the miserere,
and the sullen crowd thickening round them,—a crowd, which, if it had
its will, would stiletto every soldier that pipes to it.[5] And in the recesses
of the porches, all day long, knots of men of the lowest classes, unem-
ployed and listless, lie basking in the sun like lizards; and unregarded
children,—every heavy glance of their young eyes full of desperation and
stony depravity, and their throats hoarse with cursing,—gamble, and
fight, and snarl, and sleep, hour after hour, clashing their bruised cen-
tesimi upon the marble ledges of the church porch. And the images of
Christ and His angels look down upon it continually.

A dehumanized humanity gambles, as if casting its dice for the
robe, under the figure of Christ. In its final decadence, Ruskin sees
all classes and ages of Venice daily betraying the image which pre-
sides over its most sacred square. His horror at the nineteenth cen-
tury's infidelity to God and inhumanity to man led him to preach
the radical social gospel which he first articulated in "The Nature
of Gothic," the great central chapter of *The Stones of Venice*.

ii

"The Nature of Gothic" is most memorably, but only in part, an
indictment of the maiming enslavement of the worker to the ma-
chine. That indictment is almost too potent, for it tends to detach
itself from the rest of the chapter. The social criticism loses much
of its force if read merely as a digression, however moving, in an
essay on Gothic architecture. Similarly, Ruskin's analysis of Gothic
cannot be isolated from the larger issues of his concern, the uni-
versal truths in nature and the impulses in man which the style em-
bodies. The esthetic analysis widens into an analysis of nature, of
human nature, and of society. Each penetrates and illuminates the

[4] "And Jesus went into the temple of God . . . and overthrew the tables
of the moneychangers, and the seats of them that sold doves" (Matt. 21:12).
[5] Venice was under Austrian occupation when Ruskin wrote this passage.

other; all are part of the broad synthesis of ideas which led Ruskin in the 1850s from the criticism of art to the criticism of society.

Pointed arches or flying buttresses do not in themselves, he writes, define a building as truly Gothic. It must also possess certain "characteristic or moral elements" which endow it with a peculiarly Gothic animation and power. These qualities are Savageness or Rudeness, Changefulness, Naturalism, Grotesqueness, Rigidity, and Redundance. The first, rudeness, was rightly recognized but wrongly condemned by those who originally used "Gothic" as a term of reproach for a non-classical, "barbarous" architecture. The very uncouthness of the architecture of northern Europe—the "look of mountain brotherhood between the cathedral and the Alp"—is its strength.

Ruskin enforces this point in one of the most splendidly sustained paragraphs in *The Stones of Venice*. His prose map of Europe functions as a kind of topographic key to the Gothic spirit. Like all maps, it is somewhat distorted. Ruskin projects an image of Gothic which magnifies its rough, rock-hewn qualities and ignores its exquisite refinements. His initial stress on the rudeness of Gothic, its tolerance of ruggedly wayward and imperfect work, is crucial to the entire chapter. For on this forgiveness of error, Christian in its compassion and creative in its results, Ruskin bases his plea for the freedom of the nineteenth-century laborer from the mechanization which was crippling his body and exhausting his spirit.

Let us, Ruskin writes, try to raise ourselves above the level of the bird's flight, and imagine

the Mediterranean lying beneath us like an irregular lake, and all its ancient promontories sleeping in the sun: here and there an angry spot of thunder, a grey stain of storm, moving upon the burning field; and here and there a fixed wreath of white volcano smoke, surrounded by its circle of ashes; but for the most part a great peacefulness of light, Syria and Greece, Italy and Spain, laid like pieces of a golden pavement into the sea-blue, chased, as we stoop nearer to them, with bossy beaten work of mountain chains, and glowing softly with terraced gardens, and flowers heavy with frankincense, mixed among masses of laurel, and orange, and plumy palm, that abate with their grey-green shadows the burning of the marble rocks, and of the ledges of porphyry

sloping under lucent sand. Then let us pass farther towards the north, until we see the orient colours change gradually into a vast belt of rainy green, where the pastures of Switzerland, and poplar valleys of France, and dark forests of the Danube and Carpathians stretch from the mouths of the Loire to those of the Volga, seen through clefts in grey swirls of raincloud and flaky veils of the mist of the brooks, spreading low along the pasture lands: and then, farther north still, to see the earth heave into mighty masses of leaden rock and heathy moor, bordering with a broad waste of gloomy purple that belt of field and wood, and splintering into irregular and grisly islands amidst the northern seas, beaten by storm, and chilled by ice-drift, and tormented by furious pulses of contending tide, until the roots of the last forests fail from among the hill ravines, and the hunger of the north wind bites their peaks into barrenness; and, at last, the wall of ice, durable like iron, sets, deathlike, its white teeth against us out of the polar twilight.

The artisan of the South sets burning gems side by side and polishes the smooth sculpture of jasper pillars, which reflect a ceaseless sunshine and rise into a cloudless sky. But the Northern workman

smites an uncouth animation out of the rocks . . . and heaves into the darkened air the pile of iron buttress and rugged wall, instinct with work of an imagination as wild and wayward as the northern sea; creatures of ungainly shape and rigid limb, but full of wolfish life; fierce as the winds that beat, and changeful as the clouds that shade them.

If this image of Gothic suits the massive strength of the Romanesque portions of Mont-Saint-Michel or the bleak, rugged power of Durham Cathedral, it is scarcely appropriate to the elegant refinements of the Sainte Chapelle or the delicately poised grace of Wells Cathedral. Still, there is a touch of Stonehenge in much of the Gothic of the North, a roughness of the hewings and cleavings of the anonymous peasant. That Ruskin stressed this quality suggests a revealing affinity between his view of architecture and Wordsworth's of poetry. The same impulse which led Wordsworth to prefer the language of the Cumberland peasant to the poetic diction of the Augustans led Ruskin to exalt the "crude" carving of the medieval stonemason over the polished perfections of the Renaissance architect.

This tendency to equate the real with the untutored, the natural

with the imperfect, was a chief article of the Romantics' faith. They applied the revolutionary ideal of *egalité* to the arts, and then rejected as artificial and anti-democratic all appeal to a specialized, aristocratic taste. Both as a Romantic and as a social critic, Ruskin condemned Renaissance architecture for expressing in the proud meagerness of its lines "aristocracy in its worst characters; coldness, . . . incapability of emotion, want of sympathy with the weakness of lower men, blank, hopeless, haughty self-sufficiency." Gothic could gratify all tastes. By employing crude stone as well as marble, by contracting into a cottage as well as expanding into a castle, it spoke in universal fellowship to all classes. But the architecture of the Renaissance, incapable of stooping or conceding, "was full of insult to the poor in its every line." If Renaissance architecture was anti-democratic, it was even more fundamentally, for Ruskin, anti-Christian. It ministered to pride, to luxury, to vanity. Gothic was merciful in its concession to weakness, charitable in its wide bestowal of what could be commonly perceived and enjoyed. The image Ruskin evokes in the reader's mind is that of Gothic as the embodiment of the Christian Virtues and Renaissance as the personification of the Vices.

Now one of the Christian virtues, if it may be so called, is the frank confession of our corruption. I do not of course mean the post-Romantic perversion of this virtue, the pleasurable dwelling of the depraved upon their depravity, but rather the acknowledgment by the admittedly fallen of the Fall, and their joyous reliance on the grace which, confounding retributive justice, will restore them to a glory far greater than that possible had there been no prior transgression. The paradox of the fortunate fall underlies Ruskin's whole concept of Gothic. It draws together, with the full sanction of Christian doctrine, his esthetic and social criticism, and it lies at the heart of his belief that Gothic is at once the most Christian, the most natural, and the most humane of architectures.

Gothic "rudeness" and tolerance of imperfection are thus far more than marks of its geographic origin. They expressed, for Ruskin, a profound truth of nature, of man's condition, and of his acceptance of that condition as revealed in his arts. The very imper-

fection of Gothic is one of its "most noble . . . [and] essential" characteristics as Christian architecture. Indeed, Ruskin believed that no architecture could be truly noble which was *not* imperfect. The Classical or Renaissance architect, by demanding perfection of the less skilled artisan, turned him into a slave, a mechanical executer of balls, ridges, and rigorously symmetrical foliage which could be cut by rule and line. Gothic architecture dispensed with this slavery altogether, for Christianity recognized the value of the individual soul and accepted the fruits of its labor, however imperfect. This admission of lost power, which the Greek or Ninevite found intensely painful, the Gothic artisan made daily in his life and his work, the confession itself "tending, in the end, to God's greater glory."

All great art must make this confession. Art which denies it is arrogance; art which makes it is, ultimately, praise. Indeed, Ruskin rejected the Renaissance because in its pursuit of perfection the Renaissance denied the Fall. But we should add an important qualification. Ruskin was a Humanist as well as a Christian; he despised the Renaissance not for exalting man but for degrading his highest powers, for preferring smooth minuteness to shattered majesty. His stress upon the Fall has nothing of the Calvinist's gloomy, obsessive dwelling upon guilt. For Ruskin, as for St. Augustine, the awareness of man's lost innocence leads to a heightened awareness of his powers of felicity and fulfillment. And as St. Augustine eulogizes fallen nature, praising its remnants of a glory that was and its promise of a greater glory to be, so Ruskin, transposing the theological paradox into an esthetic one, eulogizes an imperfect art.

Turning from the Christian esthetic of imperfection, he argues that the demand for perfection always represents a misunderstanding of the ends of art. The truly great artist does not cease working until he has reached his point of failure, his powers of conception always exceeding his powers of execution. Secondly, the artist expends on the inferior portions of his work only such inferior effort as they require.[6] God alone can "finish" perfectly, Ruskin wrote in

[6] In *The Laws of Fésole* Ruskin similarly asserts: "These two . . . conditions of excellence are always discernible [in the masters of the greatest

Modern Painters; in the very unevenness of Turner's canvases—no part wholly realized, no part vacant—he perceived not only the imperative economy of art but also the closest possible approximation to the actual finish of nature. For imperfection is

in some sort essential to all that we know of life. . . . The foxglove blossom,—a third part bud, a third part past, a third part in full bloom, —is a type of the life of this world.

From the simplest leaf to the human face, the irregularities and deficiencies of all organic things are signs of life as well as sources of beauty. To banish imperfection is to limit exertion, to destroy expression, and to paralyze vitality.[7]

I have traveled quite a distance from Ruskin's prose map of Europe, but then no farther than Ruskin himself does. The rugged topography of the North and the felicitous imperfection of the foxglove blossom are both integral to his analysis of the rudeness of Gothic. Each of the remaining characteristics he discusses—naturalism, love of variety, etc.—widens the base of his analysis, until Gothic is understood not as a style but as the expression of the noblest impulses in man, which themselves derive from his continuing life in nature.

This is the broad background against which Ruskin's indictment of the nineteenth-century degradation of labor must be seen. By imposing a mechanical, exhausting perfection upon the artisan, industrialism had created a new class of slaves, mindless tools rather than men. Their capacity to think, to feel, or to create had been

schools],—that they conceive more beautiful things than they can paint, and desire only to be praised in so far as they can represent these, as subjects of higher praising" (XV, 355). He would have agreed with Browning that the fatal fault of Andrea del Sarto, "the faultless painter," was this very sacrifice of his conceptions to the faultlessness of his technique. Andrea exclaims in Browning's monologue:

> "Ah, but a man's reach should exceed his grasp,
> Or what's a Heaven for? all is silver-grey
> Placid and perfect with my art—the worse!"

[7] Again Ruskin's esthetics reveals a deeply Christian orientation. Cf. Etienne Gilson's comment, "As St. Thomas Aquinas would say, the presence of corruptible things in the universe, added to the incorruptible, only increases its beauty and perfection" (*The Spirit of Mediaeval Philosophy* [New York, Charles Scribner's Sons, 1940], p. 116).

extinguished by the demand that they not err, that they bend the
eye of the soul upon the finger point for ten hours a day until soul,
sight, and the whole human creature were at last destroyed. Lest the
charges appear too remote from the reader, Ruskin asks him to
glance about his English room (undoubtedly a fine one, for he had
paid the equivalent of thirty dollars for the volume in his hand)
and examine the meaning of its finely wrought moldings and pol-
ished ornaments. The reader had perhaps taken pride in them as
signs of England's greatness in executing even the slightest work so
thoroughly. But, if read rightly,

these perfectnesses are signs of a slavery in our England a thousand
times more bitter and more degrading than that of the scourged African,
or helot Greek. Men may be beaten, chained, tormented, yoked like
cattle, slaughtered like summer flies, and yet remain in one sense, and
the best sense, free. But to smother their souls with them, to blight and
hew into rotting pollards the suckling branches of their human intel-
ligence, to make the flesh and skin which, after the worm's work on it,
is to see God, into leathern thongs to yoke machinery with,—this is to
be slave-masters indeed; and there might be more freedom in England,
though her feudal lords' lightest words were worth men's lives, and
though the blood of the vexed husbandman dropped in the furrows of
her fields, than there is while the animation of her multitudes is sent
like fuel to feed the factory smoke, and the strength of them is given
daily to be wasted into the fineness of a web, or racked into the exact-
ness of a line.

More than the pressure of famine, this degradation of the opera-
tive into a machine was, Ruskin believed, leading the industrial na-
tions to the verge of revolution. Deprived of all pleasure in his work
and hating himself only less than he hated those who had debased
him, the laborer was being bred as a separate, dehumanized race.
Previously the gulf which separated the classes was "merely a wall
built by law; now it is a veritable difference in level of standing, a
precipice between upper and lower grounds in the field of hu-
manity." The great civilized invention of the division of labor was
in reality the division of *men*, who were being broken into mere
"fragments and crumbs of life." The little initiative allowed them

was insufficient to make even a whole pin, but exhausted itself in the making of the points of pins and the heads of nails. A menacing cry was rising louder than the furnace blast from the manufacturing towns, where

we blanch cotton, and strengthen steel, and refine sugar, and shape pottery; but to brighten, to strengthen, to refine, or to form a single living spirit, never enters into our estimate of advantages.

To put an end to such crippling labor requires the sacrifice of "such convenience, or beauty, or cheapness" as can be gotten only by degrading the workman. Thus Ruskin urges the reader never to encourage the manufacture of a nonessential object in which invention plays no part and never to demand an exact finish for its own sake. As an example of non-inventive, degrading labor he cites the manufacture of glass beads, which were being worn by the fashionable young ladies of England. Earlier in *The Stones of Venice*, the factory workers sifting glass dust on the pavement had figured with the vendors of figs and shellfish in Ruskin's sketch of the local color of Murano. But here the same fidelity of observation works to a very different end. Ruskin enters the factory and describes the men forming the beads by drawing the glass into rods, which are then chopped into beads and rounded in the furnace:

The men who chop up the rods sit at their work all day, their hands vibrating with a perpetual and exquisitely timed palsy, and the beads dropping beneath their vibration like hail.

The dreadful, hypnotic monotony of the labor is echoed by the prose itself: the beads drop with the mesmeric regularity of the anapest. Every young lady who buys glass beads, Ruskin concludes, is engaged in the slave trade.

This equation of the wearing of beads and the perpetuation of slavery is at once profoundly true and profoundly at variance with our sense of the way the world's economy really runs. Would not the laborer of Murano be *worse* off without the demand for his labor? And why should the purchaser concern himself with anything except obtaining the cheapest price? Ruskin's answer possesses

the authority or, if one prefers, the sublime incredibility of Scripture: we are our brother's keeper at all times, in as well as out of the market place. Buying and selling is not only a mercantile but also a moral act. Hence the injunction upon the purchaser never to encourage the exploitation which cripples or the monotony which corrupts. The burden of Ruskin's social criticism, beginning with "The Nature of Gothic," is the mutual dependence of all upon all, rather than the legally sanctioned war of each man against his neighbor. To define that larger identity of interest required that Ruskin redefine wealth not as indiscriminate production at any cost to life, but as the wise consumption, and just distribution, only of those things which sustain the fullest possible life.

I have glanced forward for a moment to certain ideas in *Unto This Last* which evolved from "The Nature of Gothic." But to grasp the pivotal importance of the chapter we ought also to take a brief backward glance at *The Seven Lamps*. In "The Lamp of Life" Ruskin had written that only when men cease working like machines and begin to build with their minds and hearts as well as their hands can they endow their buildings with vitality. It is not coarseness or bluntness which is deadly, but coldness: "the look of equal trouble everywhere—the smooth, diffused tranquility of heartless pains." The right question to ask of all ornament is simply this, "Was it done with enjoyment—was the carver happy while he was about it?" To enforce his point Ruskin describes a recently erected Gothic church just outside Rouen. The details are rich, tasteful, and historically accurate. But it is all as dead as leaves in December, for the men who did the work hated it. No investment of wealth could improve the church, money being incapable of buying life.

"Was it done with enjoyment?"—this shift of interest from the art object to its creator is the overriding concern of "The Nature of Gothic." England had created two entirely distinct classes, one which was supposed always to think and another which had always to work. But, Ruskin believed, the gentleman should work and the worker think. "As it is, we make both ungentle, the one envying, the other despising, his brother." The rigid separation of faculties had created a society composed of "morbid thinkers and

miserable workers." Such a division was incapable of producing either a vital art or a healthy society.

Here, at this junction of Ruskin's thought, his esthetic and social ideas can be distinguished only by their degree of emphasis, for the insights generating both are at bottom identical. In art, as in economics, there is a certain sum of capital to be invested wisely or not. The sole source of that capital is human life, its energies of mind and heart, its talents of hand and eye. These talents and energies cannot create vital art in a society which dims the eye or cripples the mind with life-consuming labor. England will produce no art at all until she learns to produce, not pin points, but souls. This is the essence of "The Nature of Gothic." From one point of view, it is the culmination of ideas first adumbrated in *The Poetry of Architecture*. From another, it is the source book for *Unto This Last*. In a wider sense "The Nature of Gothic" is, as William Morris wrote, "one of the very few necessary and inevitable utterances of the century."

In stressing the unity of Ruskin's themes, there is always the danger of silencing the inner dialogue, the clash of purposes, which accompanies his thought in a kind of embattled counterpoint. His biography is a study in contradictions and thwarted energies, his work the attempt to resolve the one and to release the other. Perhaps that is why he wrote so much, and why his books are so intensely, so remarkably, personal.

Yet in the profoundest sense Ruskin's works *were* his life. In the final volume of *Modern Painters* (1860), published in the same year as *Unto This Last,* he complained that his writing had been continually warped and broken "by digressions respecting social questions, which had for me an interest tenfold greater" than the book he was bringing to completion. After at last finishing it under his father's prodding, he wrote to Elizabeth Barrett Browning of his confusion and despair:

I've been working pretty hard, too, to get my book done . . . and have now fallen into the lassitude of surrendered effort and the disappointment of discovered uselessness, having come to see the great fact that great Art is of no real use to anybody but the next great Artist; that

it is wholly invisible to people in general—for the present—and that to
get anybody to see it, one must begin at the other end, with moral edu-
cation of the people, and physical, and so I've to turn myself quite up-
side down, and I'm half broken-backed and can't manage it.

Despite his claim of tenfold greater interest in social issues, un-
doubtedly Ruskin preferred collecting Turners, classifying minerals
at Denmark Hill, or sketching the Alps, to the labors of social re-
construction he was about to undertake.[8] Of course, his criticism
of society was a logical extension of ideas inherent in his criticism of
art; but his later work also evolved from his growing awareness of
"the vastness of the horror of this world's blindness and misery"
and from the consequent burden of guilt he bore for the cloistered
luxuries of his life.

It is impossible to isolate the precise period when Ruskin's
awareness of this world's miseries began to darken his sense of the
beauty of its art and the magnificence of its landscapes. In 1869 his
discovery of Carpaccio was almost as intense a revelation as had
been his discovery of Turner more than three decades earlier. And
he rose for the sunrise as religiously and described it almost as
ecstatically in his diaries of the 1860s and '70s as he had in the '30s.
The earlier awarenesses, however diminished in intensity, continued
to assert themselves alongside the later. But there *was* a change.
Ruskin's response to Carpaccio tells us more of his obsession with
the girlish image of St. Ursula than it does of the artist or of art.
So too, the social criticism in *Unto This Last* differs markedly from
that raised in *The Seven Lamps* by the lifeless Gothic façade.

The difference is simply this. Standing before the newly built
church, Ruskin had formulated an abstract principle regarding the

[8] This is not a conjecture but a fact. In January 1859 he wrote to the
Brownings: "For my own pleasure I should be collecting stones and mosses
. . . rejoicing tranquilly or intensely in pictures, in music, in pleasant faces,
in kind friends. But now—about me there is this terrific absurdity and wrong
going on. . . . And this working in a way contrary to one's whole nature tells
upon one at last—people . . . were meant to be able to give quiet pieces of
advice to each other . . . [not] to be always howling and bawling the right
road to a generation of drunken cabmen, their heads up through the trap-
door of the hansom, faces all over mud—no right road to be got upon after
all—nothing but a drunken effort at turning, ending in ditch" (XXXVI,
302–03).

artist's enjoyment of his labor. But in the manufacturing towns of England he confronted another order of circumstance altogether. His belief that the artisan should be happy if he is to create genuine art gave way to his concern that the laborer was being crushed in a vicious society. Such towns and such a society were polluting the springs of life as well as of art. This was the message Ruskin brought to the manufacturing cities of England in his lectures of the late 1850s. Published as *The Political Economy of Art* and *The Two Paths*, the lectures are an expansion of "The Nature of Gothic" and a prelude to *Unto This Last*.

Delivered at Manchester, then the capital of *laissez-faire* economics, *The Political Economy of Art* denounces unbridled competition and the indifference of government to the social and economic lives of the governed. The only true wealth of a society is the commonwealth of its natural and human resources. Art, like all other resources, must be wisely husbanded. It is part of the harvest of human talent and needs for its nurture not the ignorant and arbitrary patronage of the market place but the encouragement of a society which educates, employs, and rewards its artists liberally.

When Ruskin reissued *The Political Economy of Art*, he renamed it *A Joy Forever*. A sentence from one of his Oxford lectures on art in 1870 elucidates the new title and the point of the book. The whole aim of his professorship, he told his undergraduate audience, "would be accomplished,—and far more than that,—if only the English nation could be made to understand that the beauty which is indeed to be a joy for ever, must be a joy for *all*." A year earlier the same conviction had led him to assert, before the members of the Royal Institution, that good architecture can be created only by a people capable of taking a common joy and pride in the arts. Houses for the rich would not be beautiful until houses for the poor were also beautiful. "As it is a common and diffused pride, so it is a common and diffused delight on which alone our future arts can be founded."

But this broadly based delight can exist only in a society which educates all its citizens, allows them leisure, and surrounds them in their daily lives with objects which quicken rather than deaden the

senses. Clearly Victorian England was not such a society; hence Ruskin began to speak less of the appreciation of art and more of the creation of conditions in which art and life could flourish. This is the theme of his lecture on "Modern Manufacture and Design," which he gave in 1859 and published the same year in *The Two Paths*. A nation which was turning its streams into a curdling scum of slime and its cities into furnaces over which coiled a "perpetual plague of sulphurous darkness" was incapable of design or art of any kind.

Such, too, was Ruskin's message when, to the evident irritation of its members, he testified before the Parliamentary Committee investigating the possibility of opening public galleries in the evenings to promote "the healthful recreation and improvement of the people." He had been invited to testify as an instructor at the Working Men's College, where he had lectured on art since its founding in 1854, when "The Nature of Gothic" had been given to the students as a manifesto of the College's aims. But the Committee got much more than it had bargained for. When the chairman asked Ruskin if he thought galleries should be kept open from eight to ten at night, he replied that the question raised a far more important one:

How you can prepare the workmen for taking advantage of these institutions. The question before us, as a nation, is not, I think, what opportunities we shall give to the workmen of instruction, unless we enable them to receive it; and all this is connected closely, in my mind, with . . . the more difficult question, issuing out of that, how far you can get the hours of labour regulated, and how far you can get the labour during those hours made not competitive, and not oppressive to the workmen.

Later in the inquiry Sir Robert Peel, the son of the former Prime Minister, accused Ruskin of "throwing a slur upon the character of the upper classes," a charge which he did not attempt to refute. And when the chairman asked Ruskin if he were not slandering "the idea of competition," he replied, "Yes, very distinctly; I intended not only to cast a slur, but to express my excessive horror of the principle of competition, in every way." Nations, like individuals, should not compete but do the work for which each is best fitted.

To determine what should be done for the laborer, we ought to "suppose that he was our own son," and what we would want to do for him, "we should strive to do for the workman."

The inquiry was held in March of 1860. No one present should have been surprised that the witness who, in July, published the final volume of *Modern Painters* would in September issue the first chapter of *Unto This Last*. Eight years earlier, when Ruskin was completing *The Stones of Venice*, he had written in a despairing letter to his father that, if he lived, he would someday write "a great essay on Man's Work, which will be the work of my life." In turning from Ruskin's great essay on man's art to his essay on man's labor, we will not confront a new subject but complete the single massive volume, his life's work, in which both essays are bound.

VI. MY FATHER'S HOUSE

"I am, and my father was before me, a violent Tory of the old school;—Walter Scott's school, that is to say, and Homer's." So begins the autobiography of a great nineteenth-century radical, in contrast to whose criticism of society, as Bernard Shaw wrote, the invective of Lenin pales and the indictments of Karl Marx seem like the platitudes of a rural Dean.

Ruskin was introduced to English society when he was about five years old. His father was making a fortune as a sherry merchant and each summer the Ruskins toured England in a post chaise which made the rounds of John James's wealthy country patrons. Released from the somber, toyless house at Herne Hill, perched on his specially installed seat in the front of the carriage, or walking through the grand galleries and gardens of the patrons' estates, Ruskin took in with boyish, romantic eyes an England which was a survival of the previous century, when the landed aristocracy had been the center of the nation's power and wealth. As the carriage made its rounds, industrialists, financiers, and merchants like Ruskin's father were already encroaching on the preserves and disputing the prerogatives of the old ruling class.

John James Ruskin, the son of an Edinburgh grocer, dissociated himself from the class in which he was rising and espoused the tastes and politics of the old order. He passed on to his son a reverence for that order as it was celebrated in the novels of Scott, and as it could still be seen from the windows of a post chaise, provided one drew the blinds when passing the slums which were mushrooming around the industrial centers of the Midlands like some sub-human, malignant growth. As Ruskin matured, his eyes opened on a double hor-

ror: on a hovel seen not in isolation but set against the background of a castle; on Lazarus not alone but extending a hand to an unregarding Dives. He never forgot these early journeys, his father's readings from Scott, or the *noblesse oblige* which prevailed in his parents' household. In defiance of *laissez faire*, the Ruskins maintained a small army of superannuated servants; one especially old lady had the sole function of distributing desserts. From these memories, from what outraged Ruskin in the England of his day, from what he clung to of the England of the past, emerged the most personal and potent of all critiques of nineteenth-century capitalism. The "violent Tory" of the old school with equal justice described himself as the "reddest also of the red."

Yet at bottom he was neither. Seeing more widely and deeply than did either extreme of the political spectrum, Ruskin alienated both parties, as well as those who preferred to blunder along in the middle of the road. Like all genuine revolutionaries, he passed beyond politics. He wrote with the peculiar disinterestedness which, because they could not comprehend it, was repugnant to all partisans but which was intensely attractive to a classless commoner such as Gandhi, or to a classless aristocrat such as Tolstoy.

Ruskin's social criticism is at once exciting and deeply disturbing, for it attacks our preconceptions, advances attitudes we habitually assume to be antithetical, flatters our convictions and then explodes them. Midway through *Unto This Last,* after making the then radical proposals of a guaranteed annual wage and old-age benefits, he reassures his readers that he is not an egalitarian but a staunch defender of private property. The rightist reader at last recognizes a reassuring note; the leftist winces. But both are suddenly tumbled by one of those buffeting, ironic sentences which come to Ruskin so easily in *Unto This Last* because, crossing all party lines, he has the mobility to attack the elemental acquisitiveness which both right and left dignify into principle. So far, Ruskin asserts, is he from invalidating the security of property

that the whole gist of these papers will be found ultimately to aim at an extension in its range; and whereas it has long been known and declared that the poor have no right to the property of the rich, I wish it also

to be known and declared that the rich have no right to the property of the poor.

ii

Before Ruskin could write *Unto This Last*, he had to confront an agonized conflict with his parents and within himself. Indeed, the tensions inside Denmark Hill colored his social criticism as strongly as the barbarism of the world outside it. Margaret Ruskin never quite forgave her son for not becoming a distinguished Evangelical clergyman. John James Ruskin had scarcely reconciled himself to his son's being a critic of art rather than a bishop or a second Byron when he was shocked into suppressing three highly radical letters to the *Times* which Ruskin had naïvely hoped would be approved by the paternal censor. Had Ruskin's life been less tortuously bound up in the lives of his parents and theirs less obsessively centered on their son, had there existed within the intimate yet emotionally frigid Ruskin household the authority which guides without thwarting, the love which ministers without maiming, Ruskin might have turned to social criticism unburdened by the anxieties which attended his change of career. Yet without that heavy, ultimately deranging burden, he would never have become a social critic at all.

Under his father's prodding, Ruskin had at last completed *Modern Painters* in the winter of 1859–60. The following summer, feeling intensely ill at ease at Denmark Hill, he went abroad to Chamonix and in the shadow of the same mountains which had inspired the most eloquent passages of *Modern Painters* he wrote *Unto This Last*. There the eulogist of Turner and Tintoretto, of Alpine vistas and Venetian palaces, gave up his art studies and began what he called "the days of reprobation."

They were to be days of self-rebuke as well. Ruskin's social criticism is in part an atonement for pleasures which his large means and exquisitely refined senses enabled him to afford, but which his conscience never allowed him wholly to enjoy. For his mother, a rigorous Scottish Puritan who feared his being corrupted even by toys, had bequeathed him a profound sense of guilt. His social criticism sprang from still another source of discontent. Like the

innumerable charities through which Ruskin depleted the fortune he inherited from his father, the days he gave to reforming society reflect not only an innate compassion, but also a defiance of his father's mercantile principles, indeed an attempt to dissipate his authority. In the affluent yet ascetic Ruskin home the Evangelical child became an evangelizing social critic. Although he bitterly rejected his mother's creed and his father's economics, he remained throughout his life tormented by the temptations his father made possible and his mother forbade.

The role of her teaching in shaping—and warping—Ruskin's thought cannot be exaggerated. In imitation of the Biblical Hannah, Margaret Ruskin solemnly devoted her son to God before he was born. Soon after he could read, she instituted a rigorous course of Bible reading and memorization which lasted until he went to Oxford and which he continued without supervision for the rest of his life. No tutor could have been more relentless. For three weeks they had a battle of wills over the accenting of a single word, until Ruskin placed the stress where, his mother insisted, it properly belonged. He considered these tedious, fanatically disciplined lessons "the one *essential* part" of his education. They gave him a mastery of the cadenced music of words, a sensitivity to nuance and a respect for meaning, which colored all that he wrote. More important, they exposed him to a body of beliefs which endowed his life with a sense of mission and his writing with an overriding moral purpose. His first recorded words were a sermon; at the age of four, from an improvised pulpit of red cushions, he exhorted: "People, be good!" He was a moralist almost from birth. The message of *Unto This Last*, even its Biblical title, ultimately was derived from this earliest period of his awareness.

Ruskin's biographers have treated his Evangelical heritage as a protracted curse under which he labored in youth and which he finally shook off in 1858, when he shut his ears to a fire-and-brimstone sermon in a Turinese chapel. Yet the story of unconversion which Ruskin tells in *Praeterita* is quite misleading. True, he had rejected the parochialism and pietistic bigotries of his mother's creed. From these he emerged unscathed, save for the lingering Puritan

conviction that France was wicked, a prejudice which blinded him to the fact that the French Impressionists of the 1870s, whom he could not bring himself to see and could only in ignorance condemn, exemplified the very principles for which he had praised Turner in the 1840s. But in a deeper sense Ruskin was never unconverted.

Rather he worked his way through the rigid, peripheral dogmas he had inherited to the central ethical core of the Old Testament Prophets and of the Gospels. His social criticism is an impassioned attempt to endow the ethics of capitalism with the Justice taught by the one and the Mercy enjoined by the other. The whole orientation of Ruskin's attack upon Victorian society is implicit in those texts he committed to memory under the stern tutelage of his mother. He denied her desires for his career, yet he remained in essence a lay preacher throughout his life. He preached, however, to a far wider audience and to a far finer purpose than he could ever have done from the pulpit of an Evangelical chapel. Perhaps he was unconsciously fulfilling his mother's wishes when, lecturing in Edinburgh, he surprised his audience by his "eminently clerical" manner of dress and delivery.

"The great conversions of the nineteenth century," Bernard Shaw wrote, "were not convictions of individual, but of social sin. The first half of the nineteenth century considered itself the greatest of all centuries. The second discovered that it was the wickedest of all the centuries." The two kinds of conversion were intimately connected, for without Evangelicalism the discovery of "social sin" would never have been made. The early decades of the century marked a period of intense religious awakening, which was most notable among the Evangelicals. But it was also evident among the Anglicans, the Dissenters of all sects, and the many converts to Catholicism, including John Henry Newman, who was the product of an Evangelical childhood. Newman moved from lesser certainties to greater, from Low Church to High Church to Rome. In other Evangelical homes the movement was in the opposite direction. Ruskin, George Eliot, and Carlyle all radically modified or abandoned the dogmatic basis of their faith, but, like Newman, they

were deeply affected by their early religious experience. Retaining the urge to preach, to enlighten, to save, they quickened the conscience of the age. Their obsession with saving their own souls— "May I seek to be sanctified wholly!" George Eliot exclaimed on the eve of her nineteenth birthday—led to their desire to save society. George Eliot preached the Religion of Humanity; Carlyle, the Gospel of Work; Ruskin, the Gospels of Social Justice and Compassion. They gave the age its pervasive moral tone and formed a latter-day, secular analogue to the zealous friars of the thirteenth century who, preaching in market place or village square, cleansed the moral fabric of England. Conscience-stricken Puritans like Margaret Ruskin bred a generation of moralists, novelists, and social critics whose apostasy altered only the direction, not the intensity, of their fervor.

This astringent environment of self-scrutiny and dedication conditioned Ruskin's whole attitude toward his life's work. Adopting the Evangelical idiom he came to despise, he wrote in 1841 to ask a friend whether one was justified in giving oneself to the study of art "while the earth is failing under our feet, and our fellows are departing every instant into eternal pain." How might one—how might *he*—best use his gifts in the service of the Lord? When Ruskin was writing *Modern Painters* he answered the question by convincing himself that he was not selfishly cultivating his own taste but awakening the deadened sensibilities of England to the divine hieroglyph of art. After 1860 he answered it by trying to save his fellows not from eternal pain, but from the temporal hell into which *laissez faire* had thrust them.

One precept of the Evangelical ethic retained an extraordinary hold upon Ruskin long after his unconversion. The cardinal virtue of that ethic was self-denial; the cardinal vice, self-indulgence. Inevitably one would someday face the sternest of Judges, who, according to a favorite Evangelical text, "is a consuming fire, even a jealous God." Although Christ's atoning sacrifice was the ultimate hope of the sinner, God's hourly judgment of him was the present, terrifying reality. An impure thought, an unguarded gesture might

provoke the wrathful sentence, "Depart from me, ye cursed, into everlasting fire." The child of an Evangelical home, closely watched by his parents and ever under the scrutiny of his Maker, was trained to

Rise up then in the morning with the purpose that (please God) the day shall not pass without its self-denial. . . . Let your very rising from your bed be a self-denial; let your meals be self-denials.

So repressive a discipline necessarily intensified the anxieties peculiar to childhood. One thinks of the young Newman fearfully crossing himself whenever he entered a dark room or of J. A. Symonds, the *fin de siècle* poet and critic, who at the age of seven suffered from a morbid sense of sin and awoke screaming at night about imagined acts of disobedience. The danger inherent in forsaking such a faith was that one might retain the anxieties and guilts of one's childhood years after abandoning the belief that one was saved. Nightmares like those of Symonds's youth were far more fearfully to afflict Ruskin in late middle age. In 1878 his first attack of madness was marked by terrified delusions that "the Evil One," in the guise of a large black cat which sprang at him from behind a mirror, had appeared in his bedroom and commanded him to commit some fearful wrong which he was powerless to resist. Loathsome spirits crept out of the darkness and formed themselves into corporeal shapes "almost too horrible to think of." Chief among them was "the tyrant Devil," whom Ruskin still saw through the terrified eyes of an Evangelical child who had been hedged about with nameless temptations and taught to fear his most natural impulses as flames lighting the path to hell.

Long before his first attack of madness, Ruskin's life had begun to center upon a series of guilty indulgences and promised renunciations. As he neared his thirty-fifth birthday, he confessed to his father,

I cannot say that I have in any way "taken up my cross" or "denied myself"; neither have I visited the poor nor fed them. . . . I am going to preach some most *severe* doctrines in my next book, and I *must* act up to them in not going on spending in works of art.

Yet within months of making this resolution he recorded in his diary:

On Friday the 24th [of February 1854] I got the greatest treasure I have yet obtained in all my life: St. Louis' Psalter.

The vengeful furies of Ruskin's conscience would not let him possess his treasure in peace. A visitor, shocked to find Ruskin in his study cutting apart the Psalter (he had already pressed his friend Charles Eliot Norton to accept three of its leaves and had given six others to Oxford), asked him whether he could "do something to get the pages right again." "Oh yes," he replied with a sad smile, "these old books have in them an evil spirit, which is always throwing them into disorder." The evil spirit which led Ruskin to dismember his manuscripts was exacting a kind of perverse penance for his purchases.

He was a compulsive collector throughout his life and crowded his rooms with paintings, illuminated manuscripts, engravings, fragments of sculpture, cases of coins, minerals, botanical specimens, and precious stones. The more he acquired, the more he felt obliged to give away, until he came to feel that even his study of art was an unforgivable self-indulgence. He endowed a drawing school at Oxford and filled a gallery with examples from his own collection; founded a museum at Sheffield; contributed to the Fitzwilliam Museum at Cambridge, to Harrow, to the British Museum, and to several other collections. The same evil spirit which defaced Ruskin's manuscripts and prompted his innumerable benefactions at length drove him, as he phrased it, from the quiet of his study into the streets of "a besieged city, to seek . . . bread and water for its multitudes."

At the same time that his religious convictions dissolved in doubt, his sense of responsibility for his fellow man ceased to be narrowly Evangelical and became more movingly human. In 1863 he wrote to Norton that he was

tormented between the longing for rest and for lovely life, and the sense of the terrific call of human crime for resistance and of human misery for help—though it seems to me as the voice of a river of blood which can but sweep me down in the midst of its black clots, helpless.

The passage is vibrant with the anxious, corrosive conflict between self-denial and self-indulgence which darkened Ruskin's middle years and which culminated in an urge to sacrifice his energies, indeed his sanity, in the service of others.

Early in the 1860s, after Ruskin could no longer bear the tensions of Denmark Hill, he sought refuge through a kind of self-imposed exile in Switzerland. There he continued his studies of political economy and contemplated building a home of his own. For the religious heresies which strained his relationship with his mother and the economic heresies which were alienating him from his father had left him with a feeling of "unendurable solitude" in his parents' home. In an extraordinary letter to Lady Trevelyan he confessed:

I know my father is ill, but I cannot stay at home just now, or should fall indubitably ill myself, also, which would make him worse. . . . For we disagree about all the Universe, and it vexes him, and much more than vexes me. If he loved me less, and believed in me more, we should get on; but his whole life is bound up in me, and yet he thinks me a fool —that is to say, he is mightily pleased if I write anything that has big words and no sense in it, and would give half his fortune to make me a member of Parliament if he thought I would talk, provided only the talk hurt nobody, and was all in the papers.

This form of affection galls me like hot iron, and I am in a state of subdued fury whenever I am at home, which dries all the marrow out of every bone in me. . . . I must have a house of my own now somewhere.

The very futility of Ruskin's attempted flight from his parents is revealing. One mountainous tract he chose for the intended home rose four thousand feet above an Alpine plain and was without any source of water. The same pressures which drove him from Denmark Hill rendered him incapable of living elsewhere. His diary for December 15, 1862, reads: "Leave [home] for Christmas at Mornex. Cruel!" Years later, on re-reading his account of the Swiss sojourn, he wrote below his old entries, "Wilfully desolate Christmas. . . . I write this Dec[ember] 24th, 1884, desolate now in due punishment." He must have known that inevitably he would return to live with his parents, for in a letter anticipating his departure from

Switzerland he cautioned his father to be most firm in his choice of visitors to Denmark Hill: "I do not believe their religion, disdain their politics, and cannot return their affection—how should I talk to them?" John James Ruskin was perceptive enough to know that in place of "visitors" he should read "parents"; Ruskin had forsaken his mother's faith, disdained his father's politics, and could respond to his parents' affection only in the tormented knowledge that they had, unwittingly, warped his capacity to love.

Despite their growing estrangement, Ruskin published nothing that was not first subject to the censorship of his father. John James was both at a loss to comprehend his son's radicalism and deeply concerned lest his forays into political economy destroy his reputation as an art critic.[1] In 1852 Ruskin had aroused his father's fears by repeatedly requesting consent to publish three letters to the *Times* which advocated radical reforms in taxation, voting, and education. He concealed his disavowal of Tory principles from himself in order to hide his apostasy from his father: "I believe when you have read the letters once or twice more, you will see there are no very serious points of disagreement between us." Although the letters anticipated many of the reforms Ruskin was to advocate in *Unto This Last*, his almost timorous deference to his father's judgment insured their suppression.

The issue was closed to further debate when John James wrote,

My feelings of attacks on your books and on your newspaper writing differ from yours in this way. I think all attacks on your books are only as the waves beating on Eddystone Lighthouse, whereas your politics are Slum Buildings liable to be knocked down.

Ruskin capitulated, at least for the moment. But he did not forget his father's derisive image or the letters he had been pressured into setting aside. To the slur on Ruskin's politics we owe much of the

[1] Ruskin's father was always more sensitive to public opinion than was Ruskin himself, who enjoyed a kind of solitary confidence in his genius and was convinced of the ultimate acceptance of what he had to say. Cf. a letter in which John James wrote of his greater "regard for public opinion . . . a malady or weakness with me, arising from want of self-respect" (XXXVI, xix). John James retained the merchant's desire to please; his son took the prophet's license of rebuking his public.

biting intensity, the fierce concentration of language and purpose, which animate *Unto This Last*. He had eight years in which to brood over his slums and to render invulnerable the structure he at length set before the public. Undoubtedly recalling his father's words, he later spoke of *Unto This Last* as "the only book, properly to be called a book, that I have yet written myself, the one that will stand (if anything stand) surest and longest of all work of mine."

The book first appeared in 1860 in the *Cornhill Magazine*. John James, underestimating the hostile response of the press, had reluctantly approved of publication. He seems to have misread the essays, willfully blinding himself to their explosive doctrines, quite as Ruskin had done with his own letters to the *Times* a decade earlier. "I am charmed with the [first] paper," he wrote to a friend, "and it can do no harm. . . . The tone is high, and our tone in the city is much too low."

Ruskin penetrated the façade of his father's uneasy self-deception. "My father," he wrote to Lady Trevelyan, "is . . . contemplating my *Cornhill* gambols with a terrified complacency which is quite touching." But the attacks of the press soon made even the pretense of complacency impossible. Ruskin was charged with writing utter imbecility; he was wicked, sniveling, and, like "a mad governess," was trying to preach the world to death. If he were not crushed at once, his wild words might open a "moral floodgate . . . and drown us all." Thackeray, the editor of the *Cornhill*, was compelled by his publishers to discontinue the essays and notified Ruskin that the fourth installment would have to be the last. It was a felicitous injunction. Throughout his literary career Ruskin could always publish what he pleased, first at his father's and then at his own expense. Freed of editorial discipline, he was under no compulsion to purge his books of redundance or irrelevance. But now he had to concentrate the full force of his thought and rhetoric into a few pages. In the final chapter he said all that was essential, the remainder spilling over into the lesser sequel, *Munera Pulveris*. The result was the great central work of Ruskin's middle years.

After writing *Unto This Last* he lapsed into a deep depression which lasted until his father's death. Further attempts to suppress

his social criticism elicited letters that were alternately strident and contrite, rebellious and submissive. "All interference with me torments me," he wrote to his father, who disapproved of publishing part of *Munera Pulveris:* "I don't mind this a bit if it does you any good to stop the paper—only, don't think of me in such matters—the one only thing I can have is liberty." John James must have responded to his son's outburst with tact and sympathy, for Ruskin replied: "If you write such nice letters in answer, it is enough to make me go on writing half cruel letters: but I hope they are over now; I can hardly account for the instinct which forced them from me."

But the instinct which forced these letters from him would not be suppressed. The colloquy of estranged affection and guilty self-reproach persisted until John James's death in 1864, after which Ruskin was to rehearse their dialogue in pain for the rest of his life. Written with a cruel, almost frightening self-knowledge, Ruskin's last letter to his father is an angry indictment of his parents for having forced him into an effeminate dependence and thwarted him "in all the earnest fire of passion and life." The letter was posted from a girls' school where, seeking refuge from Denmark Hill and living as a kind of avuncular pet, he found the only love—a child's love—to which he could fully respond. On the eve of his father's funeral, Ruskin wrote in frigid, illusionless grief of the silence which had alienated him from his father, the silence not of hate but of embittered love. "You never have had," he told his friend Acland,

nor with all your medical experience have you ever, probably, seen—the loss of a father who would have sacrificed his life for his son, and yet forced his son to sacrifice his life to him, and sacrifice it in vain. It is an exquisite piece of tragedy altogether—very much like Lear, in a ludicrous commercial way—Cordelia remaining unchanged and her friends writing to her afterwards—wasn't she sorry for the pain she had given her father by not speaking when she should?

The tortured ambivalence of Ruskin's attitude toward his father repeats itself with striking clarity in his social criticism. Torn between the conflicting urges to revere and to oppose him, to submit

to his will and to defy it, Ruskin is, like his father, a "violent Tory" and, in defiance of him, "the reddest also of the red." John James was a merchant who had made a fortune following the precepts of the political economists; his son attacked their principles with an almost malevolent ferocity. He disbursed his inheritance as though it were a painful reminder of paternal authority and spent over £10,000 founding a utopian community in which, significantly, there were to be no merchants. When he began his attack on the political economists, he left home and stripped himself of some fifty treasured Turner drawings which his father had given him. It is impossible not to see in the pattern of Ruskin's actions during this period, or in his social criticism at large, an attempt to defy his father's dominance, to achieve in his books a freedom from paternal control which he could never achieve in life.

Yet his father and he did not, as Ruskin claimed, "disagree about all the universe." Both were authoritarian, Royalist, fiercely anti-republican. "The Americans, as a nation," he wrote in *Time and Tide*, "set their trust in liberty and in equality, of which I detest the one, and deny the possibility of the other." John James's influence extended well beyond party allegiances and ultimately dominated his son's conception of the state itself. Ruskin maintained that the true science of political economy applies not only to the operations of the mill and the market place, but to the entire *polis*, to the commonwealth and common well-being of all citizens. The ideal *polis* is a harmonious aggregate of individual households and stands in relation to its citizens as a parent does to his child. Such a state functions like "a farm in which the master was a father, and in which all the servants were sons . . . and in which all acts and services were not only to be sweetened by brotherly concord, but to be enforced by fatherly authority." Beyond the four walls of the home, the judge, the general, the employer, the landowner, ought all to serve *in loco parentis*. Ruskin's conception of the social order is insistently paternalistic, indeed feudal in its stress upon the *noblesse oblige* of the governing classes and the absolute fealty of the governed.

There is something quaint and unreal about the whole concep-

tion. In his attempt to remake the scrambling, thieving chaos of *laissez-faire* England into a plentiful garden with its gates open to all, Ruskin failed sufficiently to account for the irreducible antagonism between classes, or for the fact that human lions do not as a rule lie peaceably beside human lambs. The unreality stems from Ruskin's modeling the political economy of a nation on the extraordinary economy of his own home. The strong, paternalistic state which rules in justice and generously distributes its resources among its citizens is a fantasy born in Denmark Hill, an idealized image of John James Ruskin presiding in "fatherly authority" over his citizen-son.[2]

[2] After his father's death, Ruskin acted out this fantasy in his role as founder and Master of the St. George's Guild, over whose agrarian communities he exercised a benevolent lordship.

VII. DIVES AND LAZARUS

The reviewer who warned a century ago that Ruskin must be crushed, lest his wild words destroy us all, could better appreciate the radical intent of *Unto This Last* than can we, who accept its once revolutionary proposals as the inherent rights of citizens living under a civilized government. Legislation to harness the nation's resources in the public interest still arouses cries of "creeping socialism," but the galloping, conscienceless capitalism of the nineteenth century has ceased to exist. Adam Smith's "invisible hand" has been replaced by the visibly benevolent hand of government. Indeed, the current quarrel between left and right concerns not the establishment of the Welfare State but the definition of its frontiers; it would require a revolution to undo the revolution which Ruskin's book helped bring about.

We have only to recall the evidence which Friedrich Engels cites in *The Condition of the Working Class in England in 1844* to appreciate the magnitude of the change and the enormity of the barbarisms which impelled Ruskin to write *Unto This Last*. Summarizing a Parliamentary report, Engels wrote that children were employed in factories usually at the age of eight or nine, occasionally at the age of five, and that they worked fourteen to sixteen hours a day, exclusive of meals. Part of the wages of women went to narcotics, which pacified the underfed children left at home because they were too young to work. These doses of "quietness" were often administered three times a day. The practice persisted on so large a scale that in the 1870s Ruskin could cite in *Fors Clavigera* a newspaper account of the weekly sale of hundreds of gallons of laudanum to families living in the manufacturing districts.

Within the factories, overseers flogged those whose output fell below the minimum. Malnutrition, overwork, and the distorted positions required of the laborers produced bodily deformities of all sorts. Since it was more costly to replace unsafe machines than their operators, accidents were commonplace and often fatal. In one of the few instances in which Engels relies on personal observation rather than official reports, he compares walking among the great number of cripples in Manchester to "living in the midst of an army just returned from a campaign." The records of the Manchester Infirmary justify his simile. In 1842 alone over nine hundred lacerated or mutilated patients received treatment; the figure excludes those who died on the spot after being mangled by the cogs and belts of the various mechanisms.

Conditions in the mines were even more inhuman than in the factories. Children too small to load or haul coal were stationed in the darkened shafts to open and close doors. The more strenuous labor of hauling coal within the mines was performed by older children and by women. These "drawers," as they were called, pulled large, wheelless tubs laden with coal along uneven shafts which were often only two feet high. Crawling on their hands and knees, the drawers were fastened to the tubs by a chain which, passing between their legs, was attached to a harness around their waists. A woman drawer testified that "the belt and chain are worse when we are in a family way."

When Lord Shaftesbury in 1844 attempted unsuccessfully to move Parliament to limit the working hours of women and children to ten a day,[1] he and other Tories were opposed most vociferously by the Liberals in the belief that the greatest of evils was government interference. The Liberals argued that "women and young persons are capable of making their own bargains" and that the sponsors of factory legislation "are victims of a misguided and perverted humanity." For the prosperity of England, and hence labor's

[1] The Ten Hours Bill was passed in 1847, but it was something of a misnomer, for it applied only to textile workers and was neither wholly enforced nor enforceable. Previous factory legislation, with the exception of Shaftesbury's Act of 1833, remained almost totally ineffective for want of any provisions to compel compliance.

share of that prosperity (a child of seven earned two shillings six-pence for his week in the coal pits), would be destroyed by welfare legislation. Clearly Ruskin's attack upon Liberalism was not the outcry of a reactionary but a symptom of the misguided and per-verted humanity from which he began acutely to suffer in the 1850s.

He had seen the industrial centers at first hand, if fleetingly, when lecturing on art at Manchester and Bradford. But he con-fronted daily another segment of the working class—those who made their scant living on the streets of London and whom Henry May-hew has portrayed in shocking detail in *London Labour and the London Poor* (1851–62). Mayhew's London must be seen against a larger background of prosperity and rising productivity. The va-grants who subsisted on the decaying shrimps and offal of Hunger-ford Market scavenged not far from the Crystal Palace, where Vic-torian England displayed the machines on which it had built a prosperity it did not know how to distribute.

The image of London that emerges from Mayhew's pages is that of a sprawling yet delicately balanced mechanism in which sub-sistence for the 45,000 street sellers and scavengers was so barely above the minimum that three days of consecutive rain reduced the greater number of them to starvation. Under such pressures noth-ing that could be converted into food or farthings went unsal-vaged: vegetable parings and rotting meat, discarded tea, bones, garbage, even the excrement of animals and humans. Fantastic ar-mies, each with their appointed routes and implements, combed the streets, the cesspools, the refuse heaps, the muddy banks and waters of the Thames.

Such a city bred a grotesque, irreducible individuality that was itself a mocking caricature of reality. Mayhew's London is Dickens's London, with its heaps of "dust" and its scavengers of drowned bodies, its thieves, its orphans, its workhouses, its slums, its Scrooges. Dickens was not a caricaturist but the sternest of realists; in the vast, lucrative mounds of ordure that all levels of society connive to possess in *Our Mutual Friend*, he saw the symbol of the same perverted waste of human energies, the same preference for gold over life that Ruskin decried in *Unto This Last*.

Even the poorest of the independent poor—half-starved "bone-grubbers" and "mudlarks"—preferred their labor to the stone-breaking and semi-penal confinement of the workhouses. Charity which required no labor of its recipients was dispensed by the Asylum for the Houseless Poor of London. Its doors were opened only when the thermometer reached the freezing point. At nightfall it offered dried bread and warmth to the ragged regiment which lined up, four deep, and stretched "far up and down the narrow lane, until the crowd is like a hedge to the roadway." Many were without shirts. Some had no shoes and shifted their weight from foot to foot, the livid flesh that had tramped through the snow looking like "half-cooked meat." This was the scene Ruskin looked upon in the capital of the prosperous workshop of the world exactly one hundred years ago.

ii

Despite the constancy of human greed and brutality, it is difficult to account for the conditions I have just described. The social and economic upheavals of the Industrial Revolution do not alone explain them. One has to look for a body of beliefs, an ideology, which sanctioned a barbarism in the nineteenth century surpassed, in different areas, only by our own. For a civilized nation does not chain children to coal carts without believing that such a posture is for their own, or for some higher, good.

The body of economic dogmas which, although it did not cause, nonetheless rationalized the abuse of labor was known as the science of Political Economy. To the destruction of its claim to being a science Ruskin gave the most prominent and persuasive portions of *Unto This Last*. The bible of the political economists was Adam Smith's *Wealth of Nations* (1776). Smith wrote when England was still predominantly agricultural and the government exercised a coercive control over commerce and labor. For the tyranny of monopolies and patents royal he substituted the free functioning of supply and demand. Unfettered by "the folly of human laws," each individual's attempt to better his own condition would, as if guided by an invisible hand, result in the maximum possible benefit to all.

Smith failed to foresee that *laissez faire* would triumph at a time when labor needed not to be liberated from government but shielded from the captains of industry who had won the power to conscript, sell, and discard lives in the open market. His doctrines, elaborated in a later age by Malthus and Ricardo and then perverted by popularizers, resulted in the granting to labor of only one unquestioned freedom—the freedom to starve.

Malthus argued that charity merely swells the ranks of the poor, in turn lowering their wages and multiplying their miseries. Their only hope lay in "moral restraint" or the postponement of marriage. But since such restraint was unfeasible and since birth control was unthinkable to the early Victorians (the young J. S. Mill was arrested for distributing "obscene" literature on contraception), the practical result of Malthus's premises meant accepting near starvation as the necessary condition of the working classes. When to Malthus's grim elucidation of the dismal science Ricardo added his iron law of wages, the arsenal of the political economists was complete. Ricardo maintained that in a society composed of antagonistic classes, the "wage fund" available to labor inevitably seeks the lowest possible level consistent with survival.

But, as Ruskin was to urge in *Unto This Last*, the multiplication of human life and the distribution of the fruits of its labor need not be governed by the same laws that check the population of wolves and rats. If the poor would dissipate better wages in drink or the misery of still larger families, then there was something fatally deficient in the opportunities for fulfillment which the rich offered them. Ruskin saw that the central problem facing Victorian England was not an excessive population which threatened to consume a limited production, but the maldistribution of an *increasing* productivity:

Our cities are a wilderness of spinning wheels . . . yet the people have not clothes. We have blackened every leaf of English greenwood with ashes, and the people die of cold; our harbours are a forest of merchant ships, and the people die of hunger.[2]

[2] Cf. the opening sentences of Carlyle's *Past and Present:* "England is full of wealth, of multifarious produce, supply for human want in every

The political economists' charge that the reforms Ruskin advocated were the fantasies of a utopian sentimentalist was disproved by the fact that productivity was rising at a greater rate than population. As Ruskin pointed out, the root of the problem was not the imprudence of the poor but the avarice of the rich. Yet few others bothered to refute Malthus, partly because it was contrary to their interests to do so, and partly because the poor, too busy drinking up their wages and too afflicted with human appetites, went on behaving exactly as Malthus said they did.

In so far as the political economists formulated laws governing production and wages, they merely described certain economic arrangements as they in fact existed, not as they ought to have been. They were economists, not moralists. Yet they supplied, almost as disinterested spectators, the intellectual grist which was as essential to the running of the mills of England as the grist of cheap, abundant human labor. Dickens has dramatized in *Hard Times* this relationship between the august economists and the grossest of their industrialist followers. Like Ruskin, he sought to destroy the alliance between utilitarian ethics and *laissez-faire* economics which constituted the ethos of industrial capitalism. The central figure of the novel, Mr. Gradgrind, is a principled if grimly benighted utilitarian who brings up his children to believe only in the hard, measurable facts of the market place. He is associated with Josiah Bounderby, a rugged individualist who personifies in a brutal, comic caricature the crude greeds latent in the philosophy of Mr. Gradgrind. Mr. Gradgrind's giving of his daughter in loveless wedlock to Bounderby symbolizes the unhappy marriage of convenience that existed between the "science" of the economists and the practice of the Bounderby industrialists. Dickens was careful to distinguish between the essentially moral though misguided father and the irredeemably bestial son-in-law. Ruskin, less scrupulous in dealing with the enemy, was content to blur the distinction between the two.

kind; yet England is dying of inanition. . . . " When Ruskin gave away his copy of *Past and Present,* he wrote in an accompanying letter, "I have sent you a book which I read no more because it has become a part of myself, and my old marks in it are now useless, because in my heart I mark it all" (XXVII, 179, n. 1).

The political economists, then, were perhaps naïve but not malevolent. They were naïve to assume that economics is a mathematical science which can be divorced from the human creatures who, unlike Newtonian particles in motion, behave in curiously unpredictable ways. Inheriting the rationalistic, mechanistic assumptions of the eighteenth century, they mistook for universally valid laws certain limited principles which operated to limited advantage in a newly industrialized society. Paradoxically, the more they tried to purge their science of extraneous moral issues, the more they endowed *laissez faire* with a kind of sacred moral sanction. For they appeared to be describing not the local operations of London merchants or Lancashire mill owners, but weighty principles which, with the inevitability of natural law, govern the economic life of man. Tampering with free enterprise was tantamount to meddling with the harmony of nature itself. *Laissez faire* was natural, universal; government imposition of minimum wages or humane working conditions was unnatural and by inference evil. Thus political economy presumed to the objectivity of a science at the same time that it arrogated to itself the subtler authority of a religion.

And, indeed, a pontifical note crept into the journals which popularized the principles of the political economists. *The Economist*, their leading organ, in commenting on the miserable condition of the poor, had

no hesitation in pronouncing, because the masses are suffering, and have long been suffering, without much amending their condition, that they are greatly to blame. . . . Nature makes them responsible for their conduct—why should not we? We find them suffering, and we pronounce them in fault.

With the slightest shift in idiom, the voice of *The Economist* becomes indistinguishable from the voice of Dickens's Mr. Podsnap, who silences the tasteless comment that half a dozen people had lately starved to death in the streets of London with the remark, "Then it was their own fault." Providence, according to Mr. Podsnap, had declared that the poor shall always be with us, and it is not for him to impugn its workings. But we need not look to fiction to find the doctrines of the political economists confused with the

ways of God. William Wilberforce, the Evangelical philanthropist
who freed the black slaves of Africa but feared the liberation of the
white slaves of England, wrote in his *Practical View of Christianity*
that the lowly path of the poor "has been allotted to them by the
hand of God; . . . it is their part faithfully to discharge its duties,
and contentedly to bear its inconveniences." To which Ruskin re-
plied that calling

the confused wreck of social order and life brought about by malicious
collision and competition, an arrangement of Providence, is quite one
of the most insolent and wicked ways in which it is possible to take the
name of God in vain. . . . You knock a man into a ditch, and then you
tell him to remain content in the "position in which Providence has
placed him." That's modern Christianity.

Whether by decree of Providence or by the stern workings of
economic law, the poor, it seems, were fated to remain impover-
ished. "To prevent the recurrence of misery," Malthus wrote, "is,
alas! beyond the power of man." And the *Times* echoed Malthus in
declaring that, although the residents of London's East End lived in
abject misery, "There is no one to blame for this; it is the result of
Nature's simplest laws!" By "no one" the *Times* meant, of course,
none of the leaders of commerce and industry. For them, the *Times*
offered easy absolution by laying the iniquities of society at the door
of the goddess Necessity. But Necessity was the goddess of the
well-to-do, and, being feminine, was illogical to boot. She absolved
the rich for causing, but blamed the poor for suffering, their pov-
erty. The law of 1834 which made poverty a crime against society
epitomized the economic philosophy of the Utilitarians and Lib-
erals; it was also one of the most grimly rational pieces of legislation
ever passed.

The inspiration behind the New Poor Law was Malthus's thesis
that public relief created the very "surplus population" which it was
intended merely to maintain. The Poor Law Commissioners held
that the old system of outdoor relief ruined taxpayers, set a pre-
mium on illegitimate children, and systematically protected "the
idle, the improvident, and the vicious." To eliminate such abuses of
charity, the Law abolished relief in money or provisions and re-

quired that recipients enter workhouses, where families were split apart lest they further increase the surplus population. The workhouses excluded the undeserving by making the food scantier, the labor more rigorous, and the lodgings less attractive than they were for "the independent labourer of the lowest class." The ingenuity of the Commissioners was thus taxed by the almost impossible task of devising a regimen more strenuous than that endured by Mayhew's mudlarks or Engels's miners, yet which would not kill their wards outright.

Thirty years after the law went into effect, Ruskin could still interpolate into a lecture a newspaper account of the paupers at the Andover Workhouse gnawing scraps of putrid flesh and sucking the marrow from the bones of horses which they were required to crush. The Biblical Lazarus, he wrote, could hope to be fed with crumbs from the rich man's table, but the Victorian Lazarus subsisted on scraps from the dog's table. With some notable exceptions —Carlyle, Dickens, Ruskin—it was the considered judgment of the age that the Good Samaritan was a very bad economist.

So bad, indeed, that when Lord Althorp introduced the New Poor Law in Parliament, he felt compelled to apologize for its departure, in certain charitable provisions, from "the more strict principles of political economy." But these deviations were so slight and the bill's logic so remorseless that even the most destitute preferred starving outside the gates of the workhouse to passing through them.[3] Nor did the sub-Spartan regimen of the workhouse alone account for their aversion. The bread of charity was not only scant but exceedingly bitter. For if the system were inevitable, if only "the fittest" survived, if fitness itself were a mark of virtue, then those who failed must be an inferior species whose misery, instead of stigmatizing the system, stigmatized themselves. Ruskin's plea

[3] For a sampling of such cases, see Mayhew, I, 376, 380; II, 78, 154, 161. Cf. Dickens's portrait of Betty Higden in *Our Mutual Friend*. Aged, halfstarved, and fanatically independent, she exclaims, "Kill me rather than take me" to the workhouse and sets out on a fatal flight from London, driven by her horror of falling into the hands of charity. Dickens's apparent excess is in fact a kind of composite documentary of the dread of the workhouse felt by Mayhew's London poor.

that England feed *all* who hungered—not merely "the deserving hungry, nor the industrious hungry, nor the amiable and well-intentioned hungry"—seemed tantamount to subversion.

The Darwinian terms are wholly appropriate once we recall that Malthus's theory of population growth and checks suggested to Darwin the theory of natural selection by which he explained the origin of species. The economic Darwinians of the Victorian age— a kind of bastard progeny of Malthus—absurdly misapplied the competitive laws of the jungle to human society and assumed that fangs were virtues alike in beasts and men.[4] They divided the poor into two classes, the industrious and the idle. The industrious poor, fortunate enough to remain semi-fit, neither wanted nor received charity. The idle or "undeserving poor" were by definition denied aid. This large, miscellaneous class included not only inveterate idlers but also those who were thrown out of work by periodic depressions. In time the enforced degradation of the latter made them indistinguishable from their indolent or improvident brethren. Deprived of protection by the State, unministered to by the Church, rendered superfluous in theory and so treated in fact, they were the human waste product of industrial capitalism.

[4] One recalls Herbert Spencer's assertion that the "poverty of the incapable, the distresses that come upon the imprudent, the starvation of the idle, and those shoulderings aside of the weak by the strong, which leave so many 'in shallows and in miseries,' are the decrees of a large, far-seeing benevolence" (*Social Statics* [New York, D. Appleton & Co., 1872], p. 354). A passage from *Unto This Last* makes an interesting contrast: "In a community regulated only by laws of demand and supply, but protected from open violence, the persons who become rich are, generally speaking, industrious, resolute, proud, covetous, prompt, methodical, sensible, unimaginative, insensitive, and ignorant. The persons who remain poor are the entirely foolish, the entirely wise, the idle, the reckless, the humble, the thoughtful, the dull, the imaginative, the sensitive, the well-informed, the improvident, the irregularly and impulsively wicked, the clumsy knave, the open thief, and the entirely merciful, just, and godly person" (XVII, 90).

VIII. NO WEALTH BUT LIFE

Victorian England was so hostile to the message of *Unto This Last* that for more than a decade after its publication the book was virtually unread. Ruskin was denounced as a subversive, a utopian sentimentalist, a monger of heresies wilder and more dangerous than those which had earlier led him to praise Byzantine and Romanesque art when they were still considered the aboriginal gropings of an esthetic dark age. Yet the reforms which he advocated in *Unto This Last* are almost item for item those effected in the past half-century, and we are slowly realizing the balance of his program.[1]

It is difficult to assess precisely his role in bringing about this bloodless revolution. Clement Attlee, who became a socialist after reading the works of Ruskin and William Morris, wrote that the modern Labour Party was born in 1906, when twenty-nine independent Labourites were returned to the House of Commons; according to a questionnaire circulated among them, the book which most profoundly influenced their thought was *Unto This Last*. By 1910 one hundred thousand copies had been sold and several unauthorized editions had been printed in America. Translations appeared in French, German, and Italian; and a then obscure disciple of Ruskin translated it into Gujarati, an Indic dialect.

[1] Ruskin proposed free state education for the young; vocational training in government workshops which would set national standards of quality and manufacture; employment in these shops or on public works projects of all who were out of work; social security benefits and housing for the old and destitute; minimum wage laws and security of tenure for good work in all trades (XVII, 21–22, 33–35). For his advocacy of rent control, ceilings on the income of the rich, public ownership of transportation, and the formation of a European trading community, see XVII, 317–18, 322, 436, 530–31, and XVIII, 106.

"That book," Gandhi said, "marked the turning point in my life." He had boarded a train in Johannesburg, and to speed the full day's journey to Durban had brought along a copy of *Unto This Last*. He could not set it aside. After a sleepless night he arose with the dawn and resolved to live according to the ideals of "this great book" in which, he wrote, "I discovered some of my deepest convictions . . . and that is why it so captured me and made me transform my life."

Gandhi entitled his translation *Sarvodaya*, or "the welfare of all." His phrase renders perfectly the point of the book and of the parable from which its title derives. Over the protests of those who labored through the heat of the day, the master of the vineyard paid all alike the same wage, even those who were hired at the eleventh hour: "Friend, I do thee no wrong. . . . Take that thine is, and go thy way: I will give unto this last, even as unto thee." Ruskin's state is a secular image of the Lord's vineyard, in which labor is not forced to compete against itself and capital provides a living wage for those who work as well as those who are forced into idleness.

Gospel parables are perhaps irrelevant to a treatise on economics if one holds that the subject is concerned only with marketable commodities, and not at all with the human beings who make and consume them. But the market place cannot be sealed off from the rest of life. Economics, when it is not simply statistics, is indissolubly linked to ethics; is indeed, as Plato and Ruskin knew, a sub-branch of the ultimate science of justice. An economic theory which deliberately divorces wealth from the values of those who create it was, in Ruskin's view, not science but nescience. He perceived that the political economists were as deluded in deriving their principles from a hypothetical Economic Man, devoid of all motives save acquisitiveness, as were the estheticians who had based their study of art upon a hypothetical Esthetic Man, a mere disembodied Perceiver of Beauty. A single, unifying conviction led him to relate esthetic and moral values, economics and ethics.

There is an intellectual anger akin to joy, an exhilaration in destroying the enemy not with force but logic. In this spirit Ruskin launches his attack upon the basic postulate of the political econo-

mists. His prose, no longer flowing in the richly orchestrated paragraphs of *The Stones of Venice*, is a remarkably versatile instrument, supple, incisive, capable in Carlyle's words of cutting "through those unfortunate dismal-science people like . . . a fit of British cholera" or, with equal ease, of rising to a magnificent exhortation. In order to purge their "soi-disant science" of variables, the economists, Ruskin writes, have considered the human being "merely as a covetous machine." After formulating the laws by which this mechanism amasses the greatest possible wealth, they then reintroduce the "disturbing elements" in human nature, such as loyalty and love. But these elements, operating qualitatively and not quantitatively, alter the essence of the creature the moment they are added, and thus nullify the calculations altogether. Its premises granted, Ruskin neither doubts nor impugns the conclusions of such a science. He is simply uninterested in them, as he would be in a science of gymnastics which assumed that men lacked skeletons:

It might be shown, on that supposition, that it would be advantageous to roll the students up into pellets, flatten them into cakes, or stretch them into cables; and that when these results were effected, the reinsertion of the skeleton would be attended with various inconveniences to their constitution. The reasoning might be admirable, the conclusions true, and the science deficient only in applicability. Modern political economy stands on a precisely similar basis. Assuming, not that the human being has no skeleton, but that it is all skeleton, it founds an ossifiant theory of progress on this negation of a soul.

The political economists retorted that they were not concerned with souls, but with the production of riches and the formulation of practical laws governing their acquisition. If so, Ruskin asserted, they were merely *mercantile* and not political economists, for the riches they dealt with were largely irrelevant to the true wealth or well-being of the state.[2] Thus the economists counsel us to buy in the cheapest market and to sell in the dearest; but if charcoal is cheap

[2] Nassau Senior, the most orthodox of the economists, claimed that political economy necessarily ignores the problems of whether wealth is beneficial to its possessor or to society, what mode of distribution is most desirable, and how such distribution can best be obtained. As John T. Fain observes, Ruskin's whole economy "seems to fall under Senior's exclusions" (*Ruskin and the Economists* [Nashville, Tenn., Vanderbilt University Press, 1956], p. 54).

after our roof timbers have burned, or if we sell bread in a market made dear by famine, fire and famine are not therefore national benefits.

Since the power of the guinea in our own pocket depends upon the lack of a guinea in our neighbor's, "the art of making yourself rich, in the ordinary mercantile economist's sense, is . . . the art of keeping your neighbour poor." The economy of "merces" or "pay" simply signifies the accumulation of a legal claim upon, or power over, the labor of others, each claim implying as much debt on one side as riches on the other. It is absurd to assume that such inequalities are advantageous regardless of their method of attainment or the purposes to which they are applied. The gaining of one fortune may enrich the state, the gaining of another impoverish it. The whole issue concerning not only the utility but even the quantity of national wealth

resolves itself finally into one of abstract justice. It is impossible to conclude, of any given mass of acquired wealth, merely by the fact of its existence, whether it signifies good or evil to the nation in the midst of which it exists. Its real value depends on the moral sign attached to it, just as sternly as that of a mathematical quantity depends on the algebraical sign attached to it.

Finally, since the essence of wealth consists in power over men, does it not follow that the nobler and more numerous are the persons over whom it has power, the greater is the wealth? Perhaps "the persons themselves *are* the wealth," are indeed far more valuable than the pieces of gold with which we bridle them: "In fact, it may be discovered that the true veins of wealth are purple—and not in Rock, but in Flesh."

Political economy, then, is not simply the science of getting rich, but of producing and distributing riches to the widest possible national advantage. It is, in short, the science by which a nation grows rich *justly*. Justice is the life of Ruskin's commonwealth, as it is of Plato's. By justice I do not mean mere legality but an organic ordering of the whole society. The justice Plato defines in the *Republic* results from each individual's realizing his particular excellence and fulfilling the particular duties of his class. Since Plato conceives of justice as the virtue of a *citizen*, of an essentially social

creature, the just man can realize his capacities only in a just society. Such a society is necessarily cooperative rather than competitive, hierarchic rather than atomistic, is above all a moral rather than merely a political or economic organism. This is precisely the kind of commonwealth Ruskin sought to bring into being. In Plato's view there could be no true virtue, in Ruskin's no true wealth, save in a just state.

But Plato's state is a superb hypothesis only. At the end of the ninth book of the *Republic* Glaucon suggests that Socrates has founded a commonwealth "in the realm of discourse; for I think it nowhere exists on earth." Socrates replies that its pattern is laid up in heaven for the man who desires to see it, but whether it will ever exist on earth is of no consequence. The setting of the *Republic* is the unhurried realm of sweet reason, with endless time to spin out the most exquisitely elaborated idea in literature. It culminates in the quiescent contemplation of the Good, as its sister realm, St. Augustine's Heavenly City, culminates in the passionate contemplation of God. *Unto This Last*, however, is a call to immediate, practical action. It brings the imperturbable logic of Plato and the impassioned ethics of the Gospels directly into the market place. Its background is not the remote Realm of Ideas but the harshest of actualities: brutally repressed strikes, starvation, gross economic inequities.

One of the chief requisites of a just state, Ruskin argues, is that labor receive a stable, living wage and be assured of employment. Yet under the prevailing system the good workman, instead of laboring for a fixed wage, is forced into competition with the bad, and must either work for starvation wages or not at all. A just wage would be at least equivalent in value to the labor which the worker has expended. To establish the basis for such equivalence, Ruskin analyzes the nature of value, the definition of which constitutes the great final chapter of *Unto This Last*.

By value the political economists meant simply "value in exchange," what an object would fetch in the market.[3] But exchange

[3] The point needs qualification, or we shall fall into the vulgar error of which Ruskin himself was guilty. The political economists did not, as he maintained, deny the existence of all values apart from exchange, but insisted

value and actual value are by no means the same; the most cele-
brated of all sales was closed, after all, for only thirty pieces of
silver. A more mundane example, drawn from Ruskin's own ex-
perience, will serve as well. When living in Venice he had seen sev-
eral of Tintoretto's canvases hanging in ragged fragments from the
ceiling of the Scuola di San Rocco. In the same year, when passing
through Paris, he could buy obscene lithographs displayed under
the lofty arcades of the Rue de Rivoli. According to the laws of sup-
ply and demand, the despised Tintorettos were valueless because
they could not be "exchanged"; according to Ruskin's political econ-
omy, Venice was the wealthier for her ragged canvases, and Paris
the poorer for her obscenities.[4]

We might fairly object that Ruskin's estimate is that of a mor-
alist, not an economist, and that, in John Stuart Mill's words, politi-
cal economy has nothing to do with moral judgments. For an ob-
ject to possess value, however, it must have a certain usefulness or
agreeableness, and its utility is not intrinsic, but depends upon the
"relative human capacity" of the user. Similarly, its agreeableness is
not innate, but depends upon the desires and tastes of the consumer.
The very disposition to buy—be it pornography or art—is in essence
a *moral* disposition. Political economy, the science of value, must
inevitably concern itself not merely with commodities, but with the
"capacities and dispositions" of the consumer, who is himself the
source of value.

Ruskin's whole contribution to economics rests on his humaniza-
tion of the concept of value. He insisted that its origin was not ex-
change, but the life-sustaining capacity of the object itself, its "valor"

that exchange value was the only practicable standard which their science
could employ (see Fain, p. 47). In arguing that political economy required a
broader definition of value, Ruskin was on firm ground. But in claiming that
the economists, including John Stuart Mill, were oblivious to any other stand-
ard of value, he was buttressing his argument with slander.

[4] Shaw quotes the passage and follows it with this notable comment:
"Though Ruskin was certainly not a completely equipped economist, I put
him nevertheless with Jevons as one of the great economists, because he
knocked the first great hole in classic economics by showing that its value basis
was an inhuman and unreal basis, and could not without ruin to civilization
be accepted as a basis for society at all" (*Ruskin's Politics* [London, The Rus-
kin Centenary Council, 1921], pp. 17–18).

or power to "avail towards life." This power is twofold: "intrinsic" —the absolute capacity of a thing to sustain life, regardless of human opinion—and "effectual." An intrinsically valuable object can become effectually valuable only if the user has a corresponding "acceptant capacity." Wealth results when the two kinds of value join, when that which enhances life is in the hands of those who have the capacity to use it. Thus wealth consists not in the mere accumulation of material things, but only of certain kinds of things, and not merely in possession itself, but in *capacity* as well.

Assuming a dichotomized Economic Man, at one moment all hand and at another all mouth, the classical economists had divorced production from consumption. Ruskin's theory of value joined the two in a single, interdependent process. As a painting ultimately completes itself in the perceiver's mind, the viewer half-creating the beauty he perceives, so in Ruskin's economics the purchaser half-creates the value of the object he consumes. In both fields Ruskin's intention was essentially didactic: to create a moral climate in which art and industry could express the widest possible range of human capacities and result not in individual riches but social wealth. Such wealth depends less upon the quantity of what is produced than upon its value, its just distribution, and its wise consumption. We have, as Ruskin put it, the choice of growing grapes or grapeshot; our neighbor, on the strictest principles of exchange, will grow grapes or grapeshot for us, each reaping what he has sown. The manner and issue of consumption

are the real tests of production. Production does not consist in things laboriously made, but in things serviceably consumable; and the question for the nation is not how much labour it employs, but how much life it produces. For as consumption is the end and aim of production, so life is the end and aim of consumption.

The whole argument of the book, as of Ruskin's career as economist, culminates in the single sentence: "THERE IS NO WEALTH BUT LIFE." A strange political economy, Ruskin admits; yet all others, founded on self-interest, are "but the fulfilment of that which once brought schism into the Policy of angels, and ruin into the Economy of Heaven."

Modern Painters and *The Stones of Venice* are dazzling books; their word-painting and sustained energy of elaboration overwhelm the reader. *Unto This Last* is far briefer. It fills fewer than one hundred pages of the clean, large type of the Library Edition. There are eloquent stretches, yet the reader is far less conscious of the prose medium than he is in Ruskin's earlier writing. The effect of *Unto This Last* is not to dazzle but to move. Its impact is surprising, for the once radical program of the book is now commonplace. What, then, accounts for its particular excitement, the sense of revelation it conveyed to Gandhi and still conveys to the modern reader? Its power is that of truth, as relevant to our own age of superabundance as to Ruskin's of relative scarcity.

The glitter of our economic paradise blinds us to Ruskin's central, salutary distinction between affluence and actual wealth, between mere riches and what "avails towards life." Prosperity is measured by mere quantity of production, regardless of the social utility of what is produced, and by mere quantity of consumption, regardless of the intrinsic value of what is consumed. Our bondage to synthetically created wants causes us to neglect our true needs until we are surfeited with junk and gadgetry, possessing built-in obsolescence, the sale of which is stimulated through costly and socially maleficent techniques.[5]

Perhaps as the standard of living rises, our actual wealth—the production of intrinsically valuable things and of human beings with the "acceptant capacity" to use them—is at a standstill. In Ruskin's terms, our wealth is vitiated by its antithesis, *illth*, the expense of human and material resources in producing what is irrelevant or inimical to our real needs. The superfluities which roll off the assembly lines are less the sign of our prosperity than the frankest confession that we do not know what to make when we labor and are unprepared to take our rest. One cannot read *Unto This Last* without the disturbing awareness that the gold of our earthly para-

[5] Ruskin took his text on advertising from the Bible: "'The getting of treasures by a lying tongue is a vanity tossed to and fro of them that seek death.' . . . If we read, instead of 'lying tongue,' 'lying label, title, pretence, or advertisement,' we shall more clearly perceive the bearing of the words on modern business" (XVII, 57–58).

dise is Midas-touched, and will so remain, waiting on the acceptant capacity to transform it again into life.

ii

Ruskin's blindnesses fall into a pattern, as do his perceptions. Near the end of *Unto This Last* he states that progress toward the true felicity he has been urging can be achieved only "by individual, not public effort." Although the individual worker was powerless to improve his own condition, and few employers would voluntarily better it for him, Ruskin was totally indifferent to the attempts of labor to organize itself into an effective force. Yet precisely through such organization, labor in this country and in England won for itself the rights which Ruskin had advocated. Just as he was a prophet of modern architecture, but condemned the very materials through which its principles have been most boldly and brilliantly articulated, so he was a prophet of the Welfare State, but abjured the means by which it came into being.

His instinctive and undiscriminating hatred of industrialism blinded him to the potential role of industrial unions in curing the evils which he himself had attacked. In place of a labor movement, he called for filial loyalty from the employee, and, stranger still, for fatherly benevolence from the same captains of industry whose exploitation of their worker-sons had aroused him to write *Unto This Last*. Fine as it is, Ruskin's plea in the first chapter for the manufacturer to form the market as well as to supply it, for the merchant to accept his sixpenny loss of profit, as the soldier does of life in battle, is inspired nonsense. The paternalism he prescribed did not work in the nineteenth century and, on the whole, it does not work today. Significantly, the longest and perhaps bitterest strike in American history recently crippled a company noted not only for its paternalism but for its intransigent opposition to unions as well. Ruskin failed to realize that until labor concerted its economic power and acquired a legislative voice, such clashes would resemble, as they did late in the nineteenth century and early in the twentieth, the kind of bloody industrial wars Marx had predicted. Yet by stimulating a climate in which economic reform became possible,

Ruskin muted the very conflict which he himself never fully understood.

The simplest explanation of his hostility to a strong labor movement is that he was content to preach reform, but feared its consequences. When he told his working-class readers that their voice would never be "worth a rat's squeak" until they had something to say, and, once determining what that was, they could better achieve their ends than by squeaking in Parliament, he sounded as if he were trying frantically to restrain the revolution his frightened opponents accused him of inciting. But he was not so much opposed to the workingman's exercise of his political rights as contemptuous of politics altogether. He himself, for example, never voted in his life. Reform of the franchise, which was rightly dear to a Liberal like Mill, was for Ruskin a meaningless irrelevance:

No form of government, provided it be a government at all, is, as such, to be either condemned or praised, or contested for in anywise, but by fools. But all forms of government are good just so far as they attain this one vital necessity of policy—*that the wise and kind, few or many, shall govern the unwise and unkind.*

He failed to perceive that, under certain forms of government, the probability of the brutal governing the kind vastly increased.

Now, indifference to parliamentary forms is often the mark of the extreme right, of a contempt for representative government itself. But it can be as well the sign of the extreme left, of a Marxian contempt for bourgeois institutions. Misunderstanding of Ruskin's position often stems from the tendency to associate his distaste for the legislative process with reaction. Despite his protestations that he was a violent Tory, Ruskin was as apolitical as a rational creature can be. Above all he perceived the simple fact that "men must eat, drink, dress, and find shelter, before they can give themselves to politics, science, art, religion, or anything else." The words are not Ruskin's but Engels's. They were spoken at the grave of Marx and express the single, central affinity between Marx's and Ruskin's critiques of society: that in an age of gross exploitation, it was more immediately important to feed men than to enfranchise them.

Ruskin's indifference to the political structure appears lame indeed alongside the eloquent plea of Mill to reform it, or of Marx

to overthrow it. Yet Ruskin's social criticism rests upon a radicalism greater than that of either. Since he distrusted change in institutions and abhorred violence in all forms, he saw little point in reforming, and less in overthrowing, what he felt was unessential. Disbelieving the Marxist myth of a classless society, he recognized that hierarchies were inescapable, and that the aim of government was to insure that they be wisely instituted and justly sustained. In this, it seems to me, Ruskin was the realist; a classless society is an impossibility on earth, and even in heaven the angels are said to share an unequal glory. Marx hoped to end the war of all against all by leveling the structure of society, Ruskin by altering its very substance, humanity. This desire to revolutionize not institutions but the human heart is the ultimate radicalism, precisely as the ethics of *Unto This Last*, which are the ethics of Christ, are ultimately more revolutionary than the politics of Marx.

The Marxist, with half-justified cynicism, retorts that because Ruskin really wanted no change, he advocated an impossible one. But from Ruskin's point of view, neither ballots nor barricades very much alter man, who must himself be the source of all enduring change. And so instead of repairing old institutions, he set out to give men new hearts. In this he resembled Carlyle [6] and Dickens. All three expressed an undisguised contempt for the institutions

[6] If Turner taught Ruskin how to see, Carlyle taught him how to preach. Employing the ethics of the Gospels and the rhetoric of the Prophets in his moving indictment of England's Mammonism, Carlyle created in *Past and Present* the idiom Ruskin was to perfect in *Unto This Last*. But whereas Carlyle could offer no better cure for a viciously competitive society than love of one's masters, Ruskin analyzed the economic problem to its roots and prescribed, instead of hero-worship, the Welfare State. Still, his debt to Carlyle was enormous. In the Preface to *Munera Pulveris*, he wrote of Carlyle as the "friend and guide who has urged me to all chief labour," and in a letter marking the birthday of his "master," he signed himself, "Ever your loving disciple—son, I have almost now a right to say—in what is best of power in me" (XXXVI, 75). Carlyle became, after the death of John James Ruskin, a kind of spiritual father for Ruskin, and in his almost daily letters to "Papa" Carlyle one detects a reverence and untroubled love which, after his boyhood, Ruskin could never extend to his own father. The radical Carlyle of *Past and Present* had inspired Ruskin's own social criticism, but the aging, reactionary Carlyle of "Shooting Niagara" he knew personally and revered. For a useful discussion of Carlyle's influence on Ruskin, see Frederick W. Roe, *The Social Philosophy of Carlyle and Ruskin* (New York, Harcourt, Brace & Co., 1921), chap. iv, "Master and Disciple."

which the Liberals held sacred. For Carlyle Parliament was "our National Palaver," for Dickens the "national dust-yard," for Ruskin "darkness voluble." Dickens expressed the attitude of all three by dismissing the whole bumbling, inhuman machinery of government as a vast "Circumlocution Office" and satirizing the party system as an idiot's charade acted out by Lords Boodle and Coodle, Foodle and Noodle.

If institutions are inessential or irreparable, then only the individual soul, not the body politic, can be saved. This conviction made Carlyle, Ruskin, and Dickens moralists rather than political reformers. However much the injustices of society aroused their fury, they constantly assaulted the injustice and brutality and greed within man. Their target, as George Orwell wrote of Dickens, was "not so much society as 'human nature.'"

Of course we can take the opposing view that institutions have corrupted man and that human felicity requires their reform—requires, to reverse Ruskin's phrase, *political* rather than private effort. This was the position of Mill and the Philosophical Radicals, those intellectual sons of Jeremy Bentham who sought through legislative reform to realize the "limitless perfectibility" of man. The enemy as they saw it was not the callous heart but a lopsided ballot, a barbarous penal code, a repressive monarchy, a clergy which perpetuated superstition—those remnants of the *ancien régime* which their predecessors, the *philosophes* of the eighteenth century, had attacked in France.

Like Carlyle, Ruskin never really understood Mill, and in the arrogance of his ignorance accused him of being a libertarian who made a fetish of ballot boxes.[7] Had Mill lacked his extraordinary

[7] Ruskin never realized that his presumed adversary, working from utterly different premises, reached conclusions strikingly like his own. The motto Mill chose for *On Liberty*—"the absolute and essential importance of human development in its richest diversity"—was a constant theme of Ruskin's. And the conclusion Ruskin reached in the final chapter of *Unto This Last*—"that country is the richest which nourishes the greatest number of noble and happy human beings"—curiously resembles Mill's attempt to secure "the greatest happiness of the greatest number." Ruskin failed to distinguish between Bentham's simplistic ethics and Mill's vast enrichment of his Utilitarian heritage. ("Man, that most complex being, is a very simple one in his

tolerance of views contrary to his own, he might similarly have dismissed Ruskin as a perverse defender of the old order. Both men provide classic instances of the internecine quarrel which often besets those who approach the same truth from opposite ends: the political reformer who is unaware that to give a man a ballot does not insure his voting wisely, and the moralist who does not perceive that it is insufficient to bring him to wisdom and goodness if he is governed by fools or brutes. Preoccupied with the other's blindness, each fails to see that the real enemies are the defenders of the spiritual or political status quo, the men who in varying historical guises sell absolution or buy ballots.

While Ruskin was senselessly skirmishing with Mill, the Benthamites were methodically investigating and reforming the whole governmental apparatus. But there was always the danger that their efficient bureaus and services would ossify into a Dickensian Circumlocution Office or issue in the rational but wholly inhuman New Poor Law. And so as the Philosophical Radicals were perfecting the machinery of a newly industrialized, democratic state, radical Tories like Carlyle and Ruskin insisted that the machine was monstrous because it lacked a heart. The Benthamites preached the gospel of political equality; the evangelizing Tories, whose text was the Bible itself, preached the gospel of compassion. From opposite ends of the political spectrum, the two groups reformed nineteenth-century England, the one democratizing its institutions and the other arousing its conscience. The two traditions—secular and political, Evangelical and ethical—flowed in almost equal measure into modern British socialism.

Only a fraction of those who became Socialists were converted

eyes," Mill wrote in a remarkable essay which at once pays tribute to, and transcends, his master.) And Ruskin appears to have read only enough of Mill's *Principles of Political Economy* to make a case against it in *Unto This Last*, but not enough to discover that Mill also sought to moderate "the inordinate importance attached to the mere increase of production, and . . . [to fix] attention upon improved distribution, and a large remuneration of labour" (*Principles* . . . , ed. W. J. Ashley [London, Longmans, Green & Co., 1936], p. 752). Although Mill eventually espoused a qualified socialism quite like that in *Unto This Last*, Ruskin persisted in identifying him with the grossest defenders of *laissez faire*.

to the movement by Marx. As Clement Attlee wrote, the party was built up largely by ardent Christians: "In no other Socialist movement has Christian thought had such a powerful leavening effect." Nor is this surprising, for the movement took root in the nineteenth century, when England was still a nation of Bible readers and the fervor of the Evangelicals was still fresh.[8] British Socialism, unlike its counterparts on the Continent, has always been essentially Christian and humanitarian—essentially *Ruskinian*—rather than Marxist and doctrinaire. Far more than we realize, the economic revolution of the twentieth century is the culmination of the religious revival of the nineteenth. For that revolution represents not simply the triumph of the modern, secular ideal of equality, but also a striving toward the ancient religious one according to which, in Ruskin's words, "Christ's gift of bread, and bequest of peace, shall be 'Unto this last as unto thee.' "

The great, gray edifice of the Welfare State—secular, bureaucratic, matter-of-fact—is equally indebted to an even more antique vision which Ruskin's disciple, William Morris, expressed with singular force in his socialist utopia, *News from Nowhere*. Morris had studied Marx as well as Ruskin and had become convinced that only by a violent usurpation of power could the masses free themselves from their masters. With documentary horror he depicts a bloody class-war fought in the streets of London. Once the workers win the revolution, however, Morris constructs a society which is the antithesis of an industrialized, centralized, Communist state. His England of the remote future consists of small, idyllic villages scattered throughout a garden paradise. If Morris's revolution has the actuality of history, his utopia conveys the deeper conviction of an enduring myth. Despite its initially Marxist orientation, Morris's prophecy of England in the year 2200 reverts to a kind of pre-industrial Golden Age, an English Eden from which the smoke of industry has cleared to reveal a second Earthly Paradise.

It is difficult to exaggerate the force which this vision has ex-

[8] Attlee points out that even today one is more likely to hear Scripture quoted on the platforms of the Socialists than on those of all other parties (*The Labour Party in Perspective* [London, Victor Gollancz, 1937], p. 27).

ercised over the English mind. One thinks at once of the fair fields and crystal streams of Chaucer's countryside, of Shakespeare's rich praise of "this other Eden, demi-paradise," of Wordsworth's life-long hymn to the hills of the Lake District. Indeed, I doubt that British Socialism could have gained so broad a following were it not for the widespread fear, as of a sacrilege, that if capitalism were not checked the landscape of the poets would become a vomit of fumes and furnaces.

Clement Attlee, in his austerely restrained history of the Labour Party, indulges in lyricism or wrath only when writing of the English countryside and its desecration by an economy obsessed with profit. Ruskin drew on the same deep source of national feeling when he wrote that the lust to exploit the land had turned "every river of England into a common sewer, so that you cannot so much as baptize an English baby but with filth, unless you hold its face out in the rain; and even *that* falls dirty." Industrial capitalism had, as he saw it, committed two unpardonable sins: it had set each man at his neighbor's throat and turned the fruitful "Mother-Earth, Demeter, into the Avenger-Earth, Tisiphone—with the voice of your brother's blood crying out of it, in one wild harmony round all its murderous sphere." The apocalyptic imagery recalls William Blake, who also watched in anger as the "dark Satanic Mills" consumed the countryside and who, like Ruskin, would not rest

> Till we have built Jerusalem
> In England's green & pleasant Land.

(WILDERNESS)

IX. UNSTABLE AS WATER

Ruskin read in Jacob's deathbed prophecy to his son Reuben— "Unstable as water, thou shalt not excel"—a judgment upon his own work. Ruskin's reader, too, cannot fail to note the growing instability of temper and uncertainty of direction which mark his writing after the publication of *Unto This Last* in 1860. Increasingly, the agonies and obsessions of his personal life obtrude into his books, at once robbing them of coherence and enriching them with a peculiarly intimate and moving poignancy. He had always written out of an almost frantic urge for self-expression, a need to record all that he had ever seen or felt or thought. But during the 1860s he wrote less to register his observations than to voice his perplexity and pain, to escape from an enfolding isolation which found him beloved yet incapable of loving, ever in company yet ever alone. As the inner pressures mounted, he brought to bear upon his own psyche the great gifts of penetration and expression that he had previously focused upon external nature. He became, ultimately, his own subject.

We must ourselves risk a certain chaos in charting the chaotic course of Ruskin's career through this decade. It opens with *Unto This Last*, a model of lucidity and the last wholly sane book he wrote. It closes with *The Queen of the Air*, brilliant but erratic lectures on Greek myths of "Cloud and Storm" which tell us more of the tempest raging in his mind than of the Greek gods of cloud and air. Yet his lecture on "The Flamboyant Architecture of the Valley of the Somme," also written in 1869, is distinguished by a clarity and grace unsurpassed in the whole canon of his works. There was no sudden, irretrievable collapse into incoherence, nor

even a consistent pattern of decline. Often in a single chapter, some-
times on a single page, Ruskin displays reason and madness, genius
and fatuity, poised objectivity and the most private of obsessions.
Nor is it possible to impose a unifying theme upon the fantastic
range of subjects he wrote about during this fertile and febrile
decade: Joshua Reynolds and political economy, botany and Floren-
tine engraving, Gothic architecture and war, mythology and mam-
monism, criminal law and the motion of snakes, the stratification of
the Alps and the education of little girls. Physically as well as intel-
lectually he spent these ten years in transit, shifting from subject
to subject as rapidly as he hastened from place to place, seeking an
anchorage he could not find and fleeing a chaos he was powerless
to avoid.

The changed temper of Ruskin's books, their darker harmonies
and sharper dissonances, echo the anguish he expressed more openly
in his letters. His work had become drudgery, his religious faith had
been weakened, and his heart, as he wrote to Charles Eliot Norton
in 1861, had been "broken ages ago, when I was a boy—then
mended, cracked, beaten in, kicked about old corridors, and finally,
I think, flattened fairly out." Prematurely aged at forty-two, he
described himself in the same letter as "an entirely puzzled, help-
less, and disgusted old gentleman" who hoped soon to finish his
work on political economy and

then to write no more. . . . My present life so destroyed my health, that
I was in terrible doubt as to what to do. . . . I was seriously, and despair-
ingly, thinking of going to Paris or Venice and breaking away from all
modern society and opinion, and doing I don't know what. Intense
scorn of all I had hitherto done or thought, still intenser scorn of other
people's doings and thinkings, especially in religion; the perception of
colossal power more and more in Titian and of weakness in purism, and
almost unendurable solitude in my own home . . . and terrible discoveries
in the course of such investigation as I made into grounds of old faith—
were all concerned in this. . . .

I don't in the least know what might have been the end of it, if a
little child (only thirteen last summer) hadn't put her fingers on the
helm at the right time, and chosen to make a pet of herself for me.

The pet was Rose La Touche, thirty years Ruskin's junior, a bril-
liant but strange child whom he met in 1858, and with whom he

fell tragically and obsessively in love. His grief over losing her and his rage at its causes are among the major themes which he transposed from his life to his works.

When he turned to the study of rocks and shells to escape the despair within himself, the divine face of nature he had celebrated in *Modern Painters* seemed to stare back at him in his own agonized image. The patient study of natural history, he wrote to Norton, afforded him peace but filled him with terror as well:

Abysses of life and pain, of diabolic ingenuity, merciless condemnation, irrevocable change, infinite scorn, endless advance, immeasurable scale of beings incomprehensible to each other, every one important in its own sight and a grain of dust in its Creator's—it makes me giddy and desolate beyond all speaking.

If the Creator was indifferent to His creation, a still more fearful discovery for Ruskin was His indifference to man. God had allowed all who sought Him most earnestly to be blinded; Ruskin had looked for another world, but found "there is only this, and that is past for me: what message I have given is all wrong; has to be all re-said, in another way, and is, so said, almost too terrible to be serviceable." Preachers drove him mad with contempt, politicians mad with indignation. He was left "dead-silent," working weakly at geology and Greek, reading comparative anatomy, "and gathering molluscs, with disgust."

With a candor the more remarkable in view of the reticences of Ruskin's parents and friends, he confessed to Robert Browning in 1861 to being ill "more mentally than otherwise." But to John James Ruskin, who had reason to fear for his son's sanity,[1] he insisted upon the impersonal causes of his despair. John James had suggested that the gloom and irritability of his son's letters were due to an ailing liver. "I am depressed," Ruskin angrily retorted, "only for great and true causes, for the sufferings and deaths of thousands, the follies and miseries of millions." Had his father been writing to a petulant youth, Ruskin would have accepted the diagnosis; but he was, he insisted, "at one in every point and tone of thought with Dante and Virgil, and . . . discontented precisely as they are. . . . This grief is no more biliousness than the Lamenta-

[1] John James's father had gone mad and taken his own life in 1817.

tions of Jeremiah were biliousness." The desperate, megalomaniac assertiveness of these letters at times obtrudes upon Ruskin's books and suggests that whenever he was most dogmatic, he was most in doubt—indeed, that his dogmatism itself was a symptom of his illness.[2]

The despair which produced Ruskin's bitter letters to his father issued, in his correspondence of the same period with Norton, not in morbid stridence but in morbid pathos. From Mornex, where he had sought to escape the tensions of Denmark Hill, he wrote that

the loneliness is very great, in the peace in which I am at present, and the peace is only as if I had buried myself in a tuft of grass on a battlefield wet with blood, for the cry of the earth about me is in my ears continually if I do not lay my head to the very ground.

Three years later, in 1866, he again complained of being gravely ill and "variously tormented, down into the dust of death and near his gates." His doctors, he rightly concluded, could not cure him, for his illness was beyond their sphere of competence.

In March of 1869 Norton and a young compatriot, Henry James, visited Ruskin at Denmark Hill. James saw to the heart of the matter with clinical precision:

In face, in manner, in talk, in mind, he is weakness pure and simple. I use the word, not invidiously, but scientifically. He has the beauties of his defects; but to see him only confirms the impression given by his writing, that he has been scared back by the grim face of reality into the world of unreason and illusion, and that he wanders there without a compass and a guide—or any light save the fitful flashes of his beautiful genius.

Yet James was not wholly right. For in the next twenty years Ruskin was to create two perfect expressions of his genius, *Fors Clavigera* and *Praeterita*, the one a chronicle of his own torment and the other, composed in lucid intervals between attacks of madness, the richest in peace of all that he wrote. James accurately gauged

[2] Ruskin's occasional arrogance in print contrasts with his gentleness in life, the quality most often remarked on by those who knew him. He felt an almost excessive reverence for greatness in others, such as his "master" Carlyle, before whom he would kneel and whose hand he would kiss on parting.

the extent of Ruskin's "unreason" but underestimated his vitality, his almost infinite resourcefulness in shaping great art out of great illness.

Only the tone of Ruskin's mind altered. To the end of his career his genius remained what it had always been: immense, yet never wholly sane. Even as a boy he was not free of the compulsions which drove him into a multitude of scattered labors and later threatened to make chaos of his life and books. The child of ten who wrote that

the last year of my life was the happiest . . . because I have had more to do than I could do without cramming and ramming, and wishing days were longer and sheets of paper broader

was father to the man who, obsessed with the passage of time and fearing a premature death, engraved on his seal the motto "To-day" and counted in his diary the diminishing number of days he presumed he might live.

At the age of nine Ruskin began an epic entitled "Eudosia, or a Poem on the Universe." He abandoned the poem, but never the subject. The result was that all he wrote was necessarily a fragment, enormously ambitious, as varied as the cosmos and as disorderly as his own mind. When still a boy, he apologized to his father for his inability to write a "short, pithy, laconic, sensible" letter:

I roll on like a ball, with this exception, that contrary to the usual laws of motion I have no friction to contend with in my mind, and of course have some difficulty in stopping myself when there is nothing else to stop me.

The difficulty intensified over a lieftime. "I am almost sick and giddy," he wrote in 1869, "with the quantity of things in my head— trains of thought beginning and branching to infinity, crossing each other, and all tempting and wanting to be worked out."

Ruskin's mind, like his eye, was always hyperactive. Charged with a vertiginous energy, it led him into dizzying digressions, and although he was always perceiving, he often failed to organize his perceptions. With unbounded confidence he succeeded in *Modern Painters* in bearing witness to his whole intellectual and sensory ex-

perience. The book possesses an immense vitality and genius, but a genius whose energies and multiple interests—Turner and the structure of clouds, esthetics and geology, God and the growth of trees—constantly threaten to overflow the bounds of Ruskin's thesis. He digressed too much because he *saw* too much, because the worlds of nature and art and ideas too richly crowded themselves into his consciousness. In his later works he digressed excessively because he suffered excessively. Yet his digressions are inseparable from his subject, which was no longer the external world but himself. And as his subject changed, so too did the tone of his prose. The stately piling up of clauses in his early writing, perfectly suited to his Alpine descriptions and his own towering hopes, yielded to a subtler, quieter style which registers the very pulsations of his grief and is as moving as his earlier prose is magnificent.

ii

Ruskin's editors gathered his work of the 1860s into three stout volumes of the Library Edition and struggled to give them an appearance of order they do not in fact possess. The volumes consist largely of articles for the press and miscellaneous lectures which Ruskin later collected and published as separate books. The public lecture was his characteristic form throughout the decade. For he was no longer capable of the sustained and disciplined coherence he had achieved in *The Stones of Venice*. Nor had he yet learned to make a virtue of his vagaries, as he did in the 1870s, when he created in *Fors Clavigera* a form uniquely suited to his eccentric gifts.

For the most part, Ruskin continued to channel his energies into social criticism. *Munera Pulveris* (1862–63), *Sesame and Lilies* (1865), *The Crown of Wild Olive* (1866), and *Time and Tide* (1867) continue his attempt to Christianize and socialize England. In the middle of the decade he wrote a divertissement, *The Ethics of the Dust*, a fanciful dialogue on crystals between an "Old Lecturer of Incalculable Age" and a group of girls. But beneath the play runs Ruskin's very serious obsession with Rose La Touche. Finally, he wrote two books, both forbiddingly allusive and obscure: *The Cestus of Aglaia* (1865–66), which is ostensibly about

"the Laws of Art," and *The Queen of the Air* (1869), ostensibly about Greek myths. Their essential subject, however, is Ruskin's mind, giddy with "trains of thought . . . branching to infinity," just as the essential subject of *The Ethics of the Dust* is not crystallography but Ruskin's heart.

Munera Pulveris [3] is the first of Ruskin's books which clearly reveal his mental imbalance. The opening pages, to be sure, are a promising sequel to *Unto This Last*. Ruskin amplifies the key concepts of his political economy—wealth and value—and stresses their dependence upon the moral resources of the nation. Meeting the economists on their own ground, he abandons exhortation for definition, and sustains the somewhat forbidding rigors of his analysis to the end of the first chapter. But then he signals his own defeat: "Such being the general plan of the inquiry before us, I shall not limit myself to any consecutive following of it, having hardly any good hope of being able to complete so laborious a work."

Although Ruskin took pride in Mazzini's remark that he had the most analytic mind in Europe, he was incapable of laboriously documenting what he could so effortlessly perceive. The first chapter of *Munera Pulveris* merits Mazzini's praise; the following chapters reveal not only the pathology of Ruskin's mind—its scattering of ideas and its bondage to uncontrollable verbal associations—but its habitual unrest. In *The Stones of Venice* he characterized the vital principle of Gothic architecture as "the love of *Change*. It is that strange *disquietude* of the Gothic spirit that is its greatness." A diseased, not a vital, disquietude animates *Munera Pulveris*. Bored with his subject but incapable of rest, committed to writing a tightly organized treatise but hostile to the form, he branches into countless di-

[3] The title alludes to a phrase in Horace's *Odes* (i. 28) which Ruskin took to mean "gifts of the dust." His object in *Munera Pulveris* was to attack the political economists who, in their emphasis upon material wealth alone and upon acquisition instead of distribution, had mistaken dust and death for deity. Cf. the closing lines of the book: "You must either take dust for deity, spectre for possession . . . and for epitaph, this reversed verse of the great Hebrew hymn of economy (Psalm cxii.):—'He hath gathered together, he hath stripped the poor, his iniquity remaineth forever:'—or else, having the sun of justice to shine on you . . . leave men to write this better legend over your grave:— 'He hath dispersed abroad. He hath given to the poor. His righteousness remaineth forever.' "

gressions, some of startling brilliance and some wholly unintelligible. In a chapter on currency he explicates passages from Homer, Plato, Dante, Spenser, Goethe, and the Gospels, and he buries in a chapter on government a striking interpretation of *The Tempest* as an allegory dramatizing the true meanings of liberty and slavery, Caliban's torment representing "the physical reflection of his own nature—'cramps,' and 'side stitches that shall pen the breath up' . . . the whole nature of slavery being one cramp and cretinous contraction."

Unable to silence the echoes of the words he was writing, he divagated on their etymologies, as accidents of sound and chance associations led him from one word group to another, until both text and notes became incomprehensible.[4] His fascination with words produced a kind of hypersophisticated punning, a release from an analytic discipline he could no longer sustain. But it was as well the mark of a mind in disequilibrium, grasping for "roots," reaching for connections more verbal than real, straining to shape through sheer wit an experience too oppressive and a knowledge too various for logic alone.

Munera Pulveris was first published in *Fraser's Magazine*, but after the fourth chapter had appeared the publisher refused to print further installments. Ruskin viewed the prohibition as a timorous reaction to his radicalism. But with each successive chapter, it became more apparent that he could not complete the ambitious program he had originally outlined. Even without the publisher's intervention, the book would have remained a fragment; and, burdened with a labor which bored him, Ruskin would have drifted still further into fantasy.

No one ever felt more imperatively the need to communicate, a need which Ruskin knew he had failed to gratify in *Munera Pulveris*. He was losing touch with his audience and feared that he might also be losing his hold on reality. And so, soon after the book had been curtailed, he began a series of public lectures in which,

[4] See, for example, his word-play on charis-charitas-cher-cherish-cheer-choir-choral (XVII, 225-27).

more coherently than in *Munera Pulveris*, he continued the great work of social reform he had begun in *Unto This Last*. The shift from the privacy of his study to the public platform was a wise one. At the risk of facing empty halls, he could no longer indulge in endless verbal flights. The enigmas of *Munera Pulveris* vanish and, as if in reaction to his former excesses, he becomes almost laboriously explicit in his effort to be understood. Only the titles under which he later published the lectures—*Sesame and Lilies* and *The Crown of Wild Olive*—retain the cryptic, allusive habits he had indulged in *Munera Pulveris*.

They are above all angry lectures, full of rage at the barbarities of a professedly Christian society. Their energy is the fierce energy of wrath, of a man burning with the same outrage at injustice and pretended piety which had inflamed the Prophets. And Ruskin takes the Prophets' bold license of insulting his hearers. The heart of his address to a literate, well-intentioned audience gathered to found a library is an indictment of their illiteracy and cruelty. Reading, he insists, requires acuteness of sympathy as well as of mind.[5] But his audience and, indeed, the whole nation "despise compassion," and their illiteracy is but a symptom of their insensibility. Only a profoundly illiterate nation could tolerate the newspaper account he cites of a half-blind cobbler who was discovered starved to death in

[5] To illustrate the close scrutiny which words require, Ruskin analyzes a passage from *Lycidas*. I quote part of the explication to show that he was as perceptive a critic of literature as he was of art. This is his gloss on the phrase with which Milton, attacking the false clergy who "for their bellies sake,/ Creep and intrude, and climb into the fold," characterizes them as *Blind mouthes:*

"I pause . . . for this is a strange expression; a broken metaphor, one might think, careless and unscholarly.

"Not so. . . . Those two monosyllables express the precisely accurate contraries of right character, in the two great offices of the Church—those of bishop and pastor.

"A 'Bishop' means 'a person who sees.'

"A 'Pastor' means 'a person who feeds.'

"The most unbishoply character a man can have is therefore to be Blind.

"The most unpastoral is, instead of feeding, to want to be fed,—to be a Mouth.

"Take the two reverses together, and you have 'blind mouths' " (XVIII, 72).

his lodgings. In a truly Christian country such a death would be as inconceivable as permitting murder on the public streets. If England were even

wholesomely *un*-Christian, it would be impossible: it is our imaginary Christianity that helps us to commit these crimes, for we revel and luxuriate in our faith, for the lewd sensation of it. . . . The dramatic Christianity of the organ and aisle, of dawn-service and twilight-revival . . . this gas-lighted, and gas-inspired Christianity, we are triumphant in. . . . You had better get rid of the smoke, and the organ pipes, both: leave them, and the Gothic windows, and the painted glass, to the property man; give up your carburetted hydrogen ghost in one healthy expiration, and look after Lazarus at the doorstep.

That Ruskin's leisured, prosperous audiences were responsible for the suffering of England's Lazaruses is the burden of his lectures. He condemns his listeners precisely as he condemned himself for self-indulgence in the midst of poverty. The cruelest of men, he wrote at the end of *Unto This Last*, "could not sit at his feast, unless he sat blindfold." Ruskin sat with eyes opened and, unable to forgive himself, could not forgive others.

Perhaps he took too literally the Bible's injunction that we be our brother's keeper. For he understood the phrase not as a noble metaphor but as a frightful fact which implicated all mankind in a collectivity of suffering and sin. This same sense of collective responsibility once prompted him to suggest, while breakfasting with Gladstone, a singular remedy for crime. As the Prime Minister listened in puzzled earnestness, Ruskin held that we were all ultimately accountable for the crimes committed around us, indeed participated in them ourselves by tolerating the conditions which fostered them. He then proposed dividing London into districts, so that when a murder was committed in any one, the inhabitants might "draw lots to decide who should be hung for it."

Ruskin saw more clearly than most men that evil is a kind of contagion which multiplies itself throughout society. The remoteness of an action from its consequences, of the doer from the sufferer, neither negates their relationship nor lessens the responsibility. Hence he could argue that by financing the wars of Europe, Eng-

land was ultimately guilty of murder, just as he had once argued that to wear glass beads made by exploited labor was to engage in the slave trade. These equations strike one with the force of a revelation, for they overleap the logic of common experience and deny one the comfort of being blind. They suggest, too, that Ruskin's radicalism derives not at all from class consciousness, but from an acute consciousness of the bond which links the individuals of all classes and causes their isolated acts to reverberate through the whole social and moral order. Like Blake, Ruskin knew that

> A dog starv'd at his Master's Gate
> Predicts the ruin of the State.

Seeing so keenly, he could not repress his rage at what he saw. "The folly and horror of humanity," he wrote to Norton, "enlarge to my eyes daily." The bitter ironies and lucid indignation of his lectures recall the savage logic of Swift. Ruskin himself noted the parallel: "Putting the delight in dirt, which is a mere disease, aside, Swift is very like me, in most things, in opinions exactly the same." The likeness was to have its tragic sequel, when Ruskin's rage became indistinguishable from madness; but with his mind still poised, he could unleash his indignation in superbly controlled ironies:

We do great injustice to Iscariot, in thinking him wicked above all common wickedness. He was only a common money-lover, and, like all money-lovers, did not understand Christ;—could not make out the worth of Him, or meaning of Him. . . . He was horror-struck when he found that Christ would be killed; threw his money away instantly, and hanged himself. How many of our present money-seekers, think you, would have the grace to hang themselves, whoever was killed?

Audiences enjoy being shocked, and the simplest source of shock is insult. Perhaps this accounts for Ruskin's popularity as a lecturer. But in one notable instance—an address on war to the Royal Military Cadets at Woolwich [6]—Ruskin carried the tactic too

[6] Although the lecture contains jarring touches of jingoism, it is largely anti-war. Ruskin's ultimate position is clear enough:

"The first reason for all wars, and for the necessity of national defences, is that the majority of persons, high and low, in all European nations, are Thieves, and, in their hearts, greedy of their neighbours' goods, land, and fame.

far. He begins by extravagantly praising the military virtues as the foundation of all noble arts. But he praises inordinately in order to damn the more boldly. War, he contends, ought to be a sort of gentleman's joust, a voluntary test of skills, not a vicious test of which nation can tear to pieces the greatest number of conscripted peasants. After parodying the romantic view of war as a medieval charade, Ruskin then strips away the last of the cadets' illusions and accuses them of being sentimental schoolboys afflicted with a false sense of duty; they would do better to abandon their "peacocky motives" and, instead of burning harvests, raise them. However noble their intentions, they have surrendered their freedom and become mere weapons in the hands of the state. Too proud to be shopkeepers, they are instead slaves: "Some press the juice of reeds, and some the juice of vines, and some the blood of men. The fact of captivity is the same."

There is no record at Woolwich of Ruskin's address; the press, too, refrained from its usual practice of reporting his lectures.

If Ruskin embarrassed the authorities at Woolwich, he must have stunned the citizens of Bradford who sought his advice on the proper style for their new stock exchange. They had invited an eloquent esthetician and amateur of architecture, best known for his purple patches in *Modern Painters* and his extravagant fondness for Gothic. But the invitation had gone out ten years too late. For Ruskin had ceased to care about architecture in itself when he saw his plea for Gothic parodied by dismal churches, gingerbread pubs, and factory chimneys with besooted bands of red and black brick. He was infuriated by the popular misconception of himself as an elegant adjudicator of taste, and it was this image which he set out to destroy in his lecture on "Traffic."

He begins with a frank and bold apology: he cannot talk to his good Yorkshire friends about their exchange because he does not care about it. *He* does not care because *they* do not; they have sent

"But besides being Thieves, they are also fools, and have never yet been able to understand that . . . the prosperity of their neighbours is, in the end, their own also; and that the poverty of their neighbours, by the communism of God, becomes also in the end their own" (*Fors Clavigera*: XXVII, 126).

for him merely because, wanting to be in fashion, they seek to consult "a respectable architectural man-milliner" on the "newest and sweetest thing in pinnacles." But good architecture cannot be had simply by asking for advice. Rather it is an expression of the national character, an embodiment of a great national faith. The Greeks worshiped the Goddess of Wisdom, and their architecture "rose unerring, bright, clearly defined, and self-contained." The Middle Ages worshiped the Goddess of Salvation, and built magnificent temples to her until their faith perished and they sought remission of sins lyingly, for a fee. The Renaissance worshiped pleasure and pride, and built Versailles and the Vatican. What does England worship, and to whom does she build?

We have, indeed, a nominal religion, to which we pay tithes of property and sevenths of time; but we have also a practical and earnest religion, to which we devote nine-tenths of our property, and six-sevenths of our time. And we dispute a great deal about the nominal religion; but we are all unanimous about this practical one; of which I think you will admit that the ruling goddess may be best generally described as the "Goddess of Getting-on," or "Britannia of the Market." . . . All your great architectural works are, of course, built to her. It is long since you built a great cathedral. . . . But . . . your railroad stations, vaster than the temple of Ephesus, and innumerable . . . your warehouses; your exchanges!—all these are built to your great Goddess of "Getting-on"; and she has formed, and will continue to form, your architecture, as long as you worship her; and it is quite vain to ask me to tell you how to build to *her;* you know far better than I.

But Ruskin could not refrain from giving advice. He compressed into one savagely satiric paragraph his contempt for a nation of "pedlar-errants," ever willing to distribute the Gospel gratis, but not the loaves and fishes:

I can only at present suggest decorating its frieze with pendant purses; and making its pillars broad at the base, for the sticking of bills. And in the innermost chambers of it there might be a statue of Britannia of the Market . . . on her shield, instead of St. George's Cross, the Milanese boar, semi-fleeced, with the town of Gennesaret proper, in the field; and the legend, "In the best market," and her corslet, of leather, folded over her heart in the shape of a purse, with thirty slits in it, for a piece of money to go in at, on each day of the month.

Britannia of the Market is a strange goddess, Ruskin observes, differing from the Greek and medieval deities in the meanness of her ministration. Athena dispensed wisdom to all who sought her; the Madonna, comfort. But the Goddess of Getting-on ministers exclusively to the few—"a vital, or rather deathful, distinction." Continue to worship her, he warns, and soon art, science, and even pleasure will be impossible.

The impact of Ruskin's peroration depends upon a subtle shift in tone from satire to exhortation. The change occurs just after he reads Plato's account of the inhabitants of Atlantis, who, once semi-divine, fell prey to the iniquity of inordinate possession. If, he writes,

you can fix some conception of a true human state of life to be striven for—life, good for all men, as for yourselves . . . [then] so sanctifying wealth into "commonwealth," all your art, your literature, your daily labours . . . will join and increase into one magnificent harmony. You will know then how to build, well enough; you will build with stone well, but with flesh better; temples not made with hands, but riveted of hearts; and that kind of marble, crimson-veined, is indeed eternal.

The lecture is Ruskin's finest. But it is a work of consolidation, not of discovery. In it he draws together the central insights of "The Nature of Gothic" and *Unto This Last*. Perhaps because he stayed on familiar ground, he could retain the balance of mind which increasingly eluded him.

iii

Throughout his adult life Ruskin often indulged in a form of intellectual play which diverted him from his morbid preoccupation with self and social evil. At these times he would declare himself *hors de combat*, as it were, and toy with ideas as he toyed with crystals, turning them over in his mind's eye and following their reflected lights wherever his fancy led him. But his play, because always necessary, was always serious. The classic instance of such diversion is *The Ethics of the Dust*, a charming if trivial dialogue on crystals which he composed in the autumn of 1865 between the bursts of rage which produced his lectures on War and Traffic.

This most playful of Ruskin's books is perhaps also his most earnest, for it is a mask of great delicacy and wit disguising the profoundest passion he knew, his morbid—yet wholly innocent—passion for young girls. The *dramatis personae* are an "Old Lecturer of Incalculable Age" and a group of girls; the setting is Winnington Hall, a private school in Cheshire to which Ruskin had been invited in 1859 and to which, as benefactor, informal lecturer, and man-of-letters, he paid frequent visits until 1868.[7] He was made a pet by the girls, as he made pets of them, deeply moved by their grace, their beauty, and above all their innocence. Because he had only to win their hearts, but never to touch their bodies, he was totally at ease in their presence, as he could never be in the company of a sexually mature woman such as his wife, before whom he had recoiled in impotence.

He brought the girls his drawings and his crystals, joined in their games, danced in their dances. "We had such a game of hide-and-seek yesterday in the attics and empty rooms," he wrote to his father, "I was as hot at last as if I had been up and down the Montanvert. . . . To-day we have been playing at prisoners' base till I'm stiff with running." In the parks and gardens surrounding the hall, he watched the girls dancing "like Will o' the wisps"; and when at night he joined them in a quadrille, his slender figure appeared to be "scarcely more than a black line, as he moved about amongst the white girls in his evening dress." One evening he persuaded them to act out James Russell Lowell's poems: "I got a nice blue-eyed girl to be Minerva. . . . You should have heard the silver laughing. (*N.B.*—I had studied curtseying all the afternoon before in order to get myself nicely up as Venus.)" Fantastic behavior, of course; and pathetic, too. Yet without such releases the potent rage of Ruskin's lectures might well have degenerated into sheer hysteria.

Ruskin had just turned forty when he first visited Winnington.

[7] One can only surmise the extent of Ruskin's attachment to Winnington from the description in the Library Edition. The Pierpont Morgan Library possesses several hundred unpublished letters of Ruskin to the girls at the school and to Miss Margaret A. Bell, the headmistress. One series alone, the informal "Sermons for Birds," contains some 35,000 words. The complete correspondence is now being prepared for publication.

But he was truly, as he describes the Lecturer in *The Ethics of the Dust*, of incalculable age. The characterization applies less to his antiquity in the eyes of his young audience than to his own perverse and indeterminate passions, which were neither those of a child nor of a man. "Am I not in a curiously *unnatural* state," he wrote in 1862,

> that at forty-three, instead of being able to settle to my middle-aged life like a middle-aged creature, I have more instincts of youth about me than when I was young, and am miserable because I cannot climb, run, or wrestle, sing, or flirt—as I was when a youngster because I couldn't sit writing metaphysics all day long. Wrong at both ends of life.

He had been in an oddly unnatural state ever since 1858, when he met Rose La Touche and experienced his unconversion at Turin. There he renounced his Puritanism and for the first time allowed himself to delight unabashedly in the human form. He praised Veronese's "magnificent animality" and saw lying on a heap of sand a less ripened image of beauty which he never forgot, a black-haired girl of ten, "half-naked, bare-limbed to above the knees, and beautifully limbed . . . her little breasts, scarce dimpled yet,—white, —marble-like—but, as wasted marble, thin with the scorching and rains of Time." Deeply disturbed by the recrudescence of desires which he could neither repress nor fulfill, he thought of going to Venice or Paris "and doing I don't know what." He went instead to Winnington, in unconscious quest of the dark-haired girl of Turin and the fair-haired Rose La Touche.

Rose lived with her parents in Ireland and Ruskin could not visit her as often as he wished. But he could always see her sister-images at Winnington, where the girls seemed to possess the magical virtue of never growing up. They were a composite of perpetual girlhood, so many Roses in Ruskin's strange wonderland. The real Rose, however, was maturing far more rapidly than he wanted to believe: "I shall not see her till November," he wrote when she was thirteen. "Nay, I shall never see *her* again. It's another Rosie every six months now. Do I want to keep her from growing up? Of course I do." Seeking to arrest in her what was in himself arrested, he transferred his child's love for the child Rose to the timeless little girls in his

book, who sing and play and learn at the foot of their incalculably old Lecturer—and never age. They appeared to him not as objects of passion but of esthetic delight, immobile images of innocence all the more desirable because he could transpose them from flesh into art. Seated around their long tables at dinner, they resembled Veronese's *Feast at Cana;* dancing, they looked like Titian's sketches of ball dresses. One evening he watched them as they listened to music:

The wet eyes, round-open, and the little scarlet upper lips, lifted, and drawn slightly together, in passionate glow of utter wonder, became picture-like,—porcelain-like,—in motionless joy, as the sweet multitude of low notes fell in their timely infinities, like summer rain. Only La Robbia himself . . . could have rendered some image of that listening.

Yet Ruskin could not help turning from his fragile, porcelain-like figures to Rose herself. Abandoning the role of amiable Lecturer, he covertly and passionately pleads with her to remain his "Mouse-pet" and renounce the morbidly fervent Evangelicalism which was forcing them apart. Young girls obsessed with the other world, the Lecturer observes, acquire "a vague and wildly gentle charm [8] of manner and feature, which will give them an air of peculiar sanctity in the eyes of others." But do they not, asks one of the girls, "often get very strange, and extravagant?" "More than that," the Lecturer replies prophetically: "They often go mad."

Like so much that Ruskin wrote in the 1860s, *The Ethics of the Dust* is at bottom a plea that Rose understand his religious position and abandon the sick excesses of her own. It is she, not the little girls of Winnington, whom he warns against "abandonment of the mind to religious theory" and urges "to enter into the faith of others, and to sympathize . . . with the guiding principles of their lives. So only can you justly love them, or pity them."

Rose, quite simply, was growing up—in itself a tragic fact for Ruskin. And she was growing up in the way best calculated to

[8] The same phrase reappears in a letter which Ruskin wrote in 1868, after Rose had been dangerously ill: "In this sick one the disease has touched the brain, and she is wildly gentle . . . like a person half changed into a child. . . . It's a wild, ungentle world, with its broken wrecks of spirits—and of Fates" (XXXVI, 560).

arouse his fears. The little girl who had sent him charming, precocious letters was turning into a fanatically devout young woman, a caricature of Ruskin's former, and his mother's unabated, Evangelicalism. It had taken him half a lifetime to renounce the rigors of his inherited faith, and now he had to confront them again, raised to pathological proportions, in Rose. His dread of symptoms in her which he had already recognized in himself, added to his exacerbated sensitivity to the whole subject of piety, produced the innumerable angry warnings in his works against abandoning oneself to God while ignoring the agonies of man.

Ruskin was beginning to create out of the wreck of his private world the central, if hidden, subject of his books. He said that he wrote *Sesame and Lilies* "to please one girl"; in reality he wrote it to chide Rose for breaking his heart and hardening her own in a morbid quest for sanctity. If there is something brutal in his attacks upon her piety, the brutality was born not of malice but of desperation. In answer to his urgent, abject pleas that Rose marry him,[9] she sent him religious texts and verses, and bade him not put his love for her above love of God. "Look here," he wrote to a mutual confidante,

if I were lying wounded—bleeding slowly to death—and Rosie were withheld by her father from coming to bind the wound—she would not then be content to bid me "not stir—lest I should break the charm." Now this is literally so,—in a far deeper sense. Every hour of the pain takes some life out of my soul. . . . If I could write to her, I should say—My pettie, do you think after—through six years of my unbelieving, petulant, querulous love for you . . . that I doubt you now, when you know how intense the love was, and is. . . . Do you think I cannot trust you for three years—when I have tried you since you were a child? . . . [But] one word showing that you knew the real pain I was suffering, and that you had any clear conception of what my life was likely to be in *either* alternative (your acceptance or refusal of me)—would give me more peace than a thousand texts.

Her words came—tentative, touching, weighted with an almost obsessional solicitude for his soul:

[9] Ruskin proposed to her in February 1866. She was undecided but agreed to commit herself in three years, when she would be twenty-one. In the interim, Rose's parents turned against Ruskin and forbade them to correspond. But they continued to keep in contact through sympathetic friends.

Can you not see that it needs a greater faith in me to be silent (when I long to write, but fear it may be wrong of me) and leave you to God and believe that the love I give you is not utterly vain, not wholly disbelieved by you? . . . For however sweet it might be, I am not the little thing I was.

Even as a child she had pleaded with him to renounce his "heathenism" and cease wandering in "Bye-path Meadow." As a child, too, she had experienced fits of melancholy brooding and occasional lapses of consciousness. The year after Ruskin proposed marriage she was so violently ill that she had to be sent to a nursing home and strapped to her bed. She improved, relapsed, improved again; but even when wholly rational she remained a distraught and withdrawn *religieuse* who composed devotional lyrics and, on one occasion, suddenly knelt down at a party, forcing those present to join in her prayers for a dying friend.

No one seems to have realized how irrevocably ill Rose was, least of all Ruskin. Because he wanted her to remain a child—his "Mouse-pet in Ireland, who nibbles me to the very sick-death with weariness to see her"—he mistook her piety for childish pretension, her reluctance for childish perversity. Nor could he see beyond his torment to her own. Rose was to have written him on Christmas Day of 1867; no word came. He denounced her silence in an angry letter to a mutual friend:

When she breaks her word to me on Christmas day—and after ten years of my waiting and weary love—dismisses me by the word of a Stranger, she has no business to write to you . . . about the possibly beneficial effects on my mind. She has nothing whatever to do with God's dealings with my mind. She ought to know . . . that she has done . . . an ineffably false and cruel deed . . . that my love and tenderness to all men is greatly deadened—my own personal happiness in *any* love, destroyed—my faculties greatly injured—so that I cannot now command my thoughts except in a broken way—and such bitterness mixed with my love for her, that though it . . . possesses me even more fatally than ever—it is partly poisoned love, mixed with distrust and scorn.

Ruskin's attacks upon Rose's piety in *Sesame and Lilies* are a public venting of the frustrated, self-regarding rage of this letter. He rebukes his "girl readers" for believing themselves so much the darlings of Heaven and the favorites of the Fates as to have been

born "in the very nick of time, and in the punctual place, when and where pure Divine truth had been sifted from the errors of the Nations." With all their pretty dresses, dainty looks, and saintly aspirations, they are not a bit more loved of God "than any poor little red, black, or blue savage, running wild in the pestilent woods, or naked on the hot sands of the earth."

Above all, he urges his readers not to be cruel. Their religious beliefs encourage them to tolerate suffering and evil on the too easy assumption that God will bring all "to a good end." Rose must have read these words as a direct attack upon her faith. "God cannot," she wrote, "have meant nothing but pain to grow out of the strange link of love that still unites us to one another. Somehow or other it must work for good." For her benefit he condemns the unwise patience which misconceives "the eternal and incurable nature of real evil." Stressing his point with obsessive frequency, he writes of degrees of pain which cannot healthily be borne: "Let the cold fasten on your hand in an extreme degree, and your fingers will moulder from their sockets. . . . Let heart-sickness pass beyond a certain bitter point, and the heart loses its life for ever."

iv

In the spring of 1867, just a year after proposing to Rose, Ruskin wrote a series of letters which purport to be about "honesty of work and honesty of exchange." He addressed the letters to Thomas Dixon, a literate cutter of corks who had expressed interest in his economic views. With Ruskin's consent, Dixon published the letters in the press, and in December Ruskin revised and reissued them under the title *Time and Tide*. It is remarkable that he could write at all. His diary for the year is a record of anxious dreams, extreme depression, and morbid symptoms such as sparks which seemed to float before his eyes. When the book appeared, he "went roaming about all Christmas Day, and the day after—so giddy and wild" in his vain waiting for Rose's letter that he contemplated suicide.

To read *Time and Tide* merely as social criticism is to assume that its digressions are irrelevancies rather than the heart of the book. Nearly all that Ruskin said about labor, wages, and competition had been said to better effect in *Unto This Last* and *Munera*

Pulveris. When he told his working-class readers, who were noisily and effectively agitating for parliamentary reform, to keep out of Parliament or to create one of their own, he was hopelessly oblivious of their interests. And the ideal commonwealth he outlined in the closing letters is sheer fantasy,[10] a toying with a hypothetical kingdom which he admits cannot appear "practicable even at a remote period." The book is less a sequel to *Unto This Last* than the prelude to his masterwork of the 1870s, *Fors Clavigera.* In it Ruskin learned to articulate the drama of his own bafflement, not crudely as in *Sesame and Lilies,* but subtly and movingly. He also evolved a style—lightly ironic, allusive, richer always in implication than in statement—ideally capable of conveying great grief with great felicity.

In this manner he recounts an evening he had spent alone at Covent Garden "looking and not laughing" at a pantomime performance of *Ali Baba and the Forty Thieves:*

The forty thieves were girls. . . . There was a transformation scene, with a forest, in which the flowers were girls, and a chandelier, in which the lamps were girls, and a great rainbow which was all of girls. . . . And there was a little actress of whom I have chiefly to speak, who played exquisitely the little part she had to play. . . . The little lady . . . eight or nine years old,—dances a *pas-de-deux* with the donkey.

She did it beautifully and simply, as a child ought to dance. . . . She looked and behaved innocently,—and she danced her joyful dance with perfect grace, spirit, sweetness, and self-forgetfulness. And through all the vast theatre . . . there was not one hand lifted to give her sign of praise but mine.

Presently after this, came on the forty thieves . . . and, there being no thieving to be presently done, and time hanging heavy on their hands, arms, and legs, the forty thief-girls proceeded to light forty cigars. Whereupon the British public gave them a round of applause. Whereupon I fell a thinking; and saw little more of the piece, except as an ugly and disturbing dream.

Nightmare, not dream, would be truer to the image of corrupted innocence which Ruskin describes. For he saw mirrored on the stage

[10] The most singular of Ruskin's fantasies is based on his protracted courtship of Rose. In the letter entitled "Rose-Gardens," he proposes that, after a period of probation, maidens be crowned as *Rosières* and given in marriage to their patient "Bachelors" at a great national festival. (See R. H. Wilenski, *John Ruskin* . . . [London, Faber & Faber, 1933], p. 132, n. 2.)

the recurrent sexual nightmares of young girls and coiled serpents—
"singularly unclean, disgusting, ludicrous" dreams, he calls them in
his diary—which began to plague him in 1867. Overtly, Ruskin's
digression on the cigar-smoking girls is an indictment of the per-
versity of British taste. But its underlying energy springs from his
self-disgust at his own perversity, his horrified fascination at child-
like innocence, such as he had seen at Winnington and still longed
to see in Rose, becoming suddenly and loathsomely adult.

Following his description of the pantomime, Ruskin turns to
"the evil light and uncalm" of an evening he had spent watching the
simian dexterities of a Japanese juggler, whose two children ac-
companied his performance with "short, sharp cries, like those of
animals." As at Covent Garden, his diversion again has a night-
marish quality. The demoniac masks of the jugglers are "inventively
frightful, like fearful dreams," and the performers themselves seem
"afflicted by an evil spirit." Ruskin's description has a disturbing
vitality, a surrealist power of repugnant implication independent of
his stated subject, "The Corruption of Modern Pleasure." [11]

These were the available diversions, Ruskin writes, "when I
needed such help, in this metropolis of England." He needed help
not only because he feared losing Rose, but because he was in terror
of losing his soul to Satan. This fear underlies his remarkable digres-
sions on the reality of Satan's power. With a conviction engendered
by his own torment, he insists that hell is no mere metaphor, Satan
no mere figment of a credulous age:

I do not merely *believe* there is such a place as hell. I *know* there is.
. . . In fearful truth, the Presence and Power of Him *is* here; in the
world, with us, and within us, mock as you may; and the fight with Him,
for the time, sore, and widely unprosperous.

Satan is within *me* and *my* fight with Him is sorely unprosper-
ous, Ruskin would have written, were he not disguising his spiritual

[11] The same insinuation of evil marks his account of a grotesque dance
by a girl of twelve. She moves with "short, sharp contractions and jerks of
the body . . . such as might be produced in a puppet by sharp twitching of
strings at its joints." The rapid, vibratory beating of her accompaniment re-
minds him of "insect and reptile cries or warnings," like the "cicala's hiss
[and] . . . the deadened quivering and intense continuousness of the alarm of
the rattlesnake" (XVII, 343).

autobiography in the form of a sermon to the workingmen of England. Seeking to link his own struggle for "reform" to theirs, he urges them to cast their votes against the omnipresent fiend, their true enemy. The vitality of his description of the blue-lipped worm whose sting is death arises from the horror of his own serpent dreams, at once phallic and diabolic, which he struggled vainly to repress.[12]

Ruskin was convinced of the reality of Satan, "the Lord of *Pain*," because to no other power could he attribute the reality of his own torment: his terrifying dreams, his agony over Rose, his fear

[12] On August 14, 1867, Ruskin wrote in his diary that he was trying to conquer his base dreams, but subsequent entries record his failure. On March 9, 1868, he dreamed of showing his young cousin Joan a snake and making her "feel its scales. Then she made me feel it, and it became a fat thing, like a leech, and adhered to my hands, so that I could hardly pull it off" (*Diaries*, II, 644). On November 27, 1868, he expressed surprise at having had "no disgusting or serpent dreams lately" (*ibid.*, p. 661), but on November 1 of the following year he described "the most horrible serpent dream I ever had yet in my life. The deadliest came out into the room under a door. It rose up like a Cobra—with horrible round eyes and had woman's, or at least Medusa's, breasts. It was coming after me . . . but I got some pieces of marble off a table and threw at it, and that cowed it and it went back; but another small one fastened on my neck like a leech, and nothing would pull it off" (*ibid.*, p. 685).

The "mental evil" to which Ruskin attributed the dream was, I believe, the same one to which he confessed in an astonishingly candid letter to Mrs. Cowper, after Rose had spoken of his "sins": "Her words are fearful—I can only imagine one meaning to them—which I will meet at once—come of it what may. Have I not often told you that I was another Rousseau?" He then drew a parallel between his own and Rousseau's autoeroticism. Two years earlier, in 1866, he had written to his mother in more general terms that "the intense resemblance between me and Rousseau, in mind, and even in many of the chances of life, increases upon my mind more and more" (XVIII, xxxviii). One is reminded of some of the Biblical texts which he transcribed in his diary for 1867: "Blessed is the man that endureth temptation. . . . Oh, remember not the sins and offences of my youth. . . . I will wash my hands in innocency, oh Lord. . . . My misdeeds prevail against me. Oh, be thou merciful unto our sins! . . . Save me, oh God, for the waters are come in, even to my soul" (*Diaries*, II, 618, 622, 634, 636).

Of course, sexual guilt alone does not account for Ruskin's digressions on Satan's power. But the Serpent-Tempter who assaulted him in his dreams and who figures in his books is in part a frightening personification of that guilt. (For Ruskin's letter to Mrs. Cowper, see Derrick Leon, *Ruskin: The Great Victorian* [London, Routledge & Kegan Paul, 1949], p. 410. For the parallel with Rousseau, see Peter Quennell, *John Ruskin: The Portrait of a Prophet* [New York, Viking Press, 1949], p. 203.)

that the Serpent-Tempter would not only corrupt his soul but un-
hinge his mind. His fears proved prophetic. A decade after he wrote
Time and Tide, a grotesque hallucination of "the Evil One" ap-
peared in his bedroom. Ruskin wrestled with him through the night
and was discovered naked and insane the following morning. For
weeks he remained in a state of wild delirium from which he never
completely recovered.

One final passage confirms our conviction that *Time and Tide*
is not merely social criticism, but a missing page from Ruskin's
"book of pain," the intimate diary of emotion which he apparently
destroyed late in his life. It is not his proper work, he writes on
the first fine day of spring, to be composing "these letters against
anarchy." He ought to be among the budding banks and hedges,
tending sprays of hawthorn and primrose. But, tormented by indig-
nation and compassion, he is forced to give up his peace "and rush
down into the streets and lanes of the city." For his own part, he
concludes,

I mean these very letters to close my political work for many a day; and
I write them, not in any hope of their being at present listened to, but
to disburthen my heart of the witness I have to bear, that I may be free
to go back to my garden lawns, and paint birds and flowers there.

Ruskin wrote *Time and Tide* because he had to unburden his
heart of what tormented him not merely in the public streets but
in the recesses of his private world. Yet writing the book did not
long release him from his obsessions with social evil and private pain.
These he escaped only in his last book, *Praeterita*, in which he fi-
nally returns to the innocent garden lawns of his childhood, before
the grass seemed to be "a battlefield wet with blood," or his heart
heavy with grief and guilt.

v

In May of 1868 Ruskin went to Dublin to lecture on "The Mystery
of Life and Its Arts." He hoped that Rose would be in the audi-
ence [13] and took great pains with the lecture, putting into it all that

[13] Rose was not present but sent Ruskin a letter encouraging enough "to
throw a light over all the rest of the year" (XXXVI, 549).

he knew. The lecture is weighted with his sense of the vanity of his aspirations and the fading of his powers. It is an elegy to forsaken hopes, shattered faith, unfulfilled desires. Yet it is wholly purged of the embittered self-pity which disfigures his letters of the same period. He succeeds in creating literature from what otherwise would be merely a personal lament.

Stylistically, "The Mystery of Life and Its Arts" is a *tour de force*. Ruskin introduces into modern English the rich resonances of Donne and Browne, the majestic sonorities of the King James Bible. The haunting solemnity of his cadences has the effect of implicating the cosmos itself in his grief. He repeatedly quotes or alludes to the Bible, but one verse in particular serves as a leitmotif: "What is your life? It is even as a vapour that appeareth for a little time, and then vanisheth away." This fleeting, yet impenetrable cloud is the dominant image of the lecture. In *Modern Painters* Ruskin had pictured the cloud as a luminous veil lightly interposed between the face of nature and the face of God. Here it is an image of his own darkened spirit, his sense of the thick, unfathomable mystery of life, the evanescence of its arts, the futility of its labors. And so he writes neither of physical nor of painted clouds, but of "a terrible and impenetrable one: not a mirage, which vanished as I drew near, but a pillar of darkness, to which I was forbidden to draw near."

Ruskin was soon to become obsessed with the storm cloud, which to his sick yet prophetic mind appeared to coil in lethal vapors over Europe, poisoning the air and polluting the waters. But when he wrote "The Mystery of Life and Its Arts" this obsession had not yet seized his mind. The lecture shows a remarkable recovery from the imbalance of *Time and Tide*. There are no improbabilities, no outbursts of uncontrolled rage, no breakings of the stately chain of argument. The result is a beautifully sane, beautifully structured statement of despair.

Ruskin closed his work of the 1860s with *The Queen of the Air*, an extraordinary recreation of the Greek sense of the gods and their ruling presence throughout nature. The subtitle—"A Study of the Greek Myths of Cloud and Storm"—is misleading, for the book is less a study of certain myths than a hymn to Athena, an incantation

of astonishing yet elusive power. The prose of *The Queen of the
Air* appears less baffling once we realize that it is a prose not of
statement but of *prayer*, which at its best achieves the condition of
music and should be so read, precisely as one reads Eliot's *Four
Quartets*. Of course, a study of myths ought not to attempt the ef-
fects of music or poetry, but Ruskin does not so much trace their
origins or meanings as re-animate, through a miracle of style, the
mind, the spirit, the god-haunted groves of Greece in which the
myths were born.[14]

His Protestant soul could never quite adore the Catholic Queen
of Heaven; but that part of his soul which remained pure pagan and
pantheist did indeed adore the Greek Queen of the Air. She per-
sonified the *anima mundi* which he worshiped all his life in the
cloud, the sea, the breathing leaf, and in man. His praise of her glory
reads almost as an atonement for his earlier, Evangelical attacks upon

14 At times the music is too subtle to be followed. One senses that Rus-
kin is imprisoned in the multiple echoes of his own allusions, which beget
further allusions, until the intricate orchestration of his thought becomes un-
intelligible. The same fault marred *The Cestus of Aglaia*, in which Ruskin
first employed this excessively allusive style. See especially the chapter en-
titled "Patience," where he confesses after a vexed passage, "I cannot get to
my work in this paper, somehow; the web of these old enigmas entangles me
again and again" (XVIII, 87). Chapter V, a violent denunciation of Rem-
brandt, is more coherent but no less symptomatic of the mental imbalance
which forced him to abandon the book: "Absolutely careless of all lovely
living form," Rembrandt could paint only the pawnbroker's festering heap of
old clothes or "the lamp-light upon the hair of a costermonger's ass." His art
reflects the "grim contempt of a strong and sullen animal in its defiled den,
for the humanity with which it is at war, for the flowers which it tramples,
and the light which it fears" (XVIII, 109–12).
R. H. Wilenski (pp. 32, 138–43) maintains that Ruskin suffered from a
morbid fear of light spots against a dark background, a fear to which he at-
tributes Ruskin's attacks upon Rembrandt's "alarming explosions" of light
and upon Whistler's *The Falling Rocket*. An unpublished letter in the Pier-
pont Morgan Library lends weight to Wilenski's contention. Ruskin complains
that, despite the fine weather, he is frightfully sulky because the effects of
the light and shade are far too sharp and Rembrandtesque to be pleasant
(MS. 1740, fol. 1). Throughout his life he was morbidly anxious about his
vision, which remained remarkably keen. He saw preternaturally vivid images
during his first attack of madness and, particularly when depressed, com-
plained of weird visual phenomena such as "swimming strings and eels" which
appeared to cover the evening sky. (See VIII, xxvi; XXXVII, 249; XXXVIII,
173; *Diaries*, II, 523, 615, 657, 659, 757).

superstition and Mariolatry, which now yield to a unique pantheism of his own.

Certainly a religious emotion underlies this summation of the creative forces Athena symbolized throughout nature:

The deep of air that surrounds the earth enters into union with the earth at its surface, and with its waters. . . . It gives its own strength to the sea; forms and fills every cell of its foam; sustains the precipices, and designs the valleys of its waves . . . lifts their voices along the rocks, bears above them the spray of birds, pencils through them the dimpling of unfooted sands. . . . It spins and weaves [the clouds] into wild tapestry, rends it, and renews; and flits and flames, and whispers, among the golden threads, thrilling them with a plectrum of strange fire that traverses them to and fro, and is enclosed in them like life.

It enters into the surface of the earth, subdues it, and falls together with it into fruitful dust, from which can be moulded flesh; it . . . becomes the green leaf out of the dry ground; it enters into the separated shapes of the earth it has tempered, commands the ebb and flow of the current of their life, fills their limbs with its own lightness . . . moulds upon their lips the words by which one soul can be known to another; it is to them the hearing of the ear, and the beating of the heart; and, passing away, leaves them to the peace that hears and moves no more.

This was the Athena of the greatest people of the days of old.

The prose has the magic of an incantation, as if Ruskin were chanting a hymn to some forgotten music by which Athena was once worshiped. His words assert nothing; intone and connote rather than state; invoke her presence through mere sounds and rhythms. The passage curiously resembles a hymn to another Queen, Gerard Manley Hopkins's "The Blessed Virgin Compared to the Air We Breathe":

> Wild air, world-mothering air,
> Nestling me everywhere,
> that's fairly mixed
> With, riddles, and is rife
> In every least thing's life;
> This needful, never spent,
> And nursing element . . .

But whereas Hopkins *likens* the Virgin to the life-giving air, Ruskin insists that the air itself *is* Athena. The vitality of the passage

derives from Ruskin's very primitivism, his refusal to sophisticate Athena into the polished, ivory goddess of Phidias. Ruskin's Athena predates the Greeks, predates history. "Greek myths," he once wrote, "are full of earth, and horror, in spite of their beauty." And indeed there is a touch of terror in the very vagueness of his portrait of Athena. One cannot trace her origins or be certain of her powers. Yet one senses that he has brushed against her serpent-fringed aegis and penetrated the primitive, animistic mind in which the gods were first conceived.

The Queen of the Air, however, is scarcely a reliable guide to Greek mythology. At times chaotic, too often fantastic in its interpretations, the book cannot be wholly trusted or understood. Ruskin's discussion of the symbolic meaning of the Harpies, for example, draws less on the myth itself than on the furies which were preying upon his own heart. He writes of the Harpies—evil "deities of storm"—in almost the same words he used to describe the tremulous, malevolent plague wind and storm cloud which began to obsess him when he wrote *The Queen of the Air:*

There is a sense of provocation and apparent bitterness of purpose in their thin and senseless fury. . . . From this lower and merely malicious temper, the Harpies rise into a greater terror, always associated with their whirling motion. . . . They are devouring and desolating, merciless . . . and so, spiritually, they are the gusts of vexatious, fretful, lawless passion, vain and over-shadowing, discontented and lamenting, meagre and insane,—spirits of wasted energy, and wandering disease, and unappeased famine, and unsatisfied hope. . . . Understand that, once, deeply —any who have ever known the weariness of vain desires; the pitiful, unconquerable, coiling and recoiling, and self-involved returns of some sickening famine and thirst of heart:—and you will know what was in the sound of the Harpy Celaeno's shriek from her rock; and why, in the seventh circle of the *Inferno*, the Harpies make their nests in the warped branches of the trees that are the souls of suicides.

As the Harpies symbolize the senseless fury raging within Ruskin, so Athena—goddess of noble passion and noble peace—symbolizes the lucid energy and unbroken calm he sought. Athena is his patron saint of stainless skies, a personal intercessor through whose agency he momentarily escapes his delusion that the air of

Europe was "defiled with languid coils of smoke," the snows faded "as if Hell had breathed on them," the waters "dimmed and foul, from deep to deep, and shore to shore."

The last, chaotic chapter recalls the impression Henry James gathered, while Ruskin was writing *The Queen of the Air*, of a mind drifting without a guide through the world of unreason. The book does not conclude, but disintegrates under the weight of irrelevancies and delusions such as Ruskin's claim that his "art-gift" belonged to him "by birthright, and came by Athena's will." He once described Turner's last years in words which cast light upon the wilderness into which he himself had already wandered. The passage is an unconscious self-portrait, more revealing even than James's description of Ruskin in middle life:

Tired of labouring carefully . . . helpless and guideless, he indulges his idiosyncrasies till they change into insanities; the strength of his soul increasing its sufferings, and giving force to its errors . . . and the web of his work wrought, at last, of beauties too subtle to be understood, with vices too singular to be forgiven; all useless, because his magnificent idiosyncrasy had become solitude, or contention.

Weary and obviously ill, Ruskin went to Italy immediately after completing *The Queen of the Air*. He was at Lugano when the news reached him, in August 1869, of his election to the newly endowed Slade Professorship of Fine Art. One is at a loss whether to admire the boldness or deplore the blindness of Ruskin's Oxford friends who secured the appointment of a mind so greatly gifted and so greatly disturbed.

X. THE NIGHT COMETH

In February of 1870 Ruskin delivered his inaugural lecture as Slade Professor of Fine Art. An overflow audience had crowded into the Sheldonian Theatre to hear the slender, slightly stooped figure noted for his graceful language, radical ideas, and oddly old-fashioned dress. An ample master's gown hung loosely over his frock coat and homespun tweeds. He spoke with a faint Scottish burr and wore the velvet cap of a gentleman-commoner, a quaintly prideful reminder of his days as an undergraduate at Christ Church. One member of the audience, Henry Acland, the Regius Professor of Medicine and Ruskin's lifelong friend, recalled that in the same crowded hall thirty years earlier Wordsworth had listened to the young Ruskin read the poem which had been awarded the Newdigate prize.

The inaugural series of lectures—balanced, temperate, almost courtly in their grace of statement—justified the confidence of Ruskin's friends in urging his appointment. At the end of the second lecture Acland was in tears, "he was so pleased," Ruskin wrote to his mother, "and relieved from the fear of my saying anything that would shock people." The lectures betray none of the imbalance of mind or uncertainty of purpose which had marred *The Queen of the Air*. Nor are they disfigured by the grief Ruskin experienced during their composition. A month before he delivered the inaugural and just after the day on which he had once hoped to marry Rose, she passed him on the street without a word. He marked her silence with a blank page in his diary headed with the date alone and wrote to Mrs. Cowper that the inaugural was not what it should have been because he was "so stupid with the pain."

Ruskin's grief over Rose might have deranged him years earlier than it did, had it not been for the sense of direction the professorship imposed upon him. He put a halt to his aimless wanderings in Italy during 1869 and went to Oxford intensely dedicated to a task which arrested the still more aimless drift of his thought. Beneath the measured dignity of his letters of acceptance to his Oxford friends, one senses his relief that so demanding an honor had, momentarily at least, distracted him from distraction.

Atypically temperate and impersonal, the inaugural lectures lack the spontaneous brilliance, the exuberance of discovery, of Ruskin's earlier writing on art. They might almost have been written by a greatly gifted disciple who possessed a more orderly, less exciting mind. Because he wanted to prove his mental poise to himself and and to his audience, he reverted to old themes, resting in certainties lest he drift again into a wilderness. The most memorable phrases in the lectures deal not with art itself—which no longer moved Ruskin as it once had—but with the need for securing those conditions of national culture and well-being under which the arts might most widely flourish. The whole aim of the professorship as he conceived it was to convince his students, many of whom were born to privilege and destined to positions of patronage and power, that the beauty which is truly to be a joy forever must be a joy for all. If his message was largely a restatement in academic dress of *The Stones of Venice* and *Unto This Last*, it nonetheless had the ring of novelty at Oxford. At a time when Whistler had begun to popularize the doctrines of *l'art pour l'art* in England, Ruskin's students were told:

You never will love art well, till you love what she mirrors better. . . . The giving brightness to picture is much, but the giving brightness to life more. . . . Were it as patterns only, you cannot, without the realities, have the pictures. *You cannot have a landscape by Turner, without a country for him to paint; you cannot have a portrait by Titian, without a man to be pourtrayed.* . . . The beginning of art *is in getting our country clean, and our people beautiful.*

A remarkable, perhaps impertinent, assertion for a professor of fine arts. But if Oxford was perplexed by Ruskin's message, it could

not accuse him of neglecting his subject. He gave individual lessons, founded a school of drawing, stocked it generously with examples from his own collection, and with a gift of £5,000 endowed the school with a permanent master. His lectures fill six volumes and range widely, though with unequal brilliance, from the technicalities of drawing to Greek sculpture and Florentine engraving. Yet their vitality derives less from esthetic pleasure than moral fervor. Too long to quote and too fine to compress, the most moving passage Ruskin wrote as Slade Professor concludes, "It is the vainest of affectations to try to put beauty into shadows, while all the real things which cast them are left in deformity and pain." This conviction underlay all of his work at Oxford, even after madness had rendered that work impotent, indeed at times grotesque.

Although Acland wept tears of relief over Ruskin's early lectures, Oxford was soon to laugh in shocked embarrassment at the later vagaries of its Professor. The most celebrated of Ruskin's professorial innovations was an outdoor class in road mending which he supervised in a muddy, rutted lane near Ferry Hincksey, a pleasant wooded village on the outskirts of Oxford. In the autumn of 1874 Ruskin could be found there in the company of his gardener and a dedicated crew of undergraduates, including Arnold Toynbee and, oddly, Oscar Wilde. With picks, spades, barrows, and straw hats, the "Hincksey-Diggers" appeared regularly at the roadside and reappeared cartooned in the London press and lampooned in the Oxford journals. They continued to dig loyally, if unprofessionally, believing, as one of them said of their leader, "Well, if *he's* mad, it's a pity there are not more lunatics in the world." The project gratified Ruskin's instinct for play [1] and appeased his anxious sense that he ought not to be lecturing but laboring in the Lord's vineyard. Labor without art, he had told his students at The Workingmen's College, is brutality; now he tried to show the gentlemen of Ox-

[1] For his fondness for digging holes, see XXXV, 426. He toyed with the idea of designing grips for the spades and "coquetry of iron work" for the pickaxes. Although the project delighted him, Ruskin rightly attributed its modest success to his more practical gardener, David Downs. (See XX, xliv, and XXXVII, 90.)

ford that art without service is guilt. They were to learn the value of straining their muscles in useful service rather than in competitive sport, and in the process beautify a bit of English earth so that, should a second Turner appear, he would have a landscape to paint. But Ruskin himself pointed to the profoundest motive which led him to mend roads and risk ridicule: were it not for the labor of his hands, he wrote in *Fors Clavigera*, he would go mad.

All his life he had feared the coming of the night when no man could work; he had now begun to fear that the impending darkness was not death but the impenetrable isolation of insanity. "I have been endeavouring this morning to define the limits of insanity," he wrote to Norton in 1870. "My experience is not yet wide enough: I have been entirely insane, as far as I know, only about Turner and Rose." His experience widened tragically in the next few years.

In the summer of 1871, during a holiday at Matlock, he was stricken with an undiagnosed illness marked by a euphoric delirium, the obverse of the waking nightmares which were to plague him during later episodes of madness. Heightened by fever and haunted by visions of Rose, his dreams were pathologically prolonged and intense. He gradually regained his strength, but not his equilibrium. For he interpolated a confused, semi-mystical account of his Matlock dreams into a lecture on Florentine design. And, as if to illustrate the private symbolism of the lecture, he placed a vignette of a rose on the title page.

Except in fragments of sporadic and broken brilliance, Ruskin never fulfilled the ambitious program of art studies he had outlined in his inaugural. The lectures became increasingly disjointed and irrelevant to the arts, and well before his mental collapse in 1878 compelled him to resign, his effectiveness at Oxford had come to an end. In the spring of 1874 he was forced to cancel a series of lectures because, as he candidly put it, his brains were out of working gear. In the following year he astonished his students when, protesting what he considered the frivolousness of the music performed in one of the college chapels, he danced before the class, reciting and gesticulating excitedly as his master's gown flapped wildly about

him. He did not lecture at all in 1876; for his final course, knowing that he must not risk improvisation or further tax his mind, he confined himself to readings from *Modern Painters*.

Ruskin's unavailing struggle to preserve his sanity was the central fact of his life during the 1870s. It colored all that he wrote, from the playful trivia of his lectures on birds and stones to the magnificent, sprawling miscellany entitled *Fors Clavigera*, at once the strangest and most moving of his books. Into *Fors* he poured all his passions, releasing the "daily maddening rage" in which he lived; nearly all else that he wrote, apart from the early Oxford lectures, was a form of play, a prodigious diversion which filled eight volumes and served him in place of rest.

Incapable alike of inaction or consecutive effort, he wrote more copiously and on a greater diversity of subjects than at any other time in his life. In the fall of 1875 seven of his books—all but one incomplete—were in press simultaneously. He would enter his study at sunrise and work in spurts on each of his manuscripts as a thousand thoughts flitted through his mind "like sea-birds for which there are no sands to settle upon." He knew that at all costs he must avoid whatever threatened to derange him with grief or rage and, as in the past, he turned to those studies of nature over which his mind might range at ease.

Capricious, deliberately unscientific, unlike all other books on flowers, birds, or stones, *Proserpina, Love's Meinie,* and *Deucalion* reflect the play of a brilliant but unbalanced mind seeking to reconstruct a reality more tolerable than that which it confronted daily. He rechristened the Latin families of flowers with the names of the little girls of his acquaintance. His geology was a combination of lifelong study of the Alps and pleasant putterings in his kitchen with toast-crumb moraines and glaciers of blancmange. It is a measure of his increasing intellectual isolation that his master in geology was Saussure, whose *Voyages dans les Alpes* had first appeared in 1779. With defensive arrogance, he attacked the contribution of contemporaries, never quite realizing that his own was not science but play.

The wit of Ruskin's pseudo-science is as striking as its occasional ill temper. Substituting the play of metaphor for the dry labor of classification, he grouped the creatures of nature into strange brotherhoods related only by the ingenuities of his fancy. The secretive, chimney-haunting swallow "is an owl that has been trained by the Graces . . . a bat that loves the morning light." The serpent, covert brother to the tribe of flowers which entwine themselves around their hosts, "is a honeysuckle, with a head put on." In these virtuoso pieces of his leisure, Ruskin expended his superabundant energies on trivia of great charm. But they also served a subtler function. In *Deucalion* he transformed the serpents which had terrified him in his dreams into harmless objects of wit, lizards that had dropped off their legs, lithe ducks that waddled without feet.

Almost all that Ruskin wrote during the mid-1870s betrays an extraordinary inconsistency of tone. Like his nature studies, his guidebooks to Florence and Venice vacillate, with scarcely any middle ground, between felicitous ease and violent invective. He had gone to Italy in 1874 and again in 1876 hoping to escape the depression and irritability which had reduced him to angry silence at Oxford. But the peace he sought by returning to the remembered pleasures of Italy was destroyed by the reality of his present pain. This reality repeatedly shatters the placid surface of *Mornings in Florence* and *St. Mark's Rest* and bares a substratum of pathological fury. In the fifth of the "mornings" in Florence, Ruskin turns from the fresco of Rhetoric in the Spanish Chapel to describe the actual voices which tormented him in the streets:

You never hear a word uttered but in a rage. . . . Everybody—man, woman, or child—roaring out their incontinent, foolish, infinitely contemptible opinions and wills, on every smallest occasion, with flashing eyes, hoarsely shrieking and wasted voices,—insane hope to drag by vociferation whatever they would have, out of man and God.

After an exquisite passage in praise of Giotto's bell tower and the vanished culture it once overlooked, he turns to the Florence before his eyes and sees nothing but "Caliban bestiality and Satyric ravage —staggering, drunk and desperate," hears nothing but a "deluge of

profanity, drowning dome and tower in Stygian pool of vilest thought."

If Florence had become for him an obscene inferno, Venice had become a corpse. *St. Mark's Rest* is a requiem to a dead city and a cry of outrage at all that had dimmed her splendor in the quarter-century since Ruskin had written *The Stones of Venice.* The commercializers, the tasteless restorers, the "unclean mob" which befouled her palace walls, even the innocent tourists who had come to Venice with Ruskin's guidebook in hand—all were charged with her destruction.

Of course, Venice had in fact altered since Ruskin had written of her as a shimmering sea city of marble and gold. The campanile overlooking San Marco was in danger of collapse; steam-driven *vaporetti* were replacing the gondolas; the railroad had been extended to the very edge of the city; Giorgione's frescoes high on the façade of the Fondaco dei Tedeschi had all but vanished. Yet Venice had changed far less radically than Ruskin's vision of her. *St. Mark's Rest* is the palest reflection of *The Stones of Venice,* a mere ghost of a book whose vitality had faded like the color of Giorgione's frescoes. The bitter temper of the book is like that of a man who, because he can no longer love his mistress, despises her for the fault which arises within himself. The failure of Ruskin's own powers of delight, together with a morbid irritability, led him to portray Venice as a fallen paradise inhabited by a bestial, shrieking mob.

Where Ruskin had once perceived light, harmony, and rest, he now perceived only discord and darkness. His turgid, restless sketches of Venice in 1876–77 are the muddied images of an unquiet mind. He sketched as he wrote—in haste—and the disorder of his prose found its counterpart in the unrest of his eye. The same diseased energy which produced *St. Mark's Rest* produced his sketch of a Venetian canal, with its foreground of violent zigzags, its turbulent gloom, its angry impatience. His discipline of hand and eye had failed, and he never recaptured the serene, luminous vitality of his early drawings.

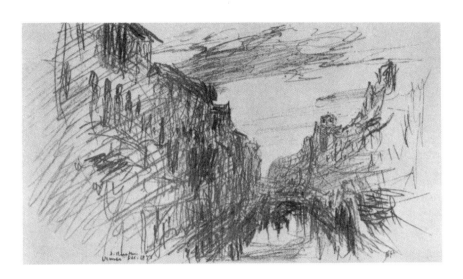

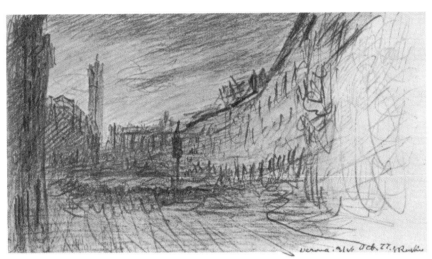

AT VENICE AND VERONA, 1876-77

To his overwrought senses, the look and sound of things had begun to assume a preternatural intensity which later terrified him during attacks of insanity. In the spring of 1874, while staying at Taormina, he described the sunrise over Mount Etna; his editors tell us that the view delighted him, but the sublimity of his description suggests terror far more than delight. The morning light took on a lurid glow and the nearby church bells rang in his ear with magnified and distorted clamor:

At the instant the sunrise touched the top of the cone of the mountain itself, the belfry of the chapel beside me broke into a discordant jangle of deep-toned bells, as if to give warning to the whole village; beating first in slow time, one stroke, hard and loud; then quicker, and . . . dreadfully painful from the discordant and violent ringing. . . . The discordance and almost terror of the beautiful body of sound was in a strange sympathy with the horror of the morning light—rose red—on the dreadful cone.

Had Ruskin written this passage thirty years earlier, the light would have appeared no less intense, but celestial rather than sinister, and the tolling of the bells would have echoed harmoniously through the cadences of his prose. Now, however, with his senses "like sweet bells jangled, out of tune and harsh," he projected upon nature the discords which arose within himself. His obsession with the satanic storm cloud stems from the same morbid heightening of sensibility, which, when it passed into actual madness, caused "all ugly things [to] assume fearfully and horribly hideous forms" and gave "a wild, lurid, fever-struck grandeur to grand things."

Ruskin's hyperesthesia made an agony of his sojourns in Italy and in part accounts for his grotesque outbursts of Italophobia. His diary is filled with passages which surpass in ferocity those he printed in *Mornings in Florence* and *St. Mark's Rest*. The sights, sounds, and smells of Italy assaulted his senses when he worked or slept. At Venice he was "driven wild" by the "crashing discordance of the church bells," and the deafening howls of the *vaporetti* made it impossible for him to write. At Fiesole hideous, drunken choruses broke into his sleep and the "accursed omnibus" trumpeted

through the streets "with noises like breaking wind—unclean." The ferocity of his irritation extended even to those whom he passed casually on the streets. At Florence the disgust and horror of his walks "were unspeakable. I met none in the streets but blackguards —wretches—and the worst sort of fools. Misery and filth everywhere; the Grave, without its peace." He left the city thankfully, for it had become "a place of torment day and night. . . . Every face one meets is full of hatred and cruelty. And the corner of every house is foul."

Ruskin was living in divided worlds: an intolerable present and a past purged of all tension and discord. Like his alternating moods of depression and euphoria,[2] his consciousness oscillated between a

[2] R. H. Wilenski (*John Ruskin* . . . [London, Faber & Faber, 1933], pp. 10, 29–31) convincingly argues that Ruskin was a manic-depressive all his life. Unmistakably his diaries reveal cycles of depression and elation which become more and more pronounced. The pattern appears with classic clarity during his Italian tour of 1874:

"*August 6th*. Fearfully despondent and confused last night.

"*August 7th*. Y[esterday] . . . had a glorious day of learning.

"*August 9th*. . . . No pleasure in *any*thing.

"*September 27th*. A wonderful day among the marble glens. . . . A day of strange peace to me.

"*September 29th*. All dark and comfortless."

After he left Italy, his hostility and depression gave way to the euphoria of his entries in the Alps:

"*October 18th*. . . . Ineffable beauty, and joy of heart for me, all along valley of Cluse." But the mood did not last; on the following day he wrote:

"My mind so paralysed with disgust, sorrow, indignation, and weary sense of my own faults and miseries. . . . The reaction from blessed yesterday morning."

The pendulum swung back and forth even more violently in the 1880s:

"*October 22nd, 82*. Up in good heart and fair strength . . . and enjoyed more than I ever thought to enjoy again.

"*October 23rd, 82*. After that exulting entry y[esterday], everything went wrong. . . . All is now cloudy and dismal, plague blackness driving from the west.

"*February 23rd* [1885]. Y[esterday] one of the best and cheerfullest days . . . that I've had for years.

"*February 24th* [1885]. Yesterday a terrible day of chagrins and difficulties . . . all humiliating and grievous."

Finally, after morbidly depressed entries, the diaries conclude with ecstatic passages on the glories of Chamonix—the identical note on which they opened, over fifty years earlier, with the young Ruskin's impassioned account of his tour of the Alps.

remembered world of clear skies and exquisite harmonies, and a present of sinister lights and monstrous dissonances. A passage in *Deucalion* describes this duality with the force and fidelity of an expressionist nightmare. Ruskin writes that he had been compelled to leave Italy because, for six months, he had heard nothing but

entirely monstrous and inhuman noises in perpetual recurrence . . . wild bellowing and howling of obscene wretches far into the night: clashing of church bells, in the morning, dashed into reckless discord, from twenty towers at once . . . filthy, stridulous shrieks and squeaks, reaching for miles into the quiet air . . . and the vociferation, endless, and frantic, of a passing populace whose every word was in mean passion, or in unclean jest.

Reading the passage, one knows at once, as Cézanne did on seeing the work of Van Gogh, that its violent, contorted vigor is superb—and insane. But suddenly the tone of the writing changes. "As in a dream" Ruskin found himself walking alone and in perfect peace through a valley in Haute Savoie which had not changed since he first saw it forty years earlier. The force of that early association overcame his obsession with the decay of nature and the brutality of man, and again he could hear music instead of discord:

Presently, as I walked, the calm was deepened, instead of interrupted, by a murmur—first low, as of bees, and then rising into distinct harmonious chime of deep bells, ringing in true cadences—but I could not tell where. The cliffs on each side of the Valley of Cluse . . . so accepted, prolonged, and diffused it, that at first I thought it came from a village high up and far away among the hills . . . I turned about and stood still, wondering; for the whole valley was filled with the sweet sound, entirely without local or conceivable origin. . . .

Perfectly beautiful, all the while, the sound, and exquisitely varied, —from ancient bells of perfect tone and series.

The passage repeats in miniature the pattern of all Ruskin's succeeding work. In *Fors Clavigera* the two antithetic worlds exist side by side: autobiographical reminiscences of great calm and clarity alternate with invectives of fantastic ferocity. Then, in *The Storm-Cloud of the Nineteenth Century*, Ruskin purged the unspent portion of his wrath in a raging, apocalyptic denunciation of the whole

century, from its fouled skies to its festering cities. Finally, in
Praeterita he recaptured in perfect peace the clear skies and crystal
streams of his childhood.

<div align="center">

ii

</div>

Of all that Ruskin wrote in the last two decades of his career, noth-
ing is stranger, more chaotic, yet more essentially the expression of
his genius than *Fors Clavigera*.[3] It is like no other book in our lit-
erature, and perhaps should not be called a book at all, but the diary
of a nobly gifted mind, disturbed but not deceived by its sickness.

Written in the form of *Letters to the Workmen and Labourers
of Great Britain*, *Fors* was published monthly from 1871 until Rus-
kin's breakdown in 1878; thereafter publication was intermittent,
the series ending with the Christmas letter of 1884. The dates are
revealing, for they almost exactly parallel the years of Ruskin's ac-
tivity at Oxford and suggest that *Fors* was written in part as a guilty
reaction to his work as Professor of Fine Art. Within a year of his
inaugural lecture, he published the first issue of *Fors;* the last ap-
peared on the eve of his final resignation from Oxford. Only then,
it seems, did he feel free to give himself to the pleasing labor of
Praeterita.

Ruskin's old, anxious conflict between the study of art and the
reformation of society, between self-indulgence and self-sacrifice,

[3] The primary source of this most elusive and allusive of Ruskin's titles
was Horace's figure of "implacable Fate, the Nail-bearer" (*Odes* i. 35. Cf. iii.
24 and XXVII, xix–xxiii). With the Horatian image of Fate he also associ-
ated an Etruscan mirror case on which he had seen an engraving of the
death-goddess Atropos, hammer in hand, about to drive home the final, fatal
nail. The first word of the title means Chance or Accident, but Ruskin used
it interchangeably in the three senses of Force, Fortitude, and Fortune.
Clavigera means Club-bearer (*clava* plus *gero*, to bear), Key-bearer (*clavis*),
and Nail-bearer (*clavus*). Force with the club represents the wise and strong
man armed; Fortitude with the key represents Patience, the portress at the
gate of Art; Fortune or Fate with the nail represents the fixed power of
Necessity. With the third meaning of *Fors*, Ruskin also associated the Three
Fates of the Greeks, the power which sustains the thread of life, the power
which controls the chances which warp it, and the power which cuts the
thread forever. Each of these meanings shades into all the others, until the
title comes finally to represent the Fate which wove the tragic pattern of
Ruskin's life and the Chance which led him to mirror that pattern with such
an anarchy of accident and digression throughout the book.

persisted throughout his Oxford years: "I began the writing of *Fors*," he explained in one of the letters, "as a byework to quiet *my* conscience, that I might be happy in . . . my own proper life of Art-teaching, at Oxford and elsewhere; and, through my own happiness, rightly help others." But his conscience would not be stilled; for fourteen years the bywork was the central achievement of his life.

Fors is first and most simply an anatomy of the folly, ugliness, and brutality of the age. Its 600,000 words record Ruskin's lonely pilgrimage through Europe and his cry of *nausée* at the desolation and horror of the entire earthly city. *Fors* is also the diary of an inner despair, a private wasteland of the spirit. There are letters which, in the magnitude of their isolation, open out upon a terrifying night of the soul. Reading them, as Cardinal Manning phrased it, is like listening to the beating of one's heart in a nightmare.

The image is perfect, for it conveys not only the peculiar loneliness of *Fors* but its almost frightening immediacy. Ruskin is at once closer to his reader in *Fors*, yet more alienated from the world he describes, than in any other of his books. As his hold on reality became more tenuous, his style became more intimate, until on the pages of *Fors* one seems to touch the lineaments of thought itself without the intervening medium of words. Rich in all the intonations of the spoken voice, capable almost of physical gesture, the letters are even more immediate than speech; one is less aware of the rhythms of the voice than of the pulse of thought—that scarcely audible and most complex of all musics, the music of consciousness itself.

Ruskin's thought is so rapid, so various, yet so intense that each sentence is charged with a vitality of its own. The cry of a fig-vendor outside Ruskin's rooms in Venice, faces in a railway carriage, a little girl spinning a top on a street in Oxford, an infant left to freeze in the snow, newspaper accounts of weddings, murders, banquets, wars—these make up the tableaux of topical trivia and monstrousness which give *Fors* its insistent actuality. Yet if *Fors* is the most topical of Ruskin's books, it is also the most timeless. Its surface reality, always shifting yet startlingly clear, is absorbed into the

larger, fixed reality of Ruskin's isolation. And, like Ruskin, we are the observers of a spectacle which is utterly engrossing but from which we are utterly apart. This being entrapped in a world which we can see and touch but not enter gives the book its obsessive quality, its peculiar suspension of time and absence of motion. The external world is less real than the mind which describes it, and which lies open and animate before us.

Because the letters were written in the haste of the moment's mood, they are devoid of all formal decorum and are as varied in tone as they are in subject. Trivial or violent, fantastic or momentous, they are in the strictest sense letters and, like all good letters, are profoundly personal. Yet the reader is never quite certain to whom they are addressed. Several appeal directly to the "Workmen and Labourers" of Great Britain to join Ruskin's Guild of St. George. The affairs of the Guild, the plans and perplexities of its "Master," form a kind of leitmotif loosely connecting the letters. Others, with their exegeses of the Bible, Dante, and *Dame Wiggins of Lee*, their digressions on Ruskin's childhood and the growth of snails, have as little to do with Ruskin's workmen or their Guild as do the habits of the humblebee, which he charmingly describes in the fifty-first letter.

Certain letters seem to arise from nowhere and lead nowhere, but capture with a fixed intensity some isolated moment of feeling or vision. *Fors* was written as much to arrest these moments, to transmit them whole from Ruskin's to the reader's mind, as to propound a scheme of social reform. "The solitude at last became too great to be endured," he wrote in *Fors* of the cause of his madness. Much earlier in the letters he had abandoned his customary salutation—"My friends"—and had ceased to sign his name at their close. Yet, he told his readers, "you will probably know whom they come from, and I don't in the least care whom they go to." He did not care because self-expression for its own sake had become a vital condition of his being, and it was far more imperative for him that the letters be written than that they be read. His anonymity was the sign of his own estrangement; yet he could no more cease writing the letters than refrain from noting in his diary the blank or hostile

faces which passed him in the streets. *Fors* was his last link with a communicable world before the solitude became too great to be endured.

Ruskin's fear of that final solitude is the subject of the great Christmas letter of 1874. It opens with a quietly ironic account of the progress of St. George's Guild. The few subscriptions he received during the years of his mendicancy, Ruskin writes, might have disappointed him if he had anticipated a sudden acceptance of his scheme for achieving national felicity. But he is content to amuse himself with his stones and pictures, and can ignore for a time the distress and disease all around him. Such even-tempered obliviousness is, after all, what most people call "rational," and he must fight steadily to keep himself out of Hanwell or Bedlam.

He is not surprised at his readers' shyness in joining the Guild, for he himself has had little success in charitably administering his funds. He tried to purify one of the polluted springs of the River Wandel, but instead of taking care of itself when once clean, the spring required "continual looking after, like a child getting into a mess." [4] Similarly, he was forced to abandon his efforts to keep a street ideally clean in the heart of the St. Giles slums, for he could not attend to all the sweeping himself, and the crew of crossing-sweeps he employed was headed, alas, by a rogue. He next set up a tea shop in Paddington Street to supply the poor with an unadulterated product at reasonable prices. But since he would not compete with the neighboring tradesmen in false advertising and for months could not decide upon the proper coloring for his sign, "Mr. Ruskin's tea-shop" languished, along with the two old servants of his mother who sold the tea in his employ.

[4] In *Praeterita* Ruskin recalls his mother's taking him to play beside "The Springs of Wandel," near her own childhood home at Croydon. The stream had become fouled with human and industrial sewage, and after Margaret Ruskin's death in 1871, he restored one of its springs and erected on its banks a memorial tablet with the inscription: "In obedience to the Giver of Life, of the brooks and fruits that feed it, of the peace that ends it, may this Well be kept sacred for the service of men, flocks, and flowers, and be by kindness called MARGARET'S WELL." But the flowers he planted were trampled, the stream again polluted, and the tablet taken down. (See XVIII, 385–86; XXII, xxiv.)

Ruskin's tone of self-mockery, his deliberate affectation or help-less display of folly, leave the reader at a loss whether to admire his eccentric benevolences or pity their absurdity. We wish that he were more clearly sane—or insane—and are forced to wonder if his folly might not be wisdom and our own sanity a species of mad-ness. He raises the question himself by pointing to the delicacy of the distinction implied by those on either side of "that long wall at Hanwell," and asking, "Does it never occur to me . . . that I may be mad myself?"

"I am so alone now in my thoughts and ways," he answers, "that if I am not mad, I should soon become so, from mere solitude, but for *my* work." It is a hard time for all men's wits, for those who know the truth "are like to go mad from isolation; and the fools are all going mad in 'Schwärmerei'— [5] only that is much the pleasanter way." It is pleasant madness for Lord Macaulay, for instance, in whose eyes we are giants of intellect "compared to the pigmies of Bacon's time, and the minor pigmies of Christ's time . . . the micro-scopic pigmies of Solomon's time, and, finally, the vermicular and infusorial pigmies—twenty-three millions to the cube inch—of Mr. Darwin's time!"

The tone of the letter has shifted from the muted ironies Ruskin had directed against himself at its opening to the sharper thrusts which he directs at the fools surrounding him. Then, in one of the climactic paragraphs of *Fors*, he drops the mask of the ironist and writes as a voice in the wilderness, crying out in the agony of his isolation and raging at the horror of an alien world:

But for us of the old race—few of us now left,—children who rever-ence our fathers, and are ashamed of ourselves; comfortless enough in that shame, and yearning for one word or glance from the graves of old, yet knowing ourselves to be of the same blood, and recognizing in our hearts the same passions, with the ancient masters of humanity;— we, who feel as men, and not as carnivorous worms; we, who are every day recognizing some inaccessible height of thought and power, and are miserable in our shortcomings,—the few of us now standing here and there, alone, in the midst of this yelping, carnivorous crowd, mad for

[5] Ruskin uses the word in Carlyle's sense of fanatical enthusiasms blindly shared by the masses.

money and lust, tearing each other to pieces, and starving each other to death, and leaving heaps of their dung and ponds of their spittle on every palace floor and altar stone,—it is impossible for us, except in the labour of our hands, not to go mad.

Throughout *Fors* there is something diseased in the very vigor and incontinence of the invective. Ruskin repeatedly fails in his resolve to keep from mounting the "Cathedra Pestilentiae," the seat of the scornful, from which, as Carlyle phrased it, he poured "fierce lightning-bolts . . . into the black world of Anarchy all around him." The British are a nation of "thieves and murderers . . . a mere heap of agonizing human maggots, scrambling and sprawling over each other for any manner of rotten eatable thing they can get a bite of." Their Parliament is a place of "havoc and loosed dogs of war," their press so many square leagues of "dirtily printed falsehood," their politics " a mad-dog's creed," their populace a "rotten mob of money-begotten traitors," their clergy sellers "of a false gospel for hire." Britannia herself, Empress of the Seas, is a "slimy polype, multiplying by involuntary vivisection, and dropping half putrid pieces of itself wherever it crawls or contracts."

Despite their ferocity, passages like these reflect the delight Ruskin took in the sheer exuberance and virtuosity of his invective. To be sure, it was a perilous pleasure which exacerbated the very irritability he fought to control. "Sun set clear," he wrote in his diary: "I knelt down to pray that it might not go down on my wrath." The "wild and whirling words" of *Fors* bear witness to his lost battles and are signs of the same pathological fury which disfigures *Mornings in Florence* and *St. Mark's Rest*. But if they are the symptoms of Ruskin's imbalance, they are as well a sort of self-administered therapy. "I don't *anger* my soul," he told a reader of *Fors*, "I relieve it, by all violent language. . . . I *live* in chronic fury . . . only to be at all relieved in its bad fits by studied expression." [6]

<hr>

[6] The best example of such expression is Ruskin's letter of May 19, 1886, spurning a request that he help liquidate the debt on an Evangelical chapel. The invective is so outrageously masterful that it culminates in an almost audible laughter: "Sir,—I am scornfully amused at your appeal to me, of all people in the world the precisely least likely to give you a farthing! My first word to all men and boys who care to hear me is 'Don't get into

The relief Ruskin derived from violent language he also found in the wild inconsequence of wit. He affected the very madness which he feared, assuming an antic disposition in order to say in seeming jest what no man could say in earnest and still be thought sane. "If I took off the Harlequin's mask for a moment," he tells his readers, "you would say I was simply mad." Ruskin's stratagem is Hamlet's stratagem, born of the same fear and cloaking the same inner bafflement. Indeed, the mind which animates *Fors* is as swift and subtle as Hamlet's, yet as tempestuous as Lear's and as wayward as the Fool's. Ruskin is never more himself in *Fors* than when he seems to speak through the mouth of the Fool, whose wisdom and charity underscore our own brute folly. Such is the method behind his madness when, after some seventy letters indicting the inhumanity of man, he tells his working-class readers that if they wish to become true gentlemen, they must first be the kindly servants of beasts:

To all good and sane men and beasts, be true brother; and as it is best, perhaps, to begin with all things in the lowest place, begin with true brotherhood to the beast: in pure simplicity of practical help, I should like a squad of you to stand always harnessed, at the bottom of any hills you know of in Sheffield,—where the horses strain;—ready there at given hours; carts ordered not to pass at any others: at the low level, hook yourselves on before the horses; pull them up too, if need be; and dismiss them at the top with a pat and a mouthful of hay. Here's a beginning of chivalry, and gentlemanly life for you, my masters.

A pat and a mouthful of hay, my masters. . . . The tone is perfect; again one hears echoes of the Fool, alone with his abused master

debt. Starve and go to heaven—but don't borrow. Try first begging—I don't mind if it's really needful—stealing! But don't buy things you can't pay for!' And of all manner of debtors pious people building churches they can't pay for, are the most detestable nonsense to me. Can't you preach and pray behind the hedges—or in a sandpit—or a coalhole—first? And of all manner of churches thus idiotically built, iron churches are the damnablest to me. And of all the sects of believers in any ruling spirit—Hindoos, Turks, Feather Idolaters, and Mumbo Jumbo, Log and Fire Worshippers—who want churches, your modern English Evangelical sect is the most absurd, and entirely objectionable and unendurable to me! . . .

"Ever, nevertheless, and in all this saying, your faithful servant, John Ruskin." The recipient sold the letter as a curiosity for a guinea, which went to paying off the debt on the Chapel (see XXXIV, 594–95).

and the pilloried Kent, diverting them with the tale of the fellow who out of pure kindness buttered his horse's hay.

Both the outrage and the anguish of *Fors* would have been too oppressive were it not for such sudden, startling shifts of tone. Ruskin's account of himself standing alone amidst a carnivorous crowd is immediately followed by his description of a dimpled, contented pig, feeding on a mess of ambrosial rottenness, with whom he would fain change places. The letter which contains his portrait of Britannia as a putrid polyp begins with an elaborate recipe for Yorkshire Goose Pie. The vegetable soup on which Theseus feasted upon his return to Athens figures in half a dozen letters and, along with like trivia, serves as a bizarre leitmotif relieving the tension of the letters and grounding them in an antic yet earthy actuality.

Sometimes Ruskin's effect defies analysis, for it lies on that border between oppositely charged emotions where laughter is indistinguishable from tears. This is the note he strikes in one of his letters from Venice, written on his balcony at the Ca' Ferro overlooking the Grand Canal. Between the shafts of the palace window

the morning sky is seen pure and pale, relieving the grey dome of the church of the Salute; but beside that vault, and like it, vast thunder-clouds heap themselves above the horizon . . . all so massive, that half-an-hour ago, in the dawn, I scarcely knew the Salute dome and towers from theirs; while the sea-gulls, rising and falling hither and thither in clusters above the green water beyond my balcony, tell me that the south wind is wild on Adria.

He has beside him a little cockle-shell, which he would like to draw and describe in peace. This is his proper business, his good friends tell him, yet he cannot mind it and be happy. It would please his friends and himself if he went on living in his Venetian palace, "luxurious, scrutinant of dome, cloud, and cockle-shell." He could do so by selling his books for large sums, if he chose to bribe the reviewers, stick bills on lampposts, and say nothing displeasing to the bishops of England:

But alas! my prudent friends, little enough of all that I have a mind to may be permitted me. For this green tide that eddies by my threshold is full of floating corpses, and I must leave my dinner to bury them,

since I cannot save; and put my cockle-shell in cap, and take my staff
in hand, to seek an unencumbered shore.

The tide of floating corpses would strike us as merely mad, as
some grotesque apparition, were it not for the banter about cockle-
shells and bill-stickings which immediately precedes it. Instead the
green tide emerges as the perfect symbol of Ruskin's guilt over the
wretchedness of the world beyond the purview of his palace. Even
so, the image retains an almost hallucinatory power, at once muted
and enriched with echoes from the mad Ophelia's song:

> . . . By his cockle hat and staff
> And his sandal shoon.

With touches as deft as this Ruskin sustains his antic progress through
Fors, bearing the cockle cap and staff of the solitary pilgrim, and
not unwilling to exchange the pilgrim's cap for that of the fool.

One mark of Ruskin's folly throughout *Fors* is his reckless and
absolute candor. Perhaps because he cared so deeply for his ideas,
he cared not at all for the figure he cut while advocating them. "I
neither wish to please, nor displease you; but to provoke you to
think," he told those readers who complained that he wrote of
things which little concerned them in words they could not easily
understand.[7] Remarkably personal, the letters are no less remarkably
disinterested. They express the idiosyncrasies, obsessions, tastes, and
distastes of a man who is simply and guilelessly the center of his
own universe; yet they are so unremittingly sincere, so devoid of
posturing or illusion, that the term subjective simply does not apply.
Perhaps because we habitually associate the objective with the im-
personal, we cannot comprehend a mind which is at once so pas-
sionately disinterested, yet so passionately itself. Certain passages in
Fors are almost frightening in their illusionlessness, in that quality of
detachment we associate with the Olympians or the dead. Such, for

[7] Yet the letters sold quite well, although Ruskin refused to advertise
them, published them himself, controlled their distribution and price, and re-
fused to allow competitive discounts on their sale. Nearly all the letters went
through several editions of 1,000 each, and collected volumes of the whole
series were later sold in two separate editions. (See XXVII, lxxxii–lxxxvi,
xci–cii; XXVIII, xxiii–xxvi; XXIX, xxix–xxxii; XXX, 358–62.)

instance, is the letter which opens with a note from a young lady who had written to Ruskin of the "wicked things" people were saying about him:

> They say you are "unreasoning," "intolerably conceited," "self-asserting"; that you write about what you have no knowledge of (Politic. Econ.); and two or three have positively asserted, and tried to persuade me, that you are mad—really mad!! They make me so angry, I don't know what to do with myself.

To which he could in truth reply:

> Indeed, my dear, it is precisely because . . . the message that I have brought is not mine, that they are thus malignant against me for bringing it. "For this is the message that ye have heard from the beginning, that we should love one another."

In defiance of this message, modern society had become in Ruskin's eyes a monstrous contrivance for defrauding one's neighbor and turning the fruitful garden of earth into a wasteland. His road mendings and street sweepings, his lectures and books had not perceptibly altered the face of England or the hearts of its inhabitants. And so, using *Fors* as his sounding board, he set out singlehandedly to rebuild Jerusalem in England's once green and pleasant land. Would any of his readers join him in giving a tenth of their wealth for the purchase of land which would be cultivated by hand, aided only by the force of wind or wave? The fund would not be an investment but a "frank and simple gift to the British people . . . to be spent in dressing the earth and keeping it,—in feeding human lips,—in clothing human bodies,—in kindling human souls." Its work would begin modestly enough, perhaps in a few poor men's gardens:

> We will try to take some small piece of English ground, beautiful, peaceful, and fruitful. We will have no steam-engines upon it, and no railroads; we will have no untended or unthought-of creatures on it; none wretched, but the sick; none idle but the dead. We will have no liberty upon it; but instant obedience to known law, and appointed persons: no equality upon it; but recognition of every betterness that we can find, and reprobation of every worseness. . . . We will have plenty . . . of corn and grass in our fields,—and few bricks. We will have some music and poetry; the children shall learn to dance to it and sing it.

. . . We will have some art, moreover; we will at least try if, like the Greeks, we can't make some pots [with pictures of] butterflies, and frogs, if nothing better. . . . Little by little, some higher art and imagination may manifest themselves among us; and feeble rays of science may dawn for us. . . . nay—even perhaps an uncalculating and uncovetous wisdom, as of rude Magi, presenting, at such nativity, gifts of gold and frankincense.

By Christmas of 1871 Ruskin had acted on his promise. He gave £7,000, the tithe of his fortune, to establish the St. George's Fund. So began his nobly ludicrous attempt to slay the dragon of industrialism.

Ruskin so egregiously failed to distinguish between the feasible and the fantastic in his role as Master of St. George's Guild that one is surprised that it came into being at all. On the one hand, the Guild was his eccentric vision of a feudal kingdom, compounded of his prejudices and ideals, over which he was to rule as absolute monarch, decreeing the laws, designing the currency, supervising the education and even the dress of its inhabitants. On the other hand, the Guild was a licensed corporation which possessed a sizable endowment and held lands tenanted by "Companions" who had subscribed to the St. George's Creed and vowed unswerving fealty to its Master. One measure of the Master's progress is that it took him seven years to win legal status for the Guild, there being no precedent within the mercantile bias of British law for a corporation which desired to hold land but not to make a profit. In 1878, when the Board of Trade at length granted the Guild its license, Ruskin went insane. His sense of the grotesque incongruity between his plans for the Guild and its actual accomplishments helped precipitate his breakdown. "The doctors said that I went mad . . . from overwork," he explained in *Fors:* "I had not been then working more than usual, and what was usual with me had become easy. But I went mad because nothing came of my work."

In a manic moment Ruskin wrote of the Guild as ultimately extending its operations over all of Europe and numbering its members by myriads. Yet its actual holdings, after fifteen years of his pleading for donors and members, consisted in some dilapidated cottages at Walkley and Barmouth, twenty acres of uncultivated

woodland at Bewdley, and a bleak, barren bit of land in Derby-
shire. At the end of his fourth year of "mendicancy," he had re-
ceived only £370/7/0 from a total of twenty-four subscribers.
And ten years after that, just before he withdrew from all partici-
pation in the Guild's affairs in 1885, the society which was to have
numbered its members in myriads had fifty-seven Companions.

If Ruskin had been wholly sane, if he had possessed the ad-
ministrative talents of a General Booth or the fanatic dedication
of a Vinoba Bhave, the "walking saint" of India, the Guild might
more nearly have fulfilled his ambitions. Instead, it was a disorderly
band of perplexed souls who never quite knew what their Master
wanted. For while they were seeking instruction in the cooperative
farming of unarable land, their Master was purchasing emeralds
for the Guild Museum at Sheffield [8] or was off in Venice making
studies of Carpaccio's *Dream of St. Ursula*. In place of actual
achievement, Ruskin offered the Guild a grandiose program for its
future. He envisioned the Guild's evolving a "vast Policy," executed
by hierarchies of Companions under the Master and his Ministers
of State, Marshals, Magistrates, and Retainers. The inner order of
the Guild—called, significantly, the Society of Mont Rose—would
reclaim the wastelands and tame the turbulent rivers of Europe.[9]

[8] The St. George's Museum—a collection of minerals, manuscripts, copies
and original works of art which Ruskin donated or commissioned—was the
only notable success of the Guild. It absorbed Ruskin's energies and much of
his capital. In 1884 alone he spent over £1,000 of the Guild's funds on pur-
chases and commissions for the Museum, which was at once an expression of
his principles and an evasion of his duties as Master. For, while the Museum
furthered the Guild's program of educating the working classes, it also di-
verted him from the management of the Guild's lands, which, after all, were
its *raison d'être*. The collection remained on loan to the Sheffield Corporation
until 1953, when it was stored in the care of the municipal Director of Mu-
seums and Art Galleries. The present Master of the St. George's Guild, Pro-
fessor H. A. Hodges, informs me that from time to time parts of the collection
are still exhibited in Sheffield and on tour throughout England.

[9] Since the late 1860s Ruskin had tried to win support for his plans to
control the flooding of the Rhine, the Rhone, and the Po, and to trap their
overflow for irrigation. The idea was sound enough in itself, but grew to
the same manic proportions as his plans for the Guild. "I will take a single
hillside," he wrote in 1869, "and so trench it that I can catch the rainfall of
three average years at once. . . . When I have done this for one hillside, if
other people don't . . . make the lost valleys of the Alps one Paradise of safe

Again Ruskin's reach exceeded his grasp. His Faustian schemes for harnessing rivers and irrigating whole valleys issued in some potterings on his grounds at Brantwood, where he drained a bit of marsh into the quiet currents of Coniston Water. The Master's Reports, which are filled with such weary disappointments, lack the eloquence even of Ruskin's despair.

The Guild's actual affairs continually intruded upon his dream kingdom. The more the fantasy became a nagging fact, the more perplexed he grew and the more he sought to extricate himself from the governance of the Guild. Perhaps this accounts for his odd ambivalence toward his role as Master. Throughout *Fors* his demands for unquestioning submission are followed by confessions of his inadequacy as a dreamy, dilatory, "make-shift Master" who prefers painting flowers to reforming the world. He attended only one of the Guild's meetings and, shortly after his first attack of madness, warned the Companions not to question him until his own good time. After his second attack in 1881, he sought to resign from the Guild altogether and told one of the Companions to wind up its affairs "at once—so that I may come out of it with clean hands and a pure heart." By nature solitary and erratic, and now periodically insane, he was perhaps the one man of his time least capable of creating a movement designed to grow "as wide as the world."

A quarter of a century earlier Ruskin had tried to reform England by replacing the coiling smoke of her cities with the spires of Gothic cathedrals. He had no illusions about his failure. But he never abandoned his vision of a pre-industrial England purged of smoke, *laissez faire*, and the New Poor Houses. The St. George's Guild was his final, futile attempt to realize this vision, to revive not a medieval style but a medieval society, with a feudal peasantry as loyal as the servants in his father's household, and lords as filled

plenty, it is their fault—not mine. But, if I die, I will die digging like Faust" (XXXVI, 567).

The whole scheme should be viewed in the light of an unpublished letter to Mrs. Cowper in which he explained that such gargantuan labor would keep him from thinking of past possibilities or present weakness and pain (May 4, 1869, the Pierpont Morgan Library, MS. 1571, fol. 65).

with *noblesse oblige* as Ruskin himself. Victorian England could no more have fed and clothed itself according to his principles than the inhabitants of William Morris's pastoral utopia could have subsisted in their machineless paradise. *Fors Clavigera,* and not St. George's Guild, is the only worthy monument to his broken and fantastic labors of the 1870s.

Yet with all Ruskin's delusions, he was spared the final delusion of believing himself entirely capable or entirely sane. After asserting his sovereignty over the Landlords, Marshals, and Companions of the Guild, he added in one of the most strangely moving passages in all of *Fors:*

And what am I, myself then, infirm and old, who take, or claim, leadership even of these lords? God forbid that I should claim it; it is thrust and compelled on me—utterly against my will, utterly to my distress, utterly, in many things, to my shame. But I have found no other man in England, none in Europe, ready to receive it. . . . Such as I am, to my own amazement, I stand—so far as I can discern—alone in conviction, in hope, and in resolution, in the wilderness of this modern world. Bred in luxury, which I perceive to have been unjust to others, and destructive to myself; vacillating, foolish, and miserably failing in all my own conduct in life—and blown about hopelessly by storms of passion—I, a man clothed in soft raiment,—I, a reed shaken with the wind, have yet this Message to all men again entrusted to me: "Behold, the axe is laid to the root of the trees. Whatsoever tree therefore bringeth not forth good fruit, shall be hewn down and cast into the fire."

XI. THE PAST RECAPTURED

In the summer of 1883 Charles Eliot Norton paid Ruskin a visit after an interval of ten years. He had last seen Ruskin in the full vigor of middle life—erect, alert, and vital; he now was shocked to find "an old man, with look even older than his years, with bent form, with the beard of a patriarch, with habitual expression of weariness, with the general air and gait of age."

The change had occurred even more suddenly than Norton had realized. Photographs of Ruskin taken as late as 1878 capture a sharpness of feature and a sensitive, astringent vitality. Between 1878 and Norton's visit, however, Ruskin had three times been violently insane. The face which Norton saw and which stares—puzzled, ponderous, and infinitely weary—from a photograph of 1882 is scarcely recognizable. The slender heretic of the 1870s had metamorphosed into the bearded and venerable "Prophet of Brantwood."

Ruskin's Brantwood period began in 1871 when, just after his delirious illness at Matlock, he purchased a house overlooking Coniston Water. For fifteen years he had wanted to live apart from his parents, but the bonds which had so long yet so uneasily held them under one roof were too strong to be broken. In words which he himself could never speak, he once advised a young correspondent that Christ's "Wist ye not that I must be about my Father's business?" must someday be spoken to all parents. When he at last believed that he had secured at Brantwood the peace of "the purposed home," he was over fifty and his mother was only three months from her death at the age of ninety. Although he sold Denmark Hill and lived at Brantwood after her death, in spirit

he moved still closer to his parents. For at the very end of his career he returned to his childhood home at Herne Hill and there, in his old nursery, he recaptured their early years together in his last and loveliest book.

The death of his dour but fiercely devoted mother left him curiously untouched. He had respected rather than loved her and now felt none of the embittered remorse, the sense of thwarted intimacy heightened by his memory of spoken cruelties and unspoken gratitude, which had assaulted him after his father's death. The day after Mrs. Ruskin died he wrote dispassionately of her cold hand lying prettily on her breast, so finely turned that it might have been cut by a Florentine sculptor. In her tranquil features he saw an image of his own almost frigid tranquility; even on her deathbed she reminded him not of the aged woman with whom he had lived for years without any true closeness, but of the Margaret Ruskin of *Praeterita* who, nearly a half-century earlier, had taught him the Sermon on the Mount.

Ruskin might have felt her death more keenly if, at the time, he had been capable of feeling at all. While still in mourning, he wrote to a friend that he had been deeply grateful to his mother, but had given all his love to Rose La Touche, who had "thrown [it] to the kites and crows." Rose had suddenly become hostile, for reasons he did not yet know. In 1870 her parents had written to Effie Millais, Ruskin's former wife, pleading that she dissuade Rose from marrying him. Mrs. Millais answered at once: Ruskin was most inhuman, unnatural, and "utterly incapable of making a woman happy." [1] Rose agreed to break off all contact with him; her friends were forbidden to name him in her presence.

Two years later, breaking the silence her parents had enjoined upon her, she wrote:

I will not judge or condemn you. But I *must* turn away from you. Can you wonder, you who know what I have had to know, that my nature recoils from you? . . . When I think what you *might* have been, to Christ,

[1] On the same day (October 10, 1870) Millais wrote to Mr. La Touche that "to this day my wife suffers from the suppressed misery she endured with him" (the Pierpont Morgan Library, MS. 1338 ["The Bowerswell Papers"], fol. x–y–z).

to other human souls, to me! How the angels must have sorrowed over you! . . . All I can do is to speak of you to Christ. At His feet we might meet; in His love our hearts might be drawn together again.

Rose was less disturbed by Ruskin's alleged impotence than by what she believed was his apostasy from Christianity. She became obsessed with saving his soul at the very time that his desire for her had itself become a religion which wasted and parched him like the "enthusiasms of the wild anchorites." In August of 1872 they met at the home of mutual friends. Rose was visibly ill—hectic, frail, at times incoherent. Haunted by the specter of his own collapse, he could discern in Rose the madness which, after her death, was to ravage him.

Yet for a few fleeting days it seemed to him that Rose again returned his love. While with her at Broadlands, the home of the Cowper-Temples, he wrote in his diary: "Entirely calm and clear morning . . . and I, for the first time these ten years, happy." Two days later he wrote to Mrs. Cowper-Temple from London that, if he could, he would come and lie at her feet all day long, trying to thank her with his eyes. However long Rose might be kept from him, whatever she did, he would wait in patience and be more worthy of her when they were at last united. But the tenor of Rose's letters changed abruptly after she returned to Ireland. A week after their meeting Ruskin was "beaten down again with uncertainty," and his diary for September 8 reads "fallen and wicked and lost in all thought." A letter which Rose had written at the time of their meeting at Broadlands suggests the cause of his despair:

His last words to me were a blessing. I felt too dumb with pain to answer him. . . . I cannot be to him what he wishes, or return the vehement love which he gave me, which petrified and frightened me. . . . When we come "face to face" in that Kingdom where love will be perfected—and yet there will be no marrying or giving in marriage— we shall understand one another.

There is no doubt that Ruskin desired Rose to be his wife in fact as well as name.[2] But she had been advised to renounce all

2 "She wished me to be Lover and Friend to her always—no more," he wrote to Mrs. Cowper-Temple in 1868. "She thought it was what I wished,

thought of marriage if she hoped to regain her health. Nor would her morbid preoccupation with her own sanctity and Ruskin's "sins against God" permit their union. For the second time in his life, Ruskin was denied marriage because of religious differences. When he was seventeen, he had fallen deeply in love with Adèle Domecq, the convent-bred daughter of his father's partner and the only other girl who had ever aroused his passion. But his mother had been horrified at the prospect of his marrying a French Catholic. Now the fervently Evangelical Rose rejected him because of his "heathenism."

By the end of 1874 Rose had passed, in Ruskin's words, "into more and more wildly imaginative and miserable life," the torment of which had become "terrible in its prolonged slaying of herself and me." In the January 1875 issue of *Fors* he wrote that the woman he had hoped would be his wife was dying. Nor could those who loved her have wished otherwise, for her mind was already dead. One night in February he was permitted to see her as she raved. He got her to lie back on her pillow and, resting her head in his arms, knelt beside the bed. Three months later she died.

Rose's death left him incapable of any sustained effort. He gave only one course of lectures at Oxford in 1875 and during the following year was unable to lecture at all. In August he set out for Venice, where, seven years earlier, he had first seen Carpaccio's painting of a young princess lying in deathlike stillness, her body "bending neither at waist nor knee, the sheet rising and falling over her in a narrow unbroken wave, like the shape of the coverlid of the last sleep, when the turf scarcely rises." An angel flooded in morning light stands in the doorway to her room; he bears a martyr's palm in his right hand and in his left, a shroud. For he is the Angel of Death, foretelling, as she dreams, her martyrdom as St. Ursula—the princess who, according to the legend Ruskin transcribed in *Fors*, vows to have "Christ alone for spouse," who is

as it had been so with my first wife. On my refusal, she refused all that she *could* refuse. She cannot, my love nor my sorrow." (Derrick Leon, *Ruskin: The Great Victorian* [London, Routledge & Kegan Paul, 1949], p. 392.)

courted by a heathen prince, defers his suit for three years, as Rose had Ruskin's, and is slain in glory while leading a pilgrimage to the Holy Land.

Carpaccio's lesson, Ruskin writes, is that the rejoicing of the bridegroom compares not to the rejoicing of those "who marry not, nor are given in marriage, but are as the angels of God, in Heaven." The allusion is to the same verse in Matthew which Rose had echoed in refusing him until they met in the Kingdom where there is no marrying. In the death dream of St. Ursula he found an image of the dead Rose, for whom this passage in *Fors* is a veiled requiem.

Rose became fixed in his mind not as the sick young woman who had rejected him, but as the pensive girl he had once seen sitting "like Patience on a monument" and later saw mirrored by Carpaccio. When he lectured on the painting at Oxford, he described St. Ursula as "a Spectral girl—an idol of a girl. . . . You will never see such hair, nor such peace beneath it on the brow—*Pax Vobiscum*—the peace of heaven, of infancy, and of death." Peace, youth, and death were always associated with Ruskin's moments of profoundest feeling: with the "marble-like" beauty of the girl at Turin, who lay motionless on the sand, "like a dead Niobid"; with the girls at Winnington, immobile and innocent, as they listened to music; with the perfect repose of Della Quercia's figure of the sleeping *Ilaria di Caretto*, which he loved above all other statues.

Shortly before her death Ruskin made a profile sketch of Rose; the eyes are all but closed, the expression of repose almost too profound for sleep. The sketch has the exquisite stillness of Della Quercia's *Ilaria* or Carpaccio's *St. Ursula*. In art as in life he was most moved by the kind of beauty which possesses the unchanging—and sexually unchallenging—remoteness of death. He had the *Dream of St. Ursula* removed from its place in the Accademia di Belle Arti and for six months kept the painting in a private room, while he wrote obsessively of St. Ursula and made countless studies of her clothes, her hair, her eyes, her lips. "Fancy having . . . leave to lock myself in with her," he wrote to Joan Severn. "There she lies, so real, that when the room's quite quiet, I get afraid of waking her!" In fact the figure of St. Ursula is quaintly rigid and stylized

rather than lifelike. He did not fear her waking but his own, lest his fragile world of "spirit messages" from Rose-Ursula be shattered.[3] Within a year of leaving Venice he went mad, immediately after "a piece of long thought about St. Ursula," and his second attack of madness, in 1881, followed an attempt to "get Rosie's ghost at least alive by me, if not the body of her."

Apart from its obsessional quality, Ruskin's interest in St. Ursula reflected his increasing sympathy with Christian art and his own heightened religious conviction. Ever since his unconversion at Turin his agonized incredulity had gone hand in hand with his belief that all truly great art is humanistic. In the summer of 1874, however, he had a religious experience which, as always with Ruskin, was intimately related to his response to art. He had been living at Assisi, copying the frescoes in St. Francis's Church and writing in the sacristan's cell, which had been given him for a study. One night, as if in answer to the sacristan's prayers, Ruskin dreamed that he had been made a tertiary in the Order of St. Francis. He came as close to converting to Catholicism as he was ever to come. But his conversion was essentially esthetic rather than religious. While copying Giotto's great fresco of *The Marriage of St. Francis to Poverty*, he discovered a fallacy under which he had labored for sixteen years: that the sacred art of the early Italians was inferior to that of the later "worshippers of Worldly visible Truth"— Titian, Tintoretto, and Veronese. He rejoiced in his discovery of the power of Giotto and at last renounced his long, uneasy espousal of the Religion of Humanity.

This temper of religious exaltation returned when he was at Venice two years later, closeted with the *Dream of St. Ursula*. But Carpaccio is not Giotto; at Assisi Ruskin for the last time had given himself wholly to an esthetic object worthy of his sensibility.

[3] See the start of the issue of *Fors* which Ruskin wrote on Christmas Day, 1876: "Last night, St. Ursula sent me her dianthus 'out of her bedroom window, with her love . . .'" (XXIX, 30). In his confused and excited diary entries for December 25–27, 1876, the dianthus and vervain depicted by Carpaccio in the window of St. Ursula's bedroom, the coincidental gift of the same flowers from friends in Venice, and "messages" from Rose and St. Ursula are all unintelligibly linked (*Diaries*, III, 920–22).

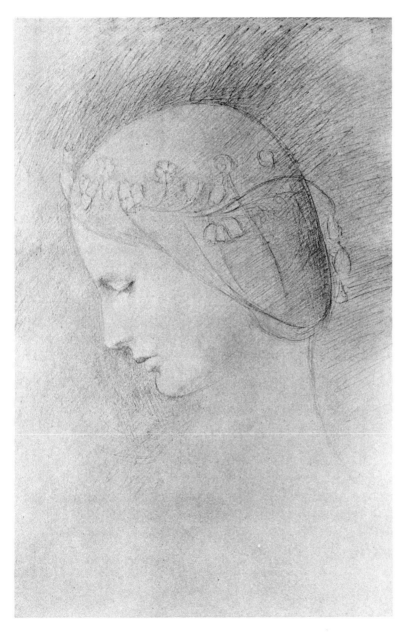

PORTRAIT OF ROSE LA TOUCHE, 1874

After completing his studies of *St. Ursula* in 1877, he returned to London, where he attended the opening of the Grosvenor Gallery. The exhibition included paintings by his protégé Burne-Jones, Whistler, and Millais. Whistler's *Nocturne in Black and Gold: The Falling Rocket* was offered for sale at two hundred guineas. In the July issue of *Fors* Ruskin wrote of this most daring and Turner-like of Whistler's paintings, "I have seen, and heard, much of Cockney impudence before now; but never expected to hear a coxcomb ask two hundred guineas for flinging a pot of paint in the public's face." Thirty-five years earlier he had begun *Modern Painters* in answer to the critic who had attacked Turner for painting as if he threw "handfuls of white, and blue, and red, at the canvas, letting what chanced to stick, stick."

Perhaps, as R. H. Wilenski contends, Ruskin was not making an esthetic judgment at all, but reacting to a morbid fear of brilliant lights bursting against a gloomy background.[4] A few months before the Grosvenor exhibition he wrote that the moonlight in Venice looked "ghastly like corpse light," and his sketches of the city made at the same time reveal an exaggerated sensitivity to light and shade. Four years earlier, however, he had attacked Whistler just as vehemently without any suggestion of a pathological motive. He had long despised Whistler as a sloppy draftsman and an esthete whose divorce of art from life impoverished both.

Whistler, unconcerned with Ruskin's motives, sued him for libel. Prior to the trial Ruskin wrote cockily confident letters to his friends, but his diary was burdened with anxious dreams and the return of the storm cloud, harbingers of his imminent collapse. The case was finally tried in November 1878. Whistler was extraordinarily witty, the jury extraordinarily obtuse; Ruskin, still weak after his "first great frenzied illness," was unable to appear in court. The jury awarded Whistler a farthing damages. The trial proved nothing, except that Whistler deserved his reputation as a wit and

[4] See p. 172, n. 14, above and compare Ruskin's oddly impassioned assertion in *Modern Painters* that all great painting conveys, through its luminous background, a sense of the infinitude of God, whereas the mark of inferior work is a dark, spectral background, such as a night sky which seems "to shut us in and down" (IV, 81–82).

that Ruskin, who had defended the avant-garde in the '40s and '50s, was now its enemy.

"Let him resign his present professorship," Whistler wrote, "to fill the Chair of Ethics at the University. As Master of English Literature he has a right to his laurels, while as the Populariser of Pictures he remains the Peter Parley of Painting." But Ruskin had already submitted his resignation. Two days after the verdict he wrote to Dean Liddell that he refused to retain a Chair from which he could not make judgments without being taxed by British law. One is relieved that the trial gave Ruskin an opportunity to resign with dignity from a position which he could no longer hold with competence.

He spent most of the following year in seclusion at Brantwood. Then, after an interruption of two years, he resumed publication of *Fors* and also began a remarkable series of essays on contemporary literature.[5] By the autumn of 1880 he had recovered sufficiently to tour the great cathedral towns of northern France. There, in a quiet ecstasy of reawakened powers, he wrote the opening section of *The Bible of Amiens*. The history, the iconography, even the stones of Amiens come to life in this final testament to Ruskin's love of the art and faith of the Catholic Middle Ages.

His own journey to Amiens inspired the pilgrimage of the young Proust, who reverently retraced Ruskin's footsteps. Proust's Preface to his translation of *The Bible of Amiens* is filled with the sense of mystic identification which he experienced during his early discipleship to Ruskin. "He will teach me," Proust wrote,

for is not he, too, in some degree, the Truth? He will enable my spirit to enter regions to which formerly it had no access, for he is the gate. He will purify me, for his inspiration is as the lily of the valley. He will intoxicate and give me life, for he is the wine of life.

The passages in the Preface most suggestive of the mature Proust are also the most Ruskinian. It is almost impossible to distinguish

[5] *Fiction, Fair and Foul*, published in 1880–81 in the *Nineteenth Century*. The first essay is one of Ruskin's most brilliant excursions into literary criticism. He defines a new genre, the novel of the city, the morbid violence of which he traces to a kind of death-wish engendered by the tedium, depersonalization, and anxious rootlessness of modern urban culture.

them from the richly orchestrated sentences from *The Bible of Amiens* which Proust employed as a leitmotif in his text. Through these long excerpts he sought to provide the reader with "an improvised memory" of Ruskin, a "whispering-gallery" of related echoes which resonate with his own. The smiling, hawthorn-fringed Madonna of the South Porch whom Ruskin describes in *The Bible of Amiens* serves as the madeleine or tilted tile of Proust's Preface, enabling him to animate the cathedral through the remembered miracle of Ruskin's animation. Proust's discovery of Ruskin was in essence a self-discovery, which began at Amiens and culminated in *A la recherche du temps perdu.*

After Ruskin returned to England, his bright, productive days at Amiens gave way to intense depression and the reappearance of the "ragged fiend-cloud . . . over all the sky—rainless, reckless, horrible, evil—continually." His sleep was broken by "grotesque, terrific, inevitable dreams"; toward the end of February 1881 his troubled nights became indistinguishable from his days, and he was once more insane. "I went wild again for three weeks or so," he wrote to Norton, "and have only just come to myself—if this be myself, and not the one that lives in dream."

Almost exactly a year later, as if in punctual observance of a dread anniversary, he went mad for the third time. The acute phase of his delirium lasted for two weeks, during which he raged against his closest friends. His doctor urged a complete change and in the autumn Ruskin set out on a tour of the Continent. In reality it was a journey into the past, for he traveled the same road he and his parents had posted with carriage and courier nearly fifty years earlier—places and days he was shortly to recall in the most felicitous pages of *Praeterita.*

But the clear skies of his childhood journey now seemed dark and hostile. The storm cloud hung ominously over Mont Blanc, and as far south as Lucca the plague wind churned the sky into a "stern, gapless gloom." Alternately elated and depressed, he mistook periods of euphoria for genuine recovery and wrote to his friends at Oxford of his desire to resume the Slade Professorship. In January 1883 he was reelected. Only a few months later Norton visited

him at Brantwood and was shocked to see the bent, wearied figure whom Ruskin's colleagues, blinded by baseless hopes and misguided loyalties, had again summoned to Oxford.

Ruskin's second tenure of the Professorship was as brief as it was disastrous. His audiences were large—so large, indeed, that the University had to issue tickets of admission to prevent overcrowding— but too many came merely to witness the eccentric displays of a great mind in its decline.

His opening lecture was a temperate and tedious tribute to Rossetti and Holman-Hunt. He sought to avoid digression or controversy, and the result was the lifeless lucidity and insignificance of his lectures throughout the year. Although Manet had exhibited twenty years earlier and Monet and Cézanne were revolutionizing art in France, Ruskin lectured on John Tenniel, Kate Greenaway, and the sweet, stilted simplicities of Francesca Alexander, his amateurish protégée. Genuine creativity in contemporary art left him untouched or aroused his hostility, as if forcing to irritable consciousness his own failure of response.[6]

He no longer reacted directly to a work of art but to the accidental associations which it evoked. During his first lecture he held up before his audience Francesca Alexander's drawing of a Tuscan peasant girl lying on her deathbed, her eyes half closed, a Bible near her hand, a sprig of roses entwined around her headboard. The girl had been a sort of local saint, and Francesca had written and illustrated the story of her life in a manuscript which Ruskin had bought in Florence shortly before resuming his professorship. When he spoke at Oxford of this sick, saintly girl "who had brought heaven down to earth" and whom he refused to believe dead, he was not speaking of art at all but of a reality as vital to him as St. Ursula or Rose La Touche.

Ruskin's lapses of taste were part of a larger regression in sensibility which robbed his Turners of interest but endowed Kate

[6] See the extraordinary note he added to the 1883 edition of *Modern Painters* on "the darkness and distortion of the vicious French schools of landscape" (IV, 212).

Greenaway's drawings with a merit far beyond their mere charm. Her wide-eyed little girls, who skip and dance and strew flowers which look as if they had been pressed in curl papers overnight, evoked the same ecstasy of innocence which he had once felt toward the saints of Fra Angelico. For he himself had retreated into Kate Greenaway's world of childlike feeling and childlike simplicities. In one of his lectures he dismayed his audience by discussing *The Travelled Ant* and *Little Downy, or the History of a Field Mouse*, fables he had read in his childhood. The same half-affected, half-uncontrollable naïveté characterizes many of his letters to Mrs. Cowper-Temple, which were written in a "little language" and signed, in one instance, your loving little boy. He experienced simultaneously a failure of adult emotion and of adult esthetic response.

Ruskin's final lectures, delivered in the Michaelmas Term of 1884, became increasingly disjointed and irrelevant to art. He had always had a gift for shocking his audiences; now, tragically, he had little else to offer. The fifth lecture created a scandal. His subject was "Protestantism: The Pleasures of Truth," and he began by displaying as an ideal type of the Catholic spirit a copy of the *Dream of St. Ursula*. As the Protestant counterpart he held up an enlargement of a pig drawn by Bewick, an earnest little pig, he remarked,

which is alert and knows its own limited business. It has a clever snout, eminently adapted to dig up and worry things, and it stands erect and keen, with a knowing curl in its tail, on its own native dunghill.

The press protested the continuation of what it termed "an academic farce"; Ruskin's friends were appalled. They dissuaded him from giving two projected lectures on "the atheist scientists" who, as he wrote, "slink out of my way now, as if I was a mad dog." He was as hostile to contemporary science as he was to contemporary art, and when the University voted approval of vivisection in its new physiology laboratory, he angrily resigned. Of course, his resignation was a necessity. But it was also the reasoned

gesture of a man who had always believed in the sanctity of all living things and who preferred to say his family prayers in the presence of his pets.

Ruskin gave his last Slade lectures in 1884, the same year in which he published the final issue of *Fors*. He had brought the ragged ends of his career as art and social critic to a close and now was free to write his autobiography. The shift in tone from the tempestuousness of the work he abandoned to the placidity of *Praeterita* is astonishing. There are no irrelevancies, no obsessional outbursts, no trace even of the ominous cloud and blighting wind which mar almost all that he wrote during his professorship. The key to this change is his lecture on *The Storm-Cloud of the Nineteenth Century*, which he gave in London in February 1884.

As if in collusion with Ruskin, the weather during the months preceding his lecture was exceptionally poor even for England. The autumn of 1883 had been marked by weirdly lurid sunsets and in London the year ended with a totally sunless week. Throughout January the sun shone for an average of less than an hour a day; the week before he lectured the barometric pressure fell to the lowest point ever recorded in Britain. Ruskin was merely hyperbolical, not deluded, when he remarked that the empire on which the sun formerly never set had become one on which it never rises. More extravagantly, he maintained that since 1870 the climate of Europe had undergone a calamitous change "unrecorded in the courses of nature" and characterized by a malevolent cloud and wind whose "range of power extends from the North of England to Sicily." In part the lecture is a "pathetic fallacy," a confusion of his own altered response to nature with an imagined decline in nature herself, a mistaking of inner and outer weather, of the cloud within his own mind and the imagined cloud without. He characterizes the storm cloud as vile, filthy, sulphurous, diabolic, seemingly "made of dead men's souls." The plague wind is "a wind of darkness . . . panic-struck, and feverish; and its sound is a hiss instead of a wail." This sense of an animate, evil power corrupting nature accounts for the sinister quality underlying a passage which he quoted from his diary:

Brantwood, 13th August, 1879

The most terrific and horrible thunderstorm . . . waked me at six. . . . [Thunder] rolling incessantly, like railway luggage trains, quite ghastly in its mockery of them—the air one loathsome mass of sultry and foul fog, like smoke . . . terrific double streams of reddish-violet fire, not forked or zig-zag, but rippled rivulets—two at the same instant . . . lasting on the eye at least half a second, with grand artillery-peals following. . . . While I have written this sentence the cloud has again dissolved itself, like a nasty solution in a bottle, with miraculous and unnatural rapidity. . . . Three times light and three times dark since last I wrote, and the darkness seeming each time as it settles more loathsome. . . . One lurid gleam of white cumulus in upper lead-blue sky, seen for half a minute through the sulphurous chimney-pot vomit of black-guardly cloud beneath.

Ruskin's response to nature here is fully as intense as it had been when he wrote *Modern Painters*, but the quality of that response has radically altered. The luminous heavens of *Modern Painters* and the lurid skies of *The Storm-Cloud* are alike *super*natural, opposing faces of a single power to which, throughout his life, he was incapable of indifference. After 1870, however, he came to believe that the elements were locked in a cosmic combat of good and evil, in which the clear skies contended unequally with "the black Devil cloud." And as the cloud seemed to gain mastery, he felt that nature herself had betrayed him. "Of all the things that oppress me," he wrote to Charles Eliot Norton in 1871, "this sense of the evil working of nature . . . my disgust at her barbarity—clumsiness—darkness—bitter mockery of herself—is the most desolating." But after his religious experience at Assisi, he attributed the darkness and barbarity less to nature herself or to her Creator than to man, who had polluted the once sacred skies and whose sins had brought down the wrath of Heaven. This is the burden of the apocalyptic close of *The Storm-Cloud*, with its alarming prophecy of "blanched Sun,—blighted grass,—blinded man" and of an earth made desolate and uninhabitable.

The very evocativeness of Ruskin's prose in *The Storm-Cloud* obscured the validity of his observations, which would have been convincing if purged of their satanic overtones. Fantastic as the lec-

ture seems, it is rooted in prosaic fact. The cloud originated not in the heavens but in the chimneys of industrialized Europe. In England alone the production of coal increased twenty-fold in the nineteenth century, and by far the sharpest increase was concentrated in the years immediately before and after Ruskin first observed a new kind of cloud which looked "as if it were made of poisonous smoke." The demonic thunderstorm Ruskin described yields to an equally prosaic interpretation. The "sulphurous chimney-pot vomit" of blackness lit by flashes of fire was simply smog broken up by a summer storm. Ruskin had indeed observed a new form of cloud which, if not sent by Satan, was nonetheless lethal enough on one occasion to raise the weekly death rate in London forty per cent.

The height of his weather obsession also coincided, in England at least, with a period of high rainfall, extreme cold, and abnormally little sunshine.[7] Even his claim that the Alps had lost their majesty cannot be dismissed as a projection of his own failing powers upon nature. "The Mont Blanc *we* knew is no more," he wrote to Charles Eliot Norton. "All the snows are wasted, the lower rocks bare, the luxuriance of light, the plenitude of power, the Eternity of Being are all gone." The letter was written in 1882, after the great glacial retreat of 1860–80 had bared areas buried under ice since the sixteenth century.

The Storm-Cloud, like Ruskin himself, is thus neither wholly mad nor wholly sane. It was based on fanatically precise but morbidly heightened responses to certain natural phenomena. Even in early life Ruskin had reacted with exceptional sensitivity to variations in atmosphere, temperature, light, wind, and cloud. Indeed, if one were to plot a graph of his mental state, the curve would almost

[7] Ruskin first observed the storm cloud in 1871; he last wrote of it in 1889. From 1869 through 1889 the temperature in London was below average for eighteen of the twenty-one years; rainfall was abnormally heavy from 1875 through 1882; reliable figures for sunshine are available only after 1879, but sixteen of the twenty autumns and winters from 1880 through 1889 were below average, and the total sunshine was below average for more than sixty per cent of the decade. (See W. A. L. Marshall, *A Century of London Weather,* Air Ministry, Meteorological Office [London, Her Majesty's Stationery Office, 1952], pp. 5–6, 74, Plates I, XXVIII–XXIX.)

constantly parallel the weather of the moment.[8] His periods of greatest anxiety cluster around spells of bad weather, and his obsession with the flight of time was most acute as the northern skies began to lose their light in autumn. The correlation is so startling that one is tempted to attribute his mental collapse not to the hereditary taint of insanity or to the presumed trauma of impotence, but to the misfortune of having been born in England.

Of course, in later life his reaction to the weather was pathological, despite the reality of the changes he had observed. The most revealing comment on *The Storm-Cloud* was made by Ruskin himself after recovering from an attack of madness. "I learn a lot in these fits," he wrote, "of the ways one sees, hears, and fancies things, in morbid conditions. . . . A real thunderstorm . . . was terrific and sublime more than anybody can see, sane." The same hyperesthesia had caused the churchbells of Taormina to ring in apparent cacophony and turned the skies of England into "a raging enemy." [9]

[8] Consider this random sampling from some three hundred similar entries:

"*January 25th* [1872]. Wild hurricane on Tuesday night. I woke with headache. Q[uery]: does barometer very low cause this?

"*March 3rd* [1874]. Black fog unbroken. . . . The weather appalls and crushes me more and more.

"*October 18th* [1874]. Exquisite, ineffable beauty, and joy of heart for me, all along valley of Cluse. . . . All the Brezon in gold and emerald—sun behind it. . . . Then a cloud seemed to come over my mind and the sky together. The old East wind here—all the way—and lowering thoughts . . . and distress.

"*February 25th* [1876]. Utterly black and horrible. . . . I very dismal therefore; appalled and hopeless. Am I never to see heaven and sweet light again?

"*September 10th* [1880]. Up, D[eo] G[ratia], in perfectly good health and lovely sunshine, and one thing lovelier always than another.

"*January 8th* [1882]. The mornings *always* as black as Newcastle and the wind malignant all day long. My mind driven away from nature wholly . . . with more harm to it than I can at all measure.

"*April 16th* [1885]. Grey all day y[esterday], and I deadly melancholy walking back in the useless gloom.

"*April 17th* [1885]. An entirely perfect morning, with calm, totally calm lake. . . . [I] plan the title page of autobiography finally. D. G."

[9] Episodes of hyperesthesia long antedated Ruskin's writing of *The Storm-Cloud*. In December 1840 he was ill with a fever in Rome and wrote to his tutor that the "perpetual beauty is more painful than pleasing, for there is a strange horror lying over the whole city . . . a shadow of death, pos-

Ruskin's disillusionment with nature, however subjective, was shared by his whole culture. The shift from the magnificence of nature in *Modern Painters* to its malevolence in *The Storm-Cloud* reflected not only his own altered temper but one of the crucial experiences of his century: the realization that the benign Nature of Wordsworth was red in tooth and claw. With that discovery the pastoral landscapes of the Romantic poets gave way to the grotesque, sinister wastelands of Tennyson's "The Holy Grail," of Browning's "Childe Roland," and of their prose counterpart, *The Storm-Cloud*. By the end of the century Shelley's skylark had become a less meaningful symbol of nature than Ruskin's plague wind or Thomas Hardy's lone bird—

> An aged thrush, frail, gaunt, and small,
> In blast-beruffled plume—

which seems to ride its blighting gusts.

ii

Lecturing on *The Storm-Cloud* was the act of exorcism which enabled Ruskin to write *Praeterita*. His obsession with the storm cloud and plague wind reached its height at the time of the lecture and never again attained the same intensity. The cloud did not pass from his life, but lifted from his writing the moment he turned to the past. Thereafter he mentioned only in his diaries and letters the wasted, malevolent nature he perceived everywhere in the present. The great invocations in *Praeterita* to the skies and mountains mark his return to the benevolent nature he had worshiped in the past and could again perceive with the fresh, ecstatic vision of his youth.

Praeterita was published at irregular intervals between 1885 and 1889, when a final siege of madness left Ruskin capable of little more than signing his name. These last years of full consciousness were the bleakest of his life; yet they produced the most charming

sessing and penetrating all things. The sunlight is lurid and ghastly. . . . Neither the eye nor the body can bear it long" (I, 381). Two weeks later, fully recovered, he described in his diary a spectacular light effect of sun filtering through cloud and factory smoke over Naples. The scene was as "lovely [as] a Turner" (*Diaries*, I, 143).

autobiography in English and the only book which he wrote with the intention of giving pleasure. He succeeded largely because of what he chose to omit or was later compelled to leave unwritten. As originally planned, the book was to have traced the course of his life until Rose's death in 1875. In its final form, the last event is the death of his father in 1864. We catch no glimpse of Ruskin's embattled, embittered years of social criticism or of the still darker years of his decline. Rose appears at the very end of *Praeterita*, but only as a child who once walked with him in the garden of Denmark Hill. As the past encroached too closely and too painfully upon the present, he lost control of his material and had to abandon the book. Precisely because *Praeterita* is a fragment it preserves a consistency of tone, a kind of truncated unity, which would inevitably have been lost if Ruskin had written of his last, tormented years.

There are gaps even in the parts of *Praeterita* which he completed. He never alludes to his marriage and mentions his wife only as a little girl for whose delight he had once written *The King of the Golden River*, a fairy tale. Yet this cardinal omission has a legitimacy which Ruskin's biographers, distrustful of the objectivity of *Praeterita*, have confused with deceit; for Effie Gray, in so far as she ever mattered to Ruskin, mattered only as the pretty young girl whom he courted and not as his wife.[10] The year after his marriage he was alone at Chamonix and, after watching a spectacular sunset, wrote in his diary:

I have . . . much to thank God for, now and ever. May it please him to permit me to be here again with my Father and Mother; and Wife.

[10] She met Ruskin in 1840, when she was twelve years old. Three years later he noted in his diary, "Phemy Gray came [to Denmark Hill]; very graceful, but has lost something of her good looks" (*Diaries*, I, 253)—by which he meant that she was growing up. A few months before their marriage in 1848 he wrote to her, "I hardly know *how* great a misfortune it may *yet* turn out to be—that I was not permitted to engage myself to you long ago," and he complained bitterly of having lost sight of her "*girlish* beauty" three years earlier, when he failed to see her at Perth. The same letter includes a trite apostrophe to her beauty and "cruelty," beneath the hyperbolical banter of which one detects a genuine fear of her womanhood. (Letter of November 30, 1847: Sir William James, *The Order of Release* [London, John Murray, 1947], pp. 58–59, 63–64.)

The order of priority is exact; the pause, with its suggestion of afterthought, perfect.

Praeterita, as Ruskin once said, is "the 'natural' me—only . . . peeled carefully." He felt no compulsion to confess what he took no pleasure in recalling, and he was beyond caring for what he was too old to amend. His own unhurried delight—expansive, immediate, unbroken—in the people and things that had once delighted him is the heart of the book. It is not surprising that Ruskin himself was one of the people he found most interesting. No writer was more self-absorbed than he; but then none ever had a more fascinating subject. To use his own phrase, *Praeterita* describes the effect on his own mind of meeting himself, by turning back, face to face. His egoism was unabashed yet uncannily objective, at once self-obsessed and ironically detached from self. Here, for example, is his description of himself as a child in the garden at Herne Hill:

The differences of primal importance which I observed between the nature of this garden, and that of Eden, as I had imagined it, were, that, in this one, *all* the fruit was forbidden; and there were no companionable beasts: in other respects the little domain answered every purpose of Paradise to me. . . .

My mother, herself finding her chief personal pleasure in her flowers, was often planting or pruning beside me, at least if I chose to stay beside *her*. I never thought of doing anything behind her back which I would not have done before her face; and her presence was therefore no restraint to me; but, also, no particular pleasure, for, from having always been left so much alone, I had generally my own little affairs to see after; and, on the whole, by the time I was seven years old, was already getting too independent, mentally, even of my father and mother; and, having nobody else to be dependent upon, began to lead a very small, perky, contented, conceited, Cock-Robinson-Crusoe sort of life, in the central point which it appeared to me, (as it must naturally appear to geometrical animals,) that I occupied in the universe.

The grace and wit of *Praeterita* almost obscure Ruskin's portrait of a child perilously isolated by its genius and upbringing. Despite his "careful peeling," Ruskin had a painful story to tell and evolved a style which enabled the telling to be both ingratiating and true. The writing is remarkably colloquial, yet taut with ironies which he directs at his parents or himself. What appears to be an ingenuous

ecstasy of pure presentation was the product of a lifelong effort to suppress all evidence of laboriousness, to substitute the suppleness of speech for the formalities of rhetoric. Through a triumph of style, Ruskin made his most sophisticated prose on his most complex subject read as if it were mere artless causerie.

Yet the serenity of *Praeterita* stems from a source deeper than style alone. To pass from *Fors* or *The Storm-Cloud* to *Praeterita* is to enter another world, in which pain has yielded to understanding, chaos to order, passion to peace. The tone of Ruskin's early writing is lyrical; that of his middle period is tragic; but his last book, like Shakespeare's last plays, exists in the uncharted area beyond tragedy. The resolution of tension achieved in *Praeterita* was, paradoxically, the product of the very madness which forced Ruskin to abandon the book. The purgative effect of his insanity can be seen as early as 1871, when he was deliriously ill at Matlock. The issue of *Fors* which he wrote immediately before his illness opens with a long, terror-ridden account of the storm cloud. A few weeks after recovering, he wrote the first of the delightful autobiographical digressions which are scattered throughout *Fors* and which he later incorporated into the opening chapters of *Praeterita*.[11] The remaining chapters, written in lucid intervals following seizures of madness, sustain the same felicity Ruskin achieved on recovering from his first clearly psychopathic illness.

Although those illnesses alienated Ruskin from the present, they brought his remembered life into crystalline focus. For the violent discontinuity they imposed upon his experience gave him the detachment he needed in order to write engagingly about a child who was whipped whenever it cried:

No toys of any kind were at first allowed;—and the pity of my Croydon aunt for my monastic poverty in this respect was boundless. On one of my birthdays, thinking to overcome my mother's resolution by splendour of temptation, she bought the most radiant Punch and Judy she could find in all the Soho bazaar—as big as a real Punch and Judy, all

[11] Most of chapters one and two and parts of chapter three were taken, with slight revision, from *Fors*. However, over nine-tenths of *Praeterita* consists of new material written between 1885 and 1889. For a collation of passages common to both books, see XXXV, xci–xcii.

dressed in scarlet and gold, and that would dance, tied to the leg of a chair. . . . My mother was obliged to accept them; but afterwards quietly told me it was not right that I should have them; and I never saw them again.

Nor did I painfully wish, what I was never permitted for an instant to hope, or even imagine, the possession of such things as one saw in toy-shops. I had a bunch of keys to play with, as long as I was capable only of pleasure in what glittered and jingled; as I grew older, I had a cart, and a ball; and when I was five or six years old, two boxes of well-cut wooden bricks. With these modest, but, I still think, entirely sufficient possessions, and being always summarily whipped if I cried, did not do as I was bid, or tumbled on the stairs, I soon attained serene and secure methods of life and motion; and could pass my days contentedly in tracing the squares and comparing the colours of my carpet;—examining the knots in the wood of the floor, or counting the bricks in the opposite houses; with rapturous intervals of excitement during the filling of the water-cart, through its leathern pipe, from the dripping iron post at the pavement edge; or the still more admirable proceedings of the turncock, when he turned and turned till a fountain sprang up in the middle of the street. But the carpet, and what patterns I could find in bedcovers, dresses, or wall-papers . . . were my chief resources.

One feels an uncanny closeness to the objects and events Ruskin describes in *Praeterita*, together with his own remoteness from whatever pain they aroused. The recall is total, yet totally unembittered. He sensed nothing unusual in his enforced isolation from other children, the austerity of his nursery, or the unbending aloofness of his parents. During the day he stared at things with rapturous and riveted attention. In the evenings he sat recessed like "an Idol in a niche" at his own little table in the drawing room, while his mother knitted and his father read aloud. No household was ever more quietly self-engrossed, and none could have drawn out his eccentric genius more fully.

For the very paucity of environing distractions, including the distraction even of love, forced him to develop his analytic and visual gifts almost from infancy. The child escaping boredom by watching for hours the dripping of a fountain or picking out patterns in wallpaper was teaching himself to see with the same fanatic fidelity and acuteness of perception which he later focused upon the seas of Turner and the intricacies of Gothic architecture. Sight

and insight were for Ruskin a single instinctive act, the one unfailing pleasure of his life. It was perforce a solitary pleasure, and hence *Praeterita*, like Ruskin's life itself, is filled with things stared at in the privacy of his visual ecstasy. He led the most isolated of lives, yet he was the most urgently communicative of writers, escaping through his words the solitude to which his eyes confined him.

To see clearly, he wrote in *Modern Painters*, is poetry, prophecy, and religion all in one. Preserving what he had seen was a sacred duty, and the agents of his memory—his notebooks and sketches—were the reliquaries in which he stored his experience. With their aid he could recall not a memory of a memory but the terror or delight, taste or touch, of first contact. An event and his recollection of the event were identical, for later impressions fell away, leaving the first inviolate.[12] It was this chastity of recall which so attracted Proust to *Praeterita* that he came to know it by heart. The aim of the artist, he had read elsewhere in Ruskin, was not to invent but to transcribe a unique vision of reality, to create more imaginatively because he perceived more accurately than other men.[13] In *Praeterita* Proust could observe the esthetic theory of *Modern Painters* put into practice: memory functions creatively; it illuminates as well as preserves, shapes as well as transmits.

Proust also observed a technique of composition, dependent upon memory, which Ruskin had employed before but never so effectively. The unity of *Praeterita* derives less from an orderly sequence of events than from a central core of perception, which manifests itself through a series of images whose function is like that of a recurrent musical phrase. One of these motifs is the crystalline stream—"an infinite thing for a child to look down into"— which flowed beside his aunt's garden at Perth. Like the springs of the River Wandel or the mysterious fountain in front of Ruskin's house, the stream symbolized the depth of his childlike wonder as

[12] In a canceled passage of *Praeterita* he wrote that "my early impressions have been invincible by later ones, however grand. . . . Skiddaw [is] still Skiddaw, however well I love Mont Blanc" (XXXV, 620).

[13] The reader of *Remembrance of Things Past* will recognize Elstir, whom Proust modeled in part on Turner, as the exponent of this idea. Elstir's role in revealing the mysteries of creativity to Marcel parallels Turner's relationship to the young Ruskin and Ruskin's to the young Proust.

well as the clarity of his recollection of that wonder. *Praeterita* is a tissue of these intertwined motifs, at times scarcely glimpsed and at times elaborated, to use a phrase André Maurois applied both to Proust and Ruskin, with *"une vision au ralenti, presque microscopique."* In a note to his translation of *Sesame and Lilies* Proust himself remarked on the elusive unity of Ruskin's writing. The passage is of dual interest, for in it we see Proust coming to an awareness of his own technique as he brilliantly defines Ruskin's:

> Mais c'est le charme précisément de l'oeuvre de Ruskin qu'il y ait entre les idées d'un même livre, et entre les divers livres des liens qu'il ne montre pas, qu'il laisse à peine apparaître un instant et qu'il a d'ailleurs peut-être tissé après coup, mais jamais artificiels cependant puisqu'ils sont toujours tirés de la substance toujours identique à elle-même de sa pensée. Les préoccupations multiples mais constantes de cette pensée, voilà ce qui assure à ces livres une unité plus réelle que l'unité de composition, généralement absente, il faut bien le dire.[14]

The early chapters of *Praeterita* are as rich in the remembered magic of childhood as Ruskin's diary is thick with gloom. He drafted these chapters in the same notebooks in which he kept his diary, and one senses the relief almost of prayer as he turned from each morning's entry of black skies and blacker moods to the unclouded world of the past. It is surprising that he could write *Praeterita* at all; it is astonishing that he wrote so much of it so well. The first three chapters were issued in the same month in which he suffered the fourth and most damaging attack of madness he had yet known.[15] Thrice again in the course of writing *Praeterita* he went insane, and in lucid intervals he could not escape the fear that *"any day I may go mad, or fall paralysed—without having had the least warning of my danger."*

Yet neither the fear nor the effects of madness are perceptible until late in the book. The interest slackens somewhat as the narra-

[14] Proust incorporated most of his Preface to *Sésame et les lys* into an essay which Gerard Hopkins has translated under the title "Days of Reading." The first part of the essay is taken up with childhood reminiscences which are of singular importance, for Proust later embodied them in *Du côté de chez Swann*. Their resemblance to *Praeterita* in style, tone, and even imagery is unmistakable. (See *Marcel Proust: A Selection from His Miscellaneous Writings*, trans. Gerard Hopkins [London, Allan Wingate, 1948], pp. 107–45.)

[15] At the end of July 1885. For Ruskin's account of the severity of his illness, see XXXVII, 540–41.

tive progresses beyond Ruskin's twentieth year, for the subject matter was intrinsically less fascinating, more intractable and remote from the sources of his genius. When Ruskin wrote primarily as an observer, as he had done at the start of *Praeterita*, his prose retained all its power. This description of the Rhone might have appeared forty years earlier, in *Modern Painters*, except that it would have been a bit stiffer and more insistent in achieving its effect:

> For all other rivers there is a surface, and an underneath, and a vaguely displeasing idea of the bottom. But the Rhone flows like one lambent jewel; its surface is nowhere, its ethereal self is everywhere, the iridescent rush and translucent strength of it blue to the shore, and radiant to the depth.
>
> Fifteen feet thick, of not flowing, but flying water; not water, neither,—melted glacier, rather, one should call it; the force of the ice is with it, and the wreathing of the clouds. . . .
>
> Waves of the sea . . . are always coming or gone. . . . But here was one mighty wave that was always itself, and every fluted swirl of it, constant as the wreathing of a shell. No wasting away of the fallen foam, no pause for gathering of power, no helpless ebb of discouraged recoil; but . . . the never-pausing plunge, and never-fading flash, and never-hushing whisper, and, while the sun was up, the ever-answering glow of unearthly aquamarine, ultramarine, violet-blue, gentian-blue, peacock-blue, river-of-paradise blue, glass of a painted window melted in the sun, and the witch of the Alps flinging the spun tresses of it for ever from her snow.

The passage occurs about two-thirds of the way through *Praeterita*. It was written in May 1886, less than a year after Ruskin's fourth attack of madness and a few weeks before his fifth.

Only at the end of Volume II does one sense that the life of the book and of Ruskin's mind were failing. He suspended publication of *Praeterita* for six months, and then issued the superb opening chapter of the final volume, "The Grande Chartreuse." Again one is struck by the resilience of a mind which could triumph over such frequent and violent derangement. Ruskin's account of his unconversion at the end of the chapter is one of the most exquisitely written passages in all of *Praeterita*.

After his sixth attack, in the summer of 1887, Ruskin convalesced on the Kentish coast, where he remained through the following spring. He was alone much of the time and could not rouse himself

from the despair which, he wrote, "has always hold on me more or less, now—the result of old sorrow—and new—fear alike of Death—and Life—lest in living I become only a burden to those who love me." Even the sea had lost its fascination for him, and the clouded skies were like "spirits of the abyss" risen to torment him.

One day late in 1887 he went up to London to visit the National Gallery. There he met Kathleen Olander, an art student some fifty years his junior, whose youthful seriousness and piety reminded him of Rose. Like Rose, she became his pupil, and then far more than a pupil. His letters to her—at first those of a master to his "dearest child," but later suggesting and in the end passionately urging marriage—are perhaps the most pathetic he ever wrote. He corresponded with her daily when he went abroad in the summer of 1888, and his letters, like his diary of the same period, vacillated between extremes of euphoria and despair. One letter was prophetic of his imminent collapse. He wrote that he had opened the Bible Rose had given him to the text, "The night cometh when no man can work." "I have noticed before," he continued, "that She is bound to give what God chooses me to hear of—message before the Resurrection. She sent me a curious warning at Beauvais, of [an] illness,—which . . . might indeed have been mortal to me." In December he suffered a complete breakdown in Paris, where he was met by Mrs. Severn and brought back to England. Kathleen still believed that she might save him and wrote repeatedly to Brantwood. But she received no reply, for Ruskin was never shown her letters.

He was already living a posthumous existence. With his mind failing and his hopes shattered, he focused his remaining energies on completing *Praeterita*. Morning after morning he tried to order his thoughts, but could not find his way through the notes and diaries which lay scattered on his desk. The final chapter, "Joanna's Care," is a thank offering to Joan Severn, his Scottish cousin who at the age of seventeen came to live at Denmark Hill and later, at Brantwood, nursed him through his illnesses and brought up her children in the shadow of his madness. But he could not carry the story beyond her arrival at the Ruskin household. The narrative began to move in reverse as the associations evoked by her native Scotland

led him helplessly into a long digression on the landscape of Scott's novels. The digression could not be controlled, for it arose from his earliest awareness, when he had played in the garden at Perth and, at home, had sat like an idol in a niche as his father read *Waverly*.

Apparently Ruskin's hand had become so unsteady that he was forced to dictate most of "Joanna's Care" to Mrs. Severn. As she recorded his infinitely grateful but confused words, he saw by his side not a middle-aged matron but "my little Joanie." And in place of the sick Rose of the 1870s, his memory offered him the fairer image of a young girl in his garden, where he had once known

the peace, and hope, and loveliness of . . . Elysian walks with Joanie, and Paradisiacal with Rosie, under the peach-blossom branches by the little glittering stream which I had paved with crystal for them. . . . "Eden-land" Rosie calls it.

Calls rather than *called* because time no longer separated his recollection from her words themselves. For twenty years his life had been centered on the pieties, places, and emotions of *temps perdu*. Now, in the closing paragraphs of *Praeterita*, he had finally recaptured the past. But it was a barren victory, for at the moment of achievement his mind became a blank, devoid alike of past, present, or future.

Between this incapacitating attack of madness in August 1889 and his death eleven years later, Ruskin spoke rarely and published nothing. There were lucid moments, and moments of insane rage; but the image which persists is that of the man seated wearily at his desk, past caring, past creating, honored by visitors whose words no longer reached him and loved by friends whom he no longer recognized. Years earlier he had written a passage prophetic of his final, mute decade:

Youth is properly the forming time—that in which a man makes himself, or is made, what he is for ever to be. Then comes the time of labour, when, having become the best he can be, he does the best he can do. Then the time of death, which, in happy lives, is very short: but always a *time*. The ceasing to breathe is only the *end* of death.

Ruskin's dying-time, unmercifully long, ended on January 20, 1900.

NOTES

Notes consisting merely of volume and page numbers refer to *The Works of John Ruskin*, ed. E. T. Cook and Alexander Wedderburn (Library Edition, 39 vols., London, George Allen, 1903–12). References to *The Diaries of John Ruskin*, ed. Joan Evans and John Howard Whitehouse (Oxford, Clarendon Press, 1956–1959), are indicated simply as *Diaries*. Catch phrases, consisting of the last words of a quotation or statement of fact, identify all passages in the text which are here documented.

1. NATURE, TRUTH, AND TURNER

Page

1 FLAT-CEILED BARN: XXXV, 132.

2 ATTACK ON TURNER: For the *Blackwood's* attack and Ruskin's reply, see III, 635–40.

2 TWO HUNDRED PAINTINGS: See R. H. Wilenski, *John Ruskin: An Introduction to Further Study of His Life and Work* (London, Faber & Faber, 1933), pp. 199–200.

3 CAN EVER GO: Letter of June 4, 1845: IV, xxxii.

3 BENCH AND LAUGH: Letter of September 24, 1845: IV, xxxviii.

3 CONDEMNED CITY: XXXV, 495–96.

4 PLEASURE IN SIGHT: XXXV, 619.

5 SUN IS GOD: See XXII, 490, n. 1; XXVIII, 147.

5 VISIONS OF THE HILLS: Bk. IX, ll. 234–35; Bk. I, ll. 464–65.

5 DETERMINED FOR ME: XXXV, 115–16, 297. The second quotation contains an allusion to Wordsworth's *The Excursion:* "We live by Admiration, Hope, and Love" (Bk. IV, l. 763). Ruskin refers to the line ten times in the course of his works.

5 THANKFUL BLESSEDNESS: *The Prelude*, Bk. IV, ll. 334–37.

6 MORAL POWER: III, 665–66.

6 COMMENTATOR ON INFINITY: III, 157.

Page

6 REVELATION TO MANKIND: III, 630–31. Cf. Ruskin's description of Turner as "a prophet of God [sent] to reveal to men the mysteries of His Universe" (III, 254).

6 NEW SENSE: Clement Shorter, *The Brontës: Life and Letters* (New York, Charles Scribner's Sons, 1908), I, 441–42.

6 SYMPATHIES AND DESIRES: IV, 28.

7 HUMILITY AND CHEERFULNESS: V, 289–93.

7 ROCKS, THE WATERS: XXXV, 166.

7 TAMELESS UNITY: III, 494.

8 WORK OF GOD: VII, 9.

8 ORGANIC FORM: XVI, 251.

8 ESTHETIC PLEASURES: See, for example, III, 101, 102, 108, and XI, 40.

8 MINDLESS IMITATION: III, 215.

8 STATEMENT OF FACTS: III, 138.

9 BLIND AUDACITY: III, 25.

9 PICTURE BY TURNER: "A Second Lecture on the Fine Arts," XIX (June 1839), 744. The same article, it should be noted, also contains high praise; Thackeray's denunciation applies only to Turner's "fancy pieces."

9 HAPPY HUNTING: See Jerome Hamilton Buckley, *The Victorian Temper: A Study in Literary Culture* (Cambridge, Mass., Harvard University Press, 1951), p. 133.

9 MILLAIS'S OPHELIA: See Fogg Museum of Art, *Paintings and Drawings of the Pre-Raphaelites and Their Circle*, Catalogue of the Exhibition of April 8–June 1, 1946 (Cambridge, Mass., Harvard University, 1946), p. 9.

9 RODE OUT A GALE: See XIII, 161–62.

10 LIBELLED THE SEA: III, 85.

11 KINDS OF TRUTH: XI, xx.

11 SCORNING NOTHING: III, 624.

11 MOCK HER: I, 421; III, 12, 289.

11 BLOTS & BLURS: *The Complete Writings of William Blake*, ed. Geoffrey Keynes (London, The Nonesuch Press, 1957), pp. 594–95.

12 DEAD FLAT: III, 329–30.

12 TRUTH AND LIFE: III, 330–31.

13 VARIOUS INFINITY: III, 331–32.

13 ART . . . CONSISTS: III, 540.

13 THEIR BEST: III, 216.

14 TREES, NOWHERE: XXXV, 314.

14 PASSIVE IN UTTERANCE: V, 125.

II. MOUNTAIN GLOOM AND MOUNTAIN GLORY

Page

22 LOVED HER: III, 628.

22 DEGREES OF BEAUTY: III, 111, 628.

23 PERIL OF DAMNATION: IV, 176–77.

23 THIS WORLD: Sir William James, *The Order of Release* (London, John Murray, 1947), p. 57.

24 IS GONE: VII, 268–69.

24 ALL DAY STARVING: VII, 269.

24 RAGS AND BONES: VII, 269–70.

25 ITS OWN CLOUDS: VII, 266–67, 271.

25 VAULTS OF PURPLE: VI, 425.

26 GOUTS OF BLOOD: VI, 388–89.

27 OUTCAST REFUSE: VI, 412–14.

27 FROM THE OTHER: VII, 422.

27 FEVER-STRUCK CHILDREN: VII, 432–33. The plates are "A Farm Yard," "The Rick-Yard," "Rustic Bridge," "Hedging and Ditching," and "The Water-Mill."

27 POWER OF DEATH: *Notes by Mr. Ruskin on His Drawings by the Late J. M. W. Turner, R. A.,* XIII, 415.

28 GIORGIONE'S SCHOOL: VII, 374–75.

28 COMMON LABOUR: VII, 375–77.

29 THEIR LIVES: VII, 378.

29 BARGE AND THE BARROW: VII, 380.

29 MARRED HUMANITY: VII, 384.

29 THAN IN THAT: VII, 386.

30 AMAZED DESPAIR: VII, 386–87.

30 BIBLE VERSES: XXXVI, 115.

30 DREAD OF DEATH: *Ruskin's Letters from Venice 1851–1852,* ed. John L. Bradley (Yale Studies in English, Vol. CXXIX, New Haven, Yale University Press, 1955), pp. 149, 244. See also pp. 245–47, 254, and XXXVI, 126–29, 137–38.

31 GONE ASTRAY: Bradley, pp. 79–81.

31 OTHER TURNING: XXXVI, 137.

32 BE SERVICEABLE: XXXVI, 381.

32 DELIGHT IN NATURE: See Bradley, p. 244.

32 LOVE OF NATURE: XXXV, 218.

32 JOY IN THE ALPS: *Diaries,* I, 196.

33 SOUL AND BODY: V, 321.

33 ORDINARY LIFE: V, 324–26.

III. A GOTHIC EDEN

Page

51 FORMER MAGNIFICENCE: A Welby Pugin, *Contrasts* . . . (London, By the author, 1836), p. 22.

51 SCIENCE OR ELEGANCE: *Ibid.*, p. 3.

52 OUR FUTURE: *The Collected Works of William Morris*, introd. May Morris (London, Longmans, Green & Co., 1910–1915), XXII, 377.

53 FOR THE PEOPLE: *Ibid.*, p. 58.

53 WITH IRON: XVI, 338–39.

54 THRONE OF GOD: XVI, 339–40.

54 ALL A VISION: *Idylls of the King*, Bk. II, ll. 203–04.

55 CITY OF GOD: Cf. Henry Adams, *Mont-Saint-Michel and Chartres*, (London, Constable & Co., 1950), pp. 92–93.

55 EUROPE CHRETIENNE: "John Ruskin," *Gazette des Beaux-Arts*, XXIV (August 1900), p. 135.

55 WILENSKI HAS SUGGESTED: *John Ruskin: An Introduction to Further Study of His Life and Work* (London, Faber & Faber, 1933), pp. 32, 143, 330.

56 HEDGE-SIDE GYPSI'S: XXXIV, 618.

56 THUMPED IT: XXXV, 132.

57 USEFUL OR NECESSARY: VIII, 30.

58 THEIR SERVICE: *Diaries*, II, 369.

58 TO THIS COUNTRY: VIII, 268.

58 BLACK DOLL: I, 379. Cf. I, 429–30.

58 ITS PRAISE: X, 66.

59 CHURCH IN EUROPE: X, 88–90.

59 PROTESTANT MIND: XXIV, 277.

59 SO CONTEMPTIBLE: IX, 437–38.

60 NO SPECIAL SECT: X, 119–20.

60 THEOLOGICAL DOGMA: XVIII, 440, 444. Cf. XI, 228, where Ruskin argues that Gothic is a Christian but not an "ecclesiastical" architecture and advocates its use in "civil and domestic buildings."

60 UNEXHAUSTED ENERGY: X, 212.

61 ROMANISM OF IT: IX, 369–71. Cf. X, 242, where Ruskin maintains that one of the characteristics of Gothic is "the Protestant spirit of self-dependence and inquiry . . . in its every line."

61 SPENT IN VAIN: XVIII, 150.

61 PSEUDO-VENETIAN CAPITALS: X, 459.

61 GLASS AND PANTILES: IX, 11.

62 WITHOUT HER DISPEACE: XI, 230.

63 NATIVE GROUND: VIII, 226.

63 NOT A METAPHYSICIAN: I, 5.

IV. WINDOWS OF AGATE

Page

64 METALLIC CONSTRUCTION: VIII, 21, 66.

64 FERROVITREOUS TRIUMPH: Henry-Russell Hitchcock, *Early Victorian Architecture in Britain* (New Haven, Yale University Press, 1954), I, 530–71. For an equally enthusiastic account, see Sigfried Giedion, *Space, Time and Architecture* (3d ed., Cambridge, Mass., Harvard University Press, 1954), pp. 247–53.

64 BLINDING SQUARE: XVI, 349.

65 WITH ART: See his pamphlet on "The Opening of the Crystal Palace," XII, 419–20.

66 THIS PAGE: IX, 242.

67 WAVE, AND TREE: XV, 174–76.

67 NEVER BE AN ART: *John Ruskin: An Introduction to Further Study of His Life and Work* (London, Faber & Faber, 1933), p. 225. See pp. 214–26 for a brilliant analysis of Ruskin's position.

67 LARGE SCALE: VIII, 10–11. Cf. I, 104–05; VIII, 27; XII, 83–85; XIX, 256.

68 CAN DO THAT: XII, 84.

68 ORGANIC FORM: XI, 70; XVI, 251.

68 GREATEST IDEAS: III, 92.

69 FORCE, AND SOLIDITY: VIII, 116, 238.

69 NOON-DAY SUN: VIII, 117. Cf. VIII, 53, and X, 165.

69 ALL SAINTS: Ruskin was not its only admirer. Charles L. Eastlake (*A History of the Gothic Revival* [London, Longmans, Green & Co., 1872], pp. 252–55) praised its innovative daring as, more recently, has Hitchcock (I, 581–82, 587–93).

69 SAN MARCO: X, 97. Cf. X, 173: "Of all God's gifts to the sight of man, colour is the holiest, the most divine, the most solemn."

70 THEM AT LAST: XI, 22. Cf. VIII, 176, and XI, 35–36.

70 PLEASANT STONES: Isa. 54:11–12.

70 BECOME REALITIES: Giedion, p. 24. See also pp. 25, 180–81, for material which I have found most useful.

71 ORGANIC FORM: XVI, 251.

72 ACTIONS AND MASSES: XIX, 36–37.

72 VITRUVIUS: IX, 85. Vitruvius' *De Architectura*, written during the reign of Augustus, was one of the main source books of the Renaissance architects.

72 MUST ALWAYS FAIL: *An American Architecture*, ed. Edgar Kaufmann (New York, Horizon Press, 1955), pp. 23, 261. Vignola, Michelangelo's successor as chief architect of St. Peter's, was the author of *The Five Orders of Architecture*.

Page

72 EXTERNAL CREATION: VII, 139.

72 NATURE-PATTERN: Wright, p. 28.

72 BUILDING A TREE: *Ibid.,* p. 260.

73 FORM FOLLOWS FUNCTION: *Ibid.,* pp. 20, 260; *An Organic Architecture: The Architecture of Democracy* (London, Lund Humphries & Co., 1939), p. 44.

73 CURVE OF A LEAF: X, 256.

73 BE-PILASTERED: *An Organic Architecture,* pp. 7, 30.

73 WAS GIGANTIC: XI, 80.

73 ITS DECAY: XI, 11. Cf. XIX, 252, where Ruskin attributes the final corruption of flamboyant Gothic ornament to its having become "a design of lace in white, on a black ground; not a true or intelligent rendering of organic form."

73 CHILDISHNESS IN THEM: XI, 108.

74 PAINTING BY MONDRIAN: See *Architectural Principles in the Age of Humanism* (London, The Warburg Institute, University of London, 1949), p. 65.

74 PALLADIAN BUILDING: See *ibid.,* pp. 63–66, for the rigorous symmetries of Palladio's buildings.

74 TRUTH AND EXACTNESS: Wittkower (pp. 131–32) quotes the passage in an excellent chapter on the disintegration of the Renaissance esthetic.

74 HER FREEDOM: XI, 118–19.

74 SUPERGEOMETRIC: *An American Architecture,* p. 33.

75 HIS CALCULATIONS: *The Last Romantics* (London, Gerald Duckworth & Co., 1949), p. 37.

75 MOZART'S REQUIEM: VIII, 163.

75 BUT OF EXISTENCE: XII, 86.

75 GIFT FROM NATURE: Recorded interview broadcast over station W.N.Y.C., July 11, 1957.

76 HIS DAY, HIS AGE: Cited without source in Carl Birger Troedsson, *Two Standpoints towards Modern Architecture: Wright and Le Corbusier* (Transactions of Chalmers University of Technology, No. 113, Gothenburg, Gumperts Förlag, 1951), p. 16. *An American Architecture,* p. 26. *An Organic Architecture,* pp. 13–14.

76 IN EVERY SENSE: *An Organic Architecture,* p. 30.

76 MORAL DELINQUENCY: VIII, 59–60. Cf. XX, 308–09.

76 INNUMERABLE WAYS: See Geoffrey Scott's persuasive apologia for Renaissance practices, *The Architecture of Humanism: A Study in the History of Taste* (2d ed., London, Constable & Co., 1924), p. 157. Cf. pp. 98–103, 150–56.

Page

77 ARTISTICAL LAWS: X, 215.

77 PERFECT SOPHISTICATION: See XVI, 279, where Ruskin criticizes as "noble faults" their "non-naturalism" and "exaggerated thinness of body and stiffness of attitude."

77 CAUSING OF THE WHOLE: VIII, 88–89.

78 ULTIMATELY RUINOUS: VIII, 89–92. Cf. XIX, 257–61.

78 TORRENT OF THE RENAISSANCE: VIII, 92–93, 97–98.

78 ORGANIC SOCIETY: *An Organic Architecture*, p. 6.

78 TUNNELS UNDERGROUND: XIX, 24.

V. VENICE: STONES AND TOUCHSTONES

79 OVERDUE JEREMIAH: *Venice Observed* (New York, Reynal & Co., [1956]), p. 6.

79 TOUCH BY TOUCH: *Ruskin's Letters from Venice 1851–1852*, ed. John L. Bradley (Yale Studies in English, Vol. CXIX, New Haven, Yale University Press, 1955), p. 293.

80 DEVELOPED IN IT: IX, 14.

80 WAS ABOUT IT: VIII, 218, 248. Cf. XVIII, 443: "The [purpose of] *The Seven Lamps* was to show that certain right states of temper and moral feeling were the magic powers by which all good architecture, without exception, had been produced," and XX, 39: "The art of any country *is the exponent of its social and political virtues.*"

81 MIRAGE OF YEARS: *Diaries*, I, 275, 354.

82 COMPOSING HIS BOOK: See X, xxxvii. Cf. IX, 3, where Ruskin complains of finding the antiquaries "not agreed within a century as to the date of the building of the façade of the Ducal Palace."

82 IN THE TEXT: See XXXV, 483.

82 THAT EDIFICE: An Architect, *Something on Ruskinism; with a "Vestibule" in Rhyme* (London, Robert Hastings, 1851), pp. 45–46, quoted in IX, xliv. Although the architects quarreled with Ruskin's judgments, the literary reviews for the most part received the book favorably.

82 STEADY TIDE: X, 4.

83 PRAISE JESUS: X, 40–41.

83 STONES OF VENICE: IX, 17.

83 FIFTH CENTURY: The permanent establishment of the city probably dates from the Lombard invasion of 568. Ruskin's conjectural date of 421 (see IX, 18–19, 417) is based upon a document now presumed to be a forgery.

84 OF THE WORLD: IX, 37–38.

Page

84 VENICE HERSELF: X, 352.

85 SEMI-SCULPTURE: IX, 50–51.

85 BECOME CARNAL: IX, 31–32.

85 ONE WRECK: IX, 45.

86 WAS THE SIGN: IX, 18, n. 1. Cf. p. 22: "I rather think, the history
 of Venice might . . . be written almost without reference to the
 construction of her senate or the prerogatives of her Doge."

86 WHICH MOLDED THEM: IX, 23.

88 FEET FOR EVER: XI, 227.

89 SCHOOLGIRLS INTO JULIETS: I, 167–68.

90 BODY IN DEATHS XI, 81–84, 104–10.

90 TURNED TO MARBLE: X, 171.

90 MASS AT SAN MARCO: See Bernard Berenson, *The Italian Painters
 of the Renaissance* (London, The Phaidon Press, 1952), p. 10.

90 THE RENAISSANCE: XI, 136–45.

91 SEVEN HUNDRED YEARS: X, 82–84.

92 UPON IT CONTINUALLY: X, 84–85.

93 RIGIDITY, AND REDUNDANCE: X, 183–84.

93 CATHEDRAL AND THE ALP: X, 188.

94 POLAR TWILIGHT: X, 186–87.

94 THAT SHADE THEM: X, 187–88.

95 SELF-'SUFFICIENCY: XI, 74. Cf. Frank Lloyd Wright's comment,
 " 'Classic' was never intended to serve life; it was mainly an
 imposition upon it, . . . monarchic and not democratic" (*An
 Organic Architecture* [London, Lund Humphries & Co., 1939],
 p. 10).

95 ITS EVERY LINE: XI, 75.

95 PERCEIVED AND ENJOYED: XI, 75.

96 CHRISTIAN ARCHITECTURE: X, 202.

96 GOD'S GREATER GLORY: X, 189–90.

96 SHATTERED MAJESTY: X, 191. Cf. XVIII, 174: "The more beautiful
 the art, the more it is essentially the work of people who *feel
 themselves wrong;*—who are striving for the fulfilment of a law,
 and the grasp of a loveliness, which they have not yet attained,
 which they feel even farther and farther from attaining the
 more they strive for it."

96 EULOGIZES FALLEN NATURE: See Etienne Gilson, *The Spirit of
 Mediaeval Philosophy* (New York, Charles Scribner's Sons,
 1940), pp. 122—23.

96 AS THEY REQUIRE: X, 202–03.

96 FINISH PERFECTLY: V, 154.

Page

97 THIS WORLD: X, 203.

97 PARALYZE VITALITY: X, 203–04.

98 EXACTNESS OF A LINE: X, 192–93.

99 ESTIMATE OF ADVANTAGES: X, 194, 196.

99 LIKE HAIL: X, 196–97.

100 BUYING LIFE: VIII, 214, 218.

101 HEALTHY SOCIETY: X, 201.

101 OF THE CENTURY: *The Nature of Gothic: A Chapter of The Stones of Venice*, ed. William Morris (Kelmscott Ed., London, George Allen, 1892), Preface, p. i.

101 TENFOLD GREATER: VII, 257.

102 CAN'T MANAGE IT: Letter of November 5, 1860: XXXVI, 348.

102 BLINDNESS AND MISERY: Letter of August 28, 1862, to Charles Eliot Norton: XXXVI, 423.

103 JOY FOR ALL: XX, 212.

103 CAN BE FOUNDED: XIX, 266.

104 SULPHUROUS DARKNESS: XVI, 338–39.

105 FOR THE WORKMAN: Ruskin's testimony, published in the House of Commons *Report of the Select Committee on Public Institutions*, is reprinted in XVI, 472–87. See especially pp. 473–74, 482, 486–87.

105 WORK OF MY LIFE: Bradley, p. 177.

VI. MY FATHER'S HOUSE

107 RURAL DEAN: *Everybody's Political What's What?* (New York, Dodd, Mead & Co., 1944), p. 179. See also Shaw, *Ruskin's Politics* (London, The Ruskin Centenary Council, 1921), pp. 12–13, and Derrick Leon, *Ruskin: The Great Victorian* (London, Routledge & Kegan Paul, 1949), p. 443.

107 OLD ORDER: See XXXIV, 99. Cf. Helen Gill Viljoen's discussion of John James Ruskin's Tory schooling at Edinburgh and of the bearing of Scott's novels on his politics (*Ruskin's Scottish Heritage* [Urbana, Ill., University of Illinois Press, 1956], pp. 58–70, 96, 100).

108 OF THE RED: XXVII, 116.

109 PROPERTY OF THE POOR: XVII, 75.

109 DAYS OF REPROBATION: XXII, 512.

110 HE WAS BORN: XXXV, 24.

110 ESSENTIAL PART: XXXV, 42–43.

110 BE GOOD: XXXV, 25–26.

Page

111 EMINENTLY CLERICAL: See the report of the lecture in the *Edinburgh Guardian*, reprinted in XII, xxxii.

111 ALL THE CENTURIES: Cited without source in Holbrook Jackson, *Dreamers of Dreams: The Rise and Fall of 19th Century Idealism* (London, Faber & Faber [1948]), p. 35.

112 SANCTIFIED WHOLLY: *George Eliot's Life as Related in Her Letters and Journals*, ed. J. W. Cross (Edinburgh, W. Blackwood & Sons, 1885), I, 43.

112 ETERNAL PAIN: I, 396–97.

113 SELF-DENIALS: See Walter E. Houghton, *The Victorian Frame of Mind: 1830–1870* (New Haven, Yale University Press, 1957), pp. 62, 234. See also Noel G. Annan, *Leslie Stephen: His Thought and Character in Relation to His Time* (Cambridge, Mass., Harvard University Press, 1952), p. 112; and G. M. Young, *Victorian England: Portrait of an Age* (Doubleday Anchor Books. Garden City, N. Y., Doubleday & Co., 1954), pp. 12–17.

113 ACTS OF DISOBEDIENCE: See Houghton, p. 63.

113 TYRANT DEVIL: For Ruskin's remarkable account of the episode, see XXXVIII, 172–73.

113 WORKS OF ART: XII, lxix.

114 ST. LOUIS' PSALTER: The manuscript was not in fact "St. Louis' Psalter" but the thirteenth-century *Psalter and Hours of Isabelle of France*. See R. H. Wilenski, *John Ruskin: An Introduction to Further Study of His Life and Work* (London, Faber & Faber, 1933), p. 59, n. 2.

114 INTO DISORDER: XII, lxx. Cf. entries in his *Diaries* (II, 486, 488) in which he describes his "hard work" cutting apart another manuscript.

114 ITS MULTITUDES: XIX, 38.

114 CLOTS, HELPLESS: XXXVI, 450.

115 UNENDURABLE SOLITUDE: XXXVI, 356.

115 NOW SOMEWHERE: XXXVI, 413–14.

115 SOURCE OF WATER: See XVII, lxxii–lxxvi, and XXXV, 436.

116 TALK TO THEM: XXXVI, 401.

116 VOTING, AND EDUCATION: See XI, 258–63, and XII, lxxviii–lxxxv, 593–603.

116 BETWEEN US: *Ruskin's Letters from Venice 1851–1852*, ed. John L. Bradley (Yale Studies in English, Vol. CXXIX, New Haven, Yale University Press, 1955), p. 232.

116 KNOCKED DOWN: XII, lxxxiv.

117 WORK OF MINE: XVIII, 103.

117 MUCH TOO LOW: XVII, xxvii.

Page
117 QUITE TOUCHING: XXXVI, 345.
117 DROWN US ALL: Reviews in *The Saturday Review of Politics, Literature, Science, and Art,* November 10, 1860 and *The Manchester Examiner and Times,* October 2, 1860.
118 IS LIBERTY: XXXVI, 415.
118 FROM ME: XXXVI, 420.
118 PASSION AND LIFE: XXXVI, 461. The letter was written in December, 1863, three months before John James's death. It is Ruskin's last *published* letter to his father, possibly not the last he wrote to him.
118 WHEN SHE SHOULD: XXXVI, 471.
119 OF THE OTHER: XVII, 432.
119 FATHERLY AUTHORITY: XVI, 25.
119 IN LOCO PARENTIS: Cf. XXXVII, 67: "The State—where Fathers are not—should be the Father."

VII. DIVES AND LAZARUS

121 EXCLUSIVE OF MEALS: Engels, trans. and ed. W. O. Henderson and W. H. Chaloner (Oxford, Basil Blackwell, 1958), p. 170. J. H. Clapham, in his authoritative *An Economic History of Modern Britain* (2d ed., Cambridge, Cambridge University Press, 1950–52), I, 39, confirms the accuracy of Engels's facts.
121 THREE TIMES A DAY: Engels, p. 161; John W. Dodds, *The Age of Paradox: A Biography of England 1841–1851* (New York, Rinehart & Co., 1952), p. 157.
121 MANUFACTURING DISTRICTS: XXVII, 432.
122 VARIOUS MECHANISMS: Engels, pp. 170–72, 181–82, 185–86. For the quotation concerning the cripples, which does not appear in the Henderson-Chaloner translation of Engels, see the translation of Florence K. Wischnewetzky (London, Allen & Unwin, 1926), p. 164. Subsequent references are to the Henderson-Chaloner edition.
122 FAMILY WAY: Engels, p. 278; Dodds, pp. 91–92.
122 PERVERTED HUMANITY: From a speech by Lord Brougham cited in Dodds, p. 158.
123 WATERS OF THE THAMES: See Mayhew, I, 8, 59, 154–55, 394–95, 528; II, 154, 158, 173, 318.
124 HALF-COOKED MEAT: *Ibid.,* III, 438.
124 INVISIBLE HAND: *An Inquiry into the Nature and Causes of the Wealth of Nations* (London, Printed for W. Strahan & T. Cadell, 1776), I, 17; II, 32, 35.

Page

125 MORAL RESTRAINT: *An Essay on the Principle of Population, As It Affects the Future Improvement of Society* (1st ed., London, Printed for J. Johnson, 1798), pp. 14, 74–87. See also *ibid.*, 4th ed. (1807), pp. 260–71.

125 WAGE FUND: *On the Principles of Political Economy and Taxation* (London, John Murray, 1817), pp. 90–115.

125 RICH OFFERED THEM: XVII, 105–06.

125 DIE OF HUNGER: XVIII, 502.

126 THAN POPULATION: See Scott Gordon, "The London *Economist* and the High Tide of Laissez Faire," *The Journal of Political Economy*, LXIII (December 1955), 473, and Harold A. Boner, *Hungry Generations: The Nineteenth-Century Case against Malthusianism* (New York, King's Crown Press, 1955), p. 144.

126 ABUNDANT HUMAN LABOR: See J. A. Hobson, "Ruskin as Political Economist," *Ruskin the Prophet and Other Centenary Studies*, ed. J. Howard Whitehouse (London, Allen & Unwin, 1920), p. 83.

127 THEM IN FAULT: "Who Is To Blame for the Condition of the People?" *The Economist*, November 21, 1846, p. 1517. Cf. Gordon, p. 480.

128 BEAR ITS INCONVENIENCES: (14th ed., London, Printed for T. Cadell & W. Davies, 1820), p. 255. In fairness I should add that Wilberforce also counsels the rich to be liberal and those in authority to bear their power with meekness (*ibid.*).

128 MODERN CHRISTIANITY: XVII, 320; XVIII, 422.

128 POWER OF MAN: Malthus (1st ed.), p. 98.

128 SIMPLEST LAWS: Matthew Arnold cites the passage in *Culture and Anarchy*, ed. J. Dover Wilson (Cambridge, Cambridge University Press, 1955), p. 190.

128 AND THE VICIOUS: See Engels, p. 322.

129 LOWEST CLASS: See Boner, pp. 125–26.

129 DOG'S TABLE: XVIII, 411. The article appeared in *The Daily Telegraph* of January 16, 1865.

129 POLITICAL ECONOMY: Boner, p. 125.

130 WELL-INTENTIONED HUNGRY: XVIII, 182.

VIII. NO WEALTH BUT LIFE

131 HOUSE OF COMMONS: See Attlee's autobiography, *As It Happened* (London, W. Heinemann, 1954), p. 21, and his *The Labour Party in Perspective* (London, Victor Gollancz, 1937), p. 39.

Page

131 QUESTIONNAIRE: See XXVII, lii–liii.

131 GERMAN, AND ITALIAN: See XVII, xxxi–xxxii, 5–9, and XXXVIII, 317–18.

132 TRANSFORM MY LIFE: Louis Fischer, *The Life of Mahatma Gandhi* (New York, Harper & Brothers, 1950), p. 69, and *The Gandhi Reader: A Source Book of His Life and Writings*, ed. Homer A. Jack (Bloomington, Ind., Indiana University Press, 1956), p. 56.

132 UNTO THEE: Matt. 20:13–14.

133 BRITISH CHOLERA: Letter to Ruskin of October 29, 1860, first published in the *English Illustrated Magazine*, IX (November 1891), 105.

133 NEGATION OF A SOUL: XVII, 25–26.

134 NATIONAL BENEFITS: XVII, 53–54.

134 ATTACHED TO IT: XVII, 44–47, 52.

134 BUT IN FLESH: XVII, 55–56.

135 OF NO CONSEQUENCE: Trans. Francis M. Cornford (Oxford, The Clarendon Press, 1941), pp. 312–13.

135 WORKER HAS EXPENDED: XVII, 33–34.

136 HER OBSCENITIES: XVII, 132–34.

136 MORAL JUDGMENTS: *Principles of Political Economy*, ed. W. J. Ashley (London, Longmans, Green & Co., 1936), p. 437.

136 CAPACITIES AND DISPOSITIONS: XVII, 80–81.

137 CAPACITY AS WELL: XVII, 84, 87–88, 153–54.

137 ECONOMY OF HEAVEN: XVII, 104–05.

138 ILLTH: See XVII, 89, 168.

139 PUBLIC EFFORT: XVII, 111.

139 UNIONS AS WELL: The strike at the Kohler plumbing-ware plant, Kohler, Wisconsin.

140 SQUEAKING IN PARLIAMENT: XVII, 326–27.

140 UNWISE AND UNKIND: XVII, 248.

142 DARKNESS VOLUBLE: *Past and Present*, Bk. III, chap. xiii. *Hard Times*, Bk. II, chap. ix. XXVIII, 18 (cf. VII, 450; XVIII, 424; XXV, 128).

142 FOODLE AND NOODLE: *Little Dorrit*, Bk. I, chap. x. *Bleak House*, chap. xii.

142 HUMAN NATURE: *George Orwell: A Collection of Essays* (Doubleday Anchor Books. Garden City, New York, Doubleday & Co., 1954), p. 58.

144 LEAVENING EFFECT: *The Labour Party in Perspective*, pp. 26–28.

144 AS UNTO THEE: XVII, 114.

Page

144 AN ENDURING MYTH: I am indebted here to Graham Hough, who
in an admirable chapter on Morris has pointed out the mythic
element in *News from Nowhere.* See *The Last Romantics*
(London, Gerald Duckworth & Co., 1949), pp. 111–12.

145 THAT FALLS DIRTY: XXVII, 92.

145 MURDEROUS SPHERE: XXVII, 92–93.

IX. UNSTABLE AS WATER

147 SHALT NOT EXCEL: Gen. 49:4. Ruskin applies the passage to himself
in XXVIII, 275.

148 HERSELF FOR ME: XXXVI, 356–57.

149 BEYOND ALL SPEAKING: XXXVI, 380.

149 MOLLUSCS, WITH DISGUST: XXXVI, 381.

149 THAN OTHERWISE: XXXVI, 392.

150 BILIOUSNESS: XVII, xl–xli.

150 VERY GROUND: XXXVI, 436–37.

150 SPHERE OF COMPETENCE: XXXVI, 521.

150 BEAUTIFUL GENIUS: *The Letters of Henry James,* ed. Percy Lub-
bock (New York, Charles Scribner's Sons, 1920), I, 20.

151 PAPER BROADER: II, xxxii.

151 HE MIGHT LIVE: See XXXV, 391, and *Diaries,* II, 519 ff.

151 STOP ME: XXXVI, 4.

151 WORKED OUT: XIX, lxiv.

153 LABORIOUS A WORK: XVII, 162–63.

153 MIND IN EUROPE: See XXXV, 44.

153 ITS GREATNESS: X, 214.

154 THE GOSPELS: XVII, 208–15.

154 CRETINOUS CONTRACTION: XVII, 258–60.

154 HIS RADICALISM: See XVII, lxviii.

154 GRATIFY IN MUNERA PULVERIS: In the Preface he apologizes for his
"affected concentration of language" and refers to the book as
merely "a dictionary of reference . . . for earnest readers"
(XVII, 145).

155 HEART OF HIS ADDRESS: "Of Kings' Treasuries," *Sesame and Lilies,*
XVIII, 53–108.

156 AT THE DOORSTEP: XVIII, 94–96.

156 HUNG FOR IT: XXXVI, lxxxii.

157 SLAVE TRADE: See XVIII, 416, and X, 197.

157 THE STATE: "Auguries of Innocence," ll. 9–10.

157 EYES DAILY: XXXVI, 437.

Page

157 EXACTLY THE SAME: XVIII, lxi.

157 WHOEVER WAS KILLED: "Work," *The Crown of Wild Olive*, XVIII, 414.

158 IS THE SAME: "War," *The Crown of Wild Olive*, XVIII, 459–60, 466, 471–72, 481–82.

158 RUSKIN'S ADDRESS: See R. H. Wilenski, *John Ruskin: An Introduction to Further Study of His Life and Work* (London, Faber & Faber, 1933), p. 317.

159 THING IN PINNACLES: XVIII, 433–34.

159 BETTER THAN I: XVIII, 445–48.

159 DAY OF THE MONTH: XVIII, 450–51.

160 BE IMPOSSIBLE: XVIII, 451–53, 458.

160 INDEED ETERNAL: XVIII, 456–58.

161 STIFF WITH RUNNING: XXXVI, 461; XVIII, lxvii.

161 EVENING DRESS: G[eorgiana] B[urne]-J[ones], *Memorials of Edward Burne-Jones* (2d ed., London, Macmillan & Co., 1906), I, 264.

161 UP AS VENUS: XXXVI, 327, 334.

162 ENDS OF LIFE: XXXVI, 404.

162 RAINS OF TIME: XXXVI, 291; XIX, 83. Cf. p. 36 above.

162 I DO: XXXVI, 375.

163 THAT LISTENING: XVIII, lxvi, lxx; XIX, 79.

163 GO MAD: XVIII, 305, 351.

163 PITY THEM: XVIII, 351, 356.

164 ONE GIRL: See XVIII, 47, and Wilenski, p. 346.

164 LOVE OF GOD: See Derrick Leon, *Ruskin: The Great Victorian* (London, Routledge & Kegan Paul, 1949), p. 371, and E. T. Cook, *The Life of John Ruskin* (London, George Allen & Co., 1911), II, 263.

164 THOUSAND TEXTS: Leon, pp. 371–72.

165 THING I WAS: *Ibid.*, p. 480.

165 BYE-PATH MEADOW: XXXVI, 367, 429.

165 LAPSES OF CONSCIOUSNESS: See Joan Evans, *John Ruskin* (London, Jonathan Cape, 1954), pp. 278–79; Wilenski, pp. 80–81; XXXV, lxxi.

165 TO HER BED: See Leon, p. 391.

165 DYING FRIEND: In 1870 Rose published a volume of devotional verse and prose entitled *Clouds and Light*, excerpts from which are reprinted in XXXV, lxxi. For the incident at the party, see XXXVII, 472–73.

Page

165 TO SEE HER: Greville MacDonald, *Reminiscences of a Specialist* (London, Allen & Unwin, 1932), p. 109.

165 DISTRUST AND SCORN: Leon, pp. 397–98.

166 SANDS OF THE EARTH: XVIII, 36. For an even more vehement denunciation of "Pride of Faith," see XVIII, 126–27.

166 WORK FOR GOOD: MacDonald, p. 121.

166 LIFE FOR EVER: XVIII, 41–42.

166 BEFORE HIS EYES: See, for example, his entries of January 27, 31; February 24; March 3, 11, 12; April 9; May 14; June 20; August 14; September 11 (*Diaries*, II, 609–13, 615, 618, 620, 629, 634).

166 GIDDY AND WILD: See Leon, p. 391, and Evans, p. 299.

167 THEIR OWN: XVII, 326–27.

167 REMOTE PERIOD: XVII, 446.

167 DISTURBING DREAM: XVII, 336–38.

168 LUDICROUS DREAMS: Entry of October 23, 1872. See also the entries of August 14, 1867, March 9 and 24, 1868, November 27, 1868, November 1, 1869, and April 13, 1873 (*Diaries*, II, 629, 644–46, 661, 685, 733, 743). The classic Freudian dream of August 9, 1867 (*ibid.*, p. 628) is a pastiche of the dancing girls Ruskin describes in Letter V and the Japanese jugglers in Letter VI.

168 AN EVIL SPIRIT: XVII, 339–42.

168 METROPOLIS OF ENGLAND: XVII, 342.

168 SATAN'S POWER: Letters X and XI, subtitled "The Meaning and Actual Operation of Satanic or Demoniacal Influence" and "The Satanic Power . . ." (XVII, 359–69).

168 WIDELY UNPROSPEROUS: XVII, 360–61.

169 THEIR TRUE ENEMY: XVII, 365–66.

169 LORD OF PAIN: XVII, 367.

170 COMPLETELY RECOVERED: See XXXVIII, 172–73, and p. 113 above.

170 BOOK OF PAIN: See *Diaries*, I, v, 74.

170 FLOWERS THERE: XVII, 376–77.

170 WET WITH BLOOD: XXXVI, 436–37.

171 HE KNEW: See XVII, lviii.

171 DRAW NEAR: XVIII, 151.

173 DAYS OF OLD: XIX, 385–86.

174 THEIR BEAUTY: XXXVI, 501.

174 SOULS OF SUICIDES: XIX, 314–15. Ruskin alludes to *The Aeneid*, iii, 245 ff., and to *The Inferno*, Bk. XIII, 10, 94–108. The mention of "sickening famine and thirst of heart" should be read in the light of Ruskin's description of *The Queen of the Air* as the first book he wrote "with full knowledge of sorrow" (XIX, lxxi).

Page

174 NOBLE PEACE: XIX, 307.

175 SHORE TO SHORE: XIX, 293.

175 ATHENA'S WILL: XIX, 396.

175 OR CONTENTION: XIX, 131–32.

X. THE NIGHT COMETH

176 SHOCK PEOPLE: XX, xlviii.

176 WITH THE PAIN: See *Diaries*, II, 693, and Derrick Leon, *Ruskin: The Great Victorian* (London, Routledge & Kegan Paul, 1949), p. 479.

177 LETTERS OF ACCEPTANCE: See Ruskin's letters to Acland and to Dean Liddell, XX, xix–xxi.

177 JOY FOR ALL: XX, 212.

177 OUR PEOPLE BEAUTIFUL: XXII, 153; XX, 107.

178 DEFORMITY AND PAIN: XXI, 103–04.

178 IN THE WORLD: XX, xlii.

179 GO MAD: XXVIII, 207.

179 TURNER AND ROSE: XXXVII, 13.

179 HIS MATLOCK DREAMS: See *Ariadne Florentina*, Lecture VI (XXII, 444–47). The lecture was delivered in 1872; Ruskin added the account in 1874, when revising the lecture for the press.

179 WORKING GEAR: XXXVII, 86. Cf. *Diaries*, III, 778.

179 GOWN FLAPPED WILDLY: See XXII, xli.

180 DAILY MADDENING RAGE: XXXVII, 113.

180 TO SETTLE UPON: XXVIII, 460.

180 GLACIERS OF BLANC-MANGE: See XXIV, xxi; XXV, 351–53; *Diaries*, III, 780, 1093.

180 SAUSSURE: See Joan Evans, *John Ruskin* (London, Jonathan Cape, 1954), p. 356.

180 CONTRIBUTION OF CONTEMPORARIES: For a sampling of Ruskin's attacks on Darwin and Tyndall in *Deucalion*, see XXVI, 99, 141–44, 161, 227, 336. Cf. his assertion that *Deucalion* "will stand out like a quartz dyke, as the sandy speculations of modern gossiping geologists get washed away" (XXV, 413).

181 HEAD PUT ON: XXV, 57; XXVI, 306.

181 WADDLED WITHOUT FEET: XXVI, 306, 309.

181 MAN AND GOD: XXIII, 388–89.

182 VILEST THOUGHT: XXIII, 414.

183 DREADFUL CONE: XXIII, xxxiv–xxxv.

183 GRAND THINGS: XXXVIII, 173; XXXVII, 207.

184 HOUSE IS FOUL: *Diaries*, III, 805, 809, 811, 948, 951–52.

Page

185 UNCLEAN JEST: XXVI, 151.

185 TONE AND SERIES: XXVI, 151–52.

187 HELP OTHERS: XXVIII, 485.

187 IN A NIGHTMARE: See XXXVI, lxxxvi.

188 TO BE ENDURED: XXIX, 387.

188 THEY GO TO: XXVII, 417.

189 HANWELL OR BEDLAM: XXVIII, 202–03.

189 INTO A MESS: XXVIII, 204.

189 IN HIS EMPLOY: XXVIII, 204–05.

190 DARWIN'S TIME: XXVIII, 206.

191 NOT TO GO MAD: XXVIII, 207.

191 CATHEDRA PESTILENTIAE: See XXIX, 361, 365.

191 ALL AROUND HIM: *The Correspondence of Thomas Carlyle and Ralph Waldo Emerson*, ed. Charles Eliot Norton (Boston, James R. Osgood & Co., 1883), II, 352.

191 CRAWLS OR CONTRACTS: XXVIII, 426; XXIX, 320; XXVII, 110; XXVIII, 646, 649, 515, 252; XXVII, 451.

191 ON MY WRATH: *Diaries*, III, 777.

191 WILD AND WHIRLING WORDS: See XXIX, 371.

191 STUDIED EXPRESSION: XXXVII, 371.

192 SIMPLY MAD: XXVIII, 513.

192 MY MASTERS: XXIX, 72.

193 HALF A DOZEN LETTERS: See XXVIII, 207–08; XXVII, 447–48, 29, 102, 357, 414, 429, 502.

193 WILD ON ADRIA: XXVIII, 756.

194 UNENCUMBERED SHORE: XXVIII, 756–58.

194 YOU TO THINK: XXVII, 98–99.

195 LOVE ONE ANOTHER: XXIX, 191–92.

196 GOLD AND FRANKINCENSE: XXVII, 95–97, 142.

196 OF ITS INHABITANTS: See XXVIII, 20–21, 377, 648–49; XXX, xxiii, 4.

196 MY WORK: XXIX, 386.

196 MEMBERS BY MYRIADS: XXX, 32.

197 LAND IN DERBYSHIRE: See XXX, xxvi–xxvii, 19–22, 71.

197 TWENTY-FOUR SUBSCRIBERS: See XXVIII, 223.

197 FIFTY-SEVEN COMPANIONS: See XXX, 86.

197 SOCIETY OF MONT ROSE: The "Society" or "Company" of Mont Rose was the name which Ruskin originally intended for the Guild. See his letter of October 4, 1869, to Mrs. Cowper (the Pierpont Morgan Library, MS. 1571, fol. 79).

198 CONISTON WATER: See XXX, 39–40, 50–51.

198 MAKE-SHIFT MASTER: See, for example, XXVII, 557; XXVIII, 19–23, 235–36, 377, 424–25, 638, 648–49; XXIX, 197.

Page
198 PURE HEART: Margaret E. Spence, "The Guild of St. George: Ruskin's Attempt to Translate His Ideas into Practice," *Bulletin of the John Rylands Library*, XL (September 1957), 175.
198 AS THE WORLD: XXVII, 557.
199 INTO THE FIRE: XXVIII, 425.

XI. THE PAST RECAPTURED

201 GAIT OF AGE: *Letters of John Ruskin to Charles Eliot Norton*, ed. Charles Eliot Norton (Boston & New York, Houghton Mifflin & Co., 1905), II, 165.
201 TO ALL PARENTS: XXXVII, 203.
201 THE PURPOSED HOME: XXXVII, 35.
202 FLORENTINE SCULPTOR: XXII, xxiii.
202 SERMON ON THE MOUNT: XXII, xxiii.
202 KITES AND CROWS: Derrick Leon, *Ruskin: The Great Victorian* (London, Routledge & Kegan Paul, 1949), p. 471.
202 WOMAN HAPPY: Sir William James, *The Order of Release* (London, John Murray, 1947), p. 255.
203 TOGETHER AGAIN: Leon, p. 488.
203 WILD ANCHORITES: Leon, p. 365.
203 TEN YEARS, HAPPY: *Diaries*, II, 729.
203 AT LAST UNITED: See the Pierpont Morgan Library, MS. 1571, fol. 121.
203 IN ALL THOUGHT: *Diaries*, II, 730, 732.
203 UNDERSTAND ONE ANOTHER: Greville MacDonald, *Reminiscences of a Specialist* (London, Allen & Unwin, 1932), p. 121.
204 SINS AGAINST GOD: See Leon, pp. 391, 489.
204 FRENCH CATHOLIC: See XXXV, 181.
204 HERSELF AND ME: From an unpublished letter to Mark Pattison of August 19, 1875, in which Ruskin summarizes the course of his relationship with Rose (Bodleian Library, Pattison MS. 57, fol. 119).
204 BESIDE THE BED: See Lucia Gray Swett, *John Ruskin's Letters to Francesca and Memoirs of the Alexanders* (Boston, Lothrop, Lee & Shepard, 1931), p. 118.
204 SCARCELY RISES: XXVII, 344.
204 TRANSCRIBED IN FORS: XXVIII, 740–43.
205 IN HEAVEN: XXVIII, 746.
205 ON A MONUMENT: See XXXV, lxvii.
205 AND OF DEATH: XXXIII, 507.

Page

205 ALL OTHER STATUES: For Ruskin's praise of Ilaria's tomb and its central role in the development of his esthetics, see XXXIV, 170–71; XXXV, 349; IV, 122–24, 347–48, XXIII, 229–32.

205 HER LIPS: See *Diaries,* III, 907–45, and cf. XXXIII, 507, where Ruskin writes of tracing every detail "accurately to a hair's breadth" and drawing the mouth twelve times over. For the crew of artists he commissioned to make additional studies of the painting, see XXX, 195.

205 WAKING HER: XXIV, xxxvii. Cf. XXXVII, 209–10, for letters to the same effect.

206 BODY OF HER: XXXVII, 355.

206 ART IS HUMANISTIC: See XX, 99.

206 WORLDLY VISIBLE TRUTH: XXIX, 86–91.

207 PUBLIC'S FACE: XXIX, 160.

207 TO STICK, STICK: *Literary Gazette,* May 14, 1842, p. 331. R. H. Wilenski notes the verbal echo on p. 198 of his *John Ruskin: An Introduction to Further Study of His Life and Work* (London, Faber & Faber, 1933).

207 LIGHT AND SHADE: See *Diaries,* III, 934; Joan Evans, *John Ruskin* (London, Jonathan Cape, 1954), p. 372; and cf. p. 182 above. Ruskin's hypersensitivity to light is most clearly shown in his sketch of Venice reproduced in XXIV, Plate D.

207 ATTACKED WHISTLER: See XXIII, 49.

207 COCKILY CONFIDENT LETTERS: See, for example, his letter of August 1877 to Burne-Jones (XXXVII, 225).

208 PARLEY OF PAINTING: *Whistler v. Ruskin: Art and Art Critics* (London, Chatto & Windus [1878]), p. 17. Whistler reprinted his account of the trial in *The Gentle Art of Making Enemies* (London, W. Heinemann, 1890).

208 BRITISH LAW: XXIX, xxv.

208 WINE OF LIFE: *Marcel Proust: A Selection from His Miscellaneous Writings,* trans. Gerard Hopkins (London, Allan Wingate, 1948), p. 54.

209 WHISPERING-GALLERY: *Ibid.,* p. 24.

209 EVIL—CONTINUALLY: *Diaries,* III, 993–94.

209 INEVITABLE DREAMS: *Ibid.,* p. 997.

209 LIVES IN DREAMS: XXXVII, 345.

209 CLOSEST FRIENDS: See XXXVII, 691.

209 GAPLESS GLOOM: *Diaries,* III, 1029. Cf. pp. 1018–41, *passim.*

210 IN A MANUSCRIPT: *The Story of Ida,* which Ruskin published in 1883. Francesca's text and drawing of Ida are printed in XXXII, 1–36.

Page
210 DOWN TO EARTH: XXXIII, 283. Cf. 282, 284, 323–25.
210 TURNERS OF INTEREST: See *Diaries*, III, 1126, and XXXVII, 505.
211 FIELD MOUSE: XXXIII, 335–36.
211 LOVING LITTLE BOY: See XXXVI, c; XXXVII, 173–74. Cf. similar letters in the Pierpont Morgan Library (MS. 1571, fol. 138–42) and Ruskin's entire correspondence with Susan Beever, an elderly friend and neighbor who lived near Brantwood (XXXVII, *passim*).
211 NATIVE DUNGHILL: XXXIII, liii–liv, 507–09.
211 ACADEMIC FARCE: XXXIII, liv.
211 MAD DOG: XXXIII, liv.
212 SUNLESS WEEK: See XXXIV, 78–79, 41, n. 2.
212 RECORDED IN BRITAIN: See W. A. L. Marshall, *A Century of London Weather*, Air Ministry, Meteorological Office (London, Her Majesty's Stationery Office, 1952), p. 75, and C. E. P. Brooks, *The English Climate* (London, English Universities Press, 1954), p. 146.
212 NEVER RISES: XXXIV, 41.
212 ENGLAND TO SICILY: XXXIV, 31–32.
212 OF A WAIL: XXXIV, 33–34, 38–39.
213 BLACKGUARDLY CLOUD BENEATH: XXXIV, 37–38.
213 DEVIL CLOUD: *Diaries*, III, 861.
213 MOST DESOLATING: XXXVII, 30. Cf. a similar letter to Norton of January 1873: "Nature herself traitress to me—whatever Wordsworth may say" (XXXVII, 57).
213 BLINDED MAN: XXXIV, 40.
214 POISONOUS SMOKE: *Fors Clavigera*, August 1871: XXVII, 133. The data on coal production are derived from J. U. Nef, *The Rise of the British Coal Industry* (London, George Routledge & Sons, 1932), I, 19–20, and from J. H. Clapham, *An Economic History of Modern Britain* (2d ed., Cambridge, Cambridge University Press, 1950–52), I, 431; II, 100; III, 162, 167.
214 FORTY PER CENT: During the great fog of December 1873. See Brooks, p. 65.
214 ALL GONE: XXXVII, 408. R. H. Wilenski (pp. 168–69) cites the letter as an example of one of Ruskin's delusions, but Ruskin was often more accurate and more sane than Wilenski contends.
214 GREAT GLACIAL RETREAT: See H. H. Hildebrandsson, "On the So-called Change in European Climate during Historic Times," *Monthly Weather Review*, U. S. Department of Agriculture, Weather Bureau, XLIV (June 1916), p. 352.

Page

215 LIGHT IN AUTUMN: See, for example, XXXVII, 179, 227, 264, and
 Diaries, II, 763.

215 SEE, SANE: XXXVII, 569.

215 RAGING ENEMY: XXXVII, 297.

216 BLAST-BERUFFLED PLUME: "The Darkling Thrush," ll. 21–22.

217 GIVING PLEASURE: See Sir Kenneth Clark's edition of *Praeterita*
 (London, Rupert Hart-Davis, 1949), p. vii.

217 IN 1875: See XXXV, lv, 633–35. Subsequent notes and chapter out-
 lines suggest a terminal date of 1882.

217 AND WIFE: Entry of July 10, 1849: *Diaries,* II, 408. Cf. the equally
 revealing entry of August 15, pp. 424–25.

218 PEELED CAREFULLY: XXXV, lii.

218 FACE TO FACE: XXXV, 279.

218 IN THE UNIVERSE: XXXV, 36–37.

219 PURE PRESENTATION: The phrase is A. C. Benson's. See *Ruskin: A
 Study in Personality* (London, Smith, Elder & Co., 1911), p. 191.

220 CHIEF RESOURCES: XXXV, 20–21.

220 IDOL IN A NICHE: XXXV, 39.

221 ALL IN ONE: V, 333.

221 BY HEART: See Marcel Proust, *Lettres à une amie, receuil de
 quarante-et-une lettres inédites, addressées à Marie Nordlinger:
 1889–1908* (Manchester, Editions du Calame [1942]), p. 14.

221 LOOK DOWN INTO: XXXV, 15. For more of these motifs, see
 XXXV, 16, 19, 21, 33, 62–63, 66–67.

222 PRESQUE MICROSCOPIQUE: "Proust et Ruskin," *Essays and Studies by
 Members of the English Association,* XVII (1931), p. 29. This
 is the best brief account of Ruskin's influence on Proust. For
 fuller, more recent studies, see Jean Autret's *L'Influence de Rus-
 kin sur la vie, les idées, et l'oeuvre de Marcel Proust* (Geneva,
 Droz, 1955), and George D. Painter's *Proust: The Early Years*
 (Boston, Little, Brown & Co., 1959), pp. 314–52.

222 BIEN LE DIRE: *Sésame et les lys,* traduction, notes, et préface par
 Marcel Proust (7me éd., Paris, Mercure de France [1906?]),
 p. 62.

222 MY DANGER: Robin Skelton, "John Ruskin: The Final Years—A
 Survey of the Ruskin Correspondence in the John Rylands Li-
 brary," *Bulletin of the John Rylands Library,* XXXVII (March
 1955), p. 571.

223 THROUGH PRAETERITA: Vol. II, chap. v, "The Simplon": XXXV,
 326–27. For the date of composition, see *Diaries,* III, 1128, and
 XXXV, xxxv.

Page

223 END OF VOLUME II: Chap. xii, "Otterburn." See especially XXXV,
 465, n. 3, in which Ruskin complains, "I cannot go on in this
 chapter to what I meant . . . being disturbed by instant troubles
 which take away my powers of tranquil thought, whether of
 the Dead or Living." The first chapter of Vol. III was issued in
 May of 1888.

224 WHO LOVE ME: XXXVII, 601.

224 LOST ITS FASCINATION: XXXVII, 599–600.

224 SPIRITS OF THE ABYSS: *The Gulf of Years: Letters from John Rus-
 kin to Kathleen Olander,* ed. Rayner Unwin (London, George
 Allen & Unwin, 1953), p. 38.

224 MORTAL TO ME: *Ibid.,* p. 74.

224 SHOWN HER LETTERS: The letters were intercepted by Mrs. Severn.
 See Joan Evans, *John Ruskin* (London, Jonathan Cape, 1954),
 p. 406.

224 ON HIS DESK: See W. G. Collingwood, *The Life of John Ruskin*
 (London, Methuen & Co., 1900), pp. 386–87.

225 TO MRS. SEVERN: The Pierpont Morgan Library (MS. 1743) has
 what is described as the first draft of the chapter, dictated to
 Mrs. Severn and dated, on its first page, May 7, 1889. Presum-
 ably Collingwood's description (pp. 386–87) of Ruskin's writing
 the chapter himself at Seascale during the summer applies to
 later additions and revisions, also contained in MS. 1743 and
 made in his own hand.

225 LITTLE JOANIE: XXXV, 553.

225 ROSIE CALLS IT: XXXV, 560–61. For similar confusions of past and
 present, see pp. 525–26 and 590, n. 1.

225 END OF DEATH: *Fors Clavigera,* August 1873: XXVII, 584.

BIBLIOGRAPHY

For a complete bibliography of works by and about Ruskin through 1911, see Vol. XXXVIII of the Library Edition. No comparable bibliography of Ruskin scholarship and criticism exists for recent years. Unpublished material to which I have referred in the text has been identified in the footnotes.

WORKS BY RUSKIN

Ruskin, John. *The Works of John Ruskin.* Edited by E. T. Cook and Alexander Wedderburn. 39 vols. Library Edition. London, George Allen, 1903–1912.

—— *The Diaries of John Ruskin.* Selected and edited by Joan Evans and John Howard Whitehouse. 3 vols. Oxford, The Clarendon Press, 1956–1959.

—— *The Gulf of Years: Letters from John Ruskin to Kathleen Olander.* Edited with a preface by Rayner Unwin. London, George Allen & Unwin, 1953.

—— *Letters of John Ruskin to Charles Eliot Norton.* Edited by Charles Eliot Norton. 2 vols. Boston & New York, Houghton, Mifflin & Co., 1905.

—— *Ruskin's Letters from Venice 1851–1852.* Edited by John Lewis Bradley. (Yale Studies in English, Vol. CXXIX.) New Haven, Yale University Press, 1955.

WORKS ABOUT RUSKIN

Autret, Jean. *L'Influence de Ruskin sur la vie, les idées et l'oeuvre de Marcel Proust.* Geneva, Droz, 1955.

Ball, A. H. R. (ed.) *Ruskin as Literary Critic: Selections.* Introduction by A. H. R. Ball. Cambridge, Cambridge University Press, 1928.

Beard, Charles A. "Ruskin and the Babble of Tongues," *The New Republic,* LXXXVII (August 1936), 370–72.

Benson, Arthur Christopher. "A Sight of Ruskin," in *Memories and Friends*. New York & London, G. P. Putnam's Sons, 1924.

—— *Ruskin: A Study in Personality*. London, Smith, Elder & Co., 1911.

Bentley, J. A. "Ruskin and Modern Fiction," *Queen's Quarterly*, XXXIX (February 1932), 145–56.

Bragman, Louis J. "The Case of John Ruskin: A Study in Cyclothymia," *The American Journal of Psychiatry*, XCI (March 1935), 1137–59.

Brown, Samuel E. "The Unpublished Passages in the Manuscript of Ruskin's Autobiography," *The Victorian Newsletter*, XVI (Fall 1959), 10–18.

Buckley, Jerome Hamilton. "The Moral Aesthetic," in *The Victorian Temper: A Study in Literary Culture*. Cambridge, Mass., Harvard University Press, 1951.

Burd, Van Akin. "Another Light on the Writing of *Modern Painters*," *Publications of the Modern Language Association*, LXVIII (September 1953), 755–63.

—— "Ruskin's Quest for a Theory of Imagination," *Modern Language Quarterly*, XVII (March 1956), 60–72.

Clark, Sir Kenneth (ed.). *Praeterita*. Introduction by Sir Kenneth Clark. London, Rupert Hart-Davis, 1949.

—— *Ruskin at Oxford: An Inaugural Lecture Delivered before the University of Oxford, 14 November 1946*. Oxford, The Clarendon Press, 1947.

Collingwood, W. G. *The Life and Work of John Ruskin*. 2 vols. London, Methuen & Co., 1893.

—— *The Life of John Ruskin*. London, Methuen & Co., 1900.

Cook, E. T. *The Life of John Ruskin*. 2 vols. London, George Allen & Co., 1911.

Dolk, Lester Charles. *The Aesthetics of John Ruskin in Relation to the Aesthetics of the Romantic Era*. (Dissertation abstract, University of Illinois.) Urbana, Ill., University of Illinois, 1941.

Dougherty, Charles T. "Joyce and Ruskin," *Notes and Queries*, CXCVIII (February 1953), 76–77.

—— "Ruskin's Views on Non-Representational Art," *College Art Journal*, XV (Winter 1955), 112–18.

Durrant, William Scott. "From Art to Social Reform: Ruskin's 'Nature of Gothic,'" *Nineteenth Century*, LXVII (May 1910), 922–30.

Evans, Joan. *John Ruskin*. London, Jonathan Cape, 1954.

Fain, John Tyree. *Ruskin and the Economists*. Nashville, Tenn., Vanderbilt University Press, 1956.

Goetz, Sister Mary Dorothea. *A Study of Ruskin's Concept of the Imagination*. Washington, D. C., The Catholic University of America, 1947.

Harrison, Frederic. *John Ruskin*. (English Men of Letters.) New York, Macmillan Co., 1902.

—— *Tennyson, Ruskin, Mill, and Other Literary Estimates*. New York, Macmillan Co., 1900.

Hobson, J. A. *John Ruskin: Social Reformer*. Boston, Dana Estes & Co., 1898.

Hough, Graham. "Ruskin," in *The Last Romantics*. London, Gerald Duckworth & Co., 1949.

Jackson, Holbrook. "Ruskin," in *Dreamers of Dreams: The Rise and Fall of 19th Century Idealism*. London, Faber & Faber, [1948].

James, Sir William. *The Order of Release: The Story of John Ruskin, Effie Gray and John Everett Millais Told for the First Time in Their Unpublished Letters*. London, John Murray, 1947.

Ladd, Henry. *The Victorian Morality of Art: An Analysis of Ruskin's Esthetic*. New York, Ray Long & Richard R. Smith, 1932.

Larg, David. *John Ruskin*. [London,] Peter Davis, 1932.

Leon, Derrick. *Ruskin: The Great Victorian*. London, Routledge & Kegan Paul, 1949.

Le Roy, Gaylord C. "John Ruskin: An Interpretation of His 'Daily Maddening Rage,'" *Modern Language Quarterly*, X (March 1949), 81–88.

Mackail, J. W. "Ruskin," in *Studies in Humanism*. London, Longmans, Green & Co., [1938].

Maurois, André. "Proust et Ruskin," *Essays and Studies by Members of the English Association*, XVII (1931), 25–32.

Meynell, Alice. *John Ruskin*. New York, Dodd, Mead & Co., 1900.

Murray, J. D. "Marcel Proust as Critic and Disciple of Ruskin," *Nineteenth Century*, CI (April 1927), 614–19.

Painter, George D. "Salvation through Ruskin," in *Proust: The Early Years*. Boston, Little, Brown & Co., 1959.

Pritchett, V. S. "The Most Solitary Victorian." Review of *The Diaries of John Ruskin, The New Statesman and Nation*, October 20, 1956, pp. 489–90.

Proust, Marcel. "John Ruskin" (Part I), *Gazette des Beaux-Arts*, XXIII (April 1900), 310–18.

—— "John Ruskin" (Part II), *Gazette des Beaux-Arts*, XXIV (August 1900), 135–46.

—— (trans.). *Sésame et les lys*. Traduction, notes et préface par Marcel Proust. Septième édition. Paris, Mercure de France, [1906?].

Quennell, Peter. *John Ruskin: The Portrait of a Prophet*. New York, Viking Press, 1949.

Ritchie, Anne. *Records of Tennyson, Ruskin, and Browning*. London, Macmillan & Co., 1892.

Robertson, John M. "John Ruskin," in *Modern Humanists*. London, Swan Sonnenschein & Co., 1891.

—— "Ruskin," in *Modern Humanists Reconsidered*. London, Watts & Co., 1927.

Roe, Frederick William. *The Social Philosophy of Carlyle and Ruskin*. New York, Harcourt, Brace & Co., 1921.

Rossetti, William Michael. *Ruskin: Rossetti: Pre-Raphaelitism, Papers 1854 to 1862*. London, George Allen, 1899.

Saintsbury, George. "Mr. Ruskin," in *Corrected Impressions: Essays on Victorian Writers*. New York, Dodd Mead & Co., 1895.

Salomon, Louis. "The Pound-Ruskin Axis," *College English*, XVI (Fall 1955), 270–76.

Sanders, Charles Richard. "Carlyle's Letters to Ruskin: A Finding List with Some Unpublished Letters and Comments," *Bulletin of the John Rylands Library*, XLI (September 1958), 208–38.

Shaw, George Bernard. *Ruskin's Politics*. (Lecture delivered at the Royal Academy, November 21, 1919.) London, The Ruskin Centenary Council, 1921.

Sizeranne, Robert de la. *Ruskin and the Religion of Beauty*. Translated by the Countess of Galloway. London, George Allen, 1899.

Skelton, Robin. "John Ruskin: The Final Years—A Survey of the Ruskin Correspondence in the John Rylands Library," *Bulletin of the John Rylands Library*, XXXVII (March 1955), 562–86.

Smart, William. *A Disciple of Plato: A Critical Study of John Ruskin*. Glasgow, Wilson & McCormick, 1883.

Spence, Margaret E. "The Guild of St. George: Ruskin's Attempt to Translate His Ideas into Practice," *Bulletin of the John Rylands Library*, XL (September 1957), 147–201.

Stephen, Leslie. "John Ruskin," in *Studies of a Biographer*. 2d series, Vol. III. London, Duckworth & Co., 1902.

Swett, Lucia Gray. *John Ruskin's Letters to Francesca and Memoirs of the Alexanders*. Boston, Lothrop, Lee & Shepard Co., 1931.

Townsend, Francis G. *Ruskin and the Landscape Feeling: A Critical Analysis of His Thought During the Crucial Years of His Life, 1843–56*. (Illinois Studies in Language and Literature, Vol. XXXV, No. 3.) Urbana, Ill., University of Illinois Press, 1951.

Viljoen, Helen Gill. *Ruskin's Scottish Heritage: A Prelude*. Urbana, Ill., University of Illinois Press, 1956.

Whistler, J. A. McNeill. *Whistler v. Ruskin: Art and Art Critics*. London, Chatto & Windus, [1878].

Whitehouse, J. Howard (ed.). *Ruskin: Centenary Addresses*. London, Oxford University Press, 1919.

—— (ed.). *Ruskin the Prophet and Other Centenary Studies.* London, Allen & Unwin, 1920.

—— *Vindication of Ruskin.* London, Allen & Unwin, 1950.

Wilenski, R. H. *John Ruskin: An Introduction to Further Study of His Life and Work.* London, Faber & Faber, 1933.

Williams-Ellis, Amabel. *The Tragedy of John Ruskin.* London, Jonathan Cape, 1928.

Woolf, Virginia. "Ruskin," in *The Captain's Deathbed, and Other Essays.* New York, Harcourt, Brace & Co., [1950].

OTHER WORKS

Adams, Henry. *Mont-Saint-Michel and Chartres.* London, Constable & Co., 1950.

Annan, Noel Gilroy. *Leslie Stephen: His Thought and Character in Relation to His Time.* Cambridge, Mass., Harvard University Press, 1952.

Arnold, Matthew. *Culture and Anarchy.* Edited with an introduction by J. Dover-Wilson. Cambridge, Cambridge University Press, 1955.

Attlee, Clement R. *As It Happened.* London, W. Heinemann, 1954.

—— *The Labour Party in Perspective.* London, Victor Gollancz, 1937.

Barzun, Jacques. *Romanticism and the Modern Ego.* Boston, Little, Brown & Co., 1943.

Baxendell, Joseph. "English Meteorological Periodicities of the Order of a Few Decades," *Meteorological Magazine,* LXXVI (April 1938), 57–62.

Beach, Joseph Warren. *The Concept of Nature in Nineteenth-Century English Poetry.* New York, Macmillan Co., 1936.

Berenson, Bernard. *The Italian Painters of the Renaissance.* London, The Phaidon Press, 1952.

Bilham, Ernest G. *The Climate of the British Isles.* London, Macmillan & Co., 1938.

Blake, William. *The Complete Writings of William Blake.* Edited by Geoffrey Keynes. London, The Nonesuch Press, 1957.

Boner, Harold A. *Hungry Generations: The Nineteenth-Century Case against Malthusianism.* New York, King's Crown Press, 1955.

Bosanquet, Bernard. *A History of Aesthetic.* London, Swan Sonnenschein & Co., 1892.

Brooks, C. E. P. *The English Climate.* London, English Universities Press, 1954.

Brunt, D. "An Investigation of Periodicities in Rainfall, Pressure and Temperature at Certain European Stations," *Quarterly Journal of the Royal Meteorological Society,* LIII, No. 221 (1927), 1–30.

B[urne]-J[ones], G[eorgiana]. *Memorials of Edward Burne-Jones*. 2d ed., 2 vols. London, Macmillan & Co., 1906.

Carlyle, Thomas. *The Correspondence of Thomas Carlyle and Ralph Waldo Emerson, 1834–1872*. Edited by Charles Eliot Norton. 2 vols. Boston, James R. Osgood & Co., 1883.

—— *On Heroes, Hero-Worship, and the Heroic in History*. Edited by H. D. Traill. Centenary Edition. London, Chapman & Hall, n.d.

—— *Past and Present*. Edited by H. D. Traill. Centenary Edition. London, Chapman & Hall, n.d.

—— *Sartor Resartus: The Life and Opinions of Herr Teufelsdröckh*. Edited by H. D. Traill. Centenary Edition. London, Chapman & Hall, 1897.

Clapham, J. H. *An Economic History of Modern Britain*. 2d ed. revised, 3 vols. Cambridge, Cambridge University Press, 1950–52.

Clark, Sir Kenneth McKenzie. *The Gothic Revival: An Essay in the History of Taste*. Revised and enlarged ed. London, Constable & Co., 1950.

Cross, John W. *George Eliot's Life as Related in Her Letters and Journals*. 3 vols. Edinburgh and London, W. Blackwood & Sons, 1885.

Dahl, Curtis. "The Victorian Wasteland," *College English*, XVI (March 1955), 341–47.

Dodds, John W. *The Age of Paradox: A Biography of England 1841–1851*. New York, Rinehart & Co., 1952.

Eastlake, Charles L. *A History of the Gothic Revival*. London, Longmans, Green & Co., 1872.

Engels, Friedrich. *The Condition of the Working Class in England [in 1844]*. Translated and edited by W. O. Henderson and W. H. Chaloner. Oxford, Basil Blackwell, 1958.

Finberg, A. J. *The Life of J. M. W. Turner, R. A.* Oxford, The Clarendon Press, 1939.

Fischer, Louis. *The Life of Mahatma Gandhi*. New York, Harper & Brothers, 1950.

Fogg Museum of Art. *Paintings and Drawings of the Pre-Raphaelites and Their Circle*. Catalogue of the Exhibition of April 8 through June 1, 1946. Cambridge, Mass., Harvard University, 1946.

Gandhi, Mohandas K. *The Gandhi Reader: A Source Book of His Life and Writings*. Edited by Homer A. Jack. Bloomington, Ind., Indiana University Press, 1956.

Gibbon, Edward. *Private Letters of Edward Gibbon (1753–1794)*. Edited by Rowland E. Prothero, with an introduction by the Earl of Sheffield. 2 vols. London, J. Murray, 1896.

Gide, Charles. *Political Economy*. Authorized translation from the 3d ed. (1913) of the *Cours d'économie politique*. Boston & New York, D. C. Heath, [1913?].

Giedion, Sigfried. *Space, Time and Architecture: The Growth of a New Tradition*. 3d ed. enlarged. Cambridge, Mass., Harvard University Press, 1954.

Gilson, Étienne. *The Spirit of Mediaeval Philosophy*. New York, Charles Scribner's Sons, 1940.

Gordon, Scott. "The London *Economist* and the High Tide of Laissez Faire," *The Journal of Political Economy*, LXIII (December 1955), 461–88.

Hildebrandsson, H. H. "On the So-called Change in European Climate during Historic Times," *Monthly Weather Review* (U. S. Department of Agriculture: Weather Bureau), XLIV (June 1916), 344–52.

Hitchcock, Henry-Russell. *Early Victorian Architecture in Britain*. 2 vols. New Haven, Yale University Press, 1954.

—— "High Victorian Gothic," *Victorian Studies*, I (September 1957), 47–71.

—— *In the Nature of Materials: 1887–1941: The Buildings of Frank Lloyd Wright*. New York, Duell, Sloan & Pearce, 1942.

Houghton, Walter E. *The Victorian Frame of Mind: 1830–1870*. New Haven, Yale University Press, 1957.

James, Henry. *The Letters of Henry James*. Selected and edited by Percy Lubbock. 2 vols. New York, Charles Scribner's Sons, 1920.

Lancaster, Osbert. *Pillar to Post, or The Pocket-Lamp of Architecture*. London, John Murray, 1938.

MacDonald, Greville. *Reminiscences of a Specialist*. London, Allen & Unwin, 1932.

Malthus, Thomas Robert. *An Essay on the Principle of Population, as It Affects the Future Improvement of Society*. London, Printed for J. Johnson, 1798.

Manson, Grant Carpenter. *Frank Lloyd Wright to 1910: The First Golden Age*. New York, Reinhold Publishing Corp., 1958.

Marshall, W. A. L. *A Century of London Weather*. (Air Ministry: Meteorological Office.) London, Her Majesty's Stationery Office, 1952.

Mayhew, Henry. *London Labour and the London Poor: The Condition and Earnings of Those That Will Work, Cannot Work, and Will Not Work*. 4 vols. London, Charles Griffin & Co., [1851–62].

McCarthy, Mary. *Venice Observed*. New York, Reynal & Co., [1956].

Mill, John Stuart. *Autobiography of John Stuart Mill*. New York, Columbia University Press, 1944.

—— *Mill on Bentham and Coleridge.* Edited with an introduction by F. R. Leavis. London, Chatto & Windus, 1950.

—— *Principles of Political Economy.* Edited with an introduction by W. J. Ashley. London, Longmans, Green & Co., 1936.

Morris, William. *The Collected Works of William Morris.* With introductions by May Morris. 24 vols. London, Longmans, Green & Co., 1910–1915.

—— (ed.). *The Nature of Gothic: A Chapter of The Stones of Venice.* Preface by William Morris. Kelmscott Edition. London, George Allen, [1892].

Nef, J. U. *The Rise of the British Coal Industry.* 2 vols. London, George Routledge & Sons, 1932.

Neff, Emery. *Carlyle and Mill: An Introduction to Victorian Thought.* 2d ed. revised. New York, Columbia University Press, 1926.

Newman, John Henry (Cardinal). *Apologia Pro Vita Sua.* Edited with an introduction by Charles Frederick Harrold. London, Longmans, Green & Co., 1947.

Orwell, George. *A Collection of Essays.* Doubleday Anchor Books. Garden City, N. Y., Doubleday & Co., 1954.

Plato. *The Republic of Plato.* Translated with an introduction and notes by Francis M. Cornford. Oxford, The Clarendon Press, 1941.

Proust, Marcel. *Lettres à une amie, recueil de quarante-et-une lettres inédites addressées à Marie Nordlinger: 1889–1908.* Manchester, Editions du Calame, [1942].

—— *Marcel Proust: A Selection from His Miscellaneous Writings.* Translated by Gerard Hopkins. London, Allan Wingate, 1948.

Pugin, A. Welby. *Contrasts; or, a Parallel between the Noble Edifices of the Fourteenth and Fifteenth Centuries, and Similar Buildings of the Present Day; Shewing the Present Decay of Taste.* London, By the author, 1836.

Ricardo, David. *On the Principles of Political Economy, and Taxation.* London, John Murray, 1817.

Scott, Geoffrey. *The Architecture of Humanism: A Study in the History of Taste.* 2d edition. London, Constable & Co., 1924.

Shaw, George Bernard. *Everybody's Political What's What?* New York, Dodd, Mead & Co., 1944.

Smith, Adam. *An Inquiry into the Nature and Causes of the Wealth of Nations.* 2 vols. London, Printed for W. Strahan & T. Cadell, 1776.

Spencer, Herbert. *Social Statics.* New York, D. Appleton & Co., 1872.

Sturge Moore, T. and D. C. (eds.). *Works and Days, from the Journal of Michael Field* [Katherine Bradley and Edith Cooper]. London, John Murray, 1933.

Thackeray, William. "A Second Lecture on the Fine Arts," *Fraser's Magazine*, XIX (June 1839), 743–50.

Trevelyan, G. M. *English Social History*. 3d ed. London, Longmans, Green & Co., 1948.

Troedsson, Carl Birger. *Two Standpoints towards Modern Architecture: Wright and Le Corbusier*. (Transactions of Chalmers University of Technology, No. 113.) Gothenburg, Gumperts Förlag, 1951.

Turnell, Martin. "Proust's Invisible Vocation," *Commonweal*, LXVIII (June 20, 1958), 306–07.

Whistler, J. A. McNeill. *The Gentle Art of Making Enemies*. London, William Heinemann, 1890.

"Who is to Blame for the Condition of the People?" *The Economist*, IV (November 21, 1846), 1517–18.

Wilberforce, William. *A Practical View of the Prevailing Religious System of Professed Christians, in the Higher and Middle Classes, in This Country Contrasted with Real Christianity*. 14th ed. London, Printed for T. Cadell & W. Davies, 1820.

Wilenski, R. H. *English Painting*. London, Faber & Faber, 1933.

Willey, Basil. *Nineteenth Century Studies*. London, Chatto & Windus, 1949.

Wittkower, Rudolf. *Architectural Principles in the Age of Humanism*. London, The Warburg Institute, University of London, 1949.

Wright, Frank Lloyd. *An American Architecture*. Edited by Edgar Kaufmann. New York, Horizon Press, 1955.

—— *An Autobiography*. New York, Duell, Sloan & Pearce, 1943.

—— *An Organic Architecture: The Architecture of Democracy*. London, Lund Humphries & Co., 1939.

Young, G. M. *Victorian England: Portrait of an Age*. Doubleday Anchor Books. Garden City, N. Y., Doubleday & Co., 1954.

ACKNOWLEDGMENTS

I wish to thank George Allen & Unwin for granting me permission to quote from unpublished letters of Ruskin, from Greville MacDonald's *Reminiscences of a Specialist*, and from Rayner Unwin's *The Gulf of Years;* the Oxford University Press for permission to quote from *The Diaries of John Ruskin*, edited by Joan Evans and John Howard White-house; Routledge & Kegan Paul for permission to quote from Derrick Leon's *Ruskin: The Great Victorian;* John Murray, Ltd., for permission to quote from Sir William James's *The Order of Release;* the Horizon Press for permission to quote from Frank Lloyd Wright's *An American Architecture;* the Librairie Gallimard for permission to quote from the preface to Marcel Proust's translation, *Sésame et les lys;* and Sir Ralph Millais for permission to quote from an unpublished letter of Sir John Everett Millais. I am also indebted to the Ashmolean Museum and the Pierpont Morgan Library for allowing me to reproduce drawings in their possession.

INDEX